Clement Greenberg
THE COLLECTED ESSAYS AND CRITICISM

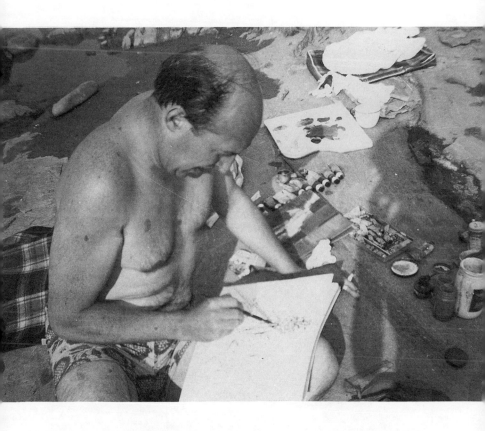

Clement Greenberg at Black Mountain College, North Carolina, 1950. Photograph by Cora Kelley Ward.

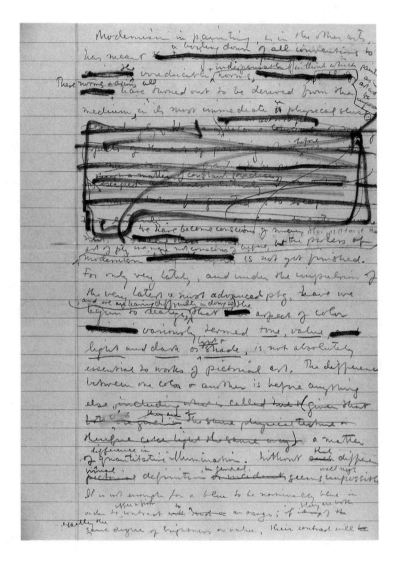

Page from an early draft of Clement Greenberg's essay "'American-Type' Painting," 1955.

Clement Greenberg

THE COLLECTED ESSAYS AND CRITICISM

Volume 3
Affirmations and Refusals

1950–1956

Edited by John O'Brian

The University of Chicago Press CHICAGO AND LONDON

CLEMENT GREENBERG, a dominant figure in
American cultural criticism since the 1940s, has
been an editor for the *The Partisan Review,* an art
critic for the *The Nation,* and a book reviewer for
the *New York Times.* John O'Brian is an associate
professor in the Department of Fine Arts at the
University of British Columbia, Vancouver.

The University of Chicago Press, Chicago 60637
The University of Chicago Press, Ltd., London
© 1993 by Clement Greenberg and John O'Brian
All rights reserved. Published 1993
Printed in the United States of America

02 01 00 99 98 97 96 95 94 93 123456
ISBN (cloth): 0-226-30619-4

Library of Congress Cataloging-in-Publication
Data
(Revised for volumes 3–4)

Greenberg, Clement, 1909–
 The collected essays and criticism.

 Includes bibliographies and indexes.
 Contents: v. 1. Perceptions and judgments,
1939–1944 — [etc] — v. 3. Affirmations and
refusals, 1950–1956 — v. 4. Modernism with a
vengeance, 1957–1969.
 1. Art. I. O'Brian, John. 22. Title.
N7445.2.G74 1986 700 85-29045

∞ The paper used in this publication meets the
minimum requirements of the American National
Standard for Information Sciences—Permanence of
Paper for Printed Library Materials, ANSI Z39.48-
1984.

700
GR

Contents

Acknowledgments

Acknowledgments due on the present volumes are the same as for the first two volumes, with some important additions.

I must again thank T. J. Clark for first encouraging me to track down and compile the uncollected writings of Clement Greenberg; Anne M. Wagner for arming me with an excellent bibliography that greatly facilitated my work in the early stages; S. J. Freedberg, Oleg Grabar, Serge Guilbaut, Michael Kimmelman, Matthew Rohn, and Henri Zerner for offering advice on publishing matters; the staffs of the New York Public Library, the Widener and Fine Arts libraries at Harvard University, the Fine Arts Library at the University of British Columbia, Vancouver, and the Robarts Library at the University of Toronto for responding, always patiently, to inquiries; and Whitney Davis, Friedel Dzubas, Helen Kessler, Andrew Hudson, Caroline Jones, Michael Leja, and Susan Noyes Platt for bringing to my attention articles I had overlooked. I would also like to thank Robert F. Brown, at the Archives of American Art, Alan M. Wald, at the University of Michigan, and Dorothy Swanson, at the Tamiment Library, New York University, for helping to locate stray material; and Patty Hoffman for preparing, and Victor Semerjian for reading, the manuscript.

For permission to publish exchanges between Greenberg and F. R. Leavis, Fairfield Porter, Thomas B. Hess, Max Kozloff, Robert Goldwater, and Herbert Read, I am grateful to Queen's University, Belfast, Mrs. Anne Porter, *The New York Times*, Max Kozloff, *Artforum* and *Encounter*. In the realm of financial support, I have benefited from the Social Sciences and

Humanities Research Council of Canada, and from a research grant awarded by the University of British Columbia.

Finally, I thank Clement Greenberg himself. He responded favorably to the idea of a "Collected Works," and encouraged the endeavor throughout.

John O'Brian

Editorial Note

The essays and criticism in this volume consist of published writings only, arranged chronologically in the order of their first appearance. Each article concludes with a reference stating when and in what publication it first appeared. Reprints are also indicated. The abbreviation A&C is used for the book *Art and Culture: Critical Essays,* the collection of Greenberg's writings published in 1961. Most of the articles in that book were revised or substantially changed by Greenberg for republication. This volume, however, reprints the articles as they appeared originally.

All titles are either Greenberg's own or those of the editors of the publications for which he wrote. In most cases the titles for the essays were supplied by Greenberg himself and the titles for book reviews and shorter pieces were supplied by others. In order to indicate the contents of reviews and articles for which no titles were given, I have supplied descriptive headings.

The text has been taken from articles as they appeared in print. Throughout, the titles of books, poems, periodicals, and works of art have been put in italics. Spelling and punctuation have, with some exceptions, been regularized to coincide with the usage in the essays written for *Partisan Review.* All ellipsis points in the text are Greenberg's.

Greenberg used a minimum of footnotes in his writing and for this edition I have followed his practice in my own footnoting. The text is footnoted only where there is a reference to a topic about which the reader could not be expected to find information in another source. The majority of Greenberg's articles were written as one or another kind of journalism and the edition attempts to preserve the sense of occasion for which they were written. In some cases, the published correspondence of writers with whom Greenberg engaged in a critical exchange has been included. The articles during the period

from 1950 to 1969, unlike those published during the 1940s, were in most cases accompanied by illustrations.

The Bibliography lists other writings by Greenberg, including books and translations from the German. It also provides a selected bibliography of secondary sources on Greenberg's work. The Chronology offers a brief summary of events from 1950 to 1969 to give some background to the criticism.

Introduction

> We would like very much to publish "Modernist Paint-
> ing" in *Art and Literature*. I was a little hesitant at first since
> it has been published elsewhere, especially since our maga-
> zine is not going to reach a very wide audience. . . . On the
> other hand, I do think it a tremendously important article
> and that it should be seen by as many readers as possible.
>
> John Ashbery, letter to Clement Greenberg,
> Paris, 16 January 1964

John Ashbery was right about the importance of Clement
Greenberg's essay, but mistaken about the audience it had al-
ready found by 1964. "Modernist Painting" lies at the heart
of Greenberg's account of how modernism works, at least the
condensed version provided by him in the 1950s and 1960s.
The essay, which followed from his two famous earlier pieces,
"Avant-Garde and Kitsch" (1939) and "Towards a Newer La-
ocoon" (1940), was widely read at the time for its explanation
of modern art's apparent need to rid itself of what was inessen-
tial to its development. Contemporary readers took it as the
touchstone of Greenberg's ideas. Ashbery in his letter credited
inaugural publication of "Modernist Painting" to *Arts Year-
book*, believing that it had initially been published in 1961. In
fact, the essay first appeared in print in 1960 as part of a series
on "the sciences and the arts in mid-century America" put out
by the Voice of America, the U.S. government radio arm used
as a propaganda instrument of American foreign policy; a short
while before that, "Modernist Painting" had been broadcast
over the agency's international shortwave airways. [1] At the time,

1. "Modernist Painting" was broadcast in the spring of 1960 and pub-
lished a short while later in the Voice of America's *Forum Lectures* (Washing-
ton, D.C.: U.S. Information Agency, 1960). The essay was republished in
Arts Yearbook 4 (1961), and then in *Art and Literature*, no. 4 (Spring 1965).

the Voice of America was reaching between thirty and fifty million listeners each day in Europe, the Soviet Union, the Middle East, Africa, South Asia, the Far East and Latin America.

There is no shortage of irony in Ashbery's misunderstanding of "Modernist Painting"'s previous circulation. Greenberg's essay had been heard by millions around the world and Ashbery was concerned with adding a few hundred more in *Art and Literature*—an ephemeral journal with a narrow readership—because, as he said, "it should be seen by as many readers as possible." The extreme imbalance in the two sets of numbers, to say nothing of the disparity in the kinds of audiences represented by the Voice of America and *Art and Literature*, marked a strange conjunction. Over the agency's airways "Modernist Painting" kept company with the likes of Perry Como; in Ashbery's journal—I am being precise here—it appeared with "Cézanne's Doubt" by Maurice Merleau-Ponty and "A Berlin Childhood" by Walter Benjamin. The solicitation of the same piece of critical writing by both the Voice of America and a poet of Ashbery's interests cannot have been commonplace, even in the Cold War climate of the first half of the 1960s. The breadth of interest in the essay served notice that "Modernist Painting" would become stereotypical Greenberg.

The introduction to the first two volumes of *Clement Greenberg: The Collected Essays and Criticism* offered an account of Greenberg's intellectual milieu in New York in the 1930s and 1940s. During the 1930s, Greenberg was a close reader of German literature, especially of Bertolt Brecht, and a translator of two books from the German, one on Goya and another, *The Brown Network: The Activities of the Nazis in Foreign Countries*, on fascist oppression. After 1936, he also revealed himself to have been in conflict with Stalinism and Communist culture and in support of Trotskyism, particularly of the kind reflected in the pages of *Partisan Review*. In 1940, Greenberg became an editor of the periodical, and a short while later the regular reviewer on art for *The Nation*. In addition, he was appointed managing editor of *The Contemporary Jewish Record* towards the end of the war, and then associate editor of *Commentary* when the former was folded into the latter. Although Greenberg selected some of his writings from the 1940s for inclusion in *Art and Culture*, the collection of his articles and essays pub-

lished in 1961, he substantially revised many of them for the occasion. "I see no reason," he wrote of work he chose not to collect, "why all the haste and waste involved in my self-education should be preserved in a book." The first and second volumes of his collected writings argued otherwise. They brought together all his published essays and criticism, without revision, in the form in which they originally appeared.

The present volumes, which cover the period from 1950 to 1969, continue the project of recovering the full range of Greenberg's activity as a critic. In introducing them, I want to flesh out the scarecrow image of Greenberg that has resulted from the focus of so much attention on "Modernist Painting," *Art and Culture*, and one or two of his other essays. In particular, I want to expand upon Greenberg's political attitudes and to suggest in what ways they informed his critical practice. How, for example, did the Cold War and America's position in it alter his views? And how, in turn, were his changing opinions received by those around him? In order to give some sense of various contemporary reactions to Greenberg's views, I have included in the volumes critical exchanges between Greenberg and several of those who took issue with him in print, namely, F. R. Leavis, Fairfield Porter, Thomas B. Hess, Herbert Read, Max Kozloff and Robert Goldwater.

The international success of Abstract Expressionism during the 1950s, and Greenberg's growing reputation as its most cogent interpreter, put increasing pressure on him to perform as an expert across an expanded front of visual culture. Museums and galleries solicited his involvement in exhibitions they wished to mount. After agreeing to organize *Talent 1950* with Meyer Schapiro, for the Kootz Gallery in New York, Greenberg went on to organize eight more exhibitions and to contribute to twice that number of catalogues in the period covered by these volumes. The mass media also sought him out. For *The New York Times Book Review* he took on the task of reviewing the first four volumes in the new Pelican series on art (vol. 3, item 36), and shortly afterwards wrote on Lascaux and Altamira for *The New York Times Magazine*, under the title "The Very Old Masters" (vol. 3, 37).[2] Academia, too, engaged

2. References to Greenberg's collected writings are hereafter cited according to their respective volume and item.

his attention. He was invited by Black Mountain College to teach, by Yale University to lecture, by Bennington College to present seminars and exhibitions, and by Princeton University (the climax) to conduct the prestigious Christian Gauss Seminar in Criticism.

The pressure on Greenberg to spread his expertise in a variety of directions continued into the 1960s. The coincidence of interests registered by Ashbery and the Voice of America is a case in point. But if the coincidence made an impression on Greenberg, he did not let on. After all, these were extraordinary years for him, when any and every kind of conjunction might occur. There was no predicting in what guise Greenberg and his work would be asked to appear next. In the period bracketed by his 1960 commission from the Voice of America and the 1965 republication of "Modernist Painting," he slipped in and out of half-a-dozen professional roles. As might be expected, he wrote for an assortment of critical and art journals, but he also wrote for a variety of glossy magazines, including *Country Beautiful, House and Garden*, and *Vogue*. He acted as an adviser to French and Co., a New York art dealer, putting the dealer in touch with artists such as Adolph Gottlieb, Morris Louis and Barnett Newman. He curated exhibitions from coast to coast, including the notorious 1964 exhibition, *Post Painterly Abstraction*, for the Los Angeles County Museum of Art. And he accepted invitations to travel abroad as a juror and a critic, visiting Canada, Britain, Argentina and points in between.

The period marked the apogee of Greenberg's reputation as a critic. It also marked the beginning of a round of challenges to his critical position. After devoting two decades to the cause and destiny of modernism, and to identifying the contemporary art he thought deserved the appellation "major," Greenberg and his theories became hotly contested in the decades following the publication of "Modernist Painting" and *Art and Culture*.

Attacks erupted from every quarter: from fellow critics, especially those with whose opinions Greenberg had quarrelled, such as Hess, Read, Kozloff, and Harold Rosenberg, but not excluding those who started out as adherents; from artists whose work failed to meet Greenberg's preconditions for what

constituted "major" art, for example Porter or the Minimalist Donald Judd; from cultural historians censorious of his stance as a Cold Warrior, initially Christopher Lasch, who in "The Cultural Cold War" (1967) took direct aim at the intellectual circle around *Commentary* of which Greenberg had been an integral part; and from all those unwilling to accept a *grand récit* of any kind (there can be no doubt that a master narrative of modern art was what Greenberg proposed). Even those sympathetic to Greenberg's practice as a critic expressed qualifications. Hilton Kramer, in a 1962 review of *Art and Culture*, noted that Greenberg's weekly and monthly articles on the current art scene had dwindled in number and shifted in tone:

> His articles appear now at infrequent intervals and seem, as the result of their scarcity perhaps, to be unduly concerned to summarize rather than to elucidate a point of view. Mr. Greenberg is still avidly read by everyone concerned with contemporary art, but one suspects that he is read now with more avidity than intellectual curiosity, and that the scarcity of his articles has encouraged certain readers to look to his utterances, rather as people read reviews of Broadway shows, to see if they contain news of a "hit."[3]

Paradoxically, the recognition of Greenberg's importance as a critic grew in inverse proportion to the direct influence of his criticism. The widespread dissemination of his ideas, and the acceptance of his theories as constituting the core of modernist criticism, announced the incipient collapse of the paradigm he proposed for modern art. For one thing, the timing coincided with the rise of Pop art, a development rejected by Greenberg in part because it trafficked in mass-cultural imagery. Kramer was among the first to recognize what was happening. "To understand *Art and Culture* is to understand a great deal about the artistic values that came out of the war and the Cold War years;" he wrote, "to question it is to question some of the salient achievements and aesthetic beliefs of those years."[4]

In the writings from the early 1950s that introduce this volume, Greenberg was still working through his version of

3. Hilton Kramer, "A Critic on the Side of History: Notes on Clement Greenberg," *Arts Magazine* 37 (October 1962), p. 60.
4. Ibid., p. 61.

modernism. That is, he was still refining his central arguments. While trying to adduce evidence about contemporary art and the social conditions under which it was produced and consumed, he interrogated the connections between the two. His analysis of the social matrix was still unequivocally Marxist. From the 1930s through the 1960s, he repeatedly stated that Marxism was the only method capable of extracting meaning from the contradictions of social flux, especially in its relations to art. But his Marxism was neither invariable nor strictly orthodox. His critical intelligence was formed by Marxian dialectical attitudes towards culture, Kramer observed in his review, and these persisted "long after he eschewed the illusions and commitments of Marxist ideology." Greenberg clarified his position in the early 1950s in a review of Arnold Hauser's recently published *Social History of Art*, which he judged to have achieved not only "a social history but an improved history of art":

> Society contains and throws light on art, receiving light in return, but this reciprocity does not completely explain either art or society. That Mr. Hauser observes this limitation without succumbing to it, that he remains both an art critic and a sociologist, is one of the important reasons why he makes such an authentic as well as large contribution (vol. 3, 21).

In other words, the process of reflection between art and social interests was too complex to allow for any straightforward explanatory model. The process should not and could not be reduced to any fixed relationship. Greenberg rejected the separation of base and superstructure posited by Marx and Engels, the conceptual prizing apart of the economic and cultural, as not adequately explaining the contemporary situation. For him the two were inextricably entangled. More than once, Greenberg criticized T. S. Eliot for being insufficiently dialectical in his formulations. In "The Plight of Our Culture," Greenberg wrote: "Culture in Eliot's view is, as Marxists would say, entirely 'superstructural'; it excludes political, social, religious and economic institutions" (vol. 3, 29).

Writers like Hauser and Eliot (the latter by counter-example as much as by example) reinforced Greenberg's understanding of the historical conditions affecting art. They also served to

heighten his appreciation of the central paradox of modernism: the way art was bound to the arrangements of capitalist society while remaining estranged from them. Greenberg had already investigated the paradox at length in "Avant-Garde and Kitsch." The dictates of modernity, by which Greenberg meant its emptiness and degradation, forced art to cut itself off from significant engagement with the phenomena of the everyday, propelling it ever more insistently towards a self-absorbed preoccupation with its own field of competence, towards a protected and autonomous sphere. The autonomy he found in certain kinds of European art, along with that art's close attention to the handling of medium, was seized on as exemplary in Greenberg's criticism of the 1940s. In a footnote to "Avant-Garde and Kitsch," he asserted that it was not "art for the masses" that was needed in America: "[I]t's Athene whom we want: formal culture with its infinity of aspects, its luxuriance, its large comprehension" (vol. 1, 2). In other words, America needed an art like that of Matisse, work that was doubly detached from the culture at large—first because it was "valid solely on its own terms," and second because it was not overtly dependent on the subject matter and content demanded by mass audiences.

Greenberg recognized the extreme peculiarity of an art that felt obliged to distinguish itself from the dominant order of society for the purpose of preserving its integrity. The tradition represented by Matisse, which Greenberg then called "avant-garde" and would later call modernist, had endured for close to one hundred years. Over this period of time, he wrote in "Towards a Newer Laocoon," "It had been the task of the avant-garde to perform in opposition to bourgeois society the function of finding new and adequate cultural forms for the expression of that same society, without at the same time succumbing to its ideological divisions and its refusal to permit the arts to be their own justification" (vol. 1, 3). The emphasis on the idea of "succumbing" is pertinent here, for it carries the same weight as it did in the Hauser review. Both Hauser and the most convincing modern artists, Greenberg was asserting, recognized the limitations placed on art; they were alike in their refusal to "succumb" to the temptation of reducing art to a mirror of the time and place in which it was

produced. But not all contemporary artists were so wise. In a subsequent review from 1947 on the work of the Mexican artist, Rufino Tamayo, he concluded that Tamayo had fallen into the historical trap, grimly adding: "In the face of current events painting feels, apparently, that it must be more than itself: it must be epic poetry, it must be theater, it must be rhetoric, it must be an atomic bomb, it must be the Rights of Man" (vol. 2, 54). Such an art was not in a position to cultivate the proper degree of disinterestedness, Greenberg advised, of aesthetic distance as a guarantee of quality.

Greenberg's theoretical formulations turned in part on a reading of Kant's philosophy, which he first referred to in 1943. Over time, Kant loomed progressively larger in Greenberg's thinking. In 1950, he used the *Critique of Aesthetic Judgment* as the centerpiece of a course on critical method that he taught at Black Mountain College; and then, in 1960, he opened "Modernist Painting" with a series of references to "Kantian self-criticism." "Because he was the first to criticize the means itself of criticism," Greenberg wrote, "I conceive of Kant as the first real Modernist." Greenberg's conception of Kant was dialectical, and by 1960 he was drawing upon Kant mainly to focus on the internal workings of art. In the 1940s, by contrast, Greenberg's formulations also possessed a strong adversarial side. Like the contemporaneous theories of Theodor Adorno, which Greenberg with his knowledge of German was certainly aware of, he underlined modernism's capacity for negation, the ability of art to disaffirm society's most cherished assumptions by remaining insistently aloof from them. "Our difficulty in acknowledging and stating the dull horror of our lives," he wrote in 1947, "has helped prevent the proper and energetic development of American art in the last two decades and more" (vol. 2, 65). As a practicing critic, therefore, Greenberg was forced to decide what art carried properly disaffirmative properties; that is, he had to decide whether or not the particular works he encountered successfully constituted a utopian (or dystopian) content of resistance in the face of the counterfeits of modern society. This meant that in his rounds of galleries and museums in New York City, he was in a position of judging works while also being preoccupied with the disorderly social reality that engulfed them.

According to Jack Kroll, in a review of *Art and Culture*, watching Greenberg at work in the 1940s was "to witness a career in contemporary art criticism-under-fire" that was "close to being unmatched."[5] Kroll particularly admired the range of Greenberg's responses to the works he encountered. Greenberg's spontaneous predilections were above all for an avant-garde art that was ordered, cool, and detached; in other words, for an art like that of Matisse as opposed, say, to Dubuffet, Pollock, or Picasso, let alone that of the Dadaists or the Surrealists. Greenberg's preference for Matisse over Picasso, for example, was initially adumbrated in a review from mid-1946. The event occasioning his remarks was an exhibition of several paintings by Matisse, Picasso, Dubuffet, Rouault, and Bonnard at the Pierre Matisse Gallery. The paintings were among the first new oils by these artists to be seen in New York since the war, Greenberg informed his readers, and for that reason they bore close scrutiny. Picasso, who only a short time earlier Greenberg had seen as the hub around which contemporary painting revolved, was now found wanting. Greenberg criticized a Picasso still life in the exhibition for insisting on a kind of representation that answered "our time with an art equally explicit as to violence and horror" (vol. 3, 29). The judgment was in marked contrast to Greenberg's opinion of Matisse's two still lifes in the show. In Matisse's paintings he saw no violence and horror, but rather a controlled sumptuousness that seemed to him to place the paintings in a hedonistic alignment with the painted medium in which they were executed.

Greenberg's judgments depended upon a highly systematic reading of art. Yet, contradictorily, Greenberg also recognized that some of the most compelling painting around him did not submit to being described as hedonistic and that it consciously opposed such a label. Moreover, he was prepared to deal with such art largely on its own terms. To this extent there was a paradox in his systemization, one that prevented it from solidifying into dogma. A nearly contemporaneous account of Pollock's third exhibition at the Art of This Century

5. Jack Kroll, "Some Greenberg Circles," *Art News* 61 (March 1962), p. 35.

gallery illustrates the point. Greenberg concluded that "Pollock's superiority to his contemporaries in this country lies in his ability to create a genuinely violent and extravagant art without losing stylistic control" (vol. 2, 33). The remarkable thing is that Greenberg was prepared to countenance Pollock at all. Despite his distaste for art that risked incoherence and nihilistic excess, art that was "genuinely violent and extravagant," as he put it, Greenberg saw in Pollock qualities that could not be dismissed on the grounds of his preferences alone. While one side of him firmly rejected the obsession in America with extreme states of mind and situations—"We have had enough of the wild artist," he once declared (vol. 2, 65)—the other side recognized Pollock, "the morbid and extreme disciple of Picasso's Cubism" (vol. 2, 77), as its most powerful painter.

This capsule example of Greenberg's critical practice forces a conclusion that runs counter to the views of several subsequent writers who have focused too narrowly on the stereo typical Greenberg.[6] Notwithstanding "the flat, declarative way in which he tends to write"—the description is Greenberg's own (vol. 4, 55)—his judgments, I am arguing, often had about them a provisional status. As much as he might have desired with Matisse an art of serenity and balance, it was a mark of his criticism that he recognized the place for its antidote, for an art of indeterminacy and extravagance which, if nothing else, questioned and kept vital the premises of its counterpart.

It is true that Greenberg's willingness to be provisional diminished during the 1950s. In "Avant-Garde and Kitsch," Greenberg had fixed his attention on the differences between high and low culture, on the traffic between them, and above all on the mechanisms that kept them separate and distinct. By the second half of the 1940s, however, he was already worrying that the distinctions he had identified only a few years

6. To name two: Leo Steinberg, *Other Criteria: Confrontations with Twentieth-Century Art* (New York: Oxford University Press, 1972); and Robert Storr, "No Joy in Mudville: Greenberg's Modernism Then and Now," in *Modern Art and Popular Culture: Readings in High and Low*, ed. Kirk Varnedoe and Adam Gopnik (New York: Museum of Modern Art, 1990).

previously were becoming blurred. The blurring had been evident for some time in literature, Greenberg thought, and was reflected in magazines like *The New Yorker* and *Harper's Bazaar* as they mediated between what was properly serious in literature and what was only popular. Now popular magazines, backed by the advertising patronage of corporate America, were playing an analogous role in blurring distinctions between high art and Kitsch. Greenberg argued in *The Nation* and *Partisan Review* that the insidiousness of the phenomenon lay in its potential to dilute the intensity and seriousness of high art. While there was guarded cause for hope in the fact that the postwar middle class in America was "surging toward culture," the problem lay in the demand by that class for an art that was "not too hard to consume" (vol. 2, 27). The threat was that artists, in the absence of a truly cultured elite to support their endeavors, would surrender to the standards of the mass-circulation magazine; or, even if artists did not surrender, that the rationalization and packaging of modern art in the mass marketplace would make it hard to separate who was serious from who was not.

Greenberg was correct in his observations about the editorial policies of American popular magazines. They were catering to an emergent consumerism and experiencing dramatic increases in circulation as a result. *Vogue*, for example, doubled its circulation between 1939 and the mid-1950s, providing readers with the information they wanted, or could be persuaded they wanted, including regular stories and photographs about modern art and artists. The cultural critic Russell Lynes, writing at the same time as Greenberg, reached similar conclusions. The rush to illustrate and promote art for profit, Lynes observed, had carried art where it had never been before, putting it on "Pepsi-Cola calendars, into the pages of *Life* and *Vogue* and *Harper's Bazaar*, on the walls of post offices, and into the collections of new art patrons such as International Business Machines, American Export Lines, Upjohn Pharmaceuticals, and a host of others." [7]

There can be no mistaking Greenberg's initial hostility to

7. Russell Lynes, "The Taste-Makers," *Harper's Magazine* 194 (June 1947), p. 489.

these developments. Nor can there be any mistaking his suc-
cumbing (that word again) to them. His resignation as *The
Nation*'s regular art critic at the end of 1949 announced the
beginning of the sea-change; and the long essay, "The Plight
of Our Culture," which appeared in two issues of *Commentary*
(where Greenberg was still associate editor) in the summer of
1953, effected its completion. In the interim, in 1952, he
wrote his first article for a popular magazine, *Harper's Bazaar*,
on "Jackson Pollock's New Style" (vol. 3, 23). The brief pas-
sage from "Eliotic Trotskyism," to use T. J. Clark's description
of Greenberg's stance in the 1940s, to what I am inclined to
call Kantian anti-Communism in the 1950s and 1960s, took
no more than a couple of years.

Greenberg remarked in 1955 that his regular writing for
The Nation had given him a "belly-full of reviewing in gen-
eral," intimating that it precipitated his resignation as art
critic for the periodical (vol. 3, 41). No doubt. But the skep-
tical will be excused for noticing another connection, between
his resignation and a demonizing letter sent by him sixteen
months later to *The Nation*'s editor, Freda Kirchwey. Kirchwey
refused to print the letter but *The New Leader*, which was tak-
ing a hard line on Communism and "liberal" fellow-traveling,
obliged by publishing it in the 19 March 1951 issue. Green-
berg wrote:

> I find it shocking that any part of your—and our—magazine
> should consistently act as a vehicle through which the inter-
> ests of a particular state power are expressed. It makes no dif-
> ference which state power: the scandal lies in the fact of the
> commitment, and that *The Nation* should thereby betray its
> claim to be a journal of independent and principled opinion.
> The operation of J. Alvarez del Vayo's column along a line
> which invariably parallels that of Soviet propaganda is some-
> thing that I protest as both a reader and a contributor.
> He presents the point of view of the Soviet Union with a
> regularity that is quite out of place in a liberal periodical
> (vol. 3, 18).

This was no ordinary dispatch. Or, rather, it was ordinary but
the times were not. Like many intellectuals within his circle
at *Commentary* and *Partisan Review* during the McCarthy era,
Greenberg became a militant anti-Communist at the same

time that he abandoned his earlier hopes for a socialist order. The letter to *The Nation* expressed a number of themes that were fast becoming staples in the polemic launched against Communism by the disaffected American Left, notwithstanding the Left's care to distance itself from the populist side of McCarthyism. Chief among these themes was the conspiratorial view that Bolshevism could be found at every level of society (del Vayo's column, Greenberg charged, had become "a medium through which arguments remarkably like those which the Stalin regime itself advances are transmitted in more plausible form to the American public"). The letter also insisted that the defense of independent opinion in the United States was inseparable from the denunciation of Communism. Unless liberalism was especially vigilant about the freedoms it had won it would surely lead the "free world" down the rocky road to totalitarianism.

A short while before his letter to *The Nation*, Greenberg had become a founding member of the American Committee for Cultural Freedom (ACCF), a subsidiary of the Congress for Cultural Freedom established in 1950 with headquarters in Paris. Both were engaged in combatting Communism. The assault on del Vayo was, in a sense, a proof of faith. The ACCF and its chairman, Sidney Hook, were looking for firm evidence of anti-Communist commitment in its members, and the committee cannot have been displeased with Greenberg's showing. A political storm broke over his letter, accompanied by a libel suit launched by *The Nation* against Greenberg's "false, defamatory and scurrilous" statements. *Time* and *Newsweek* covered the dispute, and Greenberg's charges were even read into *The Congressional Record* by no less a figure than Congressman George Dondero, who since the late 1940s had been leading a crusade against what he saw as Communist-infected modern art.[8] Such were the ironies of the cultural Cold War.

Greenberg's letter, with its implied claim to objectivity, gives currency to the neologism Kantian anti-Communism. Greenberg soon became involved in executive policy-making

8. "Soul Searching on the Left," *Time* (2 April 1951), pp. 44–45; "The State of the Nation," *Newsweek* (2 April 1951), p. 57; *The Congressional Record*, 82d Cong., 1st sess., 4 May 1951, pp. 4920–25.

at the ACCF, along with Daniel Bell, James Burnham, Irving Kristol, William Phillips, Arthur Schlesinger, Jr., and other Cold Warriors. Even after McCarthyism subsided, he wrote for a number of periodicals sponsored by the Congress for Cultural Freedom, including *Encounter*, a magazine established in England to counter the perceived backsliding of British intellectuals in the fight against Communism. Greenberg saw no reason to change his practices after it was revealed by *Ramparts* and *The New York Times* in 1966 that the ACCF, *Encounter*, and other organizations and periodicals associated with the Congress for Cultural Freedom had been supported by the CIA through a system of dummy foundations.[9] He remained committed to the Cold War agenda of the U.S. government. Under the auspices of the American State Department he undertook lecture tours of Japan and India during 1966–67, timed to coincide with U.S. government sponsored exhibitions of American painting. And, in 1969, in what turns out to be the closing item in volume four of *The Collected Essays and Criticism*, he conducted a lengthy interview with Lily Leino for dissemination by the U.S. Information Agency, the umbrella organization for the Voice of America.

Greenberg's acquiescence to the *Pax Americana* and its policies was accompanied by a corresponding shift in his stance as a cultural critic. In "The Plight of Our Culture," his lengthy essay from 1953, he revoked his earlier criticism of mass-circulation magazines and their blurring of distinctions between high and low culture. "The good and the bad are mixed," he now declared, "all the way from A movies and the *Reader's Digest* through *The Saturday Evening Post* and South Pacific to the *Times Book Review* and Rouault" (vol. 3, 29).[10] From this and other signs in American culture, Greenberg deduced that the newly dominant culture of the middle classes had the capacity to resist dilution and adulteration by mass culture as well as to produce what he still most desired: to

9. See Christopher Lasch, *The Agony of the American Left* (New York: Knopf, 1969), pp. 63–114.

10. All references here are to the 1953 version of "The Plight of Our Culture," which is reprinted in this collection; Greenberg's reworking of the essay, published in *Art and Culture* in 1961, cut its length in half.

repeat, "formal culture with its infinity of aspects, its luxuriance, its large comprehension."

The transfiguration in Greenberg's thinking was an about-face. In the space of a couple of years, pessimism about the culture of modernity had given way to optimism:

> But can it not be hoped that middlebrow culture will in the course of time be able to transcend itself and rise to a level where it will be no longer middlebrow, but high culture? This hope assumes that the new urban middle classes in America will consolidate and increase their present social and material advantages and, in the process, achieve enough cultivation to support, spontaneously, a much higher level of culture than now. And then, supposedly, we shall see, for the first time in history, high urban culture on a "mass" basis.

Greenberg's aspirations were founded on a reconsideration of the possibilities for cultural progress in American society under advanced industrialism. In "Avant-Garde and Kitsch," modern technological culture had assumed a routine and vulgar aspect for him—whether in the United States or anyplace else—saved only by the marginalized culture of the avant-garde. In "The Plight of Our Culture," the former picture shed its banality and tawdriness. Not only had the spectacular material wealth generated by the war raised standards of living and altered societal structures—Greenberg could rely here on any number of economic and sociological studies, including C. Wright Mills's *White Collar: The American Middle Classes* (1951)—but it had also transformed the cultural landscape, especially in the "mid-cult" region, making it more diversified and differentiated.

Like other contributors to *Commentary* holding to a sanguine view of American culture—David Riesman and Daniel Bell, for example—Greenberg was enthusiastic about the new managerial elite who had risen to power in the United States. Work had increasingly become "the main business of life and the ground of reality for all classes of industrial society," he observed, and recognition of the consequences was due. Although a pervasive work ethic tended to produce a culture in which leisure occupied itself with diversionary and recreational pursuits, Greenberg detected that the seriousness of work was

entering into American categories of leisure. The infusion of unalienated work into play, the argument ran, had the potential to redeem leisure from its emptiness and passivity. Greenberg's formulation was nothing if not utopian; it was as if he had taken Marx's ideas about leisure and material surplus, which he knew by heart, and inverted them.

Thus Greenberg's Cold War politics and cultural optimism merged. In this he was not alone. Many of the New York intellectuals with whom he was associated were following the same path. Democracy and capitalism, so they thought, which already were demonstrating what might be accomplished in the realm of middlebrow culture, were the necessary combination to defeat totalitarianism. The turnaround in Greenberg's thinking, his unsticking of the Trotskyist label, was complete. In subsequent writings, his former emphasis on modern art's adversarial capacity for disaffirming the dominant values of bourgeois society became muted, if not silenced altogether. The central paradox of modernism, high art's attachment to and estrangement from the arrangements of capitalism, was therefore stripped of its former political cogency. What remained was modern art's self-reflexivity, its fixation on its own field of competence, its absorption with questions of delimitation and of medium.

For Greenberg, the latter translated into modernism's preoccupation with abstraction, on the one hand, and with expendable and unwanted conventions within abstraction, on the other. The essay "'American-Type' Painting," published in *Partisan Review* in 1955, reflected Greenberg's sharply reduced scope. He began the essay by observing that abstract painting still seemed to offend people while little that was new in literature or music appeared to do so any longer. "This may be explained," he continued,

> by the very slowness of painting's evolution as a modernist art. Though it started on its "modernization" earlier perhaps than the other arts, it has turned out to have a greater number of *expendable* conventions imbedded in it, or these at least have proven harder to isolate and detach. As long as such conventions survive and can be isolated they continue to be attacked, in all the arts that intend to survive in modern society (vol. 3, 46).

In the essay, Greenberg's reference to "modern society" was not accompanied by an attack on contemporary values, as it might have been previously. Nor did it lead to an account of why "modernization" in art should have brought about a drastic refusal of the phenomena of everyday life in the work of so many artists. Instead, Greenberg turned his attention to the reasons for abstract art's undeserved marginality in America. This he attributed not to the art's proclivity for negation—as he put it, "tradition is not dismantled by the avant-garde for sheer revolutionary effect"—but to its aspect of unfamiliarity.

Not all the artists singled out by Greenberg for discussion in "'American-Type' Painting" agreed with the substance and detail of his observations. Clyfford Still fired off an angry riposte to the author, and Fairfield Porter, who was overlooked in the essay, responded with a letter to the editor of *Partisan Review* (vol. 3, 47). Willem de Kooning offered no response, though he had good reason for one. In the essay, Greenberg praised the "sophistication" of de Kooning's ambition but only as a prelude to criticizing the way his form of Abstract Expressionism "hanker[ed] after *terribilità*" and tried to "forestall the future." Greenberg did not elaborate on these observations, though the force of what he was driving at may be guessed at. The *terribilità* that Greenberg wanted to accuse de Kooning of courting, I think, had its parallel in the striving for violence and horror in art that the critic identified in Picasso's painting of the 1940s. He even employed the same term, *terribilità*, to describe both artists' work. In short, neither de Kooning nor Picasso answered to Greenberg's call for art that was ordered and balanced. However, where in the mid-1940s Greenberg felt obliged to recognize the importance and vitality of an "extravagant" expressionist art that opposed his predilections, in the mid-1950s he was less persuaded of the need to do so.

It may be asked why? In brief, because Greenberg's perception of the social conditions under which art was produced had changed. When he charged de Kooning with trying to fend off the future he was mostly referring to the need for art to dispense with unwanted conventions, but he must also have had in mind (though this remained unspoken) the inappropriateness of de Kooning's painting and ambitions—he categorized them as "Luciferian"—for the times. The future of art

lay with more detached modes of representation, Greenberg was implying, with a serene and optimistic art of abstraction that corresponded to the brightest cultural prospects in the American *imperium*.

In the 1960s, the abstract art that fulfilled Greenberg's teleological promise was that of Morris Louis, Kenneth Noland, Jules Olitski and Anthony Caro. The color-field painting of the first three, with its cool emphasis on the visual properties of paint applied to a flat surface, was complemented in the sculptural realm by the abstract syntax of Caro's welded steel objects. The art that most opposed Greenberg's teleology was Pop and Minimalism. Pop art and Minimal art represented practices that dissented from the narrative Greenberg had latterly fashioned for modernism. Initially, Greenberg was tolerant of them, reserving his strongest criticism for the endurance of second-generation Abstract Expressionism and what he took to be the empty gesturing of de Kooning's followers. As the 1960s progressed, however, he realized that the heterogeneity of artistic direction announced by Pop, Minimalism, and then Conceptualism, was likely to persist. This drew from him a round of jeremiads against "Novelty" art. As Greenberg saw it, "Novelty" art was the product of a "hypertrophied avant-garde" catering to a public that wanted "the emblems, tokens, signs, and stigmata of what it already knows and expects as advanced art" but which was unprepared to recognize the genuine article (vol. 4, 54). A sense of betrayal can be detected in Greenberg's frustration. The middle classes, on which he had pinned his hopes in the early 1950s, had settled for middlebrow culture rather than for "major" art. In "Where is the Avant-Garde?" (1967), he concluded that advanced art "would seem to have proven, finally, just as unable to protect itself from the infiltration of the middlebrow as every other department of culture in society (excluding the sciences) has been" (vol. 4, 54).

To conclude, let me return to "Modernist Painting," where Greenberg's judgments in the 1960s were given their theoretical underpinnings. There and in the subsequent essay, "After Abstract Expressionism" (1962), Greenberg fixed on abstract art's preoccupation with inessential conventions to arrive at his famous maxim: "the irreducibility of pictorial art consists in

but two constitutive conventions or norms: flatness and the delimitation of flatness" (vol. 4, 17). By this he did not mean that the validity of contemporary painting depended *solely* on material two-dimensionality and the testing of it—there were plenty of disclaimers in both essays to the effect that flatness in and of itself was no guarantee of success in painting—but his reduction was nonetheless taken to be axiomatic. Even artists who firmly rejected the logic of his reduction still took "Modernist Painting" to be a paradigmatic statement. The same was true of a generation of critics, including Michael Fried and Rosalind Krauss. The essay's emphasis on modern art's material means, at a time when former orthodoxies and hierarchies of art were being dismantled, seemed to provide contemporary audiences with the account of modernist practices they needed.

The assessment of art provided in "Modernist Painting," it must be evident, was a radically abridged and truncated version of the one Greenberg presented in his two programmatic essays of 1939–40. Moreover, the essay was as confident in its formulations about culture as "Avant-Garde and Kitsch" and "Towards a Newer Laocoon" had been doubtful and pessimistic. As a commissioned piece for the Voice of America, no doubt the confidence suited the occasion. Although the politics of the Cold War were nowhere mentioned in "Modernist Painting," they were everywhere implicit in the essay's tone of cultural optimism. The compulsion of modernist art was not to attack the values of modernity, Greenberg averred, but to urge itself towards purity and the maintenance of "standards of excellence." Its job was to preserve the integrity of the modern tradition by self-critically testing its own procedures: "In this respect alone can modernism be considered subversive." In holding to such an opinion, Greenberg came close to rehearsing the peremptoriness he had earlier observed in Eliot's criticism. He also came close to rehearsing the exclusive view of culture forwarded by Eliot, a view he had previously felt compelled to repudiate.

<div align="right">John O'Brian</div>

Clement Greenberg

THE COLLECTED ESSAYS AND CRITICISM

1950

1. An Essay on Paul Klee

"... the beautiful may be small."—Immanuel Kant

Klee inhabits, really, the closed, cautious world of the modern aesthete, which admits experience only piecemeal. No grand style here, no panoramas, but many small and precious objects. Let him be put next to Marianne Moore and Wallace Stevens, and we in America shall have a more correct idea of the place of his art and a truer estimation of its intense but circumscribed power. Also, let the mysticism if not the supernal vision be excluded, and let him be put next to e. e. cummings so that we can take the exact measure of his humor and understand how it unlocks the serious supernal vision. It is no accident that these three American poets are Klee's close contemporaries. They attempt to keep at arm's length what is more or less the same industrial world, and they struggle with a similar provincialism.

The place where Klee was born, Berne in Switzerland, lay at an intersection of French and German culture; Klee's mother was French, from Besançon, his father German. Berne is international but not cosmopolitan; and even about Munich, where he got his art education, there remains something ineradicably provincial, for all the energy with which it tries to keep abreast of the world in matters of art. Munich was not a center from which new impulses spread but one that received them, as the Blaue Reiter movement, which Kandinsky and Marc founded there in 1912 and through which Klee first became acquainted with modern art in any serious way, received the then new-born School of Paris. But the provincial atmosphere protected something valuable for Klee: the autochthonous, that which is native to the centuries-old South German cultural enclave and was in part the source of his originality,

3

as it was, say, of Altdorfer's too; whence a certain common aspect of the art of both: a minuscule, intricate brilliance of thin line and glowing, winking, jewel-like color: product of the German bourgeois art style that arose out of a crossing of peasant and Gothic urban art in the late Middle Ages, more intimate and explicitly lyrical than the painting of the Rhenish cathedral masters.

The ambient in which Klee spent most of his life was up-to-date as well as provincial, a region of a middle-sized cities where spic-and-span modernity sat side by side with the complacently old-fashioned, where the Gothic seeped and eddied around modernistic architecture, Bauhaus posters and electric lights, with a countryside lying close by in which peasant costumes and arts and crafts still could be seen from the windows of the streamlined electrified trains. It was another closed world, closed as only a German "region" could be, yet not remote.

One was forced in upon himself there and induced to cultivate his personal peculiarities. Klee is like somebody out of an E. T. A. Hoffmann story about the small-town Germany of the 18th century: comfortable, musical, modest, and fantastic—all these in his work if not his person. He has a *Wunderkammer* in which he accumulates influences, hints, notions from all over, but first he assimilates them to his domestic interior. Whereas the primitive and exotic that are present in so much of modern art are there for the sake, in part, of their startling effect, in Klee they are made homely and familiar, less strange, less direct and abrupt. Klee is surprising but he is not startling or audacious; his art is eccentric, perhaps, but it is domesticated, and his humor and whimsicality, once we decipher his plastic language, is reassuring rather than unsettling. We are reassured as to the persisting sensuous stability of a very German world in which concepts, more often than not, fail to fit actuality. Klee's real audacity was his modesty, which accepted and accomplished the task of making an easel picture out of almost nothing.

It was his great good fortune that he was born in time to develop along with the School of Paris, not too early and not too late. The School of Paris sanctioned his regional as well as personal originality, provided him with the means of realizing it, and opened his eyes to all in exotic art that he needed for

collateral inspiration. His exposure to Paris and then Africa freed him of the prejudices of Western Europe's historical tradition of art, which were particularly oppressive to most German artists because of their tributary relation to the mainstream—they as tributaries feeling less free to take liberties with the tradition than those in its center. And contact with the French avant-garde delivered him from that awe of the academy and of classical antiquity which had prevented so many German artists before him from following their native bents. (No one, I feel, did German art a greater disservice than Winckelmann with his promulgation of the cult of Greek art.) And yet Klee did succeed in going to the "Mediterranean" and possessing it as no other Germanic artist has. Perhaps it was his French mother, perhaps because his "Mediterranean" was not the same as Winckelmann's.

The School of Paris, inducing us to abandon many of our old categories of aesthetic experience, opened our eyes to the virtues of Oriental and barbaric art. It became possible to find valid art anywhere in history and geography. The artist was given *carte blanche* in the choice of his means, it having been established that what mattered most in a work of art were formal qualities, regardless of antecedents or references in other terms. The School of Paris embodied a formal discipline, a very strict one, and it was still intimately connected with Western tradition, but it had nonetheless broken with that tradition in so far as it was now ready to welcome—indeed required—ideas, suggestions, and devices from all over. In painting it was demanded of this exotic material only that it be controlled by the primary and still rather inflexible formal requirements of the easel picture, which remains always a most specifically Western and local art form.

It was between his twenty-fifth and thirtieth years that Klee seems to have begun to appreciate this new development fully. When, under its influence and inspiration, he had at last trained his talent down to the point where nothing remained but the spontaneous co-ordinations of eye, hand, and material, to which he could surrender almost all decisions in the confidence engendered by discipline become instinct—it was then, after he had been to Paris and seen Cubism (1912) and to Africa and seen Islamic art (1914), that he was able to return home and become completely himself.

5

Most likely his art would have become more or less what it is even without Africa and the Orient. His participation in the Blaue Reiter movement in Munich, where he made friends with Kandinsky and Franz Marc, exposed him in any case to much the same order of influence. But it is unthinkable that his art as we know it could have come to fruition without the example and guidance of Cubism. The latter converted him to a new and stricter sense of the necessity of preserving the organic and concrete unity of the picture surface, and showed him how this was best done by working with flat or very shallow planes. Had he not had the plastic discipline of Cubism at hand, had he had to organize his figurations by situating them in illusionistic depth, he would have produced little more than caricature. At the same time Cubism sanctioned the very liberties of his imagination. By releasing him from naturalistic representation it made accessible mankind's whole inventory of graphic signs: ideographs, hieroglyphs, children's drawings, decorative motifs, graphs, charts, etc., etc. These could now be integrated in easel pictures because Cubism had provided an effective way of ordering them within that form.

Art Nouveau, to which Klee had first given his allegiance after leaving art school, also encouraged liberties with nature but provided no plastic discipline within which to contain, intensify and develop them into something more positive than mere liberties. But the traces of Art Nouveau never quite fade from his art, any more than they do from Kandinsky's, Marc's or that of other Expressionists (or, for that matter, from Matisse's and Miró's). But unlike Marc and the later Kandinsky, Klee was able to transcend and subordinate this formation of his youth, retaining it only as a flavor and not as a substantial ingredient. Thus he avoided the impasse from which Marc did not live long enough to escape and from which Kandinsky refused to. I think it can be said that Klee is unique among artists of the Blaue Reiter group in the success with which he overcame Art Nouveau.

II

Ordinarily Klee does not create unity of design by a large scheme that the eye takes in at a glance; this was the Italian, the Renaissance mode, in which design always betrayed some

6

affiliation with wall painting and architecture. Klee's feeling is ornamental rather than decorative, if the distinction may be permitted—analytic rather than synthetic: he produces by intensification, not by extension or projection; it is fission and subdivision rather than addition. He works in small format, in the tradition of manuscript illumination. His pictures are for very private possession, to be hung on near and intimate walls.

Because it is small, the picture demands close scrutiny, confining visual attention to a compass within which the eye can travel with least effort through intricate complications of detail. Yet the eye does not make an instantaneous synthesis; with Klee design is, as it were, temporal or musical. We are conscious of elements that are to be felt in terms of succession as well as simultaneity. The all-important factor is line. Klee's line seems rarely to enclose a shape or mark a contour with definiteness; nor, as a rule, does it vary in width or color value along a single trajectory. That is, it has little plastic feel, so that it is hard to say whether it is heavy or wiry, cursive or stiff, sinuous or angular; it is all these things and none. At most it is scratchy. At times it is feathery. Adjectives do not fit the case as well as verbs. Klee's line indicates, directs, relates, connects. Unity is realized by relations and harmonies that play across neutral areas whose presence is more like an assumption than a fact.

Because line—and color too—are like disembodied elements that do not adhere to bodies and surfaces, because there is an absence of weight and mass, Klee's pictures have a tendency sometimes—when the oscillating, wavering, flickering movement that should unify them fails—to float apart into mere groupings of pictorial notations. Curiously, this happens most often (at least before his final phase) when he tries to put himself at the furthest remove from decoration. On the other hand he produces some of his very best work when he deliberately incurs that danger. It is when the picture is nailed down so firmly at the corners, with everything spread so evenly and symmetrically—in little squares like building blocks or horizontal bands like ruled paper—that his art achieves its greatest force. What might seem in conception only a tinted pattern becomes in actuality as dramatic a thing

as is possible on a flat surface. In this, his ability to exploit the decorative without succumbing to it, Klee made one of the most important conquests of modern art.

The problem of decoration versus easel painting remains the most critical one facing art today. The difficulty that besets the post-Cubist and abstract painter is that of overcoming the essentially decorative inertia into which his picture always risks falling because of its flatness. The easel picture has from the first relied upon the illusion of depth, of composition in depth, for the dramatic interest it must have to overcome its relative smallness and isolation. Now Cubism has banished that. But Klee could not altogether accept the flatness of post-Cubist painting. He showed his dissatisfaction with the impenetrability of the picture plane—impenetrable in so far as he could not pierce it by perspective or modeling—by worrying the surfaces of his pictures, by working in a variety of materials and mixing his mediums, and by returning incessantly to watercolor, where he could exploit the curl of the moisture-laden paper for the unevenness he wanted. Still, all this was too external in a sense, too physical and mechanical; the real solution had to come from within and be less tangible. Klee sought it in color—and I think he succeeded.

Klee's color does not have the range or register of his line. It is washed on in tints: light, tender, thin—un-modern. It seldom inheres within definite contours, nor does it become opaque or solid (modern) until the artist's last phase. It does not describe or define any more than his line does; it becomes intense or fades like light itself. Yet such color, in Klee's hands, did succeed in achieving a kind of depth. Not a depth in which represented objects are probable, but a matter of suffusions and breaths of color that create a faraway, ambiguous glow. Against this backdrop, lines peregrinate like melodies across chords. The surface palpitates, signs appear and disappear, yet we cannot tell whether this takes place in fictive depth or on the real surface.

As has been pointed out often enough, all this combines to make a very personal art, and therefore unstable, borne up by no conventions, not even by those such as Cubism had. Nor, after practicing it for almost twenty years, could Klee rest in it. In the last ten years of his life he was propelled to new

8

problems, or rather new aspects and new difficulties of old ones. He began to paint in larger and more solid and simplified shapes, which he mortars into the picture plane with opaque pigment. His line loses its calligraphic spontaneity, becomes heavier and firmer, and is turned into a stylized manner. His color gets brighter and flatter, a trifle acid, and often garish. There is an aspiration toward the monumental, but the frequent result is only the heavily ornamental. For the first time Klee becomes *very* uneven.

The illness from which he suffered towards the end of his life may have caused this falling off, at least in part. In one who relied so much on spontaneity and produced his art from the totality of his being, summoning to it every power, physical and mental, sickness no doubt had a more serious effect upon the quality of production than it would have had otherwise. Be that as it may, it is a disservice to Klee not to recognize how much better he painted in the teens and twenties than in the thirties. To fail to do so is to show oneself blind to the specific virtues of his art.

III

Putting the gist of his art into narrative and decorative complications rather than architecture, and using color as tint rather than body, Klee takes a relation to the School of Paris somewhat like that of Sienese painting to Florentine in the early Renaissance. He is less realistic than Paris, less physical, that is, but at the same time more literary. Space is flatter and more impervious in Matisse and Picasso. Their pictures move about in actual physical space, occurring with other events and other objects in that space; whereas Klee's inhabit a remoter region which, being nuanced if not constructed like the space of traditional painting, is more emphatically discontinuous with that in which the observer stands. In this sense Klee is less revolutionary than the School of Paris.

Which may be one of the reasons why his influence has been more immediately fruitful than that of any other master who arose in European painting between 1900 and 1925. Of all the artists who put themselves under Picasso's tutelage, hardly one realized himself in anywhere near as short a time as did those who followed Klee (think only of Dubuffet, Brauner, Tobey,

9

Graves). The explanation of this goes, however, beyond the fact of Klee's more traditional use of space—which is so, after all, only by contrast with Picasso's and amounts really to a different emphasis, not a different conception. The style Picasso formed for himself in Cubism is designed to accommodate what I would call a lordly talent. Artists who take this style as a point of departure find it difficult to disembarrass themselves of the personality that goes with this talent. It requires a native largeness and power that are rare. Even Picasso himself has since the late twenties been unable to supply consistently the power his own intentions and their means demand. Klee is an artist of smaller scope whose personality frees rather than oppresses or challenges those influenced by him. If the artist's temperament is a modest one, contact with Klee encourages him to release it in sincerity rather than inflate it in imitation. Seeing how much Klee made of relatively little, the aspirant is moved to confess how little he himself has and to make the most of that little.

Picasso asks you to construct more than invent, to build large, substantial edifices—not like Klee, to send up demountable tracery and momentary mists. Picasso asks you to be more aware of your surroundings. This does not mean that Picasso is more "intellectual" or even more deliberate than Klee; in fact, he works faster and less meditatively. The difference is that he sees the picture as a wall, while Klee sees it as a page; and when painting a wall you have to have a more conscious sense of the surroundings and of their relation to the picture. Architecture imposes itself then, and with that the monumental and the public.

It is also the customary difference between the Nordic and the Mediterranean. Klee's influence is rendered more effective inasmuch as since the centers of artistic production have moved northwards fewer artists appear from milieus possessing traditional affinities with Picasso's Mediterranean, positive, public conception of art. Klee's private lyricism is more sympathetic to those who live in industrial countries and colder climates, where the scope of art is essentially private. There art is a more solitary means of redeeming oneself from the demands of practical life; and tenuous, inward structures, like

Klee's, are less exposed than full-bodied, outward ones like Picasso's.

It is doubtful, however, whether Klee's art has enough breadth to support a major school. I would say that even the early abstract painting of Kandinsky provides a more ample basis, not to mention the main tradition of Cubism and the foundations laid down by Matisse. So far hardly any of the products of the Klee school have been able to develop beyond an original first statement. And, as I have said, Klee himself in his last decade began to find his own instrument less than adequate. The chances are therefore that as an influence in the future he will remain more effective as a liberator and an inciter to invention than as a fountainhead of style.

IV

The problematic relations between "literature" and the "purely" plastic are focussed most sharply in Klee's art, which bodies forth vividly the transition from representation to abstraction. Klee's insistence upon retaining recognizable signs and a semblance of the anecdote is part of the struggle to save easel painting. Yet he did at times paint completely abstract pictures, some of them no less ostensibly so than any of Kandinsky's. And none of the important qualities of his more representational art is missing from these, not even its humor. So we would have to conclude that Klee's painting does not stand or fall by its denoted or "literary" content, by the success with which it illustrates and represents.

The main reason, it would seem to me, that Klee preserved references to the visible world in most of his painting lies in the difficulties of invention felt by an artist committed wholly to spontaneity. To an extent Klee worked automatically; but the hand left to its own impulses tends to dissipate itself in mere rhythmic calligraphy. There must be something resistant around which to deposit form, something more resistant—in Klee's case—than just the medium; it must be a resistance that comes from outside the art. That resistance and its constraint have been found traditionally in nature; in Klee it is the idea of nature. This forces him to invention. The point at which the idea of nature enters is, as a rule, rather late in the

process by which the picture is created. Klee's method recapitulates the primitive history of graphic art as it developed out of aimless scrawling into the depiction of recognizable images. He would begin drawing with no definite subject in mind, and let the line go of its own accord until it was captured by accidental resemblances; these would be improved upon, perhaps, and elaborated. One resemblance would suggest another, and so on. Gradually, the artist would discover his subject or anecdote and, with it, the title of his picture. The picture might not always illustrate the title, but the title would always throw light on the picture.

That the title should have more than a perfunctory connection with the picture was essential to the creation, if not to the final effect, of Klee's art. The "literary" effect he himself experienced in their connection acted as both an impulse to formal invention and a source of it. The title helped him finish the picture by giving him a controlling aim. Though the final aspiration of his art was not to illustration but to form, illustration as a subsidiary goal stimulated the play of his fancy, which in turn stimulated him to the invention of form. The means is "literary," the end is not.

Yet the primacy of its formal virtues does not prevent Klee's art from also being intensely pictorial—a quality that belongs to its epiphenomenal content, as it were, and consists in the parodying of "literary" and pictorial art in general. No longer taking the pictorial for granted but seeing it as one cultural convention among others, Klee isolates its distinguishing properties in order to burlesque them. This accounts for the volubility of his painting, its air of gossip and anecdote and play. The pictorial in Klee's notion of it comprises every system of making marks on a surface that mankind has ever used for the purpose of communication: ideographs, diagrams, hieroglyphs, alphabets, handwriting, blueprints, musical notation, charts, maps, tables, etc., etc. All these he includes in his parody. And then more, much more. For the parody of the pictorial is but a core around which he wraps layer on layer of a parody that aims at all commonly held verities, all current sentiments, messages, attitudes, convictions, methods, procedures, formalities, etc., etc. Whence the irony omnipresent

in the "literary" content of his painting, an irony that is total, but not nihilistic.

As I intimated at the beginning of this article, Klee is not subversive. He is well content to live in a society and culture that he has robbed of all earnestness; in fact, he likes them all the better for that. They become safer, more *gemütlich*. Far from being a protest against the world as it is, his art is an attempt to make himself more comfortable in it; first he rejects it, then, when it has been rendered harmless by negation, he takes it fondly back. For notice that Klee's irony is never bitter.

The whole operation, in that it is an operation on his own mind, is very German. How much Klee belongs to German culture is generally overlooked; he belonged to it so much, actually, that he made himself the most philosophical as well as lyrical and musical of modern painters. One has to bring in the history of German idealist philosophy, with its penchant for explaining and changing the world by dialectics, in order to account for him . . . *Multum in parvo:* Klee is a beautiful example to refute those who talk about modern art's poverty of content.

Five Essays on Klee, ed. Merle Armitage, New York, 1950. (The four other essays were contributed by Merle Armitage, Howard Devree, Nancy Wilson Ross, and James Johnson Sweeney. [Editor's note])

2. Review of Exhibitions of van Gogh and
 Alfred Maurer

As has been said often enough, the story of van Gogh's life is partly responsible for the vogue of his art among so many people who do not otherwise feel much for modern art. He has become established as the very type of artist as tragic hero. But a certain misconception has resulted from this.

The popular and Balzacian notion of the artist as hero has him so because a martyr to his art. This van Gogh was not.

True, his painting was too unconventional to win recognition from more than a few people during his own lifetime and he would have been lonely in his art even had he been much less eccentric personally. But it was his insanity that martyred him, not his art—which was, if anything, the final means by which he tried to save himself. And in so far as he was a great painter, van Gogh was not insane; and in so far as he was, he damaged his art. This is, importantly, the pity of that art, to complement the greater pity of his life.

It has been said by competent critics that van Gogh was a divinely gifted *amateur*. The evidence both to confirm and refute this was provided by the recent large exhibition of his work at the Metropolitan Museum of Art in New York, which contained many pictures not seen in this country before, principally from the collection of the artist's nephew, Vincent W. van Gogh, and the Kröller-Müller State Museum in Otterlo, Holland. One was amazed to realize that, except for the earliest painting—*A Fisherman on the Beach* of 1882 and a few drawings from 1880–81, the one hundred and fifty-odd works on view covered a span of only six years. From the first, in such canvases as *The Loom* of 1884 and *The Potato-Eaters* of 1885, we detect an extraordinary talent. But what shows that it belongs to more than a "divinely gifted amateur?" That is, is there craft competence, did van Gogh have a professional command of his art? Or was it his derangement that made him the painter he was? The answer is by no means clear-cut. The distorted but expressive drawing of *The Potato-Eaters* and its soggy color are the result in part, I feel sure, of the pathological pressure of feeling as well as of the resistance of a medium in which the artist was not yet at home. Nevertheless, the picture has an excellent unity, imposed on elements far from tractable, and such unity is the first requirement. (Does not Max J. Friedländer, the authority on old Lowlands art, say ". . . unity—sure sign of originality?")

In the same year van Gogh did some studies in black crayon—of a peasant woman's head, of hands—and in pen and ink—of landscapes—that show an adeptness which, for all the expressive distortions involved, would satisfy academic standards. This alternation of skill and clumsiness (neither of which makes or breaks his art) continues throughout his ca-

reer. One would be inclined to say that his skill was always involved with his state of mind, and that the occasions on which the former succeeded sufficiently in resisting the latter were the occasions of his genius. In so far as van Gogh was a great painter—and I believe he was at times—he was not artless, certainly not an amateur.

Though van Gogh's originality is constituted by the distortions and displacements provoked by emotion more than normal in its intensity, his best work was done before his first attack of outright insanity. That best work was the fruit of his Paris and early Arles period (February 1886 to the end of 1888), the only time in his life when he lived with other painters. It was then that he most firmly controlled his feeling for the sake of pictorial ends. His fracas with Gauguin marks the turning point. His style may have become more strongly affirmed thereafter, his drawing more nervous, his color more direct, violent, and original, but his art lost in strength and unity; it became more striking and strident, but also more monotonous in its stridency. The pure flow and its sure, subtle coordination fail. He had become too sick to control and modulate the expression of his feeling, to the directness of which he now sacrificed almost everything else.

Thus if it is thanks in some degree to his derangement that we have van Gogh's genius, it is not thanks to his insanity that we have the greatness of his art. This is in a sense a consolation. At least his extreme anguish was not required for his best moments as a painter. And it is reassuring to have even van Gogh's case confirm one's belief that the artist functions best in the company of other artists—to know that van Gogh's career, from which the myth of the lonely artist has drawn so much of its strength, actually demonstrates the opposite. Namely, that art is an intensely social product and suffers in the long run under isolation.

Alfred Henry Maurer, the American artist who committed suicide in 1932, is another tragic case, though much more with respect to his art than his life. Perhaps it belongs to that tragedy that we have had to wait almost twenty years for the chance to obtain a comprehensive view of his work. His "memorial" show at the Whitney Museum in New York this past

November was, to say the least, belated. After an early success in the world (he won a Carnegie Gold Medal after only three years' activity as a full-time painter, and numerous other prizes in the next four years) Maurer turned away from the Whistler-*cum*-Manet-*cum*-Eakins manner to follow Matisse and the Fauves, thereby condemning himself to relative neglect and isolation. Until 1914 he was able to mitigate the isolation by living in Paris, but the neglect persisted and survived him. Not all that Stieglitz, E. Weyhe, and Sherwood Anderson did in the way of publicity and encouragement seems to have remedied that.

Maurer made himself one among the eight, nine, or ten very good painters this country produced before 1914; but he had the gifts to make himself more than that. The evidence of these gifts can be found in the earlier quasi-academic painting that won him prizes, even more specifically, I think, than in his later efforts, however much more historically significant these latter may be. The man who in 1904, at the age of thirty-six, painted the portrait *Gabrielle* did not have to apologize to any artist in the world for the fact that his style was then no further advanced than Manet's early Impressionism. Their elegance, solidity, and very pure, painterly brilliance redeem whatever the pictures of this period lack in originality of style. I remember little in American art that can compete with their perfection. And the same more or less can be said of the little landscapes and flower pieces Maurer turned out between 1907 and 1914 under the influence of Matisse, all of them so accomplished within their limits and infallible in the juxtaposition of pure colors. Obviously, Maurer had it in him to realize a much greater art than he did. That is his tragedy as an artist.

It is possible to say that his being an American was responsible. He lived for seventeen years in France and, though his work continued to advance during the last decade and a half of his life, which he spent here, it became much more uneven. There was a certain amount of frustration involved in his long effort to catch up with Cubism in the teens and twenties, and he might have been spared that had he stayed nearer Paris. And maybe not. Derain, whose original endowment was greater perhaps than any other painter's of the School of Paris,

was not saved by his advantages as a Frenchman and his proximity to Paris.

Elizabeth McCausland, in her more than competent biographical note for the catalogue of the Whitney show, takes issue with those who regard Maurer's still lifes as the "most fully realized expression" of his last period. I am afraid that I am one of those. His figures and heads strike me as invariably unsuccessful because too expressionistic, with their drawing and design too crudely simplified for the sake of expressiveness. It is an ill-digested, almost arty expressionism. The opposite is true of his Cubist still lifes, which fail, whenever they do—which is not often—because their design is excessively complicated in an effort to combine modulated natural local tones with an analytical investigation of the planes composing space. (Picasso and Braque knew from the first that the latter had to exclude the former, otherwise it was impossible to preserve the picture's unity.) Why Maurer's approach changed so radically whenever he went from the still life to the figure has not been explained; however, towards the end of his life he did indeed begin to look at the figure and head with the same eyes as he did the still life: his heads became more Cubistic, and it appeared as though he were on the way to some sort of synthesis that would go beyond Paris Cubism. In his last two or three years he came closer and closer to the abstract, and, certainly he would not have been content to follow analytical Cubism so faithfully had he lived longer.

But even so, Maurer's Cubism is personal enough, and he is one of the handful of painters who stayed close to the original conception of Cubism promulgated by Picasso and Braque without mechanically duplicating it or sacrificing their personalities. In terms of world art Maurer may not be an important painter: in his own terms he may not even be a fulfilled one; but he remains one of the few original contributions American painting made before its present phase. (A small Maurer show at the Schaefer Gallery in December gave a much better idea of the high quality of his later still lifes than did the Whitney exhibition. Judged from these alone, Maurer becomes more than a very good painter.)

Partisan Review, February 1950

3. Introduction to an Exhibition of Arnold Friedman

Arnold Friedman was born in 1874, lived all his life in New York City, except for a short stay in Paris in 1908, and died in Corona, Queens, at the end of 1946. He began to draw early but did not apply himself seriously to art until he was thirty-two, when he went to evening classes at the Art Students League, studying under that passionate teacher, Robert Henri. Meantime he had become a post office clerk at seventeen, and he remained one until he retired on a pension in his sixties. In his thirties he married a girl he had met in Paris, Renée Keller, by whom he had four children. The first public appearance of his art was in a group show in New York, in 1915; his first one-man show came in 1915, at the Bourgeois Galleries, also in New York. In the subsequent twenty years he was exhibited frequently, in group and one-man shows, at J. B. Neumann's, at Kraushaar's, at the Bonestell Gallery, and at the Marquié. The museum in Springfield, Mass., gave him a small retrospective exhibition in 1947, only a few months after his death. And the Marquié Gallery has continued to show his work right up to the present moment.

Friedman demonstrated the larger importance of his art in his last phase, when he joined that small number of painters, among whom we can name Bonnard and Vuillard, who proved that Impressionism had not lost its historical vitality with Monet. It has been a fixed conviction among the partisans of modern art, since at least 1910, that Impressionism exhausted itself in the 1880's and that its contribution to present-day advanced art is only a remote and indirect one, made by preparing the way for Cézanne and van Gogh. We are now beginning to realize, however—and Friedman is not least among those who rendered this evident—that Impressionism has remained a major force all along without which it would be impossible to explain the concrete aspect of contemporary, post-Cubist abstract painting. Cubism is still the plastic base, but the color and feeling of the abstract art of those who are establishing themselves here and elsewhere as the best painters of this period derive greatly from Impressionism, such Impressionism as is communicated by Bonnard and the early Kandinsky—and Friedman, who himself stopped only at the very threshold of abstract art.

This is not to say that his earlier work is without substantial quality. As time passes, Friedman's earlier pictures acquire an effect they did not seem to have on first view. The slightly expressionist, half-abstract landscapes he did in watercolor around 1917 have always struck me by the profound "advanced" sophistication that lies under their seemingly awkward force. This sophistication disappeared later on, to be replaced by an emphasis on the naively pictorial that had its own merits. Friedman painted portraits in high, very clear color, tightly drawn, smooth-surfaced, simplified, and firmly modelled, that remind one of the Flemish primitives, and then again of Ingres. If not for their frank color and relatively shallow modelling (here Friedman always showed his instinct as a painter, no matter in what direction he went) these portraits would be academic, yet they constitute what I hold to be some of the last serious portrait painting of our tradition. Significantly enough, the snow landscapes he did in the same manner and at about the same time are so utterly unacademic that they push over into Matisse's territory.

Then he entered upon a transitional phase in which, while he continued to paint his tight portraits, he chose park and city scenes, and views of harbors, lakes, and boats for his other subject matter. His brush become much looser, he began to use the palette knife more and more, and he sharply narrowed the range of his color, confining it to a gamut of powdery blues, grays, tawny yellows, tans, and cool earth greens. Here flecks of silvery white, applied dry and thick, galvanize the picture and tie it together. The feeling and the broken-color technique are Impressionist and become more so with every canvas, though they move later toward the brown earth hues that the original Impressionists abhorred. But these browns were used as brown had never been used before him.

Only in the last five or six years of his life, when he worked exclusively with dry pigment and the palette knife, did Friedman let his color go full blast, and then the violent complexity of the contrasts approached at times closer to Soutine than to Monet. A certain clumsiness always remains, which is there even when he reveals the full depth of his sophistication. But it forms an essential part of his virtue. It is because he insists on centering and squaring his motif with a kind of naive exactness, to satisfy a need for symmetry and stasis that belonged

as much to his conception of the essentially pictorial as it did to Pissarro's. . . .

No preconception about what makes for Jewishness in painting has led me to mention the names of Pissarro and Soutine in connection with Friedman. It is simply that one aspect of Friedman's late Impressionism has always reminded me of Pissarro, and that for another aspect I can discover no parallel except in Soutine's landscapes. The fact that both these artists were Jews may not be accidental to Friedman's affinity with them, but I would hesitate to say what there is in being Jewish that established that affinity. Like Pissarro and Soutine, Friedman took himself for granted as a Jew, but he made no particular point of it. He was also very American, looked like a frontiersman, and talked like a Yankee. But he made no particular point of being American either—except, perhaps, to say that as an American painter he could never at best be more than a "shot-gun" compared to the "big cannons" of French painting. For he took a very modest and sober view of the value of his own art; he was sure that it had genuine value and he wanted that to be recognized, but he did not think its value was unlimited and he did not try to keep himself warm by telling himself, as so many painters do, that he was "great"—maybe the greatest painter in the country, maybe in the world. I knew the man for three years and never met an artist whom I liked as much *qua* man.

At this point I should like to quote at length from William Schack's article on Friedman in *Commentary* (January 1950), the most informative and moving piece yet written on him:

> . . . Arnold Friedman was not an unknown, much less a rejected, artist, though he is only now, after his death, coming to be regarded as one of the major American artists of his generation. . . . For thirty years . . . he had served as a menial for the little freedom it gave him to paint. . . . How can an artist wait years for judgment and not be resentful of the qualified approval when it is finally rendered? . . . Praise is his (every artist's) bread; he needs it. . . . A few admirers are not enough to supply it; and without it Friedman grew bitter. . . . I think that loneliness contributed to his bitterness. He had his family, and his wife and daughter (as she grew up) were sympathetic to his work. But all the good friends of his art school days, except Pach, had drifted away.

He had little time or inclination for mere socializing. He could not cultivate and get up entertainments for 'friends' on whom to force an informal exhibition, swing a sale. And he had no stomach at all for the coquetries of the cocktail party: to Friedman, who had told a patron, "You're not giving me charity!" the artists hovering around, toadying to, all but soliciting possible patrons, seemed despicable. . . . Nor did he find companionship in the artist groups he joined, for they did not band together out of mutual respect and good will but from necessity. . . . For all his frustrations, Friedman was not the kind who goes to pieces in adversity. To look at him, say in his sixtieth year, you couldn't tell how deeply troubled he was. Very tall, lean, and tough, with a strikingly expressive head, he could have passed for fifty. . . . Look at him again now: can't you see something disquieting in those deep-set, blazing eyes? . . . Nevertheless, I do not believe that, in the end, Friedman felt himself to be defeated. Certainly he never lost heart.

The last decade of his life was in fact his most productive period. Able at last to give his full time to painting, he brought up the number of his oils to around three hundred. In these ten years, too, he created his most distinctive works— the semi-abstract canvases in which he gave the Impressionist idiom his own accent. Even in the few weeks of his final illness, when he was forbidden to climb the stairs to his studio, he still lay thinking of new work and his mind sneaked up to his brushes and paint. He never conceded that his time was running out. . . . Since his death . . . more critics have come to appraise him at his true worth: his monument is going up as he would have it, in canvas and color.

Among his friends and patrons who encouraged Friedman during his loneliness, financially and otherwise, were Mrs. Charles Liehman, Dr. Nat Wollf, J. B. Neumann. The isolation was not unmitigated. These people had the courage to invest in the artist at time when they had nothing to confirm their faith in his art except their own judgment. I feel that their names should be mentioned on any occasion that honors Friedman.

Arnold Friedman 1874–1946: Memorial Exhibition, Jewish Museum, New York, February–March 1950

4. Renoir and the Picturesque

Renoir appears to sum up Impressionism better than any of his fellows. He ranged the gamut of its various moods as none of the others did, and he was the only one of the Impressionists to address himself to all the genres, from landscape to the portrait and nude, with equal appetite and almost equal success. He was also, perhaps, the only one of them who was a master painter in point of craft and in joy of artisanship. He did not wrestle with "problems," and self-realization was not for him the tortuous struggle it has been for other artists, both greater and lesser. This is not to say that he did not have moments of doubt and self-questioning; he was capable of dissatisfaction with himself and of deliberately wrenching his art from one path to another. But by and large he was comfortable in it as few other great painters have been.

All this we see in the present full-dress show of his works at Wildenstein (for the benefit of the New York Infirmary). It is an altogether splendid and lavish affair containing some forty-odd pictures never publicly seen before in New York, and giving perhaps the fullest conspectus we have yet had in this country of Renoir's art in the period of its most consistent brilliance. In view of the incandescent variety of color and shape that covers the walls here one may find it hard to conceive at first that Renoir was at rest in his art. But being at rest on one level does not exclude a certain restlessness on another. Here it is a fecund restlessness born of a large and sure command of the art of painting, and of the coincidence of natural talent with a time and place as favorable to its development as mid-nineteenth-century Paris.

An artist like Renoir needed a going school or movement around him in order to realize the fullness of his gifts. He needed to be unsettled and challenged by the proximity of temperaments more ardent, self-conscious and doctrinaire than his own. He was lucky in meeting Monet so early in his career. His appetite for high, clear color might have drawn him to Impressionism in any case, but Monet and formal adherence to the original Impressionist program saved him time. As it was, he had his own urge to innovate, though not the missionary zeal to make a program of it. He led the way for the other Impressionists in the use of pure color; they made a program

of it, he simply painted to satisfy himself. Where he followed the others was in adopting—with his own modifications—Monet's more radical notion of the picture as a slice of nature unmanipulated by "human" interest. Though he accepted it spontaneously and made it part of the basis of his mature style, he did not adhere to this approach as religiously as Monet himself or Pissarro and Sisley did; he could deviate from it whenever he felt impelled by subject or mood. For him method or system was purely a means.

The end was the picture: more specifically, the *beautiful* picture. And it did not take the French public too long to see that Renoir's *beauty*, once the novelty of its means was digested, was an extension of the beauty they were accustomed to find in the art of tradition. It was, to be sure, a new inflection; but it was not a break. Renoir himself wanted it that way, and said so. And continuity with tradition is more marked in his case than in any other Impressionist's, not excepting Manet's, although Manet proclaimed his loyalty to the museum more insistently than Renoir (that Manet took his first cue from Velasquez and Goya did not make his art any the less revolutionary in essence; today it still looks more so than Renoir's or even Monet's—at least before 1890). But it is not only a question of the museum.

I feel that the beauty, the very valid beauty of Renoir's paintings depends very often on a faint yet crucial admixture of the *picturesque*. The picturesque is very hard to define as a formal quality, though easy enough to recognize. I would say that it consists in a set of formulas derived by simplification from the most obvious features in the design, color and color-distribution of already proven masters; it entails emphasis on what is felt to be immediately pleasing. The element of the picturesque that Renoir put into his art comes originally from eighteenth-century and early Romantic painting and was already so conventional by his time that it provided the formal substance of the popular chromo. Renoir, I believe, felt a certain affinity with popular art, as did many of the avant-garde artists and writers of his day—Seurat among them. And his notion of the picturesque seems to be taken even more directly, albeit unconsciously, from popular art than from eighteenth-century or Romantic painting. Eventually the picturesque creeps into the art of almost all the Impressionists. But with

Renoir it seems to have had a head start, owing perhaps to his early training as a porcelain painter and decorator of fans and window curtains—and also his facility. Certainly it is one of the factors to which he owed his worldly success.

Yet the picturesque in Renoir is also the source of a contradiction in so far as it conflicts with the above-mentioned Impressionist approach to the picture as a slice cut out of nature, all parts of which are to be treated with equal emphasis and equal disinterest. This may have made it easier for him to indulge his painterly brush, but the sweet crispness of the picturesque gave him a more reliable principle of unity. The difference between the two approaches created a tension to which Renoir's painting owes some of its most pleasing qualities. The picturesque does not compromise it—or not until a certain point. And without this dosage of the picturesque his lushness of color might have run over into a kind of suffocating decoration, as happened so often with the late Monet's sugary iridescence.

Renoir abandoned the picturesque only when his color began to change, shortly after 1890, becoming brassy, then coppery, and hardening his figure pieces and nudes under a monotony that his drawing, though it remained sensitive, could not relieve. The painting stays soft in his landscapes and in the little flower-pieces he turned out in increasing number, but it becomes a manner dependent on mechanically repeated infusions of alizarin and madder and—in the landscapes—hot blue, with design treated so perfunctorily that it falls apart into something neither pictorial nor decorative but simply fragmentary. This is Renoir's famous and much debated last phase. Obviously, this writer does not find it to be what its supporters claim. Yet he will admit that there are exceptions, and that the exceptions may even be worth the price. Some of the little flower pieces do rise suddenly, and far above the general dead level. And I have seen two large figures-in-landscape paintings of the last phase, the *Grandes Laveuses*, 1912, and the *Judgment of Paris*, 1914—there may be still others—that rise so far above it that they break through into a realm the picturesque Renoir was never at all able to reach, a realm where, become monumental instead of picturesque, he joins Cézanne, Velazquez, Rubens and the Venetians on the loftiest

heights of painting. So when we discuss the late Renoir we have to qualify drastically.

This exhibition was unable to include the two pictures just mentioned. It takes its stand more or less with the felicitous Renoir of the period between 1865 and 1890, and on the whole does so rightly, I would say. Yet when we have once recovered from the first impact of that felicity and the prodigal gifts that convey it, we may find ourselves looking in vain for some last intensity. This, although we remain transfixed before such masterpieces—to name a few out of many—as *Landscape at Wargemont*, 1879, *Crags at l'Estaque*, 1882, *Children at the Seashore (Guernsey)*, 1882, *Young Girl in Blue*, 1882, *Madame Renoir and Her Son*, 1885, *Girls Seated by a Brook*, 1885, and *Sea and Cliffs*, 1889. (Renoir would seem to have reached his consistently highest level in 1882, yet a year later, returning from Italy, where he had taken a good look at Raphael, he became very dissatisfied with himself and changed over to the closed and precise line and the smooth modeling that characterize his "neo-classical" phase, which lasted until 1887. He continued on a high level during this period, retaining Impressionist color in spite of himself, yet I for one marvel at why he chose to become dissatisfied precisely when he did.)

If we miss some final, highest realization in even the Renoir of the early eighties it may be because that is still the picturesque Renoir, who was something of a bourgeois and aimed at limited objectives. The limits are set high, but we expect an artist of his caliber to strive to go beyond what he knows about himself—not only to change his style and explore, but also to attain to revelations. This does not happen at the Wildenstein exhibition. The picturesque, no matter how wisely and suavely used, is a limitation. To see Renoir transcend himself we have to go to the two large late pictures.

But still—what a profusion of pleasure there is at Wildenstein's, and how ungrateful it is to carp at it: a foaming, pouring, shimmering profusion like nothing else in painting; pictures that are spotted and woven with soft, porous colors, and look in themselves like bouquets of flowers (so that whenever the actual image of a bouquet appears it tends to be a superogatory presence); pictures whose space is handled like a fluid that floats all objects to the surface; pictures in which

our eyes swim with the paint and dance with the brush-stroke. Never anywhere else, except perhaps in the Orient, have luxury objects been lifted to such a high plane of art.

Art News, April 1950; A&C (substantially changed)

5. The Seeing Eye: Review of *Landscape Painting* by Kenneth Clark and *Landscape, Portrait, Still-Life* by Max J. Friedländer

Kenneth Clark's book is a first-class example of how art criticism can be married to art scholarship, and it should be held up as a model to students in schools of art history. The author's long acquaintance with the facts and artifacts of art has not afflicted him with that obsession with "objectivity" that shuts off so many savants of art from a genuine experience of their subject. He is more interested in the quality of art than in the data accessory to it. Here he shows us how landscape paintings work and why they look the way they do; unlike so many art writers, he does not take the *appearance* of a picture for granted. He makes no bones about the fact that he accepts his own taste as his best guide, and he does so rightly, for it is obvious that it is a highly developed instrument, personal and objective at once.

Sir Kenneth must perforce give us some history, but it is sketchy, as he himself warns us; he must also go into causes and circumstances, but he is not too much interested in these and perhaps lacks the power of mind in any case to throw truly fresh light upon them; he must likewise go into classification and description, but here he triumphs by making these primarily a matter of aesthetic evaluation. He is concerned more with aesthetic results as we enjoy them here and now than with art as a historical process. Thus he accounts for the various modes of landscape painting that he distinguishes—symbolical, factual, ideal, romantic, realist, impressionist, etc.— by elucidating the inner logic of the pleasures they offer an experienced and sensitive eye. The result is very refreshing as well as edifying for someone like this reviewer who ordinarily resigns himself in advance to pusillanimity and standardized opinions when he opens a book on art.

Sir Kenneth is at his best in his chapters on landscape painting in the nineteenth century. In this, I feel, he is not unique, for the best criticism of this moment, in both art and literature, seems to be centered on the nineteenth century. One's critical faculties would appear to function at their best when the subject is something over and done with but still close enough to the present not to be altogether devoid of its original novelty. Sir Kenneth is particularly good in weighing the merits of the Impressionists and Post-Impressionists. He dares to be dissatisfied with Seurat's *Grande Jatte*, that cult object of the prophets of modernism, and he puts his finger exactly on the trouble: "Seurat has tried to create large monumental shapes in color by means of the silhouette, and this, in spite of his skill in shallow, internal modeling, produces rather the effect of pasteboard pictures in a toy theater." His analysis of the evolution of Cézanne's art is one of the most cogent I have come across, whatever small points of disagreement one may have with it. In the foreground of his consideration he instinctively keeps the premise that the end and not the means of his art was Cézanne's first concern, and the end was successful and noble pictures, not the revolutionizing of painting.

However, Sir Kenneth does not fare so well in dealing with the present state of landscape painting and in explaining the reasons for that state. Here, venturing into extra-aesthetic considerations, he can produce only second-hand opinions and some head-shaking about the new science's attack upon the unity of nature. I think it would be equally true to say that, on the contrary, the new science has revealed how horribly uniform nature is. This would help explain the abstract artist's seeming assumption that any one part of experience, no matter how small or fragmentary, is a repetition of all of it. Therefore subject matter in the external sense is of no importance.

Max J. Friedländer, who is perhaps the outstanding authority in the world on Flemish and Dutch painting, writes with an appearance of greater incisiveness yet with much less perception and sensitivity than does Sir Kenneth. It is obvious that he belongs to an older generation of art scholars and that outside the traces of scholarship he is loath to confront specific works of art at length and trust to his taste. He prefers "objective" generalities. This may be the difference between English and Continental art writing; surprisingly or not, the English

have for a long time produced the better art critics, perhaps because their empiricism does not permit them to overlook for too long the main point of works of art, namely, their aesthetic quality. On the other hand, Professor Friedländer brings a more sophisticated awareness of philosophical, political, and social factors to bear on his more or less popular account of the origins and development of the various subject classes of Western painting. His book will be useful to those who have no previous acquaintance with the history of the things it deals with. It is also interesting because it orients the perspective of European art on the Flemish, Dutch, and Germans rather than the Italians and French. And once in a while it offers some new information or a telling reformulation of something we already know—for example, the Impressionist painter "obtains wholesale trueness to nature, whereas formerly only piecemeal trueness to nature resulted." But on the whole this book remains much inferior to one like Sir Kenneth's, and has to be classed in the end, for all its pseudo-pregnancy, as one more example of the pedestrianism endemic to art writing. Professor Friedländer has written much better elsewhere.

Both books are adequately illustrated with black-and-white reproductions. The translation of Professor Friedländer's text is competent and idiomatic but not at all elegant.

The Nation, 22 April 1950

6. Foreword to a Group Exhibition at the Kootz Gallery (written jointly with Meyer Schapiro)

To the proposal that he open his gallery to a group exhibition of work by unknown or little known "Young Artists" of promise and others whose accomplishment has not been sufficiently recognized, Sam Kootz responded most generously by inviting us to arrange just such a show.[1] It was an exhilarating experi-

1. Greenberg and Schapiro are described in the exhibition pamphlet as "two writers on art who have contributed greatly to the encouragement of creative work in America." After visiting studios together, they selected work by twenty-three artists for the show. All the work exhibited was for sale. [Editor's note]

ence for us to make the rounds of the studios and galleries and to discover the robustness, the enthusiasm, and pictorial culture of "Young American Art"—at least two-thirds of the painters are under thirty. We were limited to New York and even here we have undoubtedly missed some equally good or better artists eligible for this show. We hope it will be as exciting to others as it is to us.

Talent 1950, Kootz Gallery, New York, April–May 1950

7. The Venetian Line

The paintings from the Vienna collections now on view at the Metropolitan in New York do not form so large or interesting an exhibition as those from Berlin that we saw two years ago in Washington.[1] The Austrian museum authorities did not want to expose their wood-panels to the hazards of travel, and thus confined their shipment of pictures to canvases, with the exception of a few copper-panels and some paintings on paper. However, the selection, owing no doubt to the Hapsburgs' marked taste for Venetian painting and its legatees in Spain and Flanders, makes up in sumptuousness and physical scale for a relative lack of variety. Added to this are the less spectacular virtues of some thirty Renaissance bronzes. Even when we include the tapestries, ornamental objects, and other items, the exhibition as a whole still creates that rich and suave effect that belongs so particularly to Venetian art. Golden or silvery volumes glow from out of umbered depths. Rubens, van Dyck, Velasquez, and Rembrandt sustain this general impression in their several ways; Caravaggio (even though with a bad, mechanically painted picture) and Hals conform to it. Surprisingly, even the wonderful Vermeer canvas, "The Artist in his Studio," with its very un-Italian luminosity, seems to fall well into the embrace of the Venetian tone; as does also a mellow Ruysdael landscape. But this paradox may be largely an illusion of the décor.

1. See Greenberg's review, "The Necessity of the Old Masters," *Partisan Review*, July 1948, reprinted in vol. 2. [Editor's note]

Velasquez makes the best showing of all; I suspect that his later style would always make the best showing, no matter in what company. I have never seen a better piece of painting than his *Infanta Margareta Teresa in Pink*, or for that matter, his *Infanta Maria Teresa*, which was done at about the same time and in some particulars even surpasses the other work. His small head of Philip IV, executed with a rich, melting touch, is also superlative. His other three portraits fall short of the quality of these by only a shade. In his best period Velasquez had such a consistent command of his art that the merit of individual pictures would seem to vary only according to the extent to which the nature of their subjects gave him opportunity for the display of his craft: a portrait subject with an elaborate head-dress or a distinctive physiognomy would produce a richer or more interesting picture than one with a shorn head or commonplace features. The later Velasquez could improve a painting simply by putting more things into it.

Of the four great Venetians—counting the fairly pleasant portrait ascribed to Giorgione—Tintoretto comes off the most brilliantly: because of his portraits as well as his spectacular *Susanna and the Elders*, a painting that, for all its suddenness of design and the successful and painterly daring of some of its color chords, lacks perhaps a certain final rightness in the way in which the flattish, serpentine silhouette of the nude is fitted against the dark background. (I should hate, nevertheless, to argue too much against this picture.) Tintoretto's portraits I find superior on the whole to Titian's. Psychological penetration is there, but subordinated to the art of painting, which is contained in turn by the necessity of a faithful likeness. The interaction of these three factors seems to make Tintoretto more consistently successful in his portraits than in his larger compositions; in these latter he may often be a greater painter, but he is not such an even one.

The Titian portraits at this show are not at all even in quality, perhaps because they represent such different stages of his development. The best of them have a sumptuous yet convincing objectivity—see his *Johann Friedrich*—that is just as effective as Tintoretto's more nervous statement. His four large figure compositions are all more or less successful, but ambiguously so, and in no case equal to the big Tintoretto. Perhaps

some of them need cleaning, perhaps others have been retouched too much. It is hard to explain otherwise why these pictures, with their flaming skies whose color sequences seem freely invented without reference to nature, and their elegant massing of nude forms, do not achieve the final unity which seems within their grasp. The late *Nymph and Shepherd* might achieve this if it were cleaned; it does not appear possible that its grimy surface is due solely to the master's blurred vision in his last phase.

Veronese is represented by six pictures, all but one of which are figure compositions. Acceptable enough as samples of a master's skill, they suffer nevertheless from being too hesitant and smoothed-off in color, as if Veronese's virtuosity in the matter of glazing and neutral tones had been allowed to get out of hand and cast a weakening film over pictures more strongly conceived in the beginning. Because its design is so much firmer than its color, such a painting as *Adam and Eve after the Expulsion from Eden* acquires virtues in black and white reproduction that it lacks in the original. I greatly admire some of Veronese's work, but the best—not the worst— among these present pictures help me understand why he was seldom praised in the past without strong qualification.

Van Dyck shows on the whole to better advantage than his teacher, Rubens, and it is because he is mostly represented by portraits, while the majority of the Rubenses sent over are of the kind that were worked on by his assistants. No matter how automatic and uniform the social polish van Dyck applies to his subjects, he remains great in the portrait genre. And he is always an extraordinary brush-handler, if not extraordinary artist. His marvellous *Study of the Head of Woman Looking Upwards* does everything that Delacroix failed to do in his portraits; it pushes lyric color in oil to a point of intensity beyond which there was little more left, really, for Romantic painting to say two hundred years later; one already senses Impressionism stirring in it. In a Rubensesque pastiche, *Venus in the Forge of Vulcan,* van Dyck also shows that he could spread his master's brush manner over a large expanse of canvas almost more effectively than the master himself—though he does not thereby arrive at more than a mildly pleasing effect, one insufficiently modulated to provide real satisfaction. Obviously, van

31

Dyck was not at his ease away from the portrait, as his two other figure compositions make clear; these are vapid if only because they do not lean sufficiently on Rubens. Rubens himself is worthily represented by only two pictures: one of his relatively few successful portraits, a half-length self-portrait done late in life, and another late painting, the large and amazing *Feast of Venus*, which rustles and gives off a mottled light like a curtain of flowers in the wind. Yet here again, as in the big Tintoretto, I miss a final rightness in what is otherwise a masterpiece. Was it the factor of scale alone that made this rightness so hard to come by in the larger compositions of the late Renaissance and the Baroque masters? One is tempted to think so, seeing how well Titian, early in his career, solved the problem of figures in open space, and precisely on a reduced scale, in that tawny little jewel, *Endymion and his Flock*, which was hung in a small, brilliant show of some of the old masters in their possession that the Knoedler Galleries put on in March. But then again, since this painting is mostly a landscape, the question enters as to whether the landscape, all others things being equal, does not compose itself better in painting than a multiplicity of figures. (I am told this particular Titian has an incomplete pedigree but, if Titian did not paint it, whoever did was a contemporary of his and, for at least that moment, as great as he. It is a picture I could dance in front of. And the Daumier and the Jean Provost in the same exhibition also deserve to be remarked upon.)

Among the surprises to me in the Vienna show were Palmavecchio's *Bath of Diana*, the Spanish portraits of Mor and Coëllo, Guardi's large, sketchy *Dominican Saint Rescuing Pilgrims at the Collapse of a Bridge*, and—especially out of the blue—the 17th-century Neapolitan, Andrea de Lione's, *The Departure of Jacob* and Salvator Rosa's *Astraea, the Goddess of Justice, Fleeing to the Country People*, in both of which sudden outspoken notes of color animate what would otherwise be stereotypes of the Italian Baroque manner. Other pictures, less surprising in their excellence though in most cases superior, were Rembrandt's powerful late-ish self-portrait and an even later portrait of his son, Titus, Bassano's *Adoration of the Magi*, Correggio's *Jupiter and Io*, (which, with its not too appreciably inferior companion piece, *The Rape of Ganymede*, startled and delighted me by all it foreshadowed of 19th-century academic

painting), Aert van der Neer's *Fishing by Moonlight*, Guardi's *Entrance to the Arsenal in Venice*, Ter Borch's and the elder van Mieris' two small genre subjects, and practically all of the small Brueghels. Also worth lingering before for the sake of pleasure are pictures by Paris Bordone, Annibale Carracci, Carreño de Miranda, Cerezo, Dürer (puzzling in its deficiencies), Duplessis, de Hooch, Maulpertsch, Mazo, Moretto da Brescia, Moroni, Rigaud, Savery, del Piombo and Solimena. The frequency of pleasure in this exhibition is high and I leave out of account its magnificent tapestries and other objects, including the bronzes—the consideration of which would be important but lies outside my interest.

For me the Vienna show made a point, revealing a cumulative tendency in the art of the 16th- and 17th-century masters I had not been so aware of before, though I must say that I had half-suspected it. Perhaps it is because this selection starts so emphatically with the Venetian painters. Or perhaps it is an illusion created by hindsight. An any rate it would seem that easel painting, once it had overcome the example of sculpture and the habits of book illustration, abandoning the panel for canvas and tempera for oil, strained as if towards an appointed destination for an ideal of painterliness that was to be realized most strictly—if not of necessity most greatly—in the 19th century. The flickering, lambent touch of Tintoretto and Rubens and Velasquez, the late Rembrandt's heavily loaded brush, Watteau's trembling colors, even Vermeer's buffed and lustrous surfaces—and a good deal in Brueghel too—are all driven to their conclusion by what is greatest in 19th-century painting. The entelechy of oil painting on canvas is Turner, Constable, Géricault, Delacroix, Corot, Courbet, Daumier, the Impressionists and Post-Impressionists. This is the Venetian line. If there is an exception in the 19th century, it is Ingres in his portraits; yet, to tell the truth, I find these as close to Venice as to Florence.

Oil on canvas suggests "open" rather than "closed" forms, loose rather than tight contours, broken rather than smooth, uniform colors, transparent and vibrating rather than opaque surfaces. Oil fulfills itself on canvas when the painter draws with a full brush, with color and in masses, instead of tinting or filling in a prepared outline. Then the painter invents form with his brush, not his pencil, and sees everything in terms of

transition rather than sharp separation. Venice, though starting from a different conception of painting—Gothic, then Florentine—aspires toward this in the end. With Rubens and Rembrandt the aspiration becomes more conscious. El Greco transmits it to Spain. Velasquez already says everything. We can understand why Manet, who began the devolution of the Renaissance tradition of oil painting—and even anticipated its conclusion—went to Velasquez for the original basis of his style. The flower piece to the left of the figure in the Infanta Margareta Teresa portrait could have been painted by the French artist on one of the better days of his middle period—and could also have been painted by Matisse in a conservative moment. In an aside it says everything that Manet was to say deliberately and emphatically: namely, that it is possible to *draw* color and draw *with* color, and that all painting can be brush drawing. Van Gogh and Cézanne bore that out, not to mention the Impressionists (the individual brush stroke becoming the unit of composition). Matisse and, even more distinctly though quite differently, Soutine show in our day how color can be drawn. Eventually, Matisse turned the procedure inside out by designing in flat areas with hardly any drawing, using his brush like a broom. Mondrian made the final conclusion by way of analytical Cubism, and in a sense arrived back where the Renaissance began.

Velasquez, rather than Rembrandt, is the old master whose work I would choose if I were asked to point out the exact polar opposite of Mondrian's final manner. And yet the process that ends with Mondrian begins with Velasquez. The dialectical principle by which all things are inevitably converted into their opposites may not operate in nature, but it certainly seems to do so in art.

Partisan Review, April 1950

8. Two Reconsiderations

A second, third, and fourth visit to the Vienna show at the Metropolitan gave me reason to modify in one important re-

spect the impression that I reported in the previous number of *Partisan Review* after a first visit.[1] I did much less than justice to Titian (as well as failing to praise extravagantly Brueghel's little *Adoration of the Magi* and even to remark on Lorenzo Lotto's *Virgin and Child with Saints Catherine and James the Great*). On second and calmer view, when one has assimilated the first impact of the number and general brilliance of the pictures and begun to take one's ease among them, it is discovered that those works that had originally the greatest immediate effect do not in every case remain the necessarily superior ones. Thus, as one goes from Titian to Tintoretto, the latter's instantaneously effective patterning of dark and light, with the more readily apprehendable painterly qualities produced by a faster and freer brush, does not come as the refreshing surprise it was before. This time I had taken a longer look at Titian, and Tintoretto appeared a little thin and papery in contrast. His paint remained too much on the surface, easy to be peeled off in a single fragile layer. Nor was Tintoretto the only one to make this impression. By comparison with Titian every other painter in the Vienna show, save perhaps Velasquez, began to seem thin too.

I find Titian's great and special virtue his ability to transform the canvas so completely in the interest of the illusion of mass and volume. This was the central interest of five centuries of Western painting, and it makes Titian the central and perhaps supreme master of those five centuries. Other painters have worked more sculpturally, still other painters have given a more emphatic version of deep or distant space, but none has achieved statements of the illusion, as such, of the third dimension that are equally convincing, full, and integrated. None has so thoroughly possessed a flat surface for the sake of that illusion or—to be even more exact—surrendered so little of the illusion for the sake of that surface. Yet Titian does not violate what is called the integrity of the picture plane; there are few "holes" in his paintings, few protruding bosses. It is not a question of *trompe-l'oeil* with him; he does not model and tint toward the end of a complete naturalism, for the simple sake of likeness to nature. His illusion is original and harmo-

1. See the preceding item. [Editor's note]

nious, and something that is a means; it is the illusion of the three-dimensional world that can be most convincingly rendered with paint on canvas *as art*.

The principal factor in this art is color—color modulated according to a scheme of dark and light values such as is deemed best fitted to endow flat colored surfaces with the illusion of volume. Titian's color has a substantiality of texture that makes it hard to conceive that it is the product of thin layers of paint spread on a sheet of canvas; one has the impression of configurations that well up out of infinite real space— as if the reverse as well as the obverse side of the canvas had been transformed by paint. Or as if the very threads of the fabric had been dissolved into pigment so that the picture consisted entirely of paint without a supporting surface. And yet—this is the contradiction essential to the art—the supporting surface that we know to be actually there is not denied in its flatness, and we feel this without feeling any the less the illusion that it is not there.

On the other hand, and despite all this, repeated visits to the Vienna show have not persuaded me one jot more of the final rightness of Titian's large figure compositions. They still do not quite come off, and an increasing perception of his sheer qualities as a painter makes this only more exasperating and disappointing. Nor does the fault lie as much with the grime or the possible retouching as might at first be thought. There would appear to be something wrong with the design in every one of the figure compositions; that these pictures make Titian's special virtues clearer even than do his portraits, however more unified the latter are, is but additional cause for exasperation. Perhaps Titian's way of creating form by color modelling does not accord with his insistence on frontal arrangements of solidly moulded forms parallel with the picture plane. This may explain a certain redundancy in the massing of nude figures, a certain lack of movement and plastic variety; in the context of what is after all atmospheric painting the eye is held too evenly close to the surface over too great a part of the picture, and the escape it finds through the upper right- or left-hand corner may become too pat, no matter how wonderfully the corner itself is painted.

Whatever the explanation, one sees how Tintoretto's adventurousness gave him an advantage over Titian in the depart-

ment of design. Tintoretto is not his equal as a painter and executant, but he often conceives more greatly. His *Susanna and the Elders* lacks Titian's substantiality and depth, but it has a greater and more difficult unity than can be found in the older master's figure compositions. On second view I began to suspect that the final rightness which I thought to miss in the Susanna picture had been there at least originally. The trouble is not in the way in which Susanna's undulating silhouette is fitted into the background, as I wrote last month; it's in the wattled wall that runs diagonally into depth across the left center of the canvas. This, it appears to me, has been darkened by time so that it now makes a more or less blank hole where it must originally have provided a livelier transitional passage in different shades of brown. Titian would have insured himself better against such an eventuality.

But enough of comparisons. They are dangerous to make on the basis of the relatively few works by which Titian and Tintoretto are represented in the Vienna show. A visit to Venice may cause me to reconsider my judgments again—and in a more embarrassing way than this time.

In the work of certain contemporary artists we tend at first to notice chiefly, or exclusively, that which it has in common with the work of other artists. As a result we think of these artists as un-original and derivative and too dependent on influences from outside, and we class them with the great unimportant host of imitators. Then, as their work becomes more familiar, it slowly becomes apparent that the resemblances that used to bulk so large have somehow—incomprehensibly—shrunk and lost their scope and importance, and that the main point of the art in question has become precisely that which is individual about it. This, rather than the resemblances, is now all we can notice.

The late Arshile Gorky, who died in the summer of 1948, was an artist who had the misfortune to belong to this category. He was not an innovator, but he was at the very least original by mere virtue of his gifts. They were such as no other painter's in this country could equal. And he also had a rather original temperament, but one that required time to make itself felt, especially since the artist himself seemed to lack confidence in it. In many ways Gorky was a better handler of

brush and paint than any one he was radically influenced by, including Picasso and Miró. And what he did with the hints he got from Matta made the latter look a more serious painter than he has any probable chance of really being.

The fact of Gorky's originality was the point made for me by a show at the Kootz Gallery in April of fourteen oils executed over the last several years of his life. It was the most brilliant and consistent show by an American artist that I have ever seen, and I say this advisedly. I now find Gorky a better painter than Ryder, Eakins, Homer, Cole, Allston, Whistler, or any other American one can mention.

This writer once made the mistake of thinking Gorky a slave to influences—first Picasso's and Miró's, then Kandinsky's and Matta's.[2] These influences were indeed there, but the error was in seeing them as something *obeyed* rather than assimilated and transformed. His second one-man show, at Julien Levy's in 1946, made me begin to change my mind, and a third show at the same dealer's, two years after made me change it definitely. But nothing has convinced me so flatly of my error and demonstrated its shocking extent so fully as this last show at Kootz's. I had seen all the pictures before, but during the two years since when I had last seen most of them they seemed to have blossomed into some added richness that made irrelevant whatever in them had at first appeared derivative. They struck me as being much more unified now and as possessing a singular excellence compounded of skill and feeling that owed its inspiration to no one.

Many of us who followed Gorky's course with real interest had always appreciated his enormous gift but, for all our interest, we had failed in large measure to recognize the extent to which he fulfilled it in the last four years of his life. And I have reason now to believe that the fulfillment dates back much further than this, as we would have known had we had the eyes to see. We have had to catch up with Gorky and learn taste from him; he was one of those artists who had by them-

2. On the occasion of Gorky's first exhibition at the Julien Levy Gallery in 1945, Greenberg wrote: "The critical issue in Gorky's case was how much of the value of his work was intrinsic and how much symptomatic, evidential, educational. He has had trouble freeing himself from influences and asserting his own personality." *The Nation*, 24 March 1945, reprinted in vol. 2. [Editor's note]

selves to form and extend our sensibility before they could be sufficiently appreciated. And we now see that he did do this. How otherwise can the suddenness be explained with which he is now revealed to us? Revealed in all the abundance and perfection of the fruits he garnered from his supernal skill as a draughtsman and his taste and sincerity as a colorist. In such pictures as the *Diary of a Seducer* (1945), *Landscape Table* (1945), and *The Beginning* (1947) he shows himself as one of the great painters of his time and among the very greatest of his generation. This, of course, makes his absence all the more tragic. By now Gorky would have been only forty-five, and he should have been here to receive his due.

Partisan Review, May–June 1950

9. Religion and the Intellectuals: A Symposium

All the factors you suggest play their part in the present revival of religiosity among intellectuals—and still others besides.[1] One factor attracts another, so that they converge in what seems like a concert, not of individuals, but of the "objective" forces of society. But you should have pointed out that the

1. Greenberg is responding to a series of questions and assertions put forward by the editors of *Partisan Review* as a guide to discussion. In particular, participants in the symposium were asked to respond to the following: "From a naturalistic point of view, all events (including those of history) have their causes, and the present revival of religion would not be an exception. What do you think are the causes of the present trend? Is it due to the worldwide failure and defeat of a real radical movement in politics? To a renunciation of hopes for any fundamental social improvement? Or to some kind of breakdown in the organization of modern society, to which religion would seem to supply a remedy?" In addition to Greenberg, twenty-eight writers contributed to the symposium. They were James Agee, Hannah Arendt, Newton Arvin, W. H. Auden, A. J. Ayer, William Barrett, R. P. Blackmur, George Boas, Robert Gorham Davis, John Dewey, Allan Dowling, James T. Farrell, Robert Graves, Sidney Hook, Irving Howe, Alfred Kazin, Paul Kecskemeti, Dwight Macdonald, Jacques Maritain, Marianne Moore, Henry Bamford Parkes, William Phillips, Philip Rahv, I. A. Richards, Isaac Rosenfeld, Meyer Schapiro, Allen Tate, and Paul Tillich. The responses appeared in four consecutive issues of *Partisan Review*, and were subsequently collected in a single volume. [Editor's note]

religious revival seems confined largely to literary intellectuals, and that among these it is the poets who are most affected.

I want to restrict my remarks to the state of mind among these latter. Nowadays they decide the literary climate.

T. S. Eliot first brought to our attention that "disassociation of sensibility," that divergence between thought and feeling which, he says, began to manifest itself in English poetry with Milton. It had, however, begun elsewhere and its effects were already noticeable on the Continent before they became apparent in English literature. Formally, the disassociation dates from Descartes' claim that the subject receives his surest guarantee of the fact that he exists from the presence of his own thought. Thought becomes the *prima facie* evidence of truth and throws out of court whatever is reported by direct perception or intuition or affect without being manipulated by the "categories of understanding." The truth is not what is *felt* but what works and is consistent with itself. The result is a split in consciousness, between the conative and the cognitive, the subjective and the objective. In the end we fall prey to a kind of collective schizophrenia.

This schizophrenia is part of the discomfort of our civilization. It is painful to be unable to assent to the data of immediate awareness and to be compelled to act only upon that which is derived from the operations upon experience of "objective," detached reason. How intense by comparison is the comfort of believing what we feel. And how richer seeming. Romanticism and all the revivals of religion and religiosity since the eighteenth century are attempts to restore the validity of the data of feeling. I am not saying anything new here. But I do think it necessary at this moment to repeat with added emphasis that latterday revivals of religion are still part of that which, under the name of Romanticism, is spurned by so many of the revivers themselves. And that, essentially, Romanticism is a reaction against the failure of scientific description to confirm what is *"anschaulich"* in ourselves and the world around us.

It is obvious why poets are restive in the presence of the scientific or naturalist attitude. Our total, our felt sense of reality—which is what art speaks for and to—has never yet been contained within the rules of logic and verification. It is

therefore of the essence of art that it should deal with inconsistencies, maintaining them unresolved (or in suspension, as it were). But it was only with the real rise of science that the poet became susceptible to the reproach of intellectual irresponsibility on that account. By now the gap between poetic practice and actual knowledge has grown too great and the reconciling formulas outworn. There are, and have been, poets—Yeats was one—who believe that art as such is its own warrant, and therefore the warrant of everything necessary to it. But there are other poets—and the circumstances of our day seem to increase their number—who cannot feel safe in the practice of their art unless its lack of logical consistency receive the sanction of some all-embracing, extra-aesthetic authority, such an authority as would hold good for more than simply art. This authority is to be found most conveniently in religions. Among religions Christianity, with its beautiful paradoxes of the Trinity and Transubstantiation, lends itself particularly well. Once we belive in these, we are absolved of any except the most empirical crimes against the rules of evidence, Thomas Aquinas to the contrary notwithstanding. We can believe once more in the data of our feelings, and the art whose substance they furnish becomes "responsible" again. In theory at least, the disassociation of sensibility is healed.

I have, of course, simplified the process, repeating what is already well known, in order to describe it. The fact is that no amount of devoutness is able, in these times, to protect religious sanctions or symbols in art from the pressure of naturalism with its rules of evidence. This is shown by the irony omnipresent in successful contemporary poetry, religious and otherwise: that irony which remains literary art's last defense against the disassociation of sensibility. And woe to the poet who lets this irony lapse.

The mysteries of religion have still other specious charms for the modern artist. They promise profundity. Science has told us nothing about the absolute ground of being, and I can well see how, in view of this, some people might find superficial the sureness and clarity that science displays in treating what *is* knowable. The knowable, that about which verifiable propositions can be formulated, may strike them as shallow simply because it can be known. This kind of sensibility is, however, relatively new. It dates from Romanticism and the

beginning of bourgeois society's refusal to confront the difference between its ideals and its actuality; it was only then that the unknowable became identified with the "profound," which in its turn was established as a genre almost—the genre of the allusive and illusive, of vaguenesses, hints, of clues that lead nowhere, of assumptions that are neither defined nor corroborated, of big words. We are through with the big words and what they advertise; their aesthetic credit, at least, is exhausted. But in the name of "profundity" we still long to dissolve our art and ourselves in some ultimate vagueness or confusion. And what promises this better than religion? Yet the aspiration is an aesthetic, not a moral or religious one.

Partisan Review, May–June 1950; *Religion and the Intellectuals*, 1950

10. The Art of China· Review of *The Principles of Chinese Painting* by George Rowley

It can be said that the Orientals and the West have tried to subdue to consciousness quite different areas of experience. The West has devoted itself to history, the physical environment, and practical method; the Orientals have concentrated on religion, introspection, and aesthetic experience. Thus the rich terminology developed by the Hindus for introspection makes precise distinctions between sensations and states of mind that our own culture deals with as more or less undifferentiated. The Chinese, for their part, devised an almost equally elaborate terminology for the subjective effects produced by art.

Art, according to the author of this sumptuous and informative book, has been the dominant bent of Chinese civilization, to such an extent that "all . . . other [Chinese] activities seem to have been colored by their artistic sensitivity." The art of arts in China seems to have been painting, and the codification of its principles as it was practiced there surpasses in psychological refinement anything similar in the West. What is aimed at is a fixing in words of varieties of aesthetic effect rather than of technical means. The vocabulary of Chinese art criticism makes fast modes of aesthetic experi-

42

ence that we in the West usually prefer to leave to the in-
definitely subjective, or at best try to describe with words
borrowed from the most general aspects of life. Doubtless the
intimate relation between literature and painting in China,
sealed by the practice of calligraphy as an art, contributed no
little to the creation of this vocabulary. Many Chinese painters
were also writers who turned out verse and criticism along
with their pictures; an even larger proportion of them were
amateurs, "gentlemen painters," in so far as they pursued their
art in conjunction with more formal vocations as officials and
public men. The Chinese painter seems to have been early ac-
corded a much higher cultural as well as social status than his
Western counterpart; he was expected to be a kind of scholar
first of all, literally conscious of all the references of his art,
and then a seer in whose art aesthetic effect was merged with
mystical state.

The Chinese connoisseur looked to painting for insights
into the nature of reality that were accepted as hardly less valid
than those expressed by the verbal expounders of religion and
being. A picture was read like a poem, and more than poem.
And it was an even more serious error than in the West to
regard it principally as a part of *décor*. It is true that Chinese
painting could be very decorative and that it was increasingly
subordinated to decoration, but this has been done, it seems
to me, judging by the results, at a more serious cost than in
the case of almost any other art. For it violated the Chinese
picture's function as an object of contemplative pleasure and
perverted some of its most essential plastic elements. I believe
this to be true in spite of the fact that the absence of full color
and strong modeling in Chinese painting and its, so to speak,
passive naturalism gave the decorative a foothold from the be-
ginning. The emphasis on brushstroke quality and subtlety of
dark and light values, and the exploitation of empty space
were equally important elements that of necessity resisted the
decorative. In view of this, it is my hunch that Chinese paint-
ing became as decorative as it now seems only toward the end
of its development two or three centuries ago; and it is this
that is responsible for the present insipidity of so much of it.

Most of the Chinese art we see in Europe and America
strikes me as being late. It has all the characteristics of an art
whose development had long ago brought it to the point where

it was possible to rationalize the means to a standard repertory of effects and to control these effects with a sureness that guaranteed success—but only within limits and only at the price of spontaneity and freshness. What we get in the end from this sureness within limits is the pat and the pretty. Its lateness, its decorative prettiness, its corruptedness, together with its naturalism, would seem to account for the relative quickness with which Chinese art was accepted in the West, once popular taste in the West was ready to accept exotic art; we began to acquire a taste for chinoiserie a hundred years before any of us ever looked at an Egyptian statue as something more than an archaeological curiosity. The only historical precedent I know of for the easy viability of Chinese art is Hellenistic sculpture, another art that was the late and rationalized product of a naturalistic tradition—as is also, incidentally, or own Western academic art, which, aided by the facilities of industry and science, outdoes the other two in the ease with which it conquers the taste of foreign cultures.

These remarks are, of course, not intended as a criticism of Chinese painting as a whole. Some excellent paintings are reproduced in Mr. Rowley's book, excellent for their abstract qualities as well as for their apprehensions of mood through nature. Beside them most Western landscapes of mood would appear obvious and even coarse. And when it comes to the use of the brush, that use which conveys exact feeling with every touch and harmonizes each touch, as an individual facet of feeling, with the unifying emotion of the whole picture—then the Chinese masters certainly have no equals.

The Nation, 28 October 1950

11. Advertisement for an Exhibition of Franz Kline at the Egan Gallery

"Most striking new painter in the last 3 years."—Clement Grunberg [*sic*].

The New York Times, 29 October 1950. (In 1961 Greenberg confirmed that he had been asked to provide this "blurb by me" for use as an advertisement. [Editor's note])

44

12. Self-Hatred and Jewish Chauvinism:
Some Reflections on "Positive Jewishness"

One looks into oneself and discovers there what is also in oth-
ers. A realization of the Jewish self-hatred in myself, of its
subtlety and the devious ways in which it conceals itself, from
me as well as from the world outside, explains many things
that used to puzzle me in the behavior of my fellow Jews. I do
not think that in this respect I am projecting upon others
faults I find in myself; it is only reluctantly that I have become
persuaded that self-hatred in one form or another is almost
universal among Jews—or at least much more prevalent than
is commonly thought or admitted—and that it is not confined
on the whole to Jews like myself.

The term "self-hatred" was first applied to what is better
defined as the Jewish inferiority complex—which is, strictly
speaking, more self-doubt and self-contempt than actual self-
hatred—by the late Theodor Lessing, a German Jewish writer,
in a rather unsatisfactory book on the subject called *Der Jü-
dische Selbsthass* which was published in the late 20's. The social
causes of this self-hatred were dealt with more satisfactorily by
the late Kurt Lewin, a sociologist who came to America from
Germany, in an article that appeared in the *Contemporary Jewish
Record* of June 1941 under the title "Self-Hatred Among
Jews." Dr. Lewin wrote then: "It is recognized in sociology
that the members of the lower social strata tend to accept the
fashions, values, and ideals of the higher strata. In the case of
the underprivileged group it means that their opinions about
themselves are greatly influenced by the low esteem the ma-
jority has for them. This . . . heightens the tendency of the
Jew with a negative balance [i.e., the Jew who finds his iden-
tity as a Jew too much of a psychological handicap] to cut
himself loose from things Jewish. . . . Being unable to cut
himself entirely loose from his Jewish connections and his Jew-
ish past, the hatred turns upon himself. . . ."

This states the case well enough as far as my own experience
is concerned. But when Dr. Lewin suggests that "A strong
feeling of being part and parcel of the group and having a
positive attitude toward it is, for children and adults alike, the
sufficient condition for the avoidance of attitudes based on self-
hatred," he reveals that he did not go any further inside the

45

problem than was required in order to describe it. He saw the signs of self-hatred too exclusively in an outwardly negative attitude toward fellow Jews and things Jewish, and took the absence of self-hatred for granted wherever a Jew made no bones about his "group belongingness" and accepted his Jewish connections. It does not seem so simple as that to me. Nor, perhaps, was it really so simple as that for Dr. Lewin. Otherwise he would not have reasoned in a circle.

If to have a positive attitude toward the group is *ipso facto* to be without self-hatred, the positiveness is the result of the cure, not, as Dr. Lewin suggested, its means. Nor, for that matter, is feeling "part and parcel of the group" such a sure antidote. The pressure of the larger society within which we live, according to whose traditions the Jews as a whole do not cut an attractive figure (have we not been, as Felix Frankfurter says, "the most vilified and persecuted minority in history?"), is far too strong to enable one to escape self-hatred simply by feeling oneself 100 per cent Jewish. On the contrary, such a feeling may even increase self-hatred. The pressure of the opinions of the larger society reaches everywhere, even into theological seminaries, and one may well resent oneself all the more for sensing oneself undilutedly Jewish.

The crux of the difficulty presented by self-hatred, as it affects the American Jew, lies in the different ways that it is acted out. The "negative" Jew, fleeing his Jewishness, expresses his self-hatred directly, even if he rationalizes it in some cases by maintaining that there is really no other difference than that of religion between himself and Gentiles (forgetting that he is quite aware that there is more than a religious difference between Anglo-Saxon and, for instance, Irish Gentiles). Or, in other cases, he may express his self-hatred even more openly by admitting that he dislikes Jews and things Jewish even though he is a Jew himself; then he will argue, most likely, that he is not like other Jews and therefore hasn't enough Jewishness in himself to cause him to feel self-hatred. Either way the self-hatred is not diminished, for all the directness with which it is expressed, and remains to corrode one's character. And it is compounded by a lie— namely, that Jewishness is a mere accidental detail, or that the Jew in question is less "Jewish" than other Jews. (No matter how much he may repeat this lie to himself, no Jew ever suc-

ceeds in believing it, whence stems that hidden anguish which is present in so many "inauthentic," genteel, and Gentilized Jews—the anguish, that is, of not being able to believe something one wants very much to.)

The "positive" or "affirmative" Jew is supposedly the opposite of this kind of Jew. Apparently, he, the "positive" Jew, has no self-hatred to express; he asserts, seeks out, and revels in his Jewishness. The question then is, ought his behavior be accepted at face value? Does he mean it all the way down? Was he free from self-hatred to start with? Or, if not, did he succeed in dealing with it in such a way that he became entirely free of it? If the latter is the case, then Jews like myself must sit at his feet and learn from him.

But what do I see when I take a longer look? That the Jewishness of so many of these "positive" Jews is truculent, and very sensitive to criticism; that it is also aggressive and uncharitable; that it points to itself too challengingly and has too little patience with conceptions of Jewishness other than its own; that it is too prone to polemical violence and name-calling; that, in the end, it faces outward too much and seems to get too little satisfaction from its own self. Were these "positive" Jews really and truly in possession of themselves as Jews, would they not be more at ease—even a little complacent? It is this absence of ease that makes me suspect that a certain familiar psychological mechanism is at work here. By projecting it upon others and attacking it violently in others, these "positive" Jews may be exorcising from their own consciousness an image of the Jew that is no less "negative" than that in the mind of the most cringing "assimilationist."[1]

II

"Positive Judaism" has been with us for quite a while now, but it has not yet succeeded in persuading me that it is more than a circumlocutory name for a new phase of Jewish nation-

1. Witness, for example, that innocent and lamentable delight with which so many "affirmative" Jews call attention to the prevalence of blondness and blue eyes among the Israeli youth. The phenomenon has been noted with the greatest satisfaction in precisely the most nationalist Jewish magazines and books. Yet we are always quite sure that the high value the American Negro puts on a light complexion is a symptom of his self-hatred. [Author's note]

alism in which it becomes more like other nationalisms, to the point of being infected with chauvinism.

Chauvinism, or rabid nationalism, history tells us, is a means usually of compensating for a sense of collective inadequacy or failure. As a sentiment shared by responsible people, it does not appear among nations that have enjoyed a successful history; thus it is not customarily associated with the national feelings of Americans and most Western European peoples. It is among the oppressed, frustrated, or backward peoples of Central and Eastern Europe that it has been most virulent. There we find Germans asserting Germanism, Russians Slavism, Magyars Magyarism, Lithuanians Lithuanianism as absolute ends in themselves and not needing generalization in terms of any broader value in order to be made the supreme criteria of all things on earth and in heaven. There we also find that self-consciousness about national traits which is preoccupied with determining, as the case may be, what is uniquely German or Russian, who is German or Russian, what makes Germans or Russians superior to all others, how one can go about becoming more German or Russian, and so forth.

We Jews have known something of this kind of self-preoccupation for a long time, albeit without nationalism, and while it often betrays the fact that we simply find ourselves more interesting than Gentiles, it is also the symptom of a collective feeling of self-doubt. But the self-doubt has, usually, to become general and very uncomfortable before it can furnish the fuel for chauvinism, and it is also necessary for the people concerned to have had some first taste of success.

It is with its first taste of success that a people musters up the nerve to begin actively compensating for its sense of inferiority—usually by arrogance and self-praise. Yet it continues to feel itself in the position of an upstart and is still afraid that it won't be treated with sufficient respect. Along with this goes a suspicion that the success was accidental and unearned anyhow, and one has to discover virtues in oneself that prove the opposite and quiet the suspicion. Certainly chauvinism has nothing to do with self-confidence or a truly "positive attitude" toward one's group. German nationalism became widely chauvinist only after the Franco-Prussian War, and the Germans still had—and have—one of the deepest inferiority com-

48

plexes of any territorially unified people. It is not for nothing that Goethe, Thomas Mann, and others have seen similarities between the inner attitudes of Germans and Jews.

However real or unreal these similarities may be, some of the parallels that have appeared between Jewish and German nationalism—especially the post-1918 variety of the latter—cannot at all be written off as "literature." This, no matter how painful I, as a Jew, find any resemblance between German nationalism and things Jewish: which is all the more reason why Jewish chauvinism is distressing to contemplate. Nor is the possibility of these parallels decreased by the fact that there are many similarities in the pattern of the rise itself of the two nationalisms. Like the German, Jewish nationalism was born of a history of humiliation and defeat, and required a sharp blow or succession of blows in order to be awakened to action: the pogroms of czarist Russia and the growth of secular and doctrinaire anti-Semitism were for us what subjection to Napoleon was to the Germans. The decisive shock, without which Jewish nationalism might still have remained the province largely of East European Jewish intellectuals, was Hitler's destruction of six millions of us, which has been the equivalent (and much, much more) of what the 1918 defeat was for the Germans. However, the victory in Palestine did for us *after* our disaster what their defeat of France in 1870 had done for the Germans *before* their disaster: it gave us a first taste of real success, of success won on our own. And it is only since then, apparently, that Jewish chauvinism has become a serious possibility.

Are we to fold our hands and resign ourselves to Jewish chauvinism with the excuse that the same historical factors that produced chauvinism in other peoples cannot be prevented from doing so in Jews and that we might as well bow our heads to necessity? The necessity is not pleasant, especially when we see how much like German chauvinism the Jewish variety can be. Is not Jewish identity, as a mere fact, being made a primary virtue, as the Germans made their Germanness one? Is not a "Jewishness" defined almost entirely in terms of group loyalty and group conformity, and whose only content is its function as differentiation, being elevated as the supreme criterion by which everything and every Jew is to be

judged? Worst of all, have not some of use become too quick to hate and too intemperate in our abuse of fellow Jews who disagree with us?

Chauvinism has had a fairly long history by now, long enough to make us all familiar with its practical liabilities as well as its purely aesthetic uglinesses. And one might expect that, in spite of the historical factors that encourage it among us, we Jews might have become immunized to it by all the suffering it has caused us at the hands of other people. But even if this expectation is bound to be disappointed since human beings are what they are, surely a people as literate and rational as we should not at this late date be deceived by our own chauvinism. We should be able to recognize that it no more denies a collective inferiority complex in our case than it has in that of other peoples.[2]

Actually, chauvinism—which in America means Jewish separatism—intensifies self-hatred by concealing and dissembling it, by sinking it into depths of the psyche where it becomes all the more malignant because out of sight. Remaining invisible, retreating at most, but not disappearing, self-hatred prompts us to go to ever greater lengths to convince ourselves that we have extirpated it—to strut and posture and boast. We become too prone to violent words if not violent deeds. Yet we succeed no better than before in coming to terms with ourselves, and only exchange one expression of self-hatred for another, a more indirect and deceptive one.

III

But I do not wish to argue that the self-hatred which the "positive" Jew hides is exactly the same as that which the "negative," furtive Jew reveals. The "positive" Jew and his spiritual ancestors do, after all, embody the Jewish group consciousness more than do most other Jews. The "positive" Jew

2. "Among Negro—and Jewish—school children, it has been found, those who recognize their minority status most clearly are also those who feel most ashamed of the low status of their group; in them 'group pride' and 'self-hatred' seem inextricably mixed."—From a review by Miriam Reimann of Arnold Rose's book *The Negro's Morale: Group Identification and Protest* that appeared in the October *Commentary*. [Author's note]

has accepted the burden as well as the rewards involved in that. He fights as best he knows how for Jewish self-respect, and whatever he wins redounds to the benefit of all other Jews. I am aware, moreover, of all that in Jewish history would justify an excessive nationalism on our part. The attitude of the non-Jewish world—the chief cause of our self-hatred— provides a strong practical as well as psychological argument for the uses of a Jewish national selfishness. Those of us who are sick of Europe after Auschwitz and want to have nothing more to do with Gentiles have a right for the moment to indulge our feelings, if only to recover from the trauma. But humanity in general is still the highest value and not all Gentiles are anti-Semitic. Self-pity turned a good many Germans into swine, and it can do the same to others, regardless of how much their self-pity is justified. No matter how necessary it may be to indulge our feelings about Auschwitz, we can do so only temporarily and privately; we certainly cannot let them determine Jewish policy either in Israel or outside it.

Like the spokesmen of national consciousness everywhere, most nationalist Jews want above all else power for their people, or at least the show of power. And who can say that they are not justified? Power is essential at least insofar as it means being able to take more of our fate into our own hands instead of suffering it as passive objects. Yet the nationalist tends to accept too implicitly the decisions rendered by power.

It is precisely because of his sensitivity to questions of power that the self-hatred of the nationalist Jew has been greatly aggravated by the scale and mode in which Hitler slaughtered us. The nationalist Jew wants more *from*, as well as for, his people in the way of self-reliance and force, and feels humiliated by the ease with which the Nazis were able to kill most of our six millions. And he cannot help fearing, whatever his reason may tell him, that the scale and, even more, the mode of that slaughter were somehow a judgment upon us. Unlike the "negative" Jew, however, who may fear the same thing, he does not flee the whole question and try to wipe it from his mind by pretending that he is not like other Jews and so does not have to regard the fate of the six millions as in any way a judgment on himself. He remains identified and he remains with his fear and shame, to struggle with them as best

he can. The trouble is that he, of all Jews, is the one least equipped to think through the problem.

It is, of course, more than time that we all began to make a real effort to digest the fact of Auschwitz psychologically, if only to eliminate a source of self-hatred that—unlike its other sources—is not deeply rooted in the fabric of the larger American society that surrounds us. But if the "positive" Jews don't want to start the necessary discussion, none of us others seems to want to either. Not only is the mind unable to come to terms with the dimensions of the event and so resolve some of its oppressiveness, and not only does it prefer to remain numbed in order to spare itself the pain; as I have just said, the mind has a tendency, deep down, to look on a calamity of that order as a punishment that must have been deserved. How could it have happened, on that scale and in that way, if it were not? But why deserved? For what? The mind doesn't know, but it fears—fears in an utterly irrational and amoral, if not immoral, way that we were punished for being unable to take the risk of defending ourselves. No moral considerations enter in, as they used to, to relieve our feelings when we were persecuted; we were not punished by God for having transgressed—for no people could have sinned enough against any moral code to draw down such a punishment from any just God. We were punished by history, and, given the extent to which we, and especially the nationalists among us, accept the standards of judgment upon which all the world acts, the recognition that history usually punishes people only for being helpless does not diminish the shame involved. Disaster becomes punishment, and punishment proves that one is inferior because one is not able to avert it. (André Gide says somewhere that the French too tend to feel that their defeat, in 1940, has made them morally guilty.)

The rise of a militant, aggressive Jewish nationalism is in large part an answer to this state of mind. There are, I repeat, other than psychological reasons to justify Jewish militancy in this period, but I think we really feel the psychological ones as more urgent. We have to show the world and ourselves that "Jews can fight." Whether we shall ever succeed in proving this to our own satisfaction I don't know. But to behave like chauvinists and view the matter wholly in terms of physical

aggressiveness won't do it. The main struggle, at least for us in America, still has to be fought inside ourselves. It is there, and only there, that we can convince ourselves that Auschwitz, while it may have been a historical judgment, was not a verdict upon our intrinsic worth as a people. Exactly how we can do this I am not competent to say, but I do know that it has to be done, and that in order to do it we shall have to be much franker with ourselves about self-hatred—and other things—than hitherto.

Jewish militancy has its enlightened as well as its obscurantist side, nevertheless, and I myself am all for applying a measure of militancy here as well as in Israel. Modern anti-Semitism, being what it is, gathers momentum instead of expending itself when it goes unresisted beyond a certain point. I believe that it is best coped with in this country, once that point is reached, by direct personal action on the part of individual Jews, and it would be all to the good if our new Jewish nationalism could move us to take such matters as Joe McWilliams into our own hands instead of calling the policeman. I also believe that this would contribute importantly to the lessening of our self-hatred.

Then it's a question of dealing with anti-Semites by individual force? It is—and more. It is also a question of releasing that pent-up, frightened, and festering aggressiveness which supplies the fuel for rabid nationalism, and shifting the emphasis of militancy from the mass, where it runs the danger of becoming chauvinist and irresponsible, to the individual. Jewishness, insofar as it has to be asserted in a predominantly Gentile world, should be a personal rather than mass manifestation, and more a matter of individual self-reliance. This does not mean overlooking one's responsibility to one's fellow Jews, but it does mean making Jewishness something other than a product of herd warmth and an occasion for that herd conformity out of which arise the ugliest manifestations of nationalism—as we saw in the German case.

As a herd manifestation, nationalism becomes a means of enslaving rather than of liberating the group. The herd elevates mediocrities into positions of power and influence, for only mediocrity can express it to its own satisfaction. The abuse that some "positive" Jews—rabbis, journalists, and oth-

ers—are so ready to turn upon fellow Jews who refuse to make a fetish of their, the "positive" Jews', conception of Jewishness, is, among other things, a symptom of the kind of jealous fear felt by ambitious mediocrity, as it is also a secret self-hatred. Only mediocrities, or people with hidden guilt, react so violently—and often irrelevantly—to criticism and dissent.

The East European background of most of the present leaders and spokesmen of Jewish nationalism is another factor that tends to exaggerate it. They cannot, in their political function, wholly escape the effects of the backward environment in which they grew up. Politics in Eastern and also Central Europe was involved primarily with ethnic issues and therefore encouraged national fanaticism. At the same time the only counterpoise to the disorder of a decaying feudalist society was, and apparently still is, regimentation. The social responsibility that the individual has learned to assume as a matter of course in the West is there inculcated, it would appear, only by mass organizations and factional discipline. I can understand why there are "marching youth" in Israel, and party uniforms, and why loyalty to a political party often competes with loyalty to the state. These stigmata of political backwardness will probably not disappear until Eastern Europe becomes a less vivid memory, the Oriental Jews are successfully absorbed, and Israel herself has enjoyed a security like America's or Britain's or Switzerland's for a generation. But to understand is still not to assent.

Specifically Jewish political activity in this country is open to the same influences, since most of those who are "Jewishly" politically conscious among us come from Eastern Europe, too, or have been formed by fathers and mothers who did. This, however, has not been enough to secure the regimentation of Jewish political life in America because, fortunately, our larger society is advanced and solid enough to overcome transplanted backwardness in less than a generation. We do not have to pick our way through the wreckage and poverty of a dying feudal society; we do not live in ethnic enclaves; here bourgeois enlightenment has become a good deal of an official reality, and we are citizens rather than nationals. And most of us, Jews and Gentiles, are urbanized. This is why so much of what goes as Jewish political and cultural thought in this country—

cultural autonomy on Mordecai M. Kaplan's model and ethnic-plus-religious separatism on Abba Hillel Silver's[3]—is so utterly irrelevant to the lives actually led by American Jews— even more irrelevant than the imported Bolshevism of the 30's, another product of the political backwardness of Eastern Europe, was to the lives of Americans in general. This is why "positive Judaism" and all the other varieties of Jewish nationalism still remain nothing but fuel for oratory and journalism.

IV

What the "positive" Jews have been unable to do so far is show us how the Jewish consciousness and Jewish belongingness they invoke would affect the texture and fiber of our lives as we live them in New York, Detroit, and Dallas. We know from experience how observance to the 613 prescriptions would change them, but the "positive" Jews appear to mean more than that—and less. One can be a rigidly Orthodox Jew and still be as exposed as any other American to the effects of our machine-made culture; one can still rotate from Canasta to the movies, from the radio to the television set, from over-shopping to over-eating, even if there is time out on Saturday. The "positive" Jews want to urge something more on us. I applaud them for the desire but still wish to see them become more relevant and hear phrases that are less empty come from their mouths. They still do not confront our lives honestly and from any other fundamental standpoint than the abstract and basically irrelevant one of institutionalism and politics. Nor, worst of all, do they confront themselves and recognize their own variety of "negative" Jewishness. They still say nothing, therefore, to those other Jews like myself, who make no claim to being "positive" and know that we suffer from insecurity as Jews.

What we might ask of our new Jewish self-consciousness is

3. Rabbi Silver castigates the editors and writers of this magazine (without actually naming it) as "uprooted intellectuals" (*The Day*, July 16, 1950). I should like to remind the Rabbi that the term "uprooted intellectual" has been and is a favorite in the totalitarian (and anti-Semitic) lexicon of abuse, from Mussolini and Hitler to Stalin, and that wherever we hear it we can be sure that we shall also hear demagogy and obscurantism. (And, incidentally, what is it that Rabbi Silver is "rooted" in?) [Author's note]

that it liberate rather than organize us—liberate us from the pressure of that kind of self-consciousness which weakens us as individuals because it makes us define ourselves too much in terms of the group, whether positively or negatively. In so doing we do violence to ourselves as personalities and interfere with that self-realization which I conceive as one of the primary goals of human striving.

The ultra-assimilationist Jew does violence to himself as a human being pure and simple, as well as Jew, because he tries to make himself more typically English, French, or German than any Anglo-Saxon, Gaul, or Teuton ever is. He over-defines himself, in group terms, in the effort to prove he is more English or French than Jewish—which means, really, that he always acts with reference to his Jewishness, even if it is an entirely negative reference. The nationalist Jew, too, always acts with reference to his Jewishness. But even though it is an ostensibly positive reference, by the too greater strenuousness of his effort to assert his Jewishness he likewise over defines himself in group terms. Both the assimilationist and the nationalist leave too little room for their native personalities. While there is no such thing as a human being in general, there is also no such thing as a complete Jew or a complete Englishman.

What I want to be able to do is accept my Jewishness more implicitly, so implicitly that I can use it to realize myself as a human being in my own right, and *as a Jew in my own right*. I want to feel free to be whatever I need to be and delight in being as a personality without being typed or prescribed to as a Jew or, for that matter, as an American. I am both Jew and American naturally, simply because I cannot help being them, having been born and brought up what I am. But I do not want to make any more issue of being a Jew—unless I am forced to by such things as anti-Semitism—than an enlightened Englishman makes of being English. And I want to overcome my self-hatred in order to be more myself, not in order to be a "good Jew." For I don't recognize "good Jews" any more than I do "good Americans," "good Englishmen," or "good Chinese." Nor do I feel that Jews who are "positively," nationalistically, or religiously Jewish are "better" Jews than I. I recognize only Jews who are more self-reliantly Jewish

than myself and therefore more at one with themselves, and braver and more spontaneous.

But what about my responsibility to fellow Jews, I shall be asked—what about the Jewish community and Jewish survival? My relation to the Jewish community should be as much a personal and spontaneous expression of myself as anything else; that is, it should be a natural one and not legislated to me by an ideology—not any more than my relation to the American community is. And my responsibility to fellow Jews is something taken for granted in the first place, and for a variety of reasons that do not have to be gone into here—and which hardly concern the self-hatred I want to get rid of.

As for Jewish survival, all I can say is that if we can survive only by all of us becoming nationalists, then we Jews have lost all justification for persisting as a group. I feel, however, that we shall persist as Jews, no matter how assimilated we become in our customs and manners, as long as Jewishness remains essential to our sense of our individual selves, as long as it is the truth about our individual selves. And we shall have a better chance of surviving "Jewishly" if the truth that is our Jewishness becomes one that we prefer rather than one that is felt as due only to an unfortunate "accident" of birth. Which the "positive" self-hating Jew feels to be just as much an accident as does the "negative" one. . . .

I should like to be more specific and concrete, but I cannot because I do not have the complete answer to self-hatred. The non-Jewish world, as long as it clings to its unfavorable notion of the Jew in general, will always make impossible the entire extirpation of self-hatred in the Diaspora.[4] All I claim is that we can rid ourselves of a good deal of it, despite the world's attitude, by bringing it out into the open, and by becoming aware of what it causes us to do and say. Let us express our discomfort as Jews more directly, without falsifying it by an ineffective sublimation, as the "positive" Jew does, or by a spurious rationality or an equally spurious forgetfulness, as the "negative" Jew does. The sense of Jewish inferiority is there,

4. See in this connection an article by Yehezkel Kaufman, "Anti-Semitic Stereotypes in Zionism," that appeared in English translation in the March 1949 *Commentary*. [Author's note]

but less of it will be there the moment we acknowledge it and begin to realize just how and where we act upon it. And the more we acknowledge it the less, I feel sure, we shall act upon it.

Until then no amount of Jewish education or programs for Jewish cultural endeavor will help very much. These tend to become means rather of evading and hiding the problem. For though they are designed to combat Jewish self-hatred, their sponsors are too afraid of naming it to know where to seek it out. We fool ourselves with fine-sounding phrases. The problem has to be focused directly in the individual Jew and discussed in personal, not communal, terms. For self-hatred is as intimate a thing as love.

Commentary, November 1950

13. Foreword to an Exhibition of Marsden Hartley and Alfred Maurer

The paintings of Marsden Hartley's youth show us how an American painter of the first quarter of this century struggled to educate himself in defiance of provincial limitations of time and place. It is fitting therefore that these pictures should be shown together with Maurer's.[1] Both artists, with their different equipments, set themselves the same task: to absorb European modernism and turn it to the uses of American expression. Neither wanted to be modern for the sake of modernism, but for that of self-realization. Hartley seems to have moved more slowly than Maurer; he was certainly of a narrower gift; but perhaps he anticipated the present mood of American art more clearly than any other American artist of his time by giving his modernism a German and expressionist inflection. These present landscapes have an intensity and are animated by a desire to break through to a fresh and directer reality of pictorial feeling that bring them close somehow to the most recent abstract painting.

I myself value them for their clumsiness and the sincerity of their failures almost as much as for the rightness of their

successes. There are and have been greater painters than Hartley, but few whose *sentiment* I value more. Sentiment is a dangerous term nowadays, but I dare to insist on it as something that means the valuable, very valuable, when referred to an artist as sincere and true as he was.

Hartley, Maurer: Contemporaneous Paintings, Bertha Schaefer Gallery, New York, November–December 1950. (Greenberg's foreword to the exhibition was accompanied by a brief "Homage to A. H. Maurer," written by Hans Hofmann. [Editor's note])

14. The European View of American Art

Anything in art that is surprising enough to be puzzling usually causes discomfort. It depends on the critic's sincerity whether he will suspend judgment and endure the discomfort until he is no longer puzzled. Often, however, he is tempted to ease himself by immediately pronouncing "bad." All that is likely to deter him is the fear, a lively one of late, that he might be making an egregious mistake on the order of those made by the first critics to witness the development of modern art. In Europe, apparently, this fear does not operate in the case of art coming from the United States. It seems to be assumed that since America has not yet produced anything very important in the way of art, there is little likelihood that it ever will.

The reception given by European critics to the American paintings they saw at this year's Biennale in Venice is what provokes these remarks—not, however, the appropriately contemptuous one given to the collection of "Magic Symbolists" or "Realists" sent to London this past summer under the auspices of the indefatigable Lincoln Kirstein; that show was sent with little blessing from this side either. I gather that the treatment our painters got at the hands of European critics was at best condescending, at worst indifferent or impatient. Aline B. Louchheim wrote in the last of her reports on the Biennale, in *The New York Times* of September 10, that "in general, our pavilion has been given not the 'silent treatment' [as claimed

by *Time*] but merely cursory consideration." And she went on to say: "I am inclined to believe that this attitude has little to do with the show itself, but that its explanation lies in two other factors." The first, she says, is the "habit of Europeans to think of Americans as cultural barbarians"; the second, their resentment of their present military and economic dependence upon us.

Sight unseen, I tend to agree with Mrs. Louchheim. Still, this does not prevent me from being taken aback when Douglas Cooper of England dismisses John Marin as "convulsive and somewhat inept" and Jackson Pollock as "merely silly" (I cull these words from Alfred Frankfurter's column in the September *Art News*). Nor was I any less taken aback by the remarks of another British critic, David Sylvester, which *The Nation* published in these pages on September 9. What surprises me, however, in both cases is not the prejudice but the signs of a lack of critical competence.[1]

I have had harsh words of my own to say about contemporary American art, and would still repeat a good many of them. And I do not hold a brief for all the American artists represented at Venice. Hyman Bloom and Lee Gatch are respectable painters, but the one lacks form and the other is thin, while Rico Lebrun strikes me as an out-and-out *pompier* whether he paints abstract or not. It is also possible that the examples of the others were badly chosen. I can see easily how Marin might be found clumsy in his bad pictures, of which he has painted a good many. Yet I feel sure that a few of the Marins at Venice must have been at least good enough to give pause to a competent eye. And the Gorkys, de Koonings, and Pollocks, whether good or bad examples, should have given more than pause, since their originality is larger and more impersonal than Marin's—which is not to say that they are necessarily better painters. I do not think that it is merely patriotism or provincial myopia that makes us take these four

1. David Sylvester responded to Greenberg's charge in the same issue of *The Nation*. He wrote: "Mr. Greenberg's great error is his notion that Pollock, Gorky, and de Kooning represent an exclusively American conception and that this conception is what is most contemporary in art today. I believe that something akin to what they are doing is being done very much better by Hartung and Kermadec." [Editor's note]

artists seriously in this country. We have had the chance to look at them repeatedly and we have compared them with the best of modern painting, of which there are as many examples here as in Britain. When I claim that Gorky, de Kooning, and Pollock have turned out some of the strongest art produced anywhere since 1940, it may be that I am insufficiently acquainted with the latest work done abroad. But it is with the masterpieces of Matisse, Picasso, Klee, and Miró in mind that I say that some of their work warrants a place of major importance in the art of our century.

Mr. Sylvester's remark about "the tradition of ham-fisted, paint-curdling illustration which stems from Albert Pinkham Ryder and Max Weber" makes one wonder whether he ever saw a picture by either artist. If he did, it must have been a very fleeting glance. And the glance he threw at Gorky must have been just as quick, for to connect Gorky, who was second to no painter of our time in sheer finesse, with anything "ham-fisted" and "paint-curdling" reveals a failure, not to appreciate Gorky, but to see him—that is, to make elementary use of one's eyes. There is in all this a negligent haste that forces me to suspect condescension on Mr. Sylvester's part toward things American; which is borne out by the dispatch with which he sums up our national character in a pair of clichés.

Like many other English critics, Mr. Sylvester approves of Alexander Calder among American artists—because he "makes things work"—and thought Rufino Tamayo, the Mexican, the best of all the new painters he saw at the Biennale. These preferences give us an excellent touchstone by which to estimate the taste that tried the Americans in Venice and found them wanting. We have known Calder and Tamayo longer than Europe has. The prompt, easy facility with which Calder handles a vocabulary of shapes taken over wholesale from Miró provides a kind of modern art one is prepared for. There is novelty—even if only mechanical—and an abstractness that seems racy and chic. This is modern the way it looked when it was *modern*, and the old excitement and up-to-dateness seem recaptured. But a longer look reveals the lack of inner necessity and the jejune reliance on tastefulness and little more. Tamayo is in his own way similarly destined for those who want to be let off easy by modern art, but not as easy of course as, say,

Lincoln Kirstein. Up to a point he is a very accomplished painter. His lowering, warm color makes a first impression of strength, there is a Mexican fierceness of imagery, and it all has a high finish; here is discipline, apparently, ordered energy and invention. But this impression disappears when the eye begins to seek unity. All the excellent qualities in Tamayo's painting—the warm, intense color, the sumptuous yet clear surfaces, the neo-archaic, neo-Cubist drawing in the details— are offered separately, as it were, without unity of design, unfused. And finally one begins to perceive that the fierceness is really made to order and that the drawing is too Picassoid anyhow. Still, it is modern painting the way they have got used to it in Europe these past thirty years, and with a certain twist, a new *mise en scène* that protects it at first glance from the reproach of lacking originality. It is exactly what the enlightened critic has been ready to welcome ever since 1940.

The kind of art that Pollock, de Kooning, and Gorky present does not so much break with the Cubist and post-Cubist past as extend it in an unforeseen way, as does all art that embodies a new "vision." Theirs represents, in my opinion, the first genuine and compelled effort to impose Cubist order—the only order possible to ambitious painting in our time—on the experience of the post-Cubist, post-1930 world. The formal essence of their art is penetrated through and through by this effort, which gives their works their individual unity. At Venice they must have looked too new—new beyond freshness, and therefore violent; and I can understand why the Europeans were puzzled, given also that the experience conveyed is American experience, and still a little recalcitrant to art. But I did not anticipate that the critics of the present would be no more humble in the face of the surprising than their predecessors. I now see why Jean Dubuffet, the one new French painter since 1920 with something important to say, receives a cold shoulder in certain "advanced" circles abroad. And why Graham Sutherland gets away with it in England. They are still looking forward to the Picasso of 1928, even if it is only an academicized pastiche of him.

The Nation, 25 November 1950

15. Realism and Beyond: Review of *The History of Modern Painting from Picasso to Surrealism* by Maurice Raynal et al., *Pierre-Auguste Renoir* by Walter Pach, *Vincent van Gogh* by Meyer Schapiro, and *El Greco* by Leo Bronstein

On seeing these art books in which black and white reproductions are supplanted by a profusion of color plates (most of them full-page size) one cannot, in view of past experience, be blamed for skepticism. Especially since the price per copy does not seem excessive for what the blurbs claim is offered. One soon finds the blurbs are not misleading: the color in all four books in indeed superlative by comparison with what we have been accustomed to. It is almost equally surprising that the plates in the three American items are more often than not superior to those in the Skira volume. And the latter is, even for a de luxe European art book, a tremendous effort whose livelier and more appetizing layout and format outdo the stuffier-looking American volumes in respect to sheer appearance.

When we take into account the conditions of American book-manufacturing and the slow, even though steady, progress it has made in the production of art books, the quality of the reproductions in the Abrams series does seem miraculous. All I can find fault with is the selection of the pictures, and even then not too much fault—though I do wish that the same amount of discrimination would by and large govern the practice of art editors as most editors of anthologies of literature.

The emphasis on the texts in both the Skira and Abrams series is another cause of surprise. Knowing the habits of most publishers, one might think that this would have been made an altogether secondary consideration in view of the expense and trouble invested in the illustrations. But not at all. The texts have their own importance. The Abrams Publishers are to be congratulated on their refusal to compel their writers to make too many concessions to the "layman's" ignorance or laziness. Walter Pach approaches Renoir professionally: he himself is at home among artists and their problems and he assumes that the pleasures of painting are so familiar that he

does not have to explain Renoir in terms of anything else. Also, he writes with grace and real feeling.

Meyer Schapiro is less at ease than Mr. Pach, but he digs deeper and comes up with as penetrating an analysis of van Gogh's art and development as I have yet seen. Little escapes his eye, and nothing that he sees is too much for his powers of formulation. Yet he does try to pack too much into every sentence.

The introduction and comments in the El Greco volume are written by Leo Bronstein in a fervid style that could have been edited here and there in the interests of communication; but he has had a real experience of his subject and he tries to convey that to the reader in all its intensity and complexity. The reader will profit from the effort involved in wrestling with his meanings.

The sumptuous Skira book, the final and largest volume in a series of three that describes and explains the development of modern painting from Baudelaire to Miró in both pictures and words, has a copious text supplied by a variety of hands, French and German, and is well translated by Douglas Cooper. A remarkably good job has been done in organizing the material in such a way as to give a clear and orderly exposition of the multifarious tendencies that make modern art since 1900 such a chaotic-seeming spectacle.

To those familiar with the field no particularly new insights or ideas are offered; the treatment is standard, but it is also painstaking and expert within its limits, and supported by an ample amount of historical and biographical fact. This book and its immediate predecessor, along with R. H. Wilenski's book on modern French painting, help fill the need for compendious reference books in English on latter-day painting. Another asset is that it introduces the American reader to works owned abroad that he is not likely to become acquainted with otherwise. The reproductions are perhaps too brilliant; the inking and coating of the pages are so saturating that they may traduce an original whose surface is mat. (Compare the bright Soutine self-portrait in the second Skira volume with its much duller original now being shown at the Museum of Modern Art.) Yet this book is beautiful in its own right.

In any case there is a tendency lately to exaggerate what

reproductions of paintings can do. Until some process is invented that automatically and infallibly duplicates color, any reproduction will remain to some degree a falsification—especially when it is scaled down to fit a book page (the weakest plates in the Abrams series are as a rule precisely those in which the dimensions of the originals have been most reduced). A reproduction never gives you the same aesthetic experience as its original; it can give you more or less information about the nominal appearance of the original and perhaps even a hint of its quality. Yet it is only a hint. And the quality, still to be perceived only in the actual, physical presence of the object, is what makes art art.

This is why André Malraux's notion that the "perfection" of photographic methods of reproduction has created an "imaginary museum," or one "without walls"—so that the riches of world art are at anyone's disposal and do not have to be visited in the flesh any longer—is so fallacious in part. It is true that photographic reproductions inform us as we have never been informed before about works of art in all their diversity of time and place, and that they have been of immense service to the art scholar and historian, and particularly the iconographer; but they have done relatively little for the true art-lover. The more he likes art the less do reproductions satisfy him. If he wants an adequate idea of the glory of Tintoretto he still has to travel to Venice to see him in the flesh. Any picture he sees in reproduction is a *different* picture.

It is true that a reproduction will sometimes improve a picture by reducing it in scale or, by its infidelity of color, imposing a harmony upon it that it does not have in the original. Yet then it is a new picture. Some of the modern paintings in the Skira book benefit greatly by being scaled down, and the same is often true of the pictures represented in other art books. Still, this is inadequate compensation for the absence of the feel of real paint, without which the intrinsic personality of a picture remains inaccessible. Some day, maybe, vastly improved processes of photography and printing may provide a satisfactory illusion of that real presence, but until then reproductions will continue to be sorry substitutes at best.

New York Times Book Review, 3 December 1950

16. T. S. Eliot: The Criticism, The Poetry

To my notion T. S. Eliot is the greatest of all literary critics. This is said with due respect to Aristotle, Coleridge, Arnold, Goethe, Samuel Johnson, Lessing, the best French critics of the nineteenth century, and Ezra Pound. Eliot's merit lies almost equally in his ability to raise the pertinent problems and in the fineness of his taste. He gave himself a rule of cogency early on and has had the strength of mind to obey it without evasion. This is the first critic of whom we can feel sure that the most important question will always be answered—namely, how successful *as art* is the work of art in hand? Eliot is no philosopher of aesthetics or criticism; he is both more and less than that: his critical practice demonstrates the right principles in action, and we recognize them by their fruits rather than their definition. Like the artist, the good critic acts on more than he consciously knows. And he is able to generalize from experience better than from ratiocination.

Eliot has pointed to his own signal virtue in his essay "The Function of Criticism" (1923): " . . . a critic must have a very highly developed sense of fact." He does not define "fact" either in this essay or elsewhere; he closes with the perhaps lame excuse that his only intention for the present was to find "a scheme into which" the facts might be fitted. But his practice renders it clear enough that he means primarily "aesthetic fact," what works of art actually do, not so much what they mean. A very sharp sense of this order of fact makes possible that unfailing loyalty to the relevant which, I repeat, is fundamental to Eliot. (It may be that he owes something here to Roger Fry's and Clive Bell's art criticism. Their ideas about "significant form" were very much in the English air during Eliot's first years in London; and their attempt to isolate the essential factor in the experience of painting antedates anything similar, I believe, in the literary criticism of our day—even though Mallarmé's "abstract" or "pure" poetry antedates abstract art. It should be remembered that Fry took a special interest in Mallarmé's work, and that the very nature of painting and sculpture presents the problem of determining the essence of the aesthetic more urgently to the art than to the literary critic.) If the powers of criticism increase in propor-

tion to its capacity to distinguish fact, then it is understandable why the high age of positivism should have produced the greatest literary critic. The pragmatic, empirical temper of the period 1900–25—common to its best thinking and affecting epistemologists and aesthetes alike—is precisely what helped develop in Eliot that keen eye for fact by which he has been able to discriminate the essential from the non-essential in literary experience. Scientific method is of no application in the forming of aesthetic judgment, but it can guide us in the elimination of all that is extraneous to it. Obeying its spirit, we can become very faithful in differentiating between what actually happens and what is fancied to happen. Such conscientiousness is part of Eliot's greatness as a critic, and he owes it, albeit unconsciously, to the scientific spirit of the age that formed him.

A new and expanded edition of the *Selected Essays* is most welcome, although only some three or four essays dating from between 1932 and 1936 have been added. In his preface the author implies that he has left out, among others, those essays that express opinions he no longer adheres to. It would be interesting to know which opinions. I would hazard that they are mainly the harsher ones—of the Romantic poets, for the largest instance. This may explain why "A Note on Richard Crashaw" is one of the two essays in the volume *For Lancelot Andrews* (1929) to be omitted from the present selection; perhaps Mr. Eliot would no longer be so cavalier toward Shelley's *Skylark* as he is therein. But I am even more intrigued by the omission of the Machiavelli essay, in the same volume, and wonder whether it is because the writer is less confident than in 1929 that he was practically alone in correctly appreciating Machiavelli, or whether he sees more Machiavellianism than before in Machiavelli.

On a rereading of the earlier essays I am struck again by the excellence of Eliot's prose—not so well maintained nowadays—and at the same time by the great amount of personal insecurity that was both concealed and revealed by the tone he established for himself. This was indeed the Anglophile American on his good behavior, handling the English language just a little too carefully and torn between the necessity of pontificating—if only to save words and time—and the

requirements of a decorum not quite natively his. The dilemma is bridged by a manner that conveys a formality not too solemn to be urbane, but also a circumspectness that can become priggish if not stuffy. Mr. Eliot is certainly grave. But he is also sure of his opinions. Behind the skirmishing line of qualifications there comes always the main force, in the form of a lapidary flat statement, to decide the issue. The only ones who can object to the young Eliot's dogmatism are saboteurs, vulgarians, or martinets of logic who hate literature and art as much as he loves them. The man of superior sensibility and intelligence, having discovered new and valid truth in such an atmosphere of obfuscation as was English literary opinion between 1900 and 1930, has to lay down the law.

Whether for good or bad, Eliot can number among his achievements the founding of the first true school of English-speaking literary criticism since the eighteenth century, a body of writers who operate on common assumptions toward common aims and are fairly strict in their definition of both. This school has raised the level of literary study greatly in British and American universities; it has promoted the literary quarterlies, which are a new phenomenon, at least in this country's cultural life, and which until lately have been more beneficial on the whole than otherwise. All this is ultimately Eliot's doing. But by now the losses are beginning to outweigh the gains. For the "new criticism" has become a new academy spawning and sheltering epigones, a haven for mediocrities and a blind alley for those who are not. Everything immediately discernible in Eliot's attitudes, the bad with the good, the accidental with the essential, the idiosyncratic with the viable, the non-literary with the literary, has been converted into a set of rehearsed mannerisms as easy to put on as a suit of clothes—to the infinite detriment of the sensibilities of precisely the best of our young literary people.

It must be said, to the credit of the prophet, that he is not always loyal to his followers. *He* continues to go on living. And from time to time he says things that throw the faithful into confusion. The present crisis of literature in the English language is constituted, on one level, by the fact that no critic as devoted as Eliot is to literature, and to his own experience of it, has appeared to challenge him. It has been left to Eliot

alone to do so. Thus he feels obliged, in the continuing absence of others, to throw into question whatever he finds in his own ideas and opinions that threatens to become an agent to petrifaction, whether in himself or others. As frivolous as he can be in political and social questions, he is a kind of moral hero when it comes to literature, and for this more than anything else I know about him I pay him a homage that is more personal than calling him great.

I feel that Eliot has not been as spontaneous in his poetry as in his criticism. About all his verse—or at least the art in it—I can never help smelling something of the tour de force, the contrived, the set piece: it is the man of letters peeping out of the wings, deliberate, prestidigitating, apart from the poetry—yet always hoping that this one time he won't be apart, that it will come off like the real thing and not a piece of the magician's factitious art. The miracle did happen, much more than once; genuine, perhaps great poetry was produced out of a relatively narrow endowment—he has not half the natural, indefatigable gift for poetry of a Yeats or Auden. The different sections of *The Waste Land* do not, in my opinion, hold together in the sense of composing themselves into a beginning, middle, and resolved ending, but the *disiecta membra* are separately precious. And the fervent *Ash Wednesday*, the beginning and culmination in one of Eliot's later manners, is fused into a whole by an *integrity of feeling* I find unexampled elsewhere in his poetry. There are other poems whose unity is effectively secured by a sheer intensity of the will to art or by the momentum of feelings strong enough to carry contrivances and inadequacies of talent along before them. But *mood*, while it could organize Debussy's music, could not suffice for a Beethoven's. And most of Eliot's best poetry is "mood music." It would seem to me that since the Ariel poems he has strained to prove himself as a "professional" poet with a long breath and one able to project whole experiences rather than mere moods, and in so doing has forced himself out of character as a poet. In his plays, which I find bad, and in the very uneven *Four Quartets* his material tends to shred away between his fingers and his verse to become increasingly eked out with filling—clutter, furniture, stock symbols, arch prose. No better than before does he escape from the artiness that has dogged

most of the best English-speaking poets of his generation. And his rhythms, liable from the first to a kind of neo-Swinburnian musicality, can of late fall into singsong or mere trickiness, while he seems to have lost all capacity to handle rhyme (see the *cantabile* sections of the *Four Quartets*). This is not all there is to Eliot's later poetry, but it certainly does amount to too much of it.

A recent book, *The Art of T. S. Eliot* by Helen Gardner, is focused on the *Four Quartets* and serves admirably as a guide to their understanding. This main interest does not, however, prevent her from saying many acute things about the rest of Eliot's poetical work. She reads closely and well, and extracts no more from a passage of verse than she can honestly vouch for in her own experience. She has that correct instinct of all true lovers of art which restrains them from digging too far in a work in search of explicit meanings, and delights most in significations that art suspends beyond the reach of discourse. But her book is vitiated by what I consider a radical error of judgment: she regards the *Four Quartets* as Eliot's supreme achievement and can find no fault with these poems in any detail or aspect. I may be wrong—I almost hope I am—but after many rereadings I can see no more in the *chief* substance of the *Four Quartets* than an overamplified, overelaborated, and distended inditing of a state of mind that received fresher and more concise expression in *Ash Wednesday*.

For all her awareness Miss Gardner is victim of a fallacy to which Pound, Joyce, Eliot, also, and numerous other practitioners of literary art in our time have succumbed in greater or lesser measure. She seems to hold that the consecutive parts of a literary work can be shown to be adequately joined together if it is demonstrated that they are logically or topically consistent with each other. The justification of the fallacy is usually found in a false analogy with musical form, which progresses by repetition, variation, and extension in accordance with a logic of sounds. But what is indispensable and counts most, in music as well as literature, is inner, emotional, dramatic form: the way in which middle follows beginning, and ending follows middle to form a total experience in time that seizes the reader's or auditor's attention, and with it his emotion, and possesses and controls these until, like the Ancient Mariner, it

is done, having finally satisfied the reader within the terms of the context it first set for itself. If form is this, it can do without most of the rest; by comparison all other aspects of it are mechanical and dispensable, mere means toward this as an end. To fail of this end is to fail conclusively—fail to "come off." Yet critics and poets themselves will argue that a poem, say Pound's *Cantos*, to name an egregious example, has sufficient unity because it repeats the same themes or topics from time to time, or that it has unity because its subject has, or because the subject it started out with is still present at the end. Which is like arguing that Dante's fictive presence in every canto insures the unity of form of the *Divine Comedy*; and which in any case burkes the crucial issue of whether the different parts of the work follow each in such an order that the whole which they create has its proper effect. The kind of form I am pointing to cannot be argued into existence; it is only felt; it is what we mean when we say that a work of art "progresses with inevitability." The later poetry of Yeats shows this at its best; Pound's poetry hardly shows it at all, and his example may have corrupted Eliot in a work like *The Waste Land*; Joyce's failure to appreciate the necessity of indwelling, dramatic form may in the end prove to have spoiled *Finnegans Wake*.

It must be understood that form in this sense can be recognized only emotionally, not intellectually. That is, it is a question decided by taste. Yet it can be discussed. Miss Gardner has taste, but I am not sure she is aware of the issue. Had she been, I feel, her book would have had more point. The notable lack of *Four Quartets*, separately and as a whole, is in my opinion inner form—the right succession of parts; and the scaffolding borrowed from music is—just a scaffolding. It may have been felt by the poet as an aid in the shaping of his poem, as the story of Ulysses helped Joyce shape his novel, but it is not felt by the reader as a determining and necessary element in the poem's final effect. Miss Gardner takes too much for granted that it is.

The Nation, 9 December 1950; A&C (substantially changed).

1951

17. Chaim Soutine

Soutine was until recently on the periphery of our attention here in America—not so much disregarded as overlooked. We had got used to thinking of Miró as the only significant new painter to issue directly from the School of Paris after 1918. When Soutine chanced to come into focus he was viewed with respect, only we did not see enough of him. Lately we began to suspect, when we thought of it, that he might be the greatest of the Expressionists since van Gogh; but we had not seen the right things yet. Two or three pictures and certain parts of other pictures aroused expectations—landscapes and still lifes for the most part, not the more widely known figure pieces. Since I had not been to Merion, outside Philadelphia, to see the hundred or so paintings of his, done mostly before 1923, that are in the Barnes Foundation, the current exhibition at the Museum of Modern Art of seventy-five oils representing all periods of his career gave me my first real opportunity to verify those expectations. They were disappointed.

Made manifest are capacities for a great art that went largely unrealized. Soutine aimed for a maximum of expressive intensity and he asked, perhaps, too much of painting. Certainly he paid too little heed to its inescapable requirement of a minimum of decorative organization, without which even easel-pictures must fail of unity. Rembrandt himself—Soutine's model—could not afford to dispense with that minimum, and when he did, even he suffered for it (though I prefer, in most cases, to attribute whatever he seems to lose to darkening by time rather than to his hand and eye). Having less than Rembrandt in the way of craft and culture with which to redeem its absence, Soutine had all the more reason to take pains with the decorative. That he did not do so until near the end of his life, that he showed a sovereign unconcern with it until then,

72

constitutes the source of my disappointment. And I cannot make responsible for it a bias on my part against all anti-decorative, non-Mediterranean conceptions of pictorial art; what Soutine wanted of painting seems to belong too much to the province of poetry or music, and beyond any "art of space."

The altogether extraordinary force of Soutine's touch, as discerned in every square inch of the paint that covers his canvases, affords some idea of the scale of his capacities. Coarse and yet sensitive at the same time, that touch is always completely felt. He was one of the most painterly painters there ever were, one of those who succeeded best in converting the substance of pigment into signified emotion. Other painters may have contrived more opulent textures; there may be more sap and juice in the paint of a French master; van Gogh's brush marks are more articulate and harmonious; but no one has dealt more intimately or expressively with the tactile properties of oil paint—its consistency, grain, weight—and at the same time used them so exclusively for optical effects. Soutine hardly ever used impasto sculpturally, to enrich the tactile surface; it was there for the sake of color, and of color alone, to make it more intense and concrete. The paint matter is kneaded and mauled, thinned, thickened, and rubbed in order to render it altogether chromatic, retinal.

Still, the sheer quality of pigment is only a part of the art of painting. Herein lies an equivocation—as the French would say—of Soutine's art. Like Chagall and Lipchitz, two other artists who migrated to Paris from Jewish Eastern Europe, Soutine received a tremendous impact from the museum art of the West. The shock was all the more traumatic and lasting because it came when he was already mature. This also held true for Chagall and Lipchitz, but they arrived in France in time to be affected by the first excitement of Cubism and their admiration for the museum remained for a long time something apart. Soutine, arriving a few years later, was largely untouched by Cubism and refused, at least in words, to admire anything but the old masters; at first Tintoretto and El Greco caught his attention, later on Rembrandt and Courbet (see Monroe Wheeler's catalogue for the Museum of Modern Art show). He claimed not to like van Gogh—or, for that matter, any one later—but, as Mr. Wheeler says, "it seems evident

that van Gogh's late Provençal landscapes must have embold-
ened him in his early approach. . . ." I would also say that he
was influenced in his first Parisian canvases by everything that
had happened in advanced French painting between late Im-
pressionism and Cubism, and that by 1919 German Expres-
sionism had contributed its bit too. After all, Soutine was
an avant-garde painter and never anything else. Yet his love
for the museum was more than a question of detached taste.
His dream of the heights of painting saw the declamatory
and grandiose design and subject-handling of the old masters
married to the violent and distorting immediacy of Post-
Impressionist art, Rembrandt's pathos embodied in the in-
stantaneous response and sensation of Expressionism. Only an
outsider and newcomer could think this could be done, only
someone arrogant, and hypnotized by the *pompier*'s notion of
sublimity, yet committed to the directness of modern art, in
spite of himself, by his own instinct for painting. Soutine was
not enough at home in the West adequately to criticize its
tradition of art for his own purposes as a modern painter and
still preserve his admiration for it. He had to be an advanced
painter because he was too good and too dedicated to put up
with the academy, but he broke his neck as an artist because
he persisted nonetheless in striving for an academic ideal of
greatness taken at face value. (Just as he took at face value the
bohemian liberty—demoralizing for a Jew—which seemed to
be unconditionally granted to the artist in the unfeudal West.)
 With all his stress on color as the main spokesman of his
art, Soutine never gave up entirely the traditional, and aca-
demic, reliance on sculptural values of dark and light as the
basic armature. However, self-sufficient color—used as it was
by van Gogh, Matisse, and the Fauves—unmodulated accord-
ing to values and organized by the orchestration of flat, single
hues, is incompatible on terms of equality with a pictorial
structure conceived in darks and lights; one or the other has to
be subordinated or suppressed, as Cézanne found out in the
course of his struggle to indicate volume and depth with Im-
pressionist color. Soutine appears to have begun to recognize
this only toward the end of his life, when it was already too
late. This was the equivocation of his art that was the most
immediate cause of its failure to realize itself as form.

His style developed in a circle, or rather spiral, looping back on itself again and again. At the beginning in Paris, between 1913 and 1919, it was already original and personal. The obvious influences are Cézanne, Matisse, Derain (Mr. Wheeler points to Bonnard too) but a rough, headstrong brush warps the contours and agitates the surfaces in an un-French way; the tonality is generally light-brownish, a trifle muddy, perhaps, because the pigment has been wrestled with so hard. The miraculous touch is already there: in the white folds of the *Reclining Woman* of 1917, one of the most successful and, at first sight, conventionally approached pictures of that phase. A flower piece, *Red Gladioli*, of 1919 is somewhat conventionally arranged too, but the quiet, burning clarity of its color reveals an extraordinary gift for paint. Both works already suggest that Soutine's art would be best integrated when it was generally kept close to academic principles of design; that his design and, with it, the unity of the given work would be most often satisfactorily realized when *consistently* worked out in darks and lights. But only too often he will think simultaneously in terms both of pure color *and* modeling values, and their conflict will disrupt the picture.

In his middle period, which covers roughly the decade of the twenties, Soutine tried most to overpower his medium. He produced a series of landscapes that embody, possibly, the reaction to mountainous country of a man born and brought up on the plains. Towns and hills and trees are piled up on each other topsy-turvy, all of a dark green or brown-dark tan-yellowish cast, with the tones crowded too close together, and too much in general put in. The violence of the will to direct emotion affects the drawing even more than the color, but the distortions are too exclusively and too immediately dictated by feeling and, in evading plastic controls, destroy unity. (The canting and skewing of houses and terrain remind me of German *Jugendstil* illustration as it was practiced, for instance, by Feininger in his youth.) The still lifes of a little later date are more achieved because, again, more conventional—though the reds upon which the painter insists jump out of place almost monotonously. More satisfactory, because quieter and yet just as intense, are the "studies" of dead fowl done in 1925 and 1926; here Soutine remembers the Dutch, Chardin, and

Renoir, to his benefit—though I still ask whether any one of these marvelously painted canvases achieves quite enough unity. Most of the famous figure pieces and portraits date from the twenties too. On the whole I find these ambiguous: the intensity of their feeling evokes a response that, while with a value of its own, is not quite fully an aesthetic one (the same applies at times to the pictures of Beckmann, another Expressionist). They are not great painting, whatever else they may be, and one is left with the feeling of a lack. Of all the earlier portraits shown at the Museum of Modern Art the only one to which I would give my full assent is the *Woman in Red* of 1922.

There are, however, other, later paintings. In the thirties Soutine veered closer to the museum, in practice as well as words. In the light of the rest of contemporary advanced art his painting had never been so downright radical anyhow. He had had a new personal vision, but hardly a new plastic one. Like Rouault's and the German Expressionists'—allowance made for his superior gifts—his attempt to impose a personal vision without compromise upon a more or less conventional scaffolding had produced startling results but had not transformed the scaffolding, only wrecked it. Now he began to compromise with it, and his paintings took on a more conventional appearance as his drawing became less furious and the objects it described more clearly placed in a more outspokenly traditional illusion. It is a gain, in my opinion. Soutine had gone more than halfway in the direction of tradition before—in the famous (and bigger than usual for him) *Carcass of Beef* of 1925, which has a complete and unusual unity but suffers, I feel, from an overripe translucency of surface, due to glazing, that makes it a bit too picturesque. (Chagall too has a weakness for the picturesque, but exploited it better at the same time that he suffered more from it as a factor of superficiality.) Now Soutine raises the compromise with tradition to a higher level. The subject may be addressed more conventionally, its poetry made more obvious and impersonal, but the method of the form becomes subtler, more controlled, more refined, and in exchange for the impact of the distortions we receive the more valuable unity of the whole picture. I thought the finest picture at the Museum of Modern Art the *House at Oisème* of 1934, which, however conventional and indebted to

Courbet in its approach to the subject, comes off as a triumph of closely modulated and powerfully felt paint. The color is narrower in range than before but precisely for that reason of a more clarified force; tones are no longer clotted together at too widely separated points of the value register. The *Plucked Goose* of 1933 is another unified work that might seem conventional at first but which actually possesses great originality of touch and color: it is a picture best seen from close up. Like the *House at Oisème*, it is painted, curiously enough, on a wood panel.

Among other pictures at the Museum of Modern Art that I would single out as complete works of art, in contrast to statements of sheer feeling, are the very rich red *Seated Choir Boy* (1930—and also done on wood), the *Boy in Blue* (1929), several of the smaller and later portraits such as the *Concierge* (1935), and *Woman in Profile* (1937), as well as the following landscapes: *Alley of Trees* (1936), *Windy Day, Auxerre* (1939), *Landscape with Reclining Figure* (1942). There is another landscape, *Return from School after the Storm* (1942), that shows two little girls, indicated as tiny blobs in the first two of the three landscapes just mentioned, hurrying toward the foreground along a path through open fields. I find this picture exceedingly moving, especially in the figure of the little girl on the right, without liking it altogether as art. The contradiction contains *in nuce* the problem raised by most of Soutine's work.

Mr. Wheeler, in his valuable catalogue, writes that Soutine's growing mastery of his craft in the thirties was accompanied by gradual boredom and fatigue; that the most powerful factor in his art having been "his ghastly anxiety lest the power and skill of his brush fail to fulfill the vision in his mind's eye," now "in the increase of facility, his zeal to work diminished; brilliance of style took away some of his incentive." Was it that the approach of full mastery brought home to the artist the recognition that painting, as long as it remained art, could never transcribe one's emotion in all its immediate, "existential," extra-aesthetic truth? Art demands of the artist that he censor or immolate a good part of his feeling for the very sake of art—in the public interest, as it were. Art is ultimately social, its medium social-ness incarnate. Soutine may have felt an unconscious sense of defeat as it dawned upon him that bohemian individualism could not be literally and

completely acted out in art. That to try to do so meant the destruction of the quality of form which is its essence and reality. And that he had bought his "brilliance of style" by renouncing the fullness of his ambition and emotion. Maybe this caused him to despair. I think something similar motivated Rimbaud when he gave up writing.

Partisan Review, January–February 1951; A&C (substantially changed).

18. Letters Concerning J. Alvarez del Vayo's Column in *The Nation*

To the Editor of *The New Leader*:

The letter below was addressed to *The Nation* but refused publication in its correspondence columns by the Editor, Freda Kirchwey. I have been a steady contributor to the *The Nation* over the last eight or nine years, and was its regular art critic between 1943 and 1949. Accordingly, I feel that I have a certain real stake in its welfare. And I also feel that the making public of my letter will be of benefit to the magazine.

My thanks are due *The New Leader* for giving me the hospitality of its pages for the sake of initiating an open and unprejudiced discussion of an issue that should be of concern to all genuine liberals in this country.

<div align="right">

Clement Greenberg
New York, February 21

</div>

To the Editor of *The Nation*:

I find it shocking that any part of your—and our—magazine should consistently act as a vehicle through which the interests of a particular state power are expressed. It makes no difference which state power: the scandal lies in the fact of the commitment, and that *The Nation* should thereby betray its claim to be a journal of independent and principled opinion.

78

The operation of J. Alvarez del Vayo's column along a line which invariably parallels that of Soviet propaganda is something that I protest against as both a reader and a contributor. He presents the point of view of the Soviet Union with a regularity that is quite out of place in a liberal periodical.[1]

Since he began writing in *The Nation* about a decade ago, Mr. del Vayo has defended every step in Soviet policy and, just as unfailingly, criticized or evaded every argument and step opposed to that policy. There are journalists equally consistent in their support of the same or another state power, but they write for organs that more or less declare their editorial adherence to the cause of the power in question; those who read these organs are not invited to do so under false claims. It is not the same in the case of *The Nation*, which takes pride in asserting its independence.

I would not be shocked if Mr. del Vayo appeared to be just a sympathizer of Soviet policy; but the evidence furnished by his own words would show that his column has become a medium through which arguments remarkably like those which the Stalin regime itself advances are transmitted in a more plausible form to the American public. Disingenuously, and with an abundance of circumlocution and a show of openmindedness designed to render those arguments more persuasive, he has managed to give the Soviet Union the right at every point in its differences with the Western powers. To be sure, Mr. del Vayo says, Russia is not always blameless, yet somehow he always calls upon the West to take the first step—and make the first concession—to assure peace. Thus, in the 85th anniversary issue of *The Nation*, that of December 16, Mr. del Vayo, not pausing to write a general survey piece as most of the other contributors do, hurries out the issue of Germany,

1. Greenberg's charges against J. Alvarez del Vayo and *The Nation* in the pages of *The New Leader* provoked legal action. On 31 March *The Nation* announced that it had initiated a libel suit against Greenberg and *The New Leader* for the publication of statements that were "false, defamatory and scurrilous." The suit was eventually settled out of court, but not before the matter was widely aired. For contemporary commentary, see *The New Leader* (2 April 1951), *Time* (2 April 1951), *Newsweek* (2 April 1951), *Partisan Review* (May–June 1951), and *The Nation* (2 June and 7 July 1951). [Editor's note]

that prize which is the most immediate goal of Russian longing. After two thousand words or so of speciously objective review and analysis, he produces a solution straight out of the Soviet Foreign Ministry: unify Germany politically—for a divided Germany is a greater menace to Moscow that a unified one, and a quartered one an even greater! Yet Mr. del Vayo is well aware of why the West is afraid to permit the unification of Germany at this time; so well aware that, apparently, he cannot take the chance of even mentioning the fact that the West *is* afraid.

An instance of how closely Mr. del Vayo's views at any given moment correspond with those of the Soviet publicists was given several months ago (the date can be verified by your files) when he warned of the dire economic consequences to this country of a prolongation of the cold war, adding that Russia was better able to stand up to the economic strain because of the lower living standard of its population (he used, characteristically, a much more indirect expression than "low standard of living," as if afraid that such a blunt phrase might offend someone). A few days later (the date can be verified by consulting the files of *The New York Times*) the Soviet press stated the same warning in about the same terms—though apparently, according to the *Times* story, it left out any mention of standards of living. Curiously enough, Mr. del Vayo, as well as the Soviet press, appears to have dropped this tactic of persuasion immediately afterwards.

Another instance—and I select it not because it is an extreme one but because it is typical and recent—is of Mr. del Vayo's column of December 9th. There he implies that the United States' refusal to recognize the Communist regime in China and admit it to the United Nations brought about the present crisis in Korea, as if this were sufficient excuse for a state to throw its armies into battle. Nor should we mistake Mao's "revolutionary ardor" for "primitive violence," or "ignore the sources in revolutionary tradition" of Chinese "defiance," as if revolution justified everything. Though he refers constantly to the injustice of withholding Formosa from the Peiping regime, Mr. del Vayo has not once considered the American side of the case, which, in the context of two powers jockeying for position under the threat of war, has certainly a

great deal more moral warrant than the invasion of South Korea by the North Koreans, for which he has not yet had any words of condemnation. He seldom allows that our government has its justified fears and suspicions of Russia, though he is ever ready to point out how much reason we give the latter for being suspicious of us—with the insinuation, repeated time and again, that the allaying of that suspicion is the chief task of world diplomacy.

In the same column he complains that Sir Gladwyn Jebb's speech in the United Nations pledging Britain's support of American policy in Asia "compounded the confusion by appearing to deny the differences of opinion among the United States, Britain, and France upon which the hope of compromise had been built." The "compromise" would have been largely in the Chinese Communists' favor, and Sir Gladwyn's speech was an attempt to heal the possible split in the common front of the Western states upon which the U.S.S.R. at present places its main hope of having its own way cheaply. The "confusion," that is, was Soviet Russia's, not the UN's.

Some time ago, in another column, Mr. del Vayo referred to the Socialist "feud" against the U.S.S.R. In view of how the Communist parties abroad behave, and have behaved, toward the Socialists, and of what the Soviet government did to Polish Socialists Erlich and Alter, and in view moreover of what is now happening to Socialists in Eastern Europe, this is like talking of the Jewish feud against Hitler.

I could multiply such instances of special and specious pleading on behalf of the U.S.S.R. by *The Nation's* foreign editor, but I would have to go far beyond the limits of a letter. I do not want to be misunderstood, however; I am not concerned here to discuss where the right lies in the differences between East and West. I abhor the Stalin regime and cannot see why one is obligated to consider both sides of the question any more in its case than in Hitler's, but still I do not protest here and now against the fact that it is Soviet Russia's cause in particular that Mr. del Vayo upholds. I protest simply against the fact that *The Nation* permits its columns to be used for the consistent expression of any point of view indistinguishable from that of a given state power. *The Nation* has the right to side with the Stalin regime when it holds itself compelled to

by principle (though it does it so often that that constitutes another, if lesser, scandal), but not to put its pages at the regular disposal of one whose words consistently echo the interests of that regime; nor has it the right to make that person its foreign editor.

<div style="text-align: right">Clement Greenberg
New York, February 7</div>

The New Leader, 19 March 1951

19. Cézanne and the Unity of Modern Art

The number and discord of the tendencies that constitute modern art are taken for a symptom of decadence. The species as it declines proliferates in gratuitous mutations. There is a bit of truth in this impression but it derives mainly from the fact that since de Chirico academicism has been able to regain credit in new, avant-garde versions of itself like Surrealism, Neue Sachlichkeit, Neo-Romanticism, Magic Realism—even Social Realism. When these manifestations are put aside—consigned to the outer darkness of academicism in general, where they really belong—the scene becomes more orderly. Yet not completely so: four or five different tendencies still seem to move in conflict within genuinely contemporary painting and sculpture. The reason for their discord, far from having to do with decadence, lies, however, in the very vitality of modern art.

The apostles of the modern movement, from Manet on, did not, contrary to advanced opinion—which often gallops through the history of art faster than art itself—always finish what they began. The Impressionists and Post-Impressionists, Rodin, even Turner, Redon, Monticelli, even Courbet and Daumier, left behind many loose threads the tying up of which has provided later artists with tasks whose performance asks more than unadventurous repetition. Bonnard and Vuillard did not merely imitate or execute variations on Impressionism: by extending, they completed it. There was enough left over from what Rodin had planted to ripen anew in Maillol,

Lehmbruck, Despiau, Kolbe, Lachaise, and others. Matisse did more than add to Gauguin's beginnings: he fulfilled all in the older master that had been premature, clarifying and enlarging his new vision, and rendering it less self-conscious. In their several and smaller ways Derain, Vlaminck, and Segonzac filled in what Cézanne, Manet, and Courbet had outlined, while the Expressionists have not yet finished defining those things that van Gogh adumbrated; nor have they exhausted all the hints to be found in Cézanne's early manner.

That so much of the advanced painting of the first third of this century is a knitting up of threads spun in the latter half of the nineteenth century explains its diversity as different from eclecticism; its multifarious tendencies have too common a root and supplement each other too well. These are the different directions in which insights released by one and the same revolution deploy to establish a new order, not anarchy. Their variety radiates from a common center and is the product of purposeful energy, not of dissipation. The future will see this better than we. . . .

Cézanne, as is generally enough recognized, is the most copious source of what we know as modern art, the most abundant generator of ideas and the most enduring in newness. The modernity of his art, its very stylishness—more than a retroactive effect—continues. There remains something indescribably racy and sudden—racier than Dufy, as sudden as Picasso or Matisse—in the way his crisp blue line separates the contour of an apple from its mass. Yet how distrustful he was of bravura, speed—all the attributes that go with stylishness. And how unsure down at bottom about where he was going.

On the verge of middle age Cézanne had the crucial revelation of his artist's mission; yet what he thought was revealed was in good part inconsistent with the means he was already developing under the impact of the revelation. The problematic quality of his art—the source, perhaps, of its unfading modernity—and of which he himself was aware, came from the ultimate necessity of revising his intentions under the pressure of a style that evolved as if in opposition to his conscious aims. He was making the first—and last—pondered effort to save the intrinsic principle of the Western tradition of painting: its concern with an ample and literal rendition of the

illusion of the third dimension. He had noted the Impressionists' inadvertent silting up of pictorial depth. And it is because he tried so hard to re-excavate that depth without abandoning Impressionist color, and because his attempt, while vain, was so profoundly conceived, that his work became the discovery and turning point it did. Completing Manet's involuntary break with Renaissance tradition, he fell upon a new principle of painting that carried further into the future. Like Manet and with almost as little appetite as he for the role of revolutionary, he changed the course of art out of the very effort to return it by new paths to its old ways.

Cézanne would seem to have accepted his notion of pictorial unity, of the realized, final effect of the picture, from the old masters. When he said that he wished to re-do Poussin after nature and "make Impressionism something solid and durable like the old masters," he meant apparently that he wanted a cómposition and design like that of the High Renaissance painters to be imposed on the "raw" chromatic material supplied by the Impressionist notation of visual experience. The parts, the atom units, were to be done as much as possible by the Impressionist method, held to be truer to nature, but put together into a whole according to traditional principles. The Impressionists, as consistent in their logic as they knew how to be, had permitted nature to dictate the unity of the picture along with its parts, refusing in theory to interfere consciously with their optical impressions. For all that, their pictures did not lack structure, as is so often claimed; in so far as any one of them was successful it achieved an appropriate and satisfying unity, as must any successful work of art. (The overestimation by Roger Fry and others of Cézanne's success in doing exactly what he said he wanted to do is responsible for the cant about Impressionist "formlessness," which is a contradiction in terms. How could Impressionism have eventuated in great painting, as it did, if it had been "formless?") What Cézanne wanted was a different, more emphatic, and supposedly more "permanent" kind of unity, more tangible in its articulation. Committed though he was to the motif in nature in all its givenness, he still felt that it could not of its own accord provide a sufficient basis of pictorial unity; that had to be read into it by a combination of thought and feeling—thought

that was not a matter of extra-pictorial rules, but of consistency, and feeling that was not a matter of sentiment, but of sensation.

The old masters assumed that the joints and members of a picture's composition should be as apprehensible as those of architecture; the eye was led through a rhythmically organized system of concavities and convexities, with manifold gradations of value simulating depth and volume marshaled around salient points of interest. To accommodate the weightless, flattened shapes produced by the divided tones of Impressionism to such schemes was obviously unfeasible.[1] Cézanne had to fill in his forms more solidly in order to be plausible in that direction. He set out to convert the Impressionist method of registering purely optical variations of color into a method by which to indicate variations of depth and planar direction *through*, rather than for the sake of, variations of color. Nature still came first, and indispensable to nature was the direct, light-suffused color of Impressionism; gradations of dark and light and the controlled studio illumination of the old masters were unnatural—regardless of all the masterpieces that had been produced with their aid.

Recording with a separate dab of paint almost every perceptible—or inferred—shift of direction by which the presented surface of an object defines the shape of the volume it encloses, he began in his late thirties to cover his canvases with a mosaic of brushstrokes whose net effect was to call attention to the physical picture plane just as much as the tighter-woven touches of the orthodox Impressionists did. The distortions of Cézanne's drawing, provoked by the extremely literal exactness of his vision as well as by a growing compulsion, more or less unconscious, to adjust the representation in depth to the two-dimensional surface pattern, contributed further to his inad-

1. Seurat too wanted a design in depth that would be tighter and more explicitly intelligible than that of the Impressionists. But his *magnum opus, La Grande Jatte,* which is now in the Art Institute of Chicago, fails because the stepped-back, rigidly demarcated planes upon which he set his figures serve only to give them the character—as Sir Kenneth Clark points out—of pasteboard silhouettes. Seurat's pointillist, hyper-Impressionist method of filling in color could not convey a semblance of volume within any illusion of deep space. [Author's note]

vertent emphasis on the flat plane. Whether he wanted it or not—and one can't be sure he did—the resulting ambiguity was a triumph of art, if not of naturalism. A new and powerful kind of pictorial tension was set up such as had not been seen in the West since the mosaic murals of fourth and fifth century Rome. The little overlapping rectangles of paint, laid on with no attempt to fuse their dividing edges, drew the depicted forms toward the surface while, at the same time, the modeling and contouring of these forms, as achieved by the paint dabs, pulled them back again into illusionist depth. The result was a never-ending vibration from front to back and back to front. The old masters had generally sought to avoid effects like this by blending their brushstrokes and covering the surface with glazes to create a neutral, translucent texture through which the illusion could glow with the least acknowledgment of the medium—*ars est artem celare*. This is not to say, however, that they paid no heed at all to surface pattern; they did. But given their different aim, they put a different, less obvious yet less ambiguous emphasis upon it. Cézanne, in spite of himself, was trying to give the picture surface its due as a physical entity. The old masters had conceived of it more abstractly.

He was one of the most intelligent painters about painting whose observations have been recorded. (That he could be rather intelligent about other things too has been obscured by his eccentricity and the profound and self-protective irony with which he tried, in the latter part of his life, to make himself a conformist in matters separate from art.) But intelligence does not guarantee a precise awareness on the artist's part of what he is doing or really wants to do. Cézanne overestimated the power of a conception to control, or deposit itself in, works of art. Consciously, it was the most exact reproduction of his sensations in the presence of nature that he was after, ordered more or less according to classical precepts of design. This, he seemed to feel, would assure to the individual work a unity, and therefore a power, analogous to nature's own. The power would be made permanent by human thought as felt through the design and composition. Loyalty to his sensations meant for him transcribing the distance from his eye of every part of the motif, down to the smallest facet-

plane into which he could analyze it. It also meant disregarding the texture, the smoothness and roughness, hardness and softness, the tactile feel of objects, and seeing color exclusively as a determinant of spatial position—just as the orthodox Impressionists saw it exclusively as a determinant of light. But Cézanne's actual view of nature—with its habit of bringing the background and distant objects closer than the ordinary eye saw them—could no more be fitted into the spacious architectural schemes of the old masters than could that of the Impressionists. The old masters did not sniff every inch of space and fix it exactly; they elided and glided, stopping to be definite only at those places to which they designedly pointed the spectator's eye; in between they painted for realistic effect, but not for the optical or spatial substance of reality. That was left for the nineteenth century, for painters most of whom Cézanne scorned. But he was even further from the old masters in his means than they: his registration of what he saw was too dense, not in detail but in feeling; his pictures were too compact and the individual picture too even in its compactness, since every sensation produced by the motif was equally important once its "human interest" was excluded. As often happens when the rectangle is tightly filled, the weight of the painting was pushed forward, with its masses and hollows squeezed together and threatening to fuse into a single form whose shape coincided with that of the canvas itself. Cézanne's desire to give Impressionism a solid aspect was thus shifted in its fulfillment from the structure of the pictorial illusion to the configuration of the picture as an object—as a flat surface. He got the solidity he was after, but it became in large part a two-dimensional solidity. It could hardly have been otherwise in any case once he abandoned modeling in darks and lights— even though his perception of cool tones such as green and blue in receding planes preserved something of the essence of that kind of modeling. This too was a factor in the play of tensions.

The real problem would seem to have been, not how to re-do Poussin according to nature, but how to relate more carefully than he had every part of the illusion in depth to a surface pattern endowed with equally valid aesthetic rights. The firmer binding of the three-dimensional illusion to a deco-

rative surface effect, the integration of plasticity and decoration—that was the true object of Cézanne's quest. And it was here that his expressed theory contradicted his practice most. As far as I know, not once in his recorded remarks does he show any concern with the decorative factor except—and his words here are perhaps the more revelatory because they are offhand—to refer to two of his favorites, Rubens and Veronese, as "the decorative masters."

No wonder he complained to the day of his death of his inability to "realize." The aesthetic effect toward which his means urged was not that which his mind had conceived out of the desire for the organized maximum of an illusion of solidity and depth. Every brushstroke that followed a fictive plane into fictive depth harked back by reason of its abiding, unequivocal character as a mark made by a brush, to the physical fact of the medium; the shape and placing of that mark recalled the shape and position of the flat rectangle that was the original canvas, now covered with pigments that came from tubes or pots. Cézanne made no bones about the tangibility of the medium: there it was in all its grossness of matter. He said, "One has to be a painter through the qualities themselves of painting, one has to use coarse materials."

For a long while he over-packed his canvases as he groped his way, afraid to betray his sensations by omission, afraid to be inexact because incomplete. Many—though by no means all—of his reputed masterpieces of the 1870's and 1880's I find too redundant, too cramped, lacking in unity because lacking in modulation. There is feeling in the parts, in the magnificent execution, but too little of feeling that precipitates itself as an instantaneous whole. In the last ten or fifteen years of his life, however, pictures whose power is complete as well as striking and original come from his easel more frequently. Practice, the means, fulfills itself. The illusion of depth is constructed with the surface plane more vividly in mind; the surface does not override the illusion but it does control it. The facet-planes jump forward from the images they define, to become more conspicuously elements of the abstract surface pattern; distinct and more summarily applied, the dabs of paint stand out in Cubist fashion, dilating and their edges trembling. The artist seems to relax his demand for exactness of hue in passing from one form to the next, and he no longer clots his dabs and facet-

planes so close together. More air and light circulate through the imagined space. As Cézanne digs deeper behind his shapes with ultramarine, instead of fixing their contours more firmly in place in the illusion, he makes them oscillate, and the backward and forward movement within the picture spreads and at the same time becomes more majestic in its rhythm because more unified and all-enveloping. Monumentality is no longer secured at the price of a dry airlessness. The paint itself becomes more succulent and luminous as it is applied with a larger brush and more oil. The image exists in an atmosphere made intenser because more exclusively pictorial, the result of a heightened tension between the illusion and the independent abstractness of the formal facts. This tension, is the emblem both of an originality and a mastery. It is present in all successful art, but it is particularly, uniquely, perhaps more immediately, there in the works of Cézanne's old age.

Had Cézanne died in 1890 he would still be enormous, but more so in innovation than realization. That fullest, triumphant unity which crowns the painter's work, which arrives when the ends are tightly locked to the means, when all parts fall into place and require and create one another so that they flow inexorably into a whole, when one can, as it were, experience the picture like a single sound made by many voices and instruments that reverberates without changing, that presents an enclosed and instantaneous yet infinite variety—this unity comes for him far more often in the last years of his life. Then, certainly, his art does something other than what he said he wanted it to. Though he may think just as much about its problems, he thinks much less into its execution. Having attracted young admirers who listen respectfully, he expands a little, has his remarks taken down, and writes letters about his "method." But if he did not confuse Bernard, Gasquet, and the others of that time, he confuses us now. However, I prefer to think with Erle Loran[2] that he himself was confused and contradictory in theorizing about his art. It is as difficult in

2. I am indebted to his book, *Cézanne's Composition* (University of California Press, 1943), for more than a few insights into the master's art. As far as I know, Professor Loran is the first to point to the essential importance of Cézanne's drawing and line—the fundamentals of surface pattern—and to argue against the too exclusive attention paid to his color modeling. [Author's note]

art as it is in politics for a revolutionary to realize the meaning of what he has done. And didn't Cézanne complain that Emile Bernard, with his appetite for theories, forced him to theorize unduly? (Bernard in his turn criticized Cézanne for painting too much by theory.)

Down to the last day of his life Cézanne continued to harp on the necessity of modeling, and of completeness and exactness in reporting his sensations of space. He stated his ideal as a marriage between *trompe-l'oeil* and the laws of the medium, and lamented his failure to achieve this even as his painting, under his hand, went further and further in the opposite direction. In the same month in which he died he complained still of his inability to "realize." Actually one is more surprised, in view of how remote the qualities of his last pictures are from his expressed intentions, to hear him say, as he did, that he had made "a little progress." He condemned Gauguin and van Gogh for painting flatly: "I have never wanted and will never accept the lack of modeling or gradation: it's an absurdity. Gauguin was not a painter; he only made Chinese pictures." And he was indifferent, as Bernard reports, to the primitives of the Renaissance; they too, apparently, were too flat for his taste. Yet the path—of which he said he himself was the primitive, and by following which he thought to rescue Western tradition's pledge to the three-dimensional from both Impressionist haze and Gauguinesque decoration—led straight, in an interval of only five or six years after his death, to a kind of painting as flat as any the West had seen since the Middle Ages.

Picasso's and Braque's Cubism, and Léger's, completed what Cézanne had begun, by their successes divesting his means of whatever had remained problematical about them and finding them their most appropriate ends. These means they took from Cézanne practically ready-made, and they were able to adapt them to their own purposes after only a relatively few trial exercises. Because he had exhausted so little of his own insights, he could offer the Cubists all the resources of a new discovery without requiring that much effort be spent in the process itself of discovery. This was the Cubists' luck, and it helps explain why Picasso and Braque were able, in the four or five years between 1909 and 1914, to turn out a well-nigh

uninterrupted succession of "realizations," classical in the sufficiency of their strength, the unerring adjustment of means to ends, and the largeness, ease, and sureness of their unity.

Cézanne's sincerity and steadfastness are exemplary. Great painting, he says in effect, ought to be produced the way Rubens, Velasquez, Veronese, and Delacroix did, but my sensations and capacities don't correspond to theirs, and I feel and paint only the way I must. And so he went at it for forty years, day in and out, with his clean, careful *métier*, dipping his brush in turpentine between each stroke to wash it, and then carefully depositing its load of paint in its determined place. As far as I know, no novels have been made of his life since his death, but it was more heroic as an artist's than Gauguin's or van Gogh's, notwithstanding its material ease. Think of the effort of abstraction and of eyesight that was necessary in order to analyze every part of every motif into its smallest calculable plane. And then there were the crises of confidence that overtook him almost every other day (he was also a forerunner in his paranoia). Yet he did not go altogether crazy; he stuck it out at his own sedentary pace, rewarded for his premature old age, his diabetes, his lack of recognition by the public, and the crabbed emptiness of what seems to have been his existence away from his art, by absorption in the activity itself of painting—even if, in his own eyes, it was without final success. He considered himself a weakling, "a Bohemian," frightened by the routine difficulties of life, but he had a temperament, and he sought out the most redoubtable challenges the art of his time could offer.

Partisan Review, May–June 1951; *The New Partisan Reader 1945–1953*, ed. William Phillips and Philip Rahv, 1953; A&C (substantially changed); *Readings in Art History*, ed. Harold Spencer, 1967.

20. Review of *Gustave Courbet* by Gerstle Mack

Courbet is one of the lodestars of the great French tradition, but it is doubtful whether he has received his full due. Painters

like de Chirico, Soutine and Picasso have sworn by him and his name has begun to shine more brightly in the last three decades, but justice is not yet done. Whether the intrinsic qualities of Courbet's art are responsible, or the report of his person and actions, is hard to say. The very robustness of his art and the great unevenness that went with it, have, I am sure, something to do with the case; "materialism," we are told, is incompatible with aesthetic satisfaction. And his fatuous and enormous egoism, his political pretensions, his loudness, corpulence and unrefined sensuality do not fit the usual notion of an artistic personality. Add to this the practice, in the last years of his life, of having other people paint his pictures for him, and we begin to have some explanation of the prejudice that has blinded many to the sublime as well as corporeal merits of Courbet's painting.

He can stand comparison with any of the numerous masters of his century. As a painter and nothing else, he was no cruder or narrower than Delacroix, who was able to present himself as less so largely because of superior personal culture and not by virtue of a more sensitive or sophisticated brush. Actually, Delacroix—and Ingres too—share with Courbet a certain bad taste or gaucheness that is as characteristic of the middle of the French nineteenth century as its declamatory notion of art, and evidences of which can be found in Baudelaire as well as Hugo. Courbet's virtue came in part from the spontaneity with which he accepted and capitalized upon this common quality; hence his strength and solidity, his big-figure compositions and his landscapes; hence, also, his defects, his ridiculous and well-painted nudes, his massive and beautifully executed flower pieces that are like pieces of furniture.

Gerstle Mack's biography of Courbet, following those he did of Cézanne and Toulouse-Lautrec, may be one of the signs of the re-evaluation now under way. Yet it does not do much more than make the facts available to English-speaking readers. As is the rule nowadays among those who write lives of artists, Mack is interested in his subject more as the figure of an artist in a certain time than as an artist working at his art. The remarks on Courbet's painting that he conscientiously and regularly puts in show only a second-hand acquaintance with the problems of painting as such. Nor does he compen-

sate for this by giving more than an external view of Courbet's personality, which was full of contradictions.

A comparison of Mack's book, or of any of the current run of artists' biographies, with such literary biographies as those, say, published in the American Men of Letters series would indicate what I mean: the latter are done by "professionals" who accept the challenge offered by their subjects and try to understand and appreciate them as both writers and personalities on an appropriate level. Mack's level is not appropriate to his subject in so far as it does not lift Courbet or his art above the obvious facts.

He does, at any rate, give us those facts, clearly and coherently. Courbet was born in 1819 in the Franche-Comté, near the Swiss border. His father was a modest but fairly well-off landowner, who tried to make a lawyer of his son. However, after three years of college Courbet had his own way and at the age of 21 went off to Paris on an allowance, to devote himself to painting. Though mostly self-taught, he was able to make a name for himself in only four or five years, painting more or less in the footsteps of Corot and Delacroix.

After 1848, when he reached his maturity and his full originality as a "Realist," his art became an object of controversy and its "social message" upset some people, but it was never so unconventional in form as to alienate the public or cost him representation in the official salons of the Second Empire. He was perhaps the last great painter able to move forward without seeming to break the continuity of tradition. He painted with an accuracy, ease and rapidity that amazed his contemporaries and turned out an abundance of work, though at the same time he drank, talked and ate a lot and had a succession of love affairs.

Eighteen Forty-eight, especially the crushing of the June insurrection in Paris, jarred him into an awareness of politics, and he became an absolute and simple-minded adherent of Proudhon's socialism. Politics as a reality, however, did not enter his life until 1871, when on the morrow of the French defeat he was elected a delegate to the Commune and served as an active and intelligent member of its committee on public education. Being a convinced pacifist, he took no part in the fighting or terror, but after the overthrow of the Commune

93

the Versailles Government imprisoned him for seven months. Then, in 1873, the reactionary MacMahon Government moved to force him to pay the full costs of the reconstruction of the Vendôme Column—though he had not been directly responsible for its demolition—and he fled to Switzerland for fear he would be put back in prison.

Courbet had begun to deteriorate physically while in jail. Now he began to do so morally as well. Exile speeded the decline of this amiable but frequently silly man; he became an outright alcoholic, on wine instead of his habitual beer, and relied more and more on his "apprentices" to get his work done, confining himself for the most part to a few final touches in each picture and the signing of his name. Still trying to save his property in France from confiscation, and harassed at a distance by a demented sister and her unscrupulous husband, Courbet finally died, much too young, on the last day of 1877 at the age of 58. Forty-two years later, on the hundredth anniversary of his birth, his coffin was dug up and reinterred in his native Ornans

The New York Times Book Review, 25 November 1951

21. Review of *The Social History of Art* by Arnold Hauser

Most of the talk about the relations between art and society has been by people more competent—when they are that at all—to discuss the latter than the former. This does not apply to the author of the present momentous work, which surveys the social conditions under which literature and art were produced in the Near East and Europe from Paleolithic times to the present. Arnold Hauser's sensitivity and interest in art in its own right are such that he achieves not only a social history but an improved history of art.

The social matrix is probed in order to elucidate the aesthetic facts, and these are neither reduced to merely social facts nor wrenched to make sociological points. Society contains and throws light on art, receiving light in return, but this reciprocity does not completely explain either art or society. That

94

Mr. Hauser observes this limitation without succumbing to it, that he remains both an art critic and sociologist, is one of the important reasons why he makes such an authentic as well as large contribution.

Precisely because he respects the manifoldness of his vast subject, rides no theses and tries not to simplify in order to synopsize, it is very hard to sum that contribution up in the space of a review. Suffice it to say that the author shows the social conditions under which art has been produced and consumed, and how these have determined its form as well as content. He points to the fluctuating social status of the artist (and writer) and his varying relations with his audience or public. He shows how art has reflected social interests and, more important, social moods, and how infinitely complex this process of reflection has been. What matters, however, is not so much that art illuminates society as that social factors help explain aesthetic aims. The way Mr. Hauser orders his multifarious material in constant relation to this emphasis is perhaps the most original, and even fruitful, aspect of his contribution.

His analysis of the development of society is unequivocally Marxist—appropriately so, because no other *available* method can extract equally plausible meanings from the seeming contradictoriness of social evolution, especially in its relation to art. Mr. Hauser's Marxism is too "orthodox," in the Bolshevik sense, for my taste and his interpretation of social history as such follows the standard lines closely, leading him often to glib equations, but it rarely interferes with his view of art, since he does not extend his Marxism to aesthetic questions proper.

There is no genuine Marxist aesthetics, and never was. It is only a spurious and vulgar Marxism that presumes to assess works of art, according to their "progressive" sentiment or the correctness with which they mirror the social conflicts of the place and time in which they were produced. Mr. Hauser knows better, obviously, and it is unfortunate that he uses such cant terms of Marxism as "progressive" and "dialectic" in a way that may lay him open to misunderstanding.

Mr. Hauser, who was born in Hungary and educated in Germany, Austria and France, assumes that the reader pos-

sesses a modicum of philosophical culture. Though the reader may balk at the quick-fire succession of abstract concepts, the author does not take excessive liberties. His use of abstractions enables him to avoid the trouble of laboring facts that should be familiar to any educated person. This is the language of adventurous thought in our time, and Mr. Hauser's is an adventurous enterprise. Yet it does not make for good writing; there is a tendency to pile up words in the effort to reveal every aspect of a topic that may lead to a pertinent characterization. This is excusable, even necessary, but Mr. Hauser might have taken more care to avoid unnecessary repetition and recapitulation, especially in the first part of the second volume. His mind races, and a racing mind often doubles on its tracks.

The relatively small amount of detailed information we have about social circumstances before the Renaissance and the slowness with which history seems to have moved before then, compel Mr. Hauser himself to move fast through much of his first volume, which takes him to the close of the seventeenth century.

One does wish, however, he had spent more time on Dante, since the very form of the latter's "epic" presents something of a sociological problem. And similarly with Milton, whose name is not even mentioned. Nor is there any reference to Velasquez or Goya, though their role is crucial in the development of Western painting, and the problem of accounting for the circumstances in Spain that fostered such a brilliant naturalism would seem to be one of the most challenging in a social history of art.

Perhaps I am being captious. One of the best sections in the first volume is that on Mannerism, in which the author writes art history pure and simple, with only incidental attention to social facts. His definition of Mannerism, which (following but amplifying upon his old teacher, Max Dvorák) he extends to cover Shakespeare and Cervantes, throws sudden new light on an old and familiar landscape. Here, as almost everywhere else in this book, it does not matter whether we agree or not; what counts is that we are provoked to infinite thought. New perspectives are opened, settled opinions disturbed—this, if nothing else, would make the book important.

With the French Revolution the author reaches his full stride. Thenceforth the abundance of historical knowledge, the

greater explicitness of social questions, and the increased differentiation of social relations provide him with material for an unending succession of insights, revelations and constructions. True, one finds more to take issue with, but what we read is always cogent and never deviates from a level high enough to do justice to the difficult complexity of the subject. In principle Mr. Hauser understands nineteenth-century culture as a whole as well as anyone ever has.

Much that he says appears obvious on second thought, but only because he himself has made it so. For instance: ". . . in Dickens' day, as in our own, there are two groups of people interested in belles-lettres. The only difference between that age and our own is that the popular light literature of that time still embraced the works of a writer like Dickens and that there were still many people who were able to enjoy both kinds of literature, whereas today good literature is fundamentally unpopular and popular literature is unbearable to people of taste." Or: ". . . since the advent of romanticism all cheerfulness seems to have a superficial, frivolous character."

In my opinion Mr. Hauser does not feel, or think through, the high art of the present century—which he calls the "Age of Film"—nearly so well. Without a sufficient perspective of time, his method and his sensitivity function much more unevenly; and he surrenders to the impression, as superficial as it is widespread, of disintegration, eclecticism and chaos. Mistaking, say, Picasso's rather personal desperation since the late Twenties for the attempt to find a new point of departure for the art of painting, he does not distinguish between what is truly representative, because enduring, in contemporary painting—as Impressionism was seventy years ago—and what is momentarily representative, as Pre-Raphaelitism was in its time. Yet with all that, some of the most illuminating insights of the whole book are expressed in its last chapter.

Its final paragraph states the plight of contemporary art more succinctly than I have seen done elsewhere:

> The problem is not to confine art to the present-day horizon of the broad masses, but to extend the horizon of the masses as much as possible. . . . Not the violent simplification of art, but the training of the capacity for aesthetic judgment is the means by which the constant monopolizing of art by a small minority can be prevented. Here too, as in the whole

field of cultural policy, the great difficulty is that every arbitrary interruption of the development [of art] evades the real problem, that is, creates a situation in which the problem does not arise, and therefore merely postpones the task of finding a solution. There is today hardly any practicable way leading to a primitive and yet valuable art. Genuine, progressive, creative art can only mean a complicated art today. It will never be possible for everyone to enjoy and appreciate it in equal measure, but the share of the broader masses in it can be increased and deepened. The preconditions for a slackening of the cultural monopoly are above all economic and social.

The New York Times Book Review, 23 December 1951

1952

22. "Feeling Is All"

We cannot be too often reminded how decisive honesty is in art.[1] It will not guarantee success—the artist has to have something to be honest with and about—but it is not entirely separate from the procedure of talent. Honesty and talent elicit each other. Without talent honesty is left incomplete, as can be seen from the example of the naive or "primitive" painter, which is not altogether attributable to lack of culture. Integral and honest talent makes the artist aware of what he omits, and makes him signify it. Without honesty talent is, of course, left in a void. But the honest artist is not pure in heart—or if he is, he bores us, as even Rousseau le douanier has lately begun to do. The truth is too full to be pure.

Matisse's early work, as seen in his large retrospective exhibition at the Museum of Modern Art, offers a lesson in all this.[2] Like any young artist, he worked at first in manners acquired from others, and appears to have proceeded slowly, but just as much because he was afraid to traduce his feelings as because of lack of confidence. He did not want to be original, he wanted to be true. The only reason for striving for independence was that other painters' styles required that he feel altogether the way they had, which he did not. He went on doubting himself, unwilling or unable to be facile, for ten, fifteen years after he had begun painting. He was plagued by hesitations long after he had broken with the Impressionist canon of the well-made picture and had gone into quite un-

1. "Feeling Is All" was reprinted in *Art and Culture* under the generic title "*Partisan Review* 'Art Chronicle', 1952." [Editor's note]
2. *Henri Matisse*, Museum of Modern Art, New York, November 1951–January 1952. The exhibition was organized by Alfred H. Barr, Jr., and accompanied by Barr's book, *Matisse: His Art and His Public*. [Editor's note]

known territory—and the hesitations were open, not dissembled like those of Picasso.

The Museum of Modern Art's Matisse show is not as large as the one at the Philadelphia Museum in 1948, but though duplicating a good deal of the latter, as it must, it strikes one as better chosen. It has the benefit, moreover, of several of the series of brilliant interiors painted late in 1947 and early in 1948, which are Matisse's strongest work since the twenties. In addition, it contains some of his recent designs for the decoration and objects in a Dominican chapel in Vence, in the south of France; and, even more important, presents us with the largest amount of his sculpture this country has yet had the chance to see in one place. Regrettably, however, his landscapes are still scanted, though they represent one of the most luminous sides of his art.

The New York show confirms what one had begun to recognize at Philadelphia: that Matisse had not relaxed so much during the twenties after all, even though he did go back to Chardin, Manet, the Impressionist still-life of the 1870's, and a firm modeling of the figure. He may have turned off the highway leading to abstract art and ceased from spectacular adventuring, but it was not altogether the *détente* one used to think. He began to paint with a new subtlety and, as he extended and consolidated his command of the traditional methods of painting, tradition itself received new light from the subtlety. He, the great exponent of pure color as the means to form, showed what could still be achieved by modeling with dark and light, and how this modeling could contribute to the tightness desired of modern composition—just as, in the years between 1914 and 1918, he had demonstrated how black and gray could approximate the effect of flat primary colors.

There is a habit of referring to Matisse as a decorator. The irony is that pure decoration is the area in which he has failed oftenest. His paper cut-outs, his ventures into applied art, and most of what I have seen of his tapestry designs, book decorations, and even murals seem to me the feeblest of the things he has done. He is an easel painter from first to last; this is obscured—if it really is—only by the unprecedented success of his efforts to assimilate decoration to the purposes of the easel picture without at the same time weakening the integrity

of the latter. True, something like decorativeness seemed to have an adulterating effect on his art during the 1930's and a large part of the 1940's, but it was, in a manner of speaking, an accident. Matisse was flattening and generalizing his motifs for the sake of a more abstract, "purer," and supposedly more soothing effect. Cheerfulness in pictures is always a little decorative anyhow, if it is at all sensuous. But the results were not happy as art, though certainly amounting to much more than decoration.

How little a decorator Matisse is by instinct is borne out by his sculpture. That it has real quality is not news, but the consistency and range of that quality are. How to explain how the artist who did perhaps more than anyone else since Gauguin to exclude sculptural effect from painting should be a great sculptor too—and a modeler at that, not a constructor? The answer cannot be attempted here, and in any case the originality of Matisse's sculpture, aside from its debt to Rodin, requires much fuller discussion. One would also have to explain why painters in the nineteenth century began to turn their hands to sculpture again after three hundred years during which they seemed to have left it strictly alone. And why, since then, they have so often been better at it than any but the most exceptional of professional sculptors. Also, whether there is a reason other than mechanical convenience why they model but never carve. A remarkable exhibition of sculpture by painters, from Géricault to the present, at Curt Valentin's (formerly Buchholz's), gave immediate warrant for these questions.

Recent work by the German sculptor, Gerhard Marcks, also at Curt Valentin's, offered another lesson in the rewards of probity. Marcks's thorough craft competence matters less than his tenacity in insisting on the truth of his feeling—a wonderful and profound tenacity. In stylistic terms he follows where Rodin, Maillol, Lehmbruck, and Kolbe have led, and archaicizes a little, as countless sculptors do nowadays, the inspiration in his case being late medieval German carving (though himself mostly a modeler). Thus he is not a revolutionary phenomenon like Brancusi. But the value of art that is explicit and authentic in feeling, even if "backward" in style, becomes increasingly evident of late, in the face of the "modernistic"

trickiness of someone like Henry Moore. "Plastic" novelty has to be felt all the way through, or not attempted at all. Actually, I found the earliest and more straighforwardly naturalistic piece in Marcks's show, the bronze nude *Brigitta* of 1935, to be the most satisfying among at least seven or eight superb pieces. Marcks is over sixty, but his art came to New York like a new dispensation. (Most of what was shown dates from 1943, the Nazis having melted down many of his previous bronzes.)

Marcks goes wrong only when he attempts humor, perhaps because he then becomes overly aware of his own feeling. Truth of feeling in art is in great measure an effect of detachment, but the detachment cannot be too conscious. Falsity begins with feeling about feeling. What Marcks, however, like his fellow-German sculptor, the late Lehmbruck, demonstrates to our time is that it is not necessary always to make this selfless detachment quite as explicit as Matisse does; and that the obviousness of emotion in German Expressionism is not as much a liability as we used to think. Nor is the danger of sentimentality as great as it used to be—at least not when compared to that of slickness and trickiness. It might be well for a change to invoke some "Nordic depth" against the flashiness of artists like Marini and the Giacometti of the second phase, or the all-American, streamlined quaintness of a Ben Shahn.

Tautness of feeling, not "depth," characterizes what is strongest in post-Cubist art. The taking up of slack, the flattening out of convexities and concavities—the ambitious contemporary artist presents, supposedly, only that which he can vouch for with complete certainty; he does not necessarily exclude, but he distrusts more and more of his emotions. This makes art much more of a strain, and I believe it accounts in part for the fatigue from which Picasso and Braque and even Matisse have suffered since middle age (though, of course, it is not just a question of fatigue).

A tautness that cannot be sustained affects the painting of Hans Hofmann, though it is far from being tired. I can discern little consecutive development in his art during the eight years since he began showing in New York; themes appear, disappear, and re-appear, without seeming to evolve. . . . Hofmann

is a unique force. Coming here from Germany—and Paris—in middle age, he has as a direct and indirect teacher done more than anyone else to make Matisse's indispensable contribution viable in American painting. He is over seventy, but very much part of a movement most of whose members are under forty-five. As a paint-handler pure and simple, he takes second place to no one alive, not even Matisse, for he can do some things with pigment that the French master cannot. Yet it would be hard to find an artist who has had, and still has, more trouble realizing himself. His latest show, at Kootz's, precisely because it is the most successful since his first two, in 1943 and 1944, makes this all the clearer, for what is achieved only reveals how great the unachieved potentialities are. The man who could paint the plaster-white *Ecstasy* of last year and the off-red *Scotch and Burgundy* of this, has it in him to add infinite riches to modern art. But he appears to be unable to break through to those riches—that is, the truth inside himself—except in convulsive moments. He makes a method of convulsiveness, and, of course, it does not work as a method. I think Hofmann over-rates art as against pedestrian reality, has an unduly exalted notion of art, and is therefore too reverential in his relation to it. Humility is owed to the truth inside and outside oneself, but not exactly reverence; one has to have the nerve to impose one's truth on art. If the right to that nerve has to be earned, Hans Hofmann has certainly done so by now.

The first two one-man shows of Barnett Newman, last year and the year before, at Betty Parsons', exhibited both nerve and truth. I mention him at this relatively late date because he has met rejection from a quarter where one had the most right to expect a puzzled judgment to be a suspended one. Newman is a very important and original artist. And he has little to do with Mondrian, even if his pictures do consist of only one or two (sometimes more) rectilinear and parallel bands of color against a flat field. The emphasis falls just as much on the color as the pattern, and the impression is much warmer and more painterly than anything to be gotten from Mondrian or his school. The color itself is broad and easy, sensuous without softness, in a way that is unusual in contemporary abstract painting. People have been bewildered by this

art, but there is no question of shock value; Newman simply aimed at and attained the maximum of his truth within the tacit and evolving limits of our Western tradition of painting. Some of his paintings come off, some don't; one can tell the difference. They may not be easel pictures, or murals in any accepted sense, but what do difficulties of category matter? These paintings have an effect that makes one know immediately that he is in the presence of art. They constitute, moreover, the first kind of painting I have seen that accommodates itself stylistically to the demand of modern interior architecture for flat, clear surfaces and strictly parallel divisions. Mondrian aims more at external walls, and at the townscape that replaces the landscape wherever men collect together. Newman—paradoxically, since he is even less of an easel painter than Mondrian—aims at the room, at private rather than public life.

Newman took a chance and has suffered for it in terms of recognition. Those who so vehemently resent him should be given pause, however, by the very fact that they do. A work of art can make you angry only if it threatens your habits of taste; but if it tries only to take you in, and you recognize that, you react with contempt, not with anger. That a majority of the New York "avant-garde" gave Newman's first show the reception it did throws suspicion on them—and says nothing about the intrinsic value of his art.

Another important new painter is Franz Kline, who has just had his second show at Egan's. He at least got a better reception from his fellow-artists than Newman did, even if the official and collecting art world is still wary of him (and it would speak little for him if it were not). Kline's large canvases, with their blurtings of black calligraphy on white and gray grounds, are tautness quintessential. He has stripped his art in order to make sure of it—not so much for the public as for himself. He presents only the salient points of his emotion. Three or four of the pictures in his two shows already serve to place him securely in the foreground of contemporary abstract painting, but one has the feeling that this gifted and accomplished artist still suppresses too much of his power. Perhaps, on the other hand, that is exactly the feeling one should have.

Jackson Pollock's problem is never authenticity, but that of finding his means and bending it as far as possible toward the

literalness of his emotion. Sometimes he overpowers the means but he rarely succumbs to it. His most recent show, at Parsons', reveals a turn but not a sharp change of direction; there is a kind of relaxation, but the outcome is a newer and loftier triumph. All black and white, like Kline's, and on unsized and unprimed canvas, his new pictures hint, as it were, at the innumerable unplayed cards in the artist's hand. And also, perhaps, at the large future still left to easel painting. Some recognizable images appear—figures, heads, and animal forms—and the composition is modulated in a more traditional way, no longer stating itself in one forthright piece. But everything Pollock acquired in the course of his "all-over" period remains there to give the picture a kind of density orthodox easel painting has not known before. This is not an affair of packing and crowding, but of embodiment; every square inch of the canvas receives a maximum of charge at the cost of a minimum of physical means. Now he volatilizes in order to say something different from what he had to say during the four years before, when he strove for corporeality and laid his paint on thick and metallic. What counts, however, is not that he has different things to say in different ways, but that he has a lot to say.

Contrary to the impression of some of his friends, this writer does not take Pollock's art uncritically. I have at times pointed out what I believe are some of its shortcomings—notably, in respect to color. But the weight of the evidence still convinces me—after this last show more than ever—that Pollock is in a class by himself. Others may have greater gifts and maintain a more even level of success, but no one in this period realizes as much as strongly and as truly. He does not give us samples of miraculous handwriting, he gives us achieved and monumental works of art, beyond accomplishedness, facility, or taste. Pictures *Fourteen* and *Twenty-five* in the recent show represent high classical art: not only the identification of form and feeling, but the acceptance and exploitation of the very circumstances of the medium of painting that limit such identification. If Pollock were a Frenchman, I feel sure that there would be no need by now to call attention to my own objectivity in praising him; people would already be calling him *"maître"* and speculating in his pictures. Here in this country the museum directors, the collectors, and the news-

paper critics will go on for a long time—out of fear if not out of incompetence—refusing to believe that we have at last produced the best painter of a whole generation; and they will go on believing everything but their own eyes.

Partisan Review, January–February 1952; A&C (slightly revised).

23. Jackson Pollock's New Style

The references to the human form in Pollock's latest paintings are symptoms of a new phase but not of a reversal of direction. Like some older masters of our time he develops according to a double rhythm in which each beat harks back to the one before the last. Thus anatomical motifs and compositional schemes sketched out in his first and less abstract phase are in this third one clarified and realized.

In Pollock's by now well-known second period, from 1947 to 1950, with its spidery lines spun out over congealed puddles of color, each picture is the result of the fusion, as it were, of dispersed particles of pigment into a more physical as well as aesthetic unity—whence the air-tight and monumental order of his best paintings of that time. In these latest paintings, however, the unity of the canvas is more traditional, therefore more open to imagery. Black, brown, and white forms now move within a thinner atmosphere, and around central points, not thrusting as insistently as before toward the corners to assert the canvas's rectangular shape and block it out as a solid physical object.

Even so, the change is not as great as it might seem. Line and the contrast of dark and light became the essential factors for Pollock in his second phase. Now he has them carry the picture without the aid of color and makes their interplay clearer and more graphic. The more explicit structure of the new work reveals much that was implicit in the preceding phase and should convince any one that this artist is much, much more than a grandiose decorator.

Harper's Bazaar, February 1952; *Macula* 2, 1977 (titled *"Le nouveau style de Jackson Pollock"*).

24. Cross-Breeding of Modern Sculpture

Sculpture's change of direction since Brancusi and since Picasso's first Cubist bas-relief construction is the sharpest, it would seem, in its Western history.[1] The last forty years have given birth to a new tradition with an almost entirely new vocabulary of form. But at the same time the old Gothic-Renaissance tradition of sculpture, after a decline of several centuries, has known a rebirth of its own. And curiously enough, both birth and rebirth have been presided over by the art of painting, which has acted as mother to the one and physician to the other.

The connection of sculpture and painting is closer today than for a long time in the past, but is not entirely new. Painting played a part in the death of the Graeco-Roman tradition of sculpture, when the latter flattened out into pictorial bas-relief, and then disappeared, as it were, into the frescoed or tesselated wall. And then, hundreds of years later, painting imposed certain graphic conceptions of form on Romanesque carving. The Byzantine mosaic flourished in the East and a Classical sophistication lingered on in some manuscript illustration while sculpture still struggled in the West to transcend the function of ornament. Later, the stiff, tubular forms of Romanesque sculpture are scored with lines and covered with colors whose feeling comes from wall decoration or the manuscript picture. The bas-reliefs on the tympanums of many French Romanesque churches look like embossed drawings (especially now that their color has worn off). This is not, of course, the whole story of Romanesque sculpture; far more of it is told in the process by which it wrested itself free from the architectural member, and its somewhat ambiguous success in doing so. But it remains that it evolved to a point under the influence of painting as well as the domination of architecture.

By the Gothic period, sculpture had got ahead of painting in their common progress towards realism, commanded a greater range of effect and a greater variety of mood. By then

1. This article was included in the fiftieth anniversary issue of *Art News*. For the occasion, the periodical commissioned special contributions from Bernard Berenson, Siegfried Giedion, Arnold Hauser, Henry McBride and Herbert Read, as well as Greenberg. [Editor's note]

107

the ambition to achieve the lifelike had become the prime source of aesthetic vitality in the West, and sculpture, now free to stand in the round, was far more skilful and convincing in its imitation of the appearances of life. Architecture had crowded the pictorial artist out of his role as wall-painter and confined him to small format, or to the designing of stained glass, in which capacity he was more exclusively a decorator and less a limner. Besides, the sculptor, as E. H. Gombrich points out, in any case had the initial advantage over the painter in that it demanded less of an effort of abstraction to transpose stereometric reality into a stereometric medium than into a planimetric one. And in Italy the relics of antique bas-relief offered the artist who did not participate in the Gothic movement an example in naturalism not matched, apparently, by what then could be seen of Roman painting or mosaic.

From the thirteenth century on, sculpture shows the way to painting, teaching it how to shade for roundness and depth, how to pose and group the human figure. Leon Battista Alberti, in his influential *Treatise on Painting* (1463), says ". . . I would rather have you copy an indifferent sculpture than an excellent painting. Because from paintings you will gain nothing further than ability to copy accurately, but from statues you can learn both to copy accurately and represent light and shade." And there was the practice among painters, then and later, of making little models in plaster or clay not only to paint from, but to manipulate in solving problems of arrangement and composition. This shows how much easier the painter found it to visualize in sculptural terms, and his readiness to accept sculpture as a substitute for nature.

Despite the sumptuous tradition of miniature painting behind it, Flemish and north French painting at the beginning of the fifteenth century is stamped large with the influence of Gothic sculpture. Jean Fouquet's Antwerp *Virgin and Child*, for example, is said by D. Talbot Rice to have "a distinctly sculpturesque feeling, and may be aptly compared with work on some of the great cathedrals a century or more earlier in date." But the influence of sculpture also begins to act as a check on painting's evolution towards a realism proper to itself. The wonder of Jan van Eyck is how he could so suddenly break so far away from sculptural realism in the direction of the painterly realism we see in his *St. Francis Receiving the Stig-*

mata at Philadelphia. The artists who come after him in the Flemish fifteenth century, like Rogier van der Weyden, do not attempt such a vividness of pictorial illusion and stay closer to Gothic sculpture, as the Italians of the quattrocento continue to strive after the effect of the antique. It takes painting another century to achieve anything like the fresh, plausible and composed realism that was already to be seen in the mid-thirteenth-century sculptures of Bamberg and Naumburg cathedrals in Germany. (In the meantime sculpture itself became far more pictorial as well as minute in its naturalism, out of its own resources, not by imitating painting—of which there was none more realistic than itself to take lessons from anyhow.) Only by the end of the fifteenth century does painting free itself from the bas-relief—as sculpture before it had freed itself from architecture—and really rival sculpture in naturalism. When its color begins to breathe and its edges to dissolve, then painting becomes altogether itself (although, as I cannot insist enough, this does not mean necessarily that it becomes better as art).

By the time of Michelangelo's maturity it had already gone ahead of sculpture, as his own example shows more clearly than anything else. Michelangelo, for all his gift for carving and commitment to it, actually realized himself better in painting. Wyndham Lewis wrote lately: "How Michelangelo's titanic dreams are betrayed when they emerge in marble! What a sadly different thing the Sistine *Adam* would be in white marble. The Greek naturalism, in some way, was neutralized in the flat. To affect to prefer Michelangelo's sculpture to his other forms of expression, including poetry, is the result of the literary approach." However, what frustrates Michelangelo's sculpture is not its naturalism but, on the contrary, its exaggerations of modeling, which are more pictorial than plastic and therefore of greater truth and point in the illusionistic medium of painting than in the much more literal one of sculpture. His efforts to realize his aspirations in stone violated its nature. True, he may have done some violence to the nature of painting, too, and perhaps the Sistine ceiling comes off mostly as *tour-de-force*—justifying El Greco's comment that it was marvelous but not really painting—but it is the most astounding and successful *tour-de-force* in Western art.

How sculpture declined and languished under the domina-

tion of painting, or rather of drawing, after Michelangelo's time is indicated by the universal and superstitious reverence for his own work as a sculptor. There were good or even great sculptors during the next three hundred years, but they had to cope with an audience whose taste was more informed as regards painting. Yet when sculpture, in the nineteenth century, began to show a new vitality it was precisely under the tutelage of painting—or better, under the direct intervention of painters themselves, and of painterly painters at that, not quasi-sculptural ones like David or Ingres. From Géricault to Matisse and even Picasso, the general level of the occasional sculpture of painters seems much higher than that of any but the most exceptional professional sculptors. One of the reasons for this may be, paradoxically, that the painterly touch benefited sculpture more at that point in its development than the Neo-Classical and draftsman's ideal of a hard, translucent nudity. The sculptors were too fascinated by Raphael's and Correggio's drawing, and in their devotion to outlines, shadows and silhouettes neglected mass and volume.

In a sense the sculpture of the painters culminated in Rodin, who has been reproached for vitiating sculptural form in his pursuit of Impressionistic effects. There may be a little justice in this, but it misses a larger point, which is that Rodin became loose and spontaneous as no sculptor had been for a long time before him. Barye and Bourdelle, for all their excellences, remain a little constricted. Perhaps Rodin was no great master of style in the way that the sculptors of Fifth Dynasty Egypt, Phidias, and the Gothic stone-carvers were, but he was a very great artist nevertheless. He made stone and bronze vibrate once again, restored variety to traditional sculpture and gave tradition itself a fresh impulse by which it is still moved today.

Traditional sculpture at the beginning of this century benefited by more than the example of a great artist. Avant-garde painting and poetry had generated the notion of a maximum of "aesthetic purity" that could be achieved by working as closely as possible within the essential and intrinsic limits of the medium concerned; a stricter and more radical separation of the various arts was aimed at than Lessing could ever have dreamed of. One of the ultimate results of this new and largely

unspoken aim was abstract art, but meanwhile traditional sculptors learned a new respect for the monolith, the first and last premise of the medium of carving. Maillol, Despiau, Lehmbruck, Kolbe, then Marcks and others—all of them indebted at the same time to painting for a certain approach to proportion and shape—carved and modeled now with an eye to simplified, abiding, compact form that would call back to mind the original block of stone or lump of clay. Brancusi drove this canon to an ultimate conclusion, and suddenly arrived back at architecture—and painting. Or almost. It was, at any rate, a new kind of painting whose attraction sculpture now felt, a painting infused with sculptural elements out of barbaric and exotic traditions and leading, under the more fundamental influence of Cézanne's painting, toward that sublime and supremely coherent style we call Cubism.

A few years later, shortly after 1910, painting knew its most spectacular triumph over sculpture by delivering out of itself an almost entirely new convention and tradition of sculpture. There sprang up a novel kind of art with practically no antecedents in previous sculpture (unless we include the wood carving of the Northern New Irelanders in the South Seas). It was called Constructivism at first, and drew in air with line, plane and color to create cage- or machine-like structures not solid bodies. It did not shape or form solid matter so much as manipulate space—organize and render significant its emptiness. It had emerged directly from Cubist painting, when Picasso first let the bas-relief construction rise above the physical surface of the collage. Painting had felt the urge as far back as van Gogh, even Cézanne, perhaps Renoir, too, to take over some of the powers and attributes of sculpture; now it did that by becoming sculpture itself. W. R. Valentiner has said that sculpture has the tendency in the course of time to evolve from the architectural towards the pictorial; the curious feature of the new, "open" sculpture, however, is that its means and forms, as pictorial as they are, tend to converge toward architecture, in its modern, functional manner, more than towards anything else. And yet this is all painting's doing.

For the time being the new and the old traditions of sculpture exist side by side. But the former gains constantly in energy, while the latter's seems to be slowly ebbing away, with

too few younger artists appearing to take up where the old guard of forty years ago is now leaving off. The Italian archaicizers—Marini, Manzù and Fazzini—have talent, especially the latter two, but it is all they can do to produce work that transcends superficiality and fashion; and whether Europe has other younger sculptors in the traditional line capable of doing more than they is not clear. On the other hand, what the new tradition has so far produced cannot be compared on the whole for value with the art Maillol, Lehmbruck, Brancusi and the others have created, and perhaps—as in Gerhard Marcks' case—are still creating. Yet to venture such a comparison may be unfair, since many of the representatives of the new tradition, especially in this country, where that tradition seems by now to have struck firmer root than elsewhere, still have their effective futures before them.

Some of our American constructor-sculptors, the more gifted as well as the less, flounder in their new medium, at a loss for guiding examples, go off down blind alleys, or commit horrible errors of taste—particularly now that the tide has turned for the moment away from geometrical forms toward plant and animal ones. Infatuation with their new-found liberties often leads to an attempt to force complications of line, texture and color that no kind of sculpture could admit or accommodate. A few make a virtue of these excesses, find impulses to invention in them, and then in interludes of purification realize beautifully. I think in this connection of David Smith, possibly the most powerful yet subtle sculptor (subtler, really, than Flannagan) this country has yet produced, certainly the best since Gaston Lachaise. And in a different direction there are the combinations of abstract sculpture and painting of the Austrian-born architect Frederick Kiesler, who personifies the recent stylistic union of painting, sculpture and architecture in an exemplary way. He, in particular, has given us only a sample of all he has to say.

At present sculpture is on the point of turning the tables on painting with respect to fertility of ideas and range of possible subject matter. But the new sculptor still remains a little too timid in the face of the other art, too passive, and still too ready to accept any and all of its suggestions. This is excusable when we remember for how long a time and until how re-

cently, painting did lead the way, and how much more interest and excitement could be found in almost any painting than in almost any piece of sculpture contemporaneous with it. But it is time we became conscious of the changed relation between the two arts, and that the new sculptor himself acquired more confidence in the independent power of his medium.

He is not, alas, entitled to equal confidence of its acceptance by society. The modern architects exclude sculpture from their buildings even more than they do painting, so that the new sculpture remains more or less a homeless art, unsuited as it is to the ordinary domestic interior. As has been said often, the fate of figurative art in our time hangs ultimately on its physical and social reunion with architecture. Romanseque sculpture began as an accessory of architecture, took its style and value from it, and prospered thereby. The new sculpture began and grew entirely outside architecture, and gives to it more than it receives, perhaps, in the way of style. This may be one of the reasons why the modern architect resents or feels indifferent to its presence, just as he does to that of painting, to which he owes even more stylistically. I believe this is one of the serious aesthetic misdeeds of our time. With all the talk, right or wrong, about the "inhumanity" of a strict functionalism, one would think that the modern architect could cope more effectively with the complaint by calling in sculpture as well as painting, instead of plaguing himself with the task of complicating what is rightly simple.

Art News, Summer 1952; A&C (substantially changed).

25. Cézanne: Gateway to Contemporary Painting

Modern painting is franker in color, as a rule, than the work of the Old Masters. It is also flatter, that is, it shows us much less of an illusion of three-dimensional space. This, and not fantasy or wildness of imagination, is the fundamental factor in its refusal to copy nature as we ordinarily see it.

The Old Masters saw objects sculpturally more or less, as standing free in space. The moderns, when they address them-

selves at all to recognizable objects, see them as interwoven with or emerging from the flat physical surface of the picture—in something of the same way as in Oriental, medieval, and primitive painting.

As a general practice, painters from the late fifteenth to the middle of the nineteenth century covered their canvases and panels with a greater proportion of dark or shaded than of light or bright color. This was so even when the picture seemed to make a predominantly bright impression (which was often due to the high translucency of the color). And they almost always avoided sharp contrasts in passing from one color area to the next; they graded and softened transitions, as they also did all large areas of a single color. This was done to make the color effect harmonious; but just as much, and even more, to prevent any part of the picture from looking too utterly flat and thus breaking the illusion of deep space by reminding us that the picture actually did have an utterly flat physical surface.

Edouard Manet (1832–1883) was the first painter in our tradition to flatten foreground and middleground objects systematically, and bring the background forward to lock their outlines in by sharp color contrasts. This worked to suppress the illusion of free space inside the picture. Furthermore, he occasionally gave light, crude color the upper hand over dark and shaded tones, and even when he let black and gray predominate, as he liked to do, they acted as flat, independent colors rather than as shadow, shading, or gradation. Because Manet's pictures looked so flat by contrast with anything preceding, he was accused by his contemporaries in French of painting "playing cards."

The Impressionists—Claude Monet (1840–1926), Pierre-Auguste Renoir (1841–1919), Camille Pissarro (1830–1903), Alfred Sisley (1839–1899), Edgar Degas (1834–1917)—began as disciples of Manet. Manet, though painting mostly indoors, had abandoned the studio lighting of the Old Masters and let light control and determine shadow rather than the other way around. This the Impressionists took as their cue. They made light, or luminosity, their most immediate aesthetic aim, and went out of doors with a vengeance. There they heightened their palettes, giving up black and brown almost entirely, and tried to tell the truth about nature in

terms of light and its colored refractions and reflections alone. The Old Masters had painted with highlights, quarter, half, and full shadows and shading; but there are no highlights in the open, and only relatively small and definite shadows, in even the deepest of which the Impressionists could perceive variegated color. Gone from their pictures was that diffused, massed shadow which hovers behind everything indoors, and which enclosed and modelled forms for the Old Masters as well as produced the opposition of highlight and deep shading. The Impressionists came to see all shapes as functions of comparatively pure color, with surfaces defined without the help of dark and light tones (or "values"), but only by variations of reflected light. Since the illusion of solid, three-dimensional form depends largely on dark and light shading, the increasing absence of this from the Impressionist picture induced an appearance of flatness, a floating, cottony, ambiguous flatness, different from Manet's, that gave the illusion of depth only in the form of an "aerial" or "atmospheric perspective" attained by hazy blues, violets, purples, and tinted grays. People complained, for the most part wrongly, that the paintings of the Impressionists lacked form and solidity.

Of Paul Cézanne (1839–1906) it is often said that he remedied this lack—which is another error, in my opinion. But it can at least be said that he made the relative flatness of the Impressionist picture a solid and more powerful one.

It was lucky for Cézanne that his father was rich enough to support him and then leave him a small fortune. For the difficult and involuntary originality of his art deprived him of any hope of earning a living by selling his work, and he was incapable of adapting himself to anybody else's taste. Moreover, he had poor control of his emotions, which caused him trouble in his relations with people, and finally turned him into an eccentric. Yet he was an intelligent man, in painting and out of it—and well aware of what he was doing when he gave himself out as uncouth and unwashed to elegant people like Manet. It was his way of declaring how much he felt set apart from the rest of the world by his inability to cope with it economically, socially, or even artistically.

At bottom Cézanne was an Impressionist always, and he learned painting from the Impressionists, though he did not

belong to their orthodoxy. For various reasons, however—among them the failure of his exhibited works to gain anything better than ridicule from the art public in Paris—he decided in his thirties to go back to his native Provence and try to solve the problems of his art in isolation. But it was only a relative isolation: he still went to Paris for several weeks or months every year to see the Old Masters in the Louvre and the shows of contemporaries; and from time to time he would visit and be visited by fellow-painters. (For in painting and sculpture it is very difficult to produce ambitious work without the stimulation and pressure that are only to be gotten from fellow-workers; which is why these arts, since the Middle Ages, have always revolved around large urban centers.)

Cézanne's aim was to carry over the frank, liberated color of the Impressionists into pictures that would be as firmly and lucidly put together as those of an Old Master like Raphael or Poussin. He would use the color method of the Impressionists to show the surfaces of things not as mere catchers and reflectors of light, but as enclosing masses and volumes and stopping the flow of empty space. Then the picture would look more compact and monumental than the blurred, melting rectangle of the Impressionists (which had a virtue of its own, nonetheless); its parts would be fitted together more tightly, interlocked like those of a watch's mechanism. The Impressionists had crosshatched or juxtaposed little dabs of pure color to get their effects; Cézanne got his with loose rows of squarish, more regular brushstrokes, each of which by its difference in color (not necessarily pure or uniform) indicated a change of direction or plane in the surface of the object shown. He followed the Impressionists, however, in concentrating on the main masses and shapes of the theme from which he painted, to the neglect of minor and "realistic" details. But whereas in the Impressionist case these were obliterated by the play of daylight, in his they were erased solely in order to make the relations of planes clearer. Cézanne, once he found his final path, had lost interest in light effects.

The outcome for him was a paradox that has invited misinterpretation. He painted some very great pictures, of a monu-

mentality and a radiance of paint substance without parallel; and it is true that these conveyed an impression of greater depth, weight, and mass than the pictures of the Impressionists. Yet in another sense they looked even flatter. His strongly marked and uniform brushstroke called attention to the physical surface of the canvas; his preference for direct frontal views and his way of changing the outlines and positions of objects, so that they were tipped up, with an unnaturally high horizon line, and presented a broader and simpler set of planes to the eye, tended to close up the illusion of free space and push everything forward; furthermore, he made his backgrounds just as emphatic as the objects in the foreground. Last but not least, he suppressed shadows and dark and light shading just as much in his way as the Impressionists had in theirs, feeling that shadows obscured the essential forms of objects and the logic of their relations in space, while shading dulled the natural and desirable liveliness of color. Cézanne did try to shade, much more than the Impressionists did, but with "natural," frank color; yet the very freshness and warmth of this color tended to negate its purpose. It was supposed to show planes that receded, but light, bright, or "warm" colors give the effect of coming forward. Cézanne tried to counteract this and resolve the contradiction by digging around the contours of objects—which represent their furthest points of recession from the eye—with deep blue lines, blue being a "cool" or receding color. But the contradiction, or ambiguity, was only heightened thereby—happily, I feel, for this ambiguity is precisely one of the largest sources of pleasure in art. Herein lay its solid flatness, or flat solidity, and it was from this that Picasso and Braque, as Cubists, took their point of departure in 1908, shortly after Cézanne's death, and went on to produce what is still the greatest painting of the two or three generations since.

But if Cézanne was so interested in the essential, abiding aspects of nature, why did he alter or distort? Because, fundamentally, there are two main factors in the artist's attempt to capture on a two-dimensional surface his vision of the three-dimensional world we move and live in. First, there is the illusion itself, or representation, of that world, which is situ-

ated within the space that seems to lie below the actual flat surface of the picture; then there is the pattern or design made on the surface itself—which the artist sees when he squints his eyes to judge his own or other artists' pictures. In all successful painting some attention and care are paid to this last, but the Old Masters were more absorbed by the first and made every effort, as I have already said, to prevent the spectator's eye from resting too long on the surface. Manet, however, and then Cézanne began, unconsciously for the most part, to shift the emphasis precisely there (where abstract painting has put it almost entirely), and when Cézanne altered contours and proportions in an unrealistic manner, it was largely because he felt so strongly the need to enhance the unity and decorative force of the surface design that he let himself sacrifice the realism of the illusion to it. It was certainly not because he could not draw well enough.

This concern with surface pattern was, of course, part of a tendency to flatness in painting (the unconscious motives of which have yet to be explored) that goes back to Manet, and, perhaps, Ingres. Matisse and the Fauves, the Expressionists and the Cubists, all took up where Cézanne—and Gauguin and van Gogh—had left off, and the final result has been abstract painting, which is the flattest pictorial art we have ever seen in the West.

Those fortunate enough to have visited the large international exhibition of Cézanne's oils, watercolors, and drawings that was installed through February and March of this year at the Art Institute of Chicago, and through April and much of May at the Metropolitan Museum of Art in New York, must surely have recognized the source of many things they had already seen in later painting. Some of the late landscapes—which I feel to be the culmination of Cézanne's art—are certainly as striking and as "extreme" as a good deal of our best contemporary work. For this and other reasons there is no better way for anyone who wants to learn to enjoy—not "understand"—modern art than to apply himself to the pictures of the master from Aix.

American Mercury, June 1952

26. Foreword to an Exhibition of Jackson Pollock

This is Jackson Pollock's first retrospective show, and I think it furnishes telling evidence of the magnitude of his achievement over the past decade.[1] Most of the paintings on view are major works, major in a way that very little in American art has been up to now. That is, they determine the main tradition of painting at their point in time.

Bennington College is to be congratulated on having given this artist such a well chosen and representative exhibition. It does much to clarify what has been happening in American art since the war, and shows why the most adventurous painters of the latest generation in Paris have begun to look to this country with apprehensive rivalry.

A Retrospective Show of the Paintings of Jackson Pollock, Bennington College, Vermont, and the Lawrence Museum, Williams College, Massachusetts, November–December 1952; *Jackson Pollock: A Catalogue Raisonné of Paintings, Drawings, and Other Works*, ed. Francis Valentine O'Connor and Eugene Victor Thaw, 1978.

1. Eight paintings were selected by Greenberg for the exhibition. The earliest was *Pasiphaë* (c. 1943) and the latest *No. 25, 1951*. [Editor's note]

1953

27. Foreword to a Group Exhibition at
the Stable Gallery

This exhibition was conceived and organized by artists.[1] The
event rightly to be considered the precedent for this one was
the famous "Ninth Street" show held in the spring of 1951 on
the ground floor of a vacated store, on East 9th St. Like this
one, that exhibition was organized, and its participants named
and invited, by artists themselves, and a range of the liveliest
tendencies within the mainstream of advanced painting and
sculpture in New York was presented. I don't think the rever-
berations of that show have died away yet.

The present exhibition, like its predecessor, has the merit
of giving a large place to the work of artists, some who do not
show regularly with dealers, and who thus have the chance to
measure themselves against their more established colleagues
in a directer way than usual. At the same time the public has
a chance to see what is going on in the studios, many blocks
distant from 57th Street, where the newer generation of paint-
ers and sculptors incubate what may be—in some instances—
the livest art of the near future.

This is invaluable to artists themselves, as both stimulation
and information—a certain amount of rivalry is indispensable,
and you have to be aware of what your rivals are doing if rivalry
is to provoke self-criticism—but it ought also to be stimulat-
ing to those who take an interest in contemporary art without
practicing it themselves. Exhibitions like these serve to bring
art alive as a current issue, as something fluid and moving,
still on the way to fulfillment and decision, not yet pinned

1. Approximately one hundred artists took part in the exhibition, in-
cluding Greenberg himself. Exhibitions continued to be held in subsequent
years. [Editor's note]

down and fixed by the verdicts of critics or museums or "safe" collectors. And this, to some degree, is the way most of art, past and present, should be for those who have really acquired the need for it.

I earnestly hope that this show, too, will find a successor, that it becomes just enough of an institution to be repeated every year, with no less a breadth of choice and no lower a level of taste.

Second Annual Exhibition of Painting and Sculpture, Stable Gallery, New York, January–February, 1953

28. Foreword to an Exhibition of Willem de Kooning

Modern art is not the sudden eruption out of nowhere that many people think it to be. To the extent that it is successful as art it flows from the past without break in continuity. One can find no better demonstration of this than in Willem de Kooning's painting, although—or rather, precisely because— it belongs to the most advanced in our time.

The supple line that does most of the work in de Kooning's pictures, whether these are representational or not, is never a completely abstract element but harks back to the contour, particularly that of the human form. Though it is a disembodied contour, seldom closing back upon itself to suggest a solid object, it continues in the great tradition of sculptural draughtmanship which runs from Leonardo through Michelangelo, Raphael, Ingres and Picasso. The play of the planes whose edges this line creates—embedding them in the picture surface here, freeing them from it there—reminds one, however, of how nude forms in the big decorative canvases of the Venetians and Rubens undulate in and out of foreground light. De Kooning's restraint in the use of color serves but to let the rhythm of the undulation come through more clearly.

De Kooning strives for synthesis, and in more ways than one. He wants to re-charge advanced painting, which has largely abandoned the illusion of depth and volume, with something of the old power of the sculptural contour. He

wants also to make it accommodate bulging, twisting planes like those seen in Tintoretto and Rubens. And by these means he wants in the end to recover a distinct image of the human figure, yet without sacrificing anything of abstract painting's decorative and physical force. Obviously, this is highly ambitious art, and indeed de Kooning's ambition is perhaps the largest, or at least the most profoundly sophisticated, ever to be seen in a painter domiciled in this country.

This is painting in the grand style, the grand style in the sense of tradition but not itself a traditional style, attempted by a man whose gifts amount to what I am not afraid to call genius (his ability as a colorist is larger than even his admirers ordinarily recognize). No wonder de Kooning has had such a tremendous impact on American painting in the last several years. He is one of the important reasons, moreover, why that painting has ceased to be a provincial one and become a factor in the mainstream of Western art today.

Willem de Kooning Retrospective, Workshop Center for the Arts, Washington, D.C., and School of the Museum of Fine Arts, Boston, 1953.

29. The Plight of Our Culture

T. S. Eliot's most recent book on a non-literary subject, *Notes Towards the Definition of Culture*, proceeds largely on the assumption, familiar by now, that our culture is in decline.[1] The book, when it appeared in 1949, received an amount of attention proportionate to its author's fame, but the quality of that attention did not match the importance of the problems raised. The assumption as to cultural decline was neither questioned nor explicitly rejected. Most of the regular reviewers scolded *Notes Towards the Definition of Culture* for its reactionary tendencies and left it at that, whereas the literary magazines,

1. This essay was published in two parts, subtitled, respectively, "Industrialism and Class Mobility" and "Work and Leisure Under Industrialism." The first part comprised sections I–II of the essay, and the second part, sections III–IV. [Editor's note]

with even greater obtuseness, treated it as one more item to be placed in the temple of Eliot's reputation. (William Barrett and Robert Gorham Davis, in *Kenyon Review* and *Partisan Review*, respectively, formed exceptions, as did also the contributors to a symposium in *Scrutiny* in England.) True, the assertion that our culture was deteriorating was made without being argued, just as Eliot tended throughout to pontificate rather than consider evidence and draw conclusions from it, though professing in all earnestness to be writing as a responsible sociologist. And just as, too often in general, partial glimpses of partial truths were offered as complete answers, truisms as fresh contributions. Nevertheless, Eliot did pose a problem of enormous importance, state cogently some of the limits within which it would have to be solved, and remind us of our failure, so far, to have thought about it seriously enough.

In any case, his book would be important as an influence and a symptom. We cannot forget who Eliot is: one of the very greatest of all literary critics, a remarkable poet, and a writer whose prestige at the moment is probably larger than that enjoyed by any other English-speaking literary man during his own lifetime. Also, he has been a great reformer of sensibility, outside as well as inside literature, with consequences felt in areas of intellectual life seemingly remote from *belles-lettres* or art. Sensibility may not be identical with intelligence, but prepossessions of feeling can become premises of thought, and limitations of thought, limitations of emotion and experience.

Eliot has done as much as anyone in our time to expose the superficialities that have accompanied the popularization of the ideas of the Enlightenment, of Utilitarianism, and "scientism"—but by criticizing a kind of sensibility, not systems of ideas. Nor does his quarrel seem in the beginning to have been with the ideas of liberalism as such, or with any set of ideas, but with deadness of sensibility wherever he found it, on the right and left, in church and out; and if he found it more often on the left, it was not so much because he wanted, at first, to find it there. Only later, when he began to deal publicly with non-literary matters, did he fix on liberalism as the main enemy, and adopt a consciously "anti-modern" religious and political position. But it was then, too, that his own sensi-

bility showed the first symptoms of the same ailment he had diagnosed. His cure turned out to be a variant of that malady, and he, too, became an ideologue, remaining fixed, with no further understanding, in his original disgust with "modernism." And as he has gone on flogging the same tired horse—omitting in his criticism of the Enlightenment to distinguish between the root ideas and their vulgarization—he has become less and less able to distinguish between insight and banality in the notions he himself advances.

Nowhere in Eliot's later writings do we find so much evidence of this inability as in *Notes Towards the Definition of Culture*. Its disconcerting mixture of sense and superficiality, penetration and obtuseness, makes it a treacherous springboard for further discussion, and I can understand why most reviewers should have drawn back from the plunge. For this very reason, however, and for others, it may be worth going a little further into the deficiencies of the *Notes* before considering independently some of the issues that it raises.

Eliot has obeyed that rule established in the 18th century according to which the eminent man of letters begins to feel in middle age that literature is not enough, and aspires to some larger power over public opinion. But like Thomas Mann, he has made the big mistake of offering himself as a head as well as conscience. Victor Hugo knew better; so, really, did Matthew Arnold, and even Carlyle: they lectured and admonished, confident of their instinct for moral issues, but, for all their *obiter dicta*, seldom tried to theorize consistently. Besides, literary men have a tendency to confuse aesthetic with social values (see, for example, Arnold on America). This, I think, has been particularly the case with Eliot. And he is also prone to adopt attitudes that, however honestly meant, are not honestly come by (whence sometimes a note of involuntary parody enters—as if seriousness, especially that with which he wishes to take himself, were a strain requiring comic relief).

Whether or not he got his first political notions from the late Charles Maurras, Eliot has been chronically susceptible (perhaps because early impressed by the high cultural level of French reaction) to the kind of thing Maurras expressed most consistently: that type of reaction, trimmed out with Ca-

tholicism, "tradition," "classicism," "hierarchism," "authority," ultra-nationalism, and anti-Semitism, which an eminent section of French literary, if not political, opinion has professed ever since de Maistre and de Bonald, in the first half of the 19th century, laid down a systematic basis for rejecting the French Revolution. The main trouble with this position is less that it is reactionary than that it is irrelevant, and their own half-suppressed realization of this has the effect of driving its adherents to but further extremes of irrelevance—as we saw when Maurras collaborated with the Germans under the Occupation (for which he sat in jail for six years). Eliot, repeating a number of the same ideas to an English-speaking public in books like *After Strange Gods* and *The Idea of a Christian Society*, has been, if anything, more irrelevant, and some of his published remarks on politics, made over the last two decades, belong together with many leftist expressions of the period in an anthology of political nonsense. That, as I have heard, he voted Labor in 1945 would only bear out the charge.

Like most inveterate aesthetes, Eliot appears to lack a sense of the urgent reality of politics as a matter of weal and woe, and to regard correct opinion as an end in itself. Nor does he seem to appreciate the multiplicity and variability of the factors that determine social reality. This is as much a deficiency of sensibility as of intelligence, and the fact that Eliot shows a real awareness of historical movement inside literature does not gainsay this, but only demonstrates, once again, how much better his mind functions—and how much more he respects his subject—where aesthetic ends are the decisive ones.

But in *Notes Towards the Definition of Culture* we will also find things chargeable to what has to be called mindlessness, not just want of sensibility. It is startling to come across sentences like " . . . it may be argued that complete equality means universal irresponsibility. . . ." Or: "A democracy in which everybody had an equal responsibility in everything would be oppressive for the conscientious and licentious for the rest." Such statements are neither correct nor incorrect, but simply useless. The writer settles a very large and complicated question at a stroke by repeating an old saw sententiously, thus sparing himself further thought—which is exactly the function of cant. And when he apologizes, with that ele-

phantine humor which can astound us again and again in Eliot, for a paragraph, otherwise full of good sense, that ends with the words "destroying our ancient edifices to make ready the ground upon which barbarian nomads of the future will encamp in their mechanized caravans," by adding that this was but an "incidental flourish to relieve the feelings of the writer and perhaps a few of his more sympathetic readers," we are far from sure that he himself realizes what a threadbare piece of journalism he has just repeated. Eliot can begin another paragraph with the sentence: "The colonization problem arises from migration." And refer to "vast impersonal forces." And "the oriental cast of the Russian mind." American movies are called "that influential and inflammable article the celluloid film." Something even worse than mindlessness is involved in: "I do not approve of the extermination of the enemy; the policy of exterminating or, as is barbarously said, liquidating enemies, is one of the most alarming developments of modern war and peace, from the point of view of those who desire the survival of culture. One needs the enemy." (Who, in modern times, has needed what exterminated enemy?) Never was a humane sentiment expressed with such barbaric and fatuous humor. At this point one becomes alarmed for the author's soul, not his mind. And, after all, Eliot is, or was, a great writer.

One can see why this present book of his is so difficult to deal with. Yet this does not make the issues he deals with any the less momentous; nor does this tendency to clown of which I have given examples prevent him from saying much that is arresting and true—if not exactly original.[2]

I

Eliot writes in his introductory chapter: "The most important question that we can ask, is whether there is any permanent standard, by which we can compare one civilization with another, and by which we can make some guess at the improve-

2. To be wholly fair to Eliot, a "note" on culture that he published in *Partisan Review* in 1944 should be taken into account. No part of this "note" has been retained in original form in the present book, although it says more in fewer, apter, and carefuller words than does any chapter in the latter. [Author's note]

ment or decline of our own. We have to admit, in comparing one civilization with another and in comparing the different stages of our own, that no one society and no one age of it realizes all the values of civilization. Not all of these values may be compatible with each other; what is at least certain is that in realizing some we lose the appreciation of others. Nevertheless, we can distinguish between higher and lower cultures; we can distinguish between advance and retrogression. We can assert with some confidence that our own period is one of decline; that the standards of culture are lower than they were fifty years ago; and that the evidences of this decline are visible in every department of human activity." Nowhere does Eliot even hint at the "permanent standard" of comparison that enables him to make this assertion with "some confidence"; he appears to assume, simply, that the reader's own experience will confirm it, and leaves the question of the "permanent standard" itself—theoretically, a far more important one—wide open. If he had tried to close it, perhaps his book would have done more to stimulate a fruitful discussion.

At the same time his definition of culture is not (as the title of his book might indicate) worked "towards" but merely handed down. Culture, in Eliot's view, is, as Marxists would say, entirely "superstructural"; it excludes political, social, religious, and economic institutions, which come, presumably, under the broader term of *civilization*. Culture "includes all the characteristic activities and interests of a people: Derby Day, Henley Regatta . . . the pin table, the dart board, Wensleydale cheese, boiled cabbage cut into sections . . . 19th century Gothic churches and the music of Elgar." There is the individual's culture, which depends on that of his class and group, which derive in turn from the culture of the "whole society." Obviously, much has to be investigated and weighed before one can assert with *any* confidence that every present aspect of culture, even under this definition—much less "every department of human activity"—bears evidence of a decline of cultural standards. Little in Eliot's book testifies to such an investigation.

A reasonable question is whether enough evidence of cultural improvement might not be discovered in each "department of human activity" to balance the evidence of decline. I

would agree with Eliot that decline predominates in most of the arts, in standards of taste, in some departments of learning, and many aspects of manners, but would hesitate to say this of *all* the arts, *all* areas of taste, *all* departments of learning, or manners on *all* social levels. Do the *majority* of people in England and America eat more poorly prepared food than fifty years ago? Have dress and décor declined since then? Has—particularly—architecture? The majority of people in the industrial countries of the West are certainly gentler in their relations with one another than they used to be, whatever the upper classes have lost in formal grace. The poor remain the most numerous, and fifty years ago they were not only poorer, but, according to the mass of evidence, much more brutal and brutish. Culture has lost much on its higher levels, but may there not have been some compensation on those where the multitude find their "characteristic activities and interests?"

Such questions are not easy to answer, least of all with "confidence." The problem is far more complicated than Eliot actually does acknowledge, however much he seems to do so. And in its complication may lie reasons for hope as well as despair. The reasons for the latter—the war, the exterminations, the oppression, the present tawdriness of our machine-made environment with its commercial culture and its leveling, etc.—are obvious, all too obvious. By seizing upon the obvious so confidently, Eliot, and others like him, collaborate with journalists in diverting attention from causes to effects, though they may think they are doing the opposite. The general readiness to cry woe, the crisis-mongering, may itself be the symptom of a decline of culture.

Granted, nevertheless, that our culture is in decline on its highest levels: what can be done about it? The weight of Eliot's short book is placed on a description of three conditions he deems more or less indispensable to a recovery. He does not propose that we set about directly to establish or restore these, but hopes rather to clarify the problem by dissipating false hopes: we are to infer that certain social and political conditions now present will largely frustrate any *ad hoc* measures to remedy the plight of culture, and that these conditions must be changed first.

The first desirable condition is an "organic (not merely planned, but growing) structure, such as will foster the hereditary transmission of culture within a culture; and this requires the persistence of social classes. The second is the necessity that a culture should be analyzable, geographically, into local cultures: this raises the problem of 'regionalism.' The third is the balance of unity and diversity in religion—that is, universality of doctrine with particularity of cult and devotion." But: "The reader must keep in mind that I am not pretending to account for all the necessary conditions for a flourishing culture; I discuss three which have especially struck my attention . . . so far as my observation goes, you are unlikely to have a high civilization where these conditions are absent."[3]

Yet almost nothing is presented of the content of the "observation" that has led to this important conclusion; we can only surmise that Periclean Athens, the medieval West, Elizabethan England, Renaissance North Italy, 17th-century France, and so forth, are meant—the accepted golden ages of art and literature. It is implied that successful *novelty* in the social and political structures which support culture is by and large impossible: as culture developed in the past, so must it in the future.

We can quibble over the necessity or importance, even in the past, of the second and third conditions that Eliot lays down, but the indispensability, so far in history, of class differences to a high urban culture cannot be denied, since there is no record of any such culture without them. The big question is whether class divisions—or, to be exact, the traditional alignment of small upper class over against large lower class—will continue to be as necessary to high culture as in

3. Eliot's discussion of the relations between religion and culture, and more particularly, art, is, in my opinion, the most original part of his book. He is as cavalier here with the rules of discourse and evidence as elsewhere (of what use is it to say that culture is impossible without religion when we know of no society—not even the USSR—that has existed without religion?) but at least he seems to have experienced a good deal of what he talks about. And because he reveals more frankly, if unintentionally, the profound aestheticism that sways him in his religious convictions no less than in his political and social ones, he rings truer. [Author's note]

the past. Eliot's answer in the affirmative provoked most of the hostile comment his book received (in their heat the reviewers overlooked his introductory statement that class divisions may not be essential to the achievement of other, perhaps higher, values than culture; though later on, it is true he does imply that a "graded" society is the best form of society in general). Marx pointed out that productivity in even the most materially advanced societies of the past was always so low that the majority had to work full time to provide, in addition to their own necessities, the material surplus to support the leisure and ease of the relatively tiny minority that maintained high culture wherever it appeared. Marx's prognosis of a socialist future was founded on the assumption that science and industrial technology would eventually make it possible for society to produce material goods in such plenty as to render social differences unnecessary and put the dignified leisure required for the pursuit of high culture within reach of everyone. Whether this expectation is utopian or not, Marx did at least sense the big difference that industrialism would make as far as the *structure* of society was concerned. Eliot's failure to give more than a passing glance to industrialism, on the implied assumption that it contains little but harm for culture, prevents his discussion of modern culture from advancing, in effect, beyond the point at which Spengler left it.

Like Spengler, Eliot gives one to infer that industrialism is but another of the time-bound phenomena that, along with skeptical rationalism and hugeness of cities, accompany the decline of any high civilization. But to judge from the past again, humanity, barring some unprecedented catastrophe, will no more forget industrial technology than it has, amid the rise and fall of civilizations, forgotten the use of metal tools, the wheel, domestic plants, or domestic animals. Technological progress has been irreversible by and large; that is, there has been a cumulative gain in our control of the material environment. As a rule, once a people learned to use bronze it never went back to stone, and once it learned to handle iron it never went back to bronze. There have been temporary retreats, especially in quality of workmanship, but the evidence shows that these have almost always been made good. (Franz Borkenau, in "Will Technology Destroy Civilization?" in *Commentary* of January 1951, quotes Alfred Weber,

the German historian, to this effect.) That industrialism will remain with us in one form or another would seem to be the largest single circumstance to be taken into account in any discussion of the future prospects of our culture.

Radical changes in technology have in the past always transformed the inner, or cultural, as well as the outer, or social, structure of society. We have reason to expect that industrialism—to which, really, we are still new—will, in the long run, effect more radical and comprehensive changes in the fundamental *scheme* of culture and civilization (as Franz Borkenau pointed out in his *Commentary* article of January 1951) than anything that has happened since the Neolithic revolution which some eight or nine thousand years ago replaced the hunting and gathering economy of the Paleolithic Age with an agricultural and herding one. Hence many premises based on observation of the relatively recent past must be discarded, and the prospects of culture, now as well as in the hypothetical future, viewed within a new perspective—not altogether new, of course, but new enough to demand a re-examination of the assumptions that ideologues of "tradition," like Eliot, proceed on.

At best one can reason from past experience only under the most general terms. The "Iron Age" civilizations of the past three millennia form in their aggregate only one part of the history of civilization as such, and at this point in time it is as hazardous to reason towards the future on their basis as it would have been, a thousand years before Jesus, to do so in terms of the material and cultural premises of the Bronze Age civilizations. Novelty has always to be allowed for, if not believed in. Spengler, Toynbee, *et al.*, may still be right in seeing the present as a period of decline that will end relatively soon in the collapse or paralysis of Western civilization, in accordance with the pattern followed by all other high civilizations so far; nevertheless science and industrialism do, and will, make a great difference, and the future is likely to present a scheme, and possibilities, radically different from those of the expired or moribund civilizations we already knew. Many of the conditions under which a flourishing culture again becomes possible will therefore be different from those that made one possible in the past.

It would be wiser, accordingly, not to speculate so exclu-

sively on the basis of past precedent. Rather we ought to examine more closely the situation of culture here and now, and try to ascertain its inherent tendencies and drift, to see what in the situation is so new that it cannot be understood in terms of anything we know from the past.

II

As has been observed, culture in the urban, industrial West is now stratified on three main levels. First, there is commercialized, "mass," "popular," "jukebox," or "lowbrow" culture; then there is "middlebrow" culture; and finally—and traditionally—high or "highbrow" culture.[4] All three belong to the city; rural, folk, or peasant culture is now, for the first time since it appeared thousands of years ago, practically extinct over much of the countryside in the Western world. This in itself amounts to a very radical piece of novelty. What, however, is almost equally novel is that the stratification of culture no longer coincides as uniformly as before with class lines. Whereas in the past the culture of the highest level usually received the greatest social as well as economic support, today the greatest economic support is given to the bottom level, and the greatest social support to the middle. Yet the uppermost level still carries the main history of culture, and exerts the most influence on the other levels.

The culture of the majority of the *rich* in a country like ours has by now become definitely middlebrow, with only a small minority directly supporting highbrow culture. The middle classes furnish more customers in absolute numbers for lowbrow than middlebrow culture, yet still make up the bulk of the audience for the latter. Everybody with a high school education gets at least a taste of middlebrow culture, and almost everybody in American society comes in daily contact with the

4. "Highbrow," "middlebrow," and "lowbrow" are terms of brutal simplification. Nor were they coined to denote types of culture so much as types of social personality, and all three in an invidious sense—as if any kind of personal culture were a foible, and all the more a legitimate object of ridicule because revealed in one's physiognomy. But I am afraid that no other terms available fit the realities I am trying to deal with as well as these three. And the reader, I feel sure, will understand immediately what they mean, and at the same time realize that the distinctions they make are not hard and fast ones. [Author's note]

lowbrow variety. Only among the poorest classes, who can be presumed to belong altogether to the lowbrow audience, does social level seem to determine cultural level as consistently as it used to do.

The middle, for a variety of reasons, has become the crucial level as far as social power is concerned, and deserves special attention. At the same time it is the most difficult level to define. "Middlebrow" is no longer a term with which to "relieve one's feelings," but means a very large if disorderly piece of reality. Eliot remarks in his book on the desirability of "a structure of society in which there will be, from 'top' to 'bottom,' a continuous gradation of cultural levels. . . ." This is not as lacking in an advanced industrial country like our own as he seems to imply. There is a vast distance between high culture and lowbrow—vaster, perhaps, than anything similar in the past—but it is covered without apparent break by the infinite shadings and gradings of middlebrow culture, which is defined roughly by the fact that, though its audience shrinks from the trials of highbrow culture, it nonetheless refuses to let its culture be simply a matter of entertainment and diversion on the lowbrow order. Middlebrow culture has to do in one way or another with self-improvement, and is born almost always out of the desire and effort of newly ascended social classes to rise culturally as well.

Something like middlebrow culture emerged in Western Europe in the 17th century—say, with Bunyan and Defoe in England—but did not quite establish a separate identity, and so remained for a time more or less tributary to aristocratic and patrician high culture. It was during the 19th century, as industrialism raised newer, rawer, and larger middle classes out of petty bourgeois or proletarian obscurity, and these tried to turn high culture to their own purposes, that middlebrow culture began really to differentiate itself. However, these new classes, for all their buying power, did not yet form a large enough proportion of society to upset the old balance between huge sweating majority and small leisured minority upon which traditional high culture had depended so far; they could still be assimilated, or at least controlled, by the old educated classes. Therefore middlebrow culture remained an ambiguous thing, largely subservient to high culture in social prestige if

not economic power. Only within the last decades, and chiefly in this country, has this relation changed, and middlebrow culture acquired a positive identity and become an unmistakable force.

The revolutionary cultural phenomenon of the recent past has been not so much the spread of "mass" or lowbrow culture—which was already here a hundred years ago—as the rapid expansion of the middlebrow kind and the multiplication of its degrees and shades. This is owing to the appearance, for the first time, of a middle class large enough to amount to a *mass*, if not a majority—a mass that is now, thanks to industrial prosperity, in the material position at least to aspire to the kind of culture that used to be the exclusive prerogative of a small minority. This position does not automatically produce aspirations towards higher culture—in the 1920's the newest, and largest, American middle class did not feel them— yet material ease does in the long run tend to awaken them if only because culture, and cultivation, assert social status.

Behind the shrill and spectacular lowbrow culture that holds the foreground of American life, just such aspirations have begun lately to spread in ever widening circles as standards of living are consolidated and continue to rise. The fact is being remarked upon in many places. Whatever its immediate causes, the "culture boom" that started shortly before the recent war was due, fundamentally, to the settling in of the enormous new middle class created by the more rapid development of industrialism after 1914, and to the coming of age of its second generation. And the largest increment by far of this boom has to be booked to the account of our middlebrow culture.[5]

5. A similar boom started in England—and in Scandinavia, too—in the late 1930's, and the causes were somewhat the same. However, the spread of higher living standards may have been less of an immediate factor abroad than the popularization of socialist ideas—which meant increased self-awareness on the part of lower classes and, with that, a desire for adult education and an interest in self-education in general. The most typical phenomena of the British culture boom are the BBC's Third Program, with its magazine *The Listener*, and the success of the Penguin books, whereas the emphasis in America is not so much on self-education as on gentility, correctness of taste, knowingness, "gracious living"—that is, emblems of status. [Author's note]

High culture, however—authentic, disinterested culture—
has so far suffered more than it has gained in the process. Be-
ing, among other things, the expression of unconscious taste
and habit, of assumptions that never get stated, of a way of
life and an ingrained sense of proportion, it has as a rule to
begin being acquired during childhood, from the immediate
and everyday just as much as from books and works of art. The
antecedents of the new middle classes do not lie in such child-
hoods; higher culture comes to them from the outside, in ado-
lescence at most, and has to be acquired by conscious effort,
therefore tends to remain somewhat external and artificial.
According to everything we know so far, Eliot is right when he
repeats that the family is still "by far the most important chan-
nel of transmission of culture." Nor is this the whole story.

Other handicaps are imposed by the very scale and rapidity
(both proportional and absolute) with which the new Ameri-
can middle classes have been expanding. Every generation
since the Civil War, but especially since 1918, has brought a
new mass of people to the social surface. And each new mass,
being larger usually than the one before, yet quickly rising to
the same social level, has acted as a drag, culturally, on its
predecessors. The traditional structure of culture, which could
assimilate these newcomers as long as they arrived in limited
numbers and at sufficient intervals, cannot maintain itself
when they come in such steady and huge throngs (the increase
of the population in absolute figures alone is enough to unset-
tle the situation). By sheer demographic weight and buying
power, the newcomers force all levels of the cultural market
down to meet the lower standards they bring with them from
their culturally inferior origins. The old upper classes become
helpless in the matter. Nor, for that matter, do these classes
enjoy the prestige in connection with culture that the old up-
per classes of, say, England do, and they are that much the less
able to maintain the continuity of traditional standards—
which are in their care if they are in anyone's—with enough
authority to tame parvenus.

At the same time lowbrow, "machine," commercial culture
is there everywhere to offer its relief to all those who find any
sort of higher culture too much of an effort—lowbrow culture
being powerful not only because it is "easy" and still suits the

majority, but also because it has replaced folk culture as the culture of *all* childhood, and thereby become our "natural," "autochthonous" culture. (And, unlike folk culture, lowbrow culture neither contributes—at least not fundamentally—to high culture nor effaces itself in its social presence.)

Armed with their new wealth, their optimism, and their political power, the new American middle classes have in this situation been able to ask with more confidence and success than any upstart class before them that high culture be delivered to them by a compromise, precisely, with their limitations. Hence, above all, middlebrow culture.

The liberal and fine arts of tradition, as well as its scholarship, have been "democratized"—simplified, streamlined, purged of whatever cannot be made easily accessible, and this in large measure by the same rationalizing, "processing," and "packaging" methods by which industrialism has already made lowbrow culture a distinctive product of itself. Almost all types of knowledge and almost all forms of art are stripped, digested, synopsized, "surveyed," or abridged. The result achieved in those who patronize this kind of capsulated culture is, perhaps, a respect for culture as such, and a kind of knowingness, but it has very little to do with higher culture as something lived.

The middlebrow in us wants the treasures of civilization for himself, but the desire is without appetite. He feels nostalgia for what he imagines the past to have been, and reads historical novels, but in the spirit of a tourist who enjoys the scenes he visits because of their lack of resemblance to those he has come from and will return to. A sense of continuity with the past, a continuity at least of truth, of enduring relevance, belongs to a genuine culture almost by definition, but this is precisely what the middlebrow does not acquire (the fault is not entirely his own). He might be able to do so, eventually, by exerting humility and patience, but these he is somehow never able to muster in the face of culture. In his reading, no matter how much he wants to edify himself, he will balk at anything that sends him to the dictionary or a reference book more than once. (Curiosity without energy or tenacity is a middlebrow trait wherever and in whomever it appears.) Towards his entertainment, no matter how much he wants it to be "signifi-

cant" and "worthwhile," he will become recalcitrant if the "significance" is not labeled immediately and obviously, and if too many conditioned reflexes are left without appropriate stimuli. What the middlebrow, even more conspicuously than the lowbrow, wants most is to have his expectations filled exactly as he expects to have them filled.

Middlebrow culture, because of the way in which it is produced, consumed, and transmitted, reinforces everything else in our present civilization that promotes standardization and inhibits idiosyncrasy, temperament, and strong-mindedness; it functions as order and organization but without ordering or organizing. In principle, it cannot master and preserve fresh experience or express and form that which has not already been expressed and formed. Thus it fails, like lowbrow culture, to accomplish what is, perhaps, the most important task of culture for people who live in a changing, *historical* society: it cannot maintain continuity in the face of novelty, but must always forget and replace its own products.

But I said "in principle." Like lowbrow, middlebrow culture is not all of a piece. The good and the bad are mixed, all the way from Class A movies and the *Reader's Digest* through *The Saturday Evening Post* and *South Pacific* to the *Times Book Review* and Rouault. Middlebrow art, if not middlebrow learning or thought, is not wholly adulteration and dilution. Novelists like Hemingway, Faulkner, Fitzgerald, and O'Hara can profit as well as lose by a certain middlebrow impatience with intellectual distinctions that enables them to make new distinctions in experience itself. And while the middlebrow's respect for culture may be too pious and undifferentiated, it has worked to save the traditional facilities of culture—the printed word, the concert, lecture, museum, etc.—from that complete debauching which the movies, radio, and television have suffered under lowbrow and advertising culture. And it would be hard to deny that some sort of enlightenment does seem to be spread on the broader levels of the industrial city by middlebrow culture, and certain avenues of taste opened. Just as, in general, an authoritative part of the public has begun to show a greater sense of responsibility towards disinterested culture, and to censor its own philistine impulses.

But doesn't the damage still outweigh the gains, and can

any amount of improvement at the lower levels compensate for deterioration at the highest, where the most authentic manifestations still have their being, where the forms and values of every other level originate—no matter how perverted subsequently—and where our experience is still most significantly and enduringly preserved?

III

High, highbrow, genteel, academic (in the original sense), or aulic culture is now pursued by a relatively small number of people most of whom come from the middle classes. The largest proportion, however, of those who pay to maintain this kind of culture still come from among the rich. But the cultivated minority among the rich seems to shrink steadily in proportionate numbers. Or, rather, their culture itself seems to shrink.

Thrown upon the mercy of the market which bourgeois society has set up to determine the social utility of as many things as possible, and faced with consequences of technological change for which it is unprepared by tradition, high culture has lost much of its old implicit authority. Even in the eyes of those who still pay for it, it has become a commodity instead of a standard and a way of life—and not a very competitive commodity. Where all classes have money to spend on culture, the cheaper, or easier, article must inevitably drive out the more difficult, or expensive, one.[6]

At the same time high culture, after having been synonymous for centuries with culture as such, is now set apart by industrial life as something special and even artificial, being regarded no longer as the product of inclination, but as a pretension. The "highbrow" has sprung up to confirm this accusation in part, but also to answer it as he needs must answer it. The distinctions between the genuine and the spurious, the elevated and the vulgar, becoming more and more blurred, those who have the interests of high culture at heart are compelled to make these distinctions all the more emphatic, at the

6. An important factor in this connection is the rise in value of labor under industrialism, which makes it less and less feasible to produce things, no matter how highly priced, for a restricted market. The number of buyers necessary to keep, say, a publisher in business is much larger than what it was a century ago. [Author's note]

risk of exaggeration. The highbrow has, as it were, to price his product out of the market in order to protect it from the market's demands.

Today a large part of the essential activity of high culture consists simply in asserting a level, *its* level, and this excuses many, if not all, of the phenomena in latterday literature, art, and thought that might otherwise be condemned as precious or affected. Nevertheless the preciousness is very often there. It is hard to think of a great poet, composer, or artist of the last hundred years not guilty in one way or another of "artiness"—which is a symptom of, and at the same time a protest against, the fact that genuine art is increasingly cut off from the main routines of life.

The avant-garde—which is the "cadre" that has led the fight for aesthetic truth, high standards, continuity with tradition, and against the utilitarian ethos during the past century—tends to make a virtue of its isolation and identify this with high culture by definition. But it is no longer as easy as it was in Baudelaire's and Flaubert's day to be so militant in one's isolation. The political convulsions of our time have revealed more immediate threats to culture than those of bourgeois routine. And the bourgeois public, for its part, has through the medium of middlebrow culture begun to make conciliatory overtures to the avant-garde. The more ashamed philistinism becomes of itself the less benefit does culture get from an attitude whose main point is anti-philistinism, and the less meaning does such an attitude in itself retain.

For a variety of reasons it is no longer possible anyhow to rest a fruitful criticism of contemporary life on a total rejection of the kind of experience that gives rise to philistinism. We are better able today to appreciate the benefits of a middle class confident enough in its philistinism—as the German middle classes were not—to insist that politics be expedient rather than ideological. The avant-garde will have to acquire new content for itself if it is to stay cogent and not degenerate into Alexandrianism. At this moment the latter eventuality is not so remote.

With less and less to say of the truth about life under the industrial system—a truth which therefore goes unsaid—the avant-garde grows crabbed and half-baked, given over to the canonizing, codifying, and imitating of itself, to the conning

of a limited repertory of dissident attitudes. Nor does the fact that part of the middlebrow public now accepts Proust and Eliot, Matisse and Picasso, Stravinsky and even Schoenberg, and that the younger "advanced" writers appear in pocket-book anthologies lend new vitality to high art and literature as activity in the here and now. Indeed, the effect may be the opposite, for the genuinely ambitious young writer or artist must now spend more of his energy in establishing distance between himself and the well-meaning but impatient middle-brow than he ever had to with the out-and-out philistine.

It would seem therefore that it is middlebrow, not low-brow, culture that does most nowadays to cut the social ground from under high culture. The middlebrow aspect is taken more and more for culture as such, for representative culture, even by educated people who still regard culture as a matter of personal parts instead of as a means merely of assert-ing status. Active high culture is left increasingly to special-ists, and the middlebrow becomes the highest form to which the amateur, or dilettante, can aspire. There have almost al-ways been specialists of culture, but their interests and con-cerns used to merge intimately with those of the educated and socially powerful amateur. Today, however, there is a grow-ing estrangement. And since the socially powerful amateur, whether he be few or many, still controls our kind of culture, the middlebrow level tends to become its crucial one, where the fate of the whole of our culture may be decided.

But can it not be hoped that middlebrow culture will in the course of time be able to transcend itself and rise to a level where it will be no longer middlebrow, but high culture? This hope assumes that the new urban middle classes in America will consolidate and increase their present social and material advantages and, in the process, achieve enough cultivation to support, spontaneously, a much higher level of culture than now. And then, supposedly, we shall see, for the first time in history, high urban culture on a "mass" basis.

IV

Rostovtzeff explained the decline of Roman culture by the fact that the old educated classes were swallowed up by half and uneducated new classes; too many of the traditional functions of culture were discarded or oversimplified in order to suit

them to the limitations of lowbred people with new social and money power. Purely political and social forces have been working to similar effect in our own society, but the result in our case has been magnified, and complicated, by the great revolution in technology. Such a revolution creates new modes of production, service, and communication that do not, as a rule, square with inherited social arrangements, everyday habits, or hitherto agreed-upon interpretations of life. Since many traditional forms tend to impede action, they become distorted, misused, or discarded. Culture undergoes a weakening from which it does not recover until viable new forms are developed, or old forms sufficiently changed, to ease, control, and render more meaningful the new kind of life that the new technology dictates.

The present Industrial Revolution is the fourth great revolution in technology that we know of. Each of these revolutions seems to have been accompanied by cultural breakdown or at least regression. The evidence is not indisputably clear for the first two—the Neolithic and the "urban"—both of which took place before the invention of writing, but we do at least see how, in the course of the Neolithic revolution, the vivid representational cave painting of the Paleolithic hunters in Southwestern Europe gave way around the Mediterranean to a mechanical kind of decoration. And for most of what V. Gordon Childe calls the "urban revolution," which went on all through the 4th millennium B.C.E. (and which, after many inventions and discoveries such as metallurgy, the wheel, sails, the plough, the harnessing of beasts, culminated in the founding of the first cities in the Near East) the archaeological evidence would show that plastic art led an uncertain existence. We know infinitely more about the consequences of the third technological revolution, that of the Iron Age, which occurred around the Eastern Mediterranean between 1100 and 800 B.C.E. and saw the first widespread use of iron: societies and states foundered, and culture seemed during that period to thin out even as the area of civilization itself expanded fourfold. (See V. Gordon Childe's *What Happened in History*, and his more recent and specialized *Social Evolution*, 1952.)

There were no great technological revolutions in the three thousand years between the Iron Age and the beginning of the Industrial Age in 18th-century Western Europe, and the crises

of culture and society during that crowded and comparatively well-recorded epoch do not seem to have been significantly determined by technological change. Such improvements in technological equipment as were made were piecemeal and never large or radical enough anywhere to revolutionize technology as a whole. This, it can be argued, is exactly why the format, general scheme, or pattern of the different civilizations in Europe and Asia changed so little during the time in question—which, in turn, is why Spengler and Toynbee have been able, with some plausibility, to set forth rules of sequence for the growth and decline of civilizations that take little account of technological factors.

Today, however, we are in the presence of a technological "mutation" of an order and scale such as mankind has not experienced in some five thousand years. As regards its ultimate effects no one is able to talk with any real confidence, if only because we have so little memory or record of the last time that technological change operated radically enough to turn the course of history. But one might assume that this factor, added to the "usual" political and social causes of decline in an "old" civilization, and intensifying them, would make the crisis of our culture even graver. But could it not also bring altogether new factors to bear, the effects of which are unpredictable in terms of "rise" and "fall?"

Now it is true that culture under advanced industrialism has plumbed depths of banality unknown to previous societies. But the very classes that patronize this debased and stultifying kind of culture manifest, in America and Northwestern Europe, a level of civic "culture" that, as a mass phenomenon, is just as unprecedented, and which seems to persist and grow in the face of the increasing tawdriness of "cultural" culture. It is doubtful whether this rise in the general level of civic and political consciousness (which is overlooked by critics of culture like Eliot, Ortega y Gasset, and the rest, because they are oblivious *in the end* to anything but aesthetic considerations) would have been possible without the material margin granted by industrialism for the fuller development of enlightened political traditions, particularly in some of the Protestant countries. Consequently, we see that, as great as are the dangers to culture raised by the latest technological revolution, it has also promoted forces on a scale historically unique to countervail

them in other areas of social life. New "contradictions"—or rather old ones that have become unprecedentedly sharp and concrete—emerge at this point. One of these—of which Eliot shows awareness—is that between culture as such and the well-being of society at large.

Industrial productivity has made the well-being of the majority a vivid possibility and there is a universal urge to subordinate almost all other considerations to that further increase of productivity which will realize this possibility. (The talk about our change-over from a "producer's" to a "consumer's" mentality ought not deceive us in this respect.) At the same time increased productivity accelerates social mobility, and this, beyond a certain point, endangers the continuity of culture. As we have seen, the wider the social front on which material, social and political advances are made, and the faster that front moves forward, the greater the danger, for the time being, of cultural regression. The ideologues of tradition propose to resolve the difficulty by reducing one of its terms— social mobility—in order to permit the re-emergence of a hereditary elite (if they do not, like Russell Kirk, look to "Providential change"). The liberals, however, would simply strengthen the other term, on the assumption that once well-being has become universal the contradiction between material progress and culture will disappear automatically, and that material and cultural values will then coincide in their means, with the aesthetic and intellectual culture of the majority rising to the same level as their civic "culture," and both continuing thenceforth to rise as one. Some liberals look to socialism to bring this happy fusion about; others, like David Riesman, Lyman Bryson, and many more, seem to expect it to be realized if American society is able to continue undisturbed in its present course.

If, as the past would indicate, technological gain is irreversible and the industrial system is here for good, then it is very unlikely that a new upper class will be able to perpetuate itself and foster culture in the *old* way, with the same privileges and authority, that Eliot has in mind; a vast police force and a vast censorship would be needed to protect such a class and its culture from the potentialities of industrialism. On the other hand, the proponents of the equalitarian solution do not see the whole problem, and underrate the extent to which indus-

trialism, along with the social equality it may or may not promote, is incompatible with any elevated culture of a traditional kind. The changes brought about by industrialism go deeper than class relations or the question of exploitation as such. Industrialism throws up problems that are as unprecedented in the cultural as in the economic and political sphere, and which demand solutions that cut to even deeper roots.

V

There has been much talk about how the new leisure created by the shortening of hours of work can be turned to the advantage of humanist culture by providing it with a broader social basis than ever before. Leisure is seen as not a matter merely of free, empty time, but as also determined by the material and social circumstances under which it is enjoyed. What is not realized, however, is the even greater degree to which it is determined by the kind of work, or necessary activity, that sets it off. Leisure—even for those who do not work—is down at bottom a function of work, flows from work, and changes as the nature of work changes.

Leisure in traditional society (the "peasant," feudal, semi-feudal, or merchant's society which was the most we knew until two hundred years ago) was—for most classes in theory, and for the upper classes that supported high culture, in practice—the *positive* aspect of life, and the condition for the realization of its highest values. Economically productive work lacked prestige, as we know, and was regarded as life's negative aspect. (However much the peasant or farmer has praised himself since time immemorial for doing such work, it was almost always with the resentful feeling that nobody in city or manor really agreed with him.) But even more fundamental was the fact that purposeful work was not separated from all that was not work as sharply and unequivocally in terms of time, effort, and attitude as it is now. For one thing, most work used to be work on the land, which is difficult to compartmentalize in terms of time; for another, traditional work was adulterated more or less by irrational practices—customs, rites, observances—that, conceived of originally as means of helping work achieve its ends, then becoming ingrained as matters of propriety and custom, actually furnished occasions *inside* work for relief from the strain of its purposefulness. With the distinc-

tion between work and leisure blurred in this way, culture could preserve a certain place and role within the former—at the cost, to be sure, of its efficiency.

Whether work was rendered much less of an affliction thereby is debatable. But the easier or more "natural" rhythm and pace of traditional work did, it would appear, take a lighter toll of the nerves—and if the working classes of traditional society lived more brutish lives than ours, that may have been not so much because they toiled like beasts of burden, but because they had less material goods at their disposal as a result, precisely, of the fact that they did not work hard or rationally enough. The upper classes, at least—those whose members did not perform manual labor—were able to take fuller advantage of the orientation of traditional work towards leisure, and turn it to the benefit of high culture as well as of themselves, while escaping most of the consequences of its low productivity.

To the exact end of greater productivity, capitalism, Protestantism, and industrialism have brought about a separation of work from all that is not work which is infinitely sharper and more exclusive than ever in the past. And as work has become more concentratedly and actively work—that is, more strictly controlled by its purposes, more efficient—it has pushed leisure out of the foreground of life and turned it into the negative instead of positive complement of itself. Work may be less arduous physically than it used to be, but its present standards of efficiency require one to key oneself to a higher pitch of nervous and mental effort, if only for the sake of the self-control and self-denial required by any kind of sustained activity directed solely towards an end outside itself. Leisure, in compensation, has become much more emphatically the occasion for flight from all purposefulness, for rest, respite, and recuperation.[7] It is certainly no longer the sphere *par excellence*

7. The difference between modern and traditional work lies in this tension, and not as much as is commonly thought in the difference between the machine-tending "robot's" boredom and the solicitous interest and commitment of the craftsman who shapes the product of his work from beginning to end. It is forgotten that only a small proportion of traditional work was done by craftsmen; most of it was labor, drudgery, in town as well as country, and of a kind demanding even less use of the intelligence than does factory work. [Author's note]

of realization, but a passive state, primarily, in which one's least passive need is for distraction and vicarious experience that will give those immediate satisfactions denied one during working hours by the constraint of efficiency. This in itself is a valid need, but when one's nerves insist that it be met with a minimum of mental exertion on one's own part only a base kind of culture can satisfy it, a kind of culture that has lost all efficacy as recreation (in the literal sense) and become entirely a matter of rudimentary entertainment and diversion—of the sort, exactly, that we see in lowbrow and much of middlebrow culture.

This new relation between work and leisure—which I have simplified and exaggerated in order to describe—would have less of an effect on culture, and particularly on high culture, were the rich still exempted from work. But as their monopoly on comfort has been broken by industrialism, so has the monopoly on economic work of those who are less than rich (as though industrialism could shorten working hours only by making work universal). The upper classes can no longer say to the rest of society: "Work—that's your fate, not ours." Status and prestige are not derived so implicitly as before from social origin, and are conferred more and more preponderantly on achievement, and sustained achievement at that. Old-fashioned, complete leisure is now felt by the rich, too, as idleness, as remoteness from reality, and therefore the way to demoralization, thus no longer presupposed as the natural and positive condition of the realization of the highest values— much less as the end for which one strives in youth as well as old age.[8]

8. See Aristotle in his *Politics*, VIII. With his customary psychological realism, he reports the common view, held from the dawn of urban civilization until a short while ago, of leisure as the highest condition of life for the young no less than the old: " . . . we should be able, not only to work well, but to use leisure [*schole*] well; for, as I must repeat once more, the first principle of all action is leisure. Both are required, but leisure is better than work and is its end; and therefore the question must be asked, what ought we do when at leisure? Clearly we ought not to be amusing ourselves, for then amusement would be the end of life . . . we should introduce amusements only at suitable times, and they should be our medicines, for the feeling that they create in the soul is a relaxation, and from the pleasure we get rest. But leisure *as such* [my italics] gives pleasure and happiness and

In this point if no other, Puritanism has won a lasting victory. Work has now become the main business of life and the ground of reality for all classes of industrial society. And while the rich man may be far less "alienated" from his job than the poor, he is subject to the same "banausic" rule and pace of efficiency, which transform his leisure, too, into one without mental ease, a series of breathing spells, no matter how extended, in which it is difficult for him, too, to collect and recreate himself.[9]

The highest level that humanist culture seems to be able to attain under this new kind of leisure is the middlebrow. And according to the evidence we have so far, the quantitative increase and diffusion of such leisure do not promise of themselves to raise that level very much. Nor would the restriction of social movement, the further improvement of standards of living, or even the raising of standards of public education—not of themselves, not as long as leisure, and work, remain what they have latterly become for everyone.

Marx expected socialism, with a working day of four hours or less, to solve the problem of culture under modern industrialism (a problem to which he did not, for that matter, give a great deal of thought), but work, and efficiency in work, would still be necessary to the success of an integrally socialist as to any other kind of industrial order, and leisure, no matter how much enlarged, would still be dominated and enervated by work, and colored by the anxiety that the rule of efficiency seems to provoke wherever it is "internalized"—as it must be if industrialism is really to function.[10]

Nor is it likely that the presumably greater security of life

enjoyment of life; these are experienced, not by the busy man, but by those who have leisure. . . . there are branches of learning and education which we must study merely with a view to leisure spent in intellectual activity, and these are to be valued for their own sake. . . ." [Author's note]

9. Also important is the difference between a leisure supported by servants and one in which you have to fend for yourself with the aid of "modern conveniences" and labor-saving appliances. A single housekeeper provides more ease than a thousand gadgets, as Schumpeter says. [Author's note]

10. Once efficiency becomes a matter of conscience, the failure to be completely efficient—or even to be able to imagine what the perfection of efficiency is—weighs like a sense of sin. For no one is ever efficient *enough*. [Author's note]

under socialism would radically lessen that kind of anxiety and the demand for anodynes to relieve it. Thus not purely political or economic, not purely social or cultural measures appear to promise to solve the problem of authentic and high culture under industrialism—not as long as it goes unsolved in the sphere of work.

It is doubtful, moreover, whether that solution could be achieved merely by so changing work as to restore leisure as the theater of genuine culture while leaving work, as before, outside. This would require making leisure again the positive aspect of life and work the negative one. But this is impossible under full-fledged industrialism because it would mean relaxing efficiency. Industrialism, with all its burden, its work and routine, is accepted by and large because it opens up and begins to realize—for the first time—the prospect of a higher level of material well-being for all classes; to slacken efficiency would postpone that realization, and to this the mass of people in a country like ours, where the awareness of the relation between such causes and such effects has become almost universal, will not consent. If, therefore, the problem of achieving an authentic culture under industrialism has to be solved without reducing efficiency, or else not at all, then the only way out becomes the highly improbable one of making work itself the main sphere of culture—that is, of integrating it with culture *without* sacrifice of its efficiency. Which is also to say that work under industrialism, whether in factory or office, must be made the source of more immediate satisfactions for those who perform it.

The problem as stated looks so formidable, so unprecedented, that one's first impulse is to cast around for alternatives. So may we not ask, with Sir Herbert Read, whether it won't be possible for an authentic non-utilitarian culture to develop in industrial leisure on the basis of the kind of interest and activity that go into the hobby? May not leisure in that way be infused with some of the positive spirit of work and redeemed from its passivity? As it happens, the hobby is in its nature and history closely tied to industrialism. It has taken hold only during the last two centuries and, as distinct from the dilettante's or leisured man's avocation, can be defined as a homeopathic reaction from the purposefulness of serious and

necessary work (or acquisition) that takes the form of work (or acquisition) itself. One works at the hobby for the sake of the pleasure in work, and is able to take pleasure in it because its end is not serious or necessary enough to subject its means to the rule of efficiency (though one can make a hobby of efficiency too). The hobby asserts the value of one's time and energy in terms of immediate rather than ultimate satisfactions, and relates the end of work directly to the particular person who performs it.

The hobby is play, and play, according to Jan Huizinga, is the mother of culture. But play as such, under industrialism, is no longer *serious* enough to open the way to the heart of things—is rather a detour or escape. Authentic culture must, by definition, not be that. It has, instead, to lie at the center, and from there irradiate the whole of life, the serious as well as the not serious. It is serious work that has become, as I have said, the center of all our lives. If serious work—not leisure—can be infused with something of the spirit of the hobby, with something of its unseriousness, well and good; but not the other way round—not as long as leisure remains peripheral, as it must, and the hobby finds its only existence there.

But looking again into the remoter past, we discover that the necessity of integrating non-material culture with economic work is not altogether novel. We have only to follow traditional society far enough back. In certain respects, as Marx saw, we have come full circle. Everyone, as a rule, had to work in primitive societies, as they do now in an advanced industrial one. This made the question of culture in early societies, too, coincide largely with that of work, for they likewise had no leisure class to carry on culture as something apart from work. But these societies solved the problem automatically: that is, it did not exist before its solution.

The remoter pre-urban, and archaic urban past shows us art, religion, and lore, not only as barely distinguishable from one another in practice, but also as hard to distinguish, in intention, from the technologies of production, war, and healing. Rite, myth, magic, decoration, image, music, dance, and poetry appear to have been art, religion, lore, defense, work, and healing at once, all of them parts of a single complex

meant to safeguard mortal existence. Five thousand years of urban history have gradually separated these activities, with their implicit ends, and sealed them off from each other, so that we at last have art (or culture) for its own sake, religion for the sake of things knowable only outside life (or, like art to some degree, for the sake pure and simple of states of mind), and work for the sake of exclusively practical, "objective" aims. The problem now is to restore intimate relations between the three, or—with religion, as I think, ruling itself out as a social form—between the two. For if culture cannot be again closely related to work, it cannot be related closely enough to that reality which has again become fundamental for all of society.

Industrialism, imposing work on everyone—without, by that fact, doing away with exploitation—has confronted us more explicitly than ever before with work in its aspect as a limitation on human freedom—the aspect that author of Genesis must have had in mind when he described the fall of man (and beginning of history) as a fall into reproduction, work, and death. If man is to continue discovering and realizing his possibilities in history he will, at this point, have to broach the problem of culture and work—which is to say, of his mastery over work—more radically than he has so far.

It may be that industrial man will not be able even to begin to solve the problem; [11] it may be that the problem is permanently insoluble. But if so, then Eliot will have been right, and a revival of high, authentic urban culture must await the collapse or retreat of the industrial system, and the reemergence of a leisured ruling class on the basis of a new form

11. We do, I think, get a glimpse—if only that—of a part of such a solution in architecture, the healthiest of contemporary arts. The revival called the "international school" and—with less accuracy—"functionalism" is due in great measure to formal architecture's having, for practically the first time, been given the task of designing places of work. And in this task it has benefited from the growing realization on the part of industrial experts that cheerfulness and comfort can be as essential to efficiency as the more literally functional qualities of a building. That some number of people now get an immediate satisfaction from the décors in which they work such as they do not from the décors of their homes, and that this is provided by advanced, "highbrow" architecture, may be considered at least one gain for high culture under industrialism. [Author's note]

of the old order and of an economy of the old scarcity and squalor. . . . In the meantime, high culture, on its non-aesthetic side, may be able to survive as a set of special disciplines practiced during working hours by professionals—and to the extent necessary for the maintenance of the skills and knowledges required for the operation of the industrial system—but not as art, not as humanistic culture, not as something that informs, and is nurtured by, the presence of the mere well-educated citizen. And then high culture, as a department of industrial work—that is, as a thing worked at but not flowing from work—will impose the same strain as every other kind of industrial work, and the mandarins who work at it will have to devote their leisure to recuperation the way the rest of us do.

This is a speculation, not an assertion. The ingenuity shown by man in solving his social problems in the past—and especially in the pre-urban past—gives reason to hope that he will eventually solve this one too. The solution will not guarantee his happiness, but it will, if found, certainly make him more human.

VI

The field on which Eliot cast his eyes in *Notes Towards the Definition of Culture* is a limitless one. And in trying to show that his perspective was too short and too narrow, I myself have had to range breakneck over vast periods of time and through a variety of enormous questions. The reader will understand, of course, that I have had to simplify dangerously, and he will, I hope, make the necessary allowances.

Whether I have been able to offer more cheer than Eliot is doubtful. But I did want at least to avoid an even more dangerous simplification. Modern times are not as uninteresting, culturally or otherwise, as Eliot would let them be. And his tendency to assess our present situation with reference only to his proposed solution—an impossible return to a hypothetical past—makes his discussion much too simple. The situation is not only more interesting as a problem; it is also more interesting, and difficult and profound, as experience. Nor are the ideas of Spengler, Toynbee, and the other historical philosophers of "decline"—these ideas, too, involving a premature

rejection of the times—large enough to illuminate that experience sufficiently. And that last card—the return to God—which most of the conservative critics of modern culture will pull out of their sleeves in the showdown to trump all arguments and end all discussion, serves but to derogate reality further, and justify the failure to try to understand one's own experience of it. In that way, too, culture declines.

It may be Eliot's failure to continue experiencing his times—or at least to continue trying to understand his continuing experience—that explains his recent manifestations of weakness as a poet and literary critic no less than as a critic of culture. Pessimism as such is not to blame, but the uncritical quality of his version, the uninterestingness, the very completeness of it (which his somewhat Manichaean religious faith does not lessen). An utter pessimism can be just as banal and sterile as an utter optimism, just as remote from reality in all that manifoldness and contradictoriness without which it would be less than real. Reality is what we are concerned with in discussing the plight of our times, not in order to praise it, but for the sake of truth, the lack of which will do genuine culture more harm than any number of jukeboxes.

Commentary, June and July 1953; A&C (substantially changed).

30. Independence of Folk Art: Review of *Folk Art in Europe* by Helmut Bossert

Folk art in Europe goes back thousands of years, but it has been all but killed off now by industrialism. Not accidentally, German scholars were the first to take serious notice of what was until a short while ago too much under one's nose to arouse sustained curiosity. The Germans, for lack of a political past with which to identify themselves, sought an ethnic one that would serve the same purpose, and ended up by finding the non-urban past of all Europe. Professor Bossert had this all-European past in mind when he began to collect material in the 'twenties from every part of Europe for a thesaurus of decoration and ornament in folk or peasant art.

The book at hand is the distillation of a much larger prewar publication, and its intention is more practical than scholarly: namely, to serve as handbook for the stimulation of designers and decorators. Professor Bossert makes it quite explicit that he does not recommend it as a source of models for imitation. What are really two books with separate introductions are bound into one. The first contains forty plates in color of textiles, rugs and embroidered cloths; the second, thirty-two colorplates, plus sixteen in monochrome, devoted to wood and metal craft, pottery, beadwork and some further examples of weaving and embroidery. Each plate shows from ten to twenty-five different items, all from the same country, and an ample table of contents gives their dates of origin, their classification, provenance and present location. Not only is all Europe represented, but every century since the sixteenth. The reproductions are made on the basis of photographic tracings filled in with watercolor, and in some cases, I would surmise, actually enhance their originals.

Folk art had, like most of exotic art, to wait for modern painting in order to become appreciated seriously. And as art continues to grow more abstract, the formal virtues of folk art differentiate themselves increasingly for our eyes, and appreciation loses every vestige of condescension. Folk art is mostly decorative and applied, but decoration is no longer so humble. Nor are the applied arts either. Or rather, city art—what Professor Bossert calls *Stilkunst* in contradistinction to *Volkskunst*—is no longer so implicity patrician and turns against its Greco-Roman and even Gothic antecedents. Modern artists have, for that matter, shown us how intense and profound sheer decoration, or what looks like sheer decoration, can be. We are not put off as we used to be by the oppositions of bright flat color, or by a forthright geometrical regularity. This change in urban taste may rescue something of the spirit, if not substance, of folk art for industrial as well as high art—may, at least, enable something of its flavor to survive in more than a quaint or arts-and-craftsy way.

Was folk art an independent and aboriginal product of rural society, as Alois Riegl wrote in 1894, or was it city art gone to seed, as R. Forrer suggested in 1906? Professor Bossert's position is somewhere in between. Much of folk or peasant art

153

is undoubtedly a "parody" and distortion of motifs taken from urban art and surviving on the countryside long after their abandonment by the city. Yet the distortion and re-combination of these motifs were often so complete as to result in something largely new and independent. For folk art seems to have had some sort of nucleus to which to assimilate its borrowings. Certain habits in it, certain chains of association, are held to go back to pre-Christian times—though these things have not yet been sufficiently specified.

Professor Bossert charges Forrer with a failure to recognize the very essential difference between folk and *provincial* art. The latter maintains a constant contact with the city, the former a much more indirect and intermittent one. Provincial art is typical for those places where, as in Asia and Southeastern Europe until the last hundred and fifty years or so, the separation between way of life in country and town is not as sharp as it has been in Western Europe since the Renaissance and the rise of humanist culture (whose non-urban roots, such as they were, lay far back in the extinct rural life of ancient Greece and Rome). Thus folk or peasant art, as a distinctive art of the countryside, would belong only to Europe, for only there did city art become so incomprehensible to the "yokel" that in imitating it he changed it into something quite different.

Just as he is on the point, apparently, of claiming "unconditional originality for folk art as an independent primitive art over against *Stilkunst*," despite its ample borrowings from the latter, Professor Bossert draws back. It may still be possible, notwithstanding its pre-Christian nucleus, to conclude that folk art descends substantially from the provincial art of bygone times. This possibility remains because we still know too little about the "Romanesque, Gothic, Byzantine, and Islamic provincial styles that have to be taken into account as the preliminary stages of certain folk styles." The problem is a fascinating one. Some of the things illustrated in this book look singularly beautiful. The freshness of color and pattern in the textiles often takes one's breath away. In the wood and metal work and the ceramics, the quality is much more uneven, as if the peasant artist could not conceive large shapes, or decorate irregular ones with the same unembarrassed ingenuity that he displayed when patterning rectangular pieces of cloth. (We see

once again how much Klee got from peasant art, and how well he transmuted what he got in order to make it easel painting.) Professor Bossert reminds us, however, that the point of folk art was not originality, and that the forms and patterns of the objects illustrated in his book were duplicated countless times with variations only in skill and in details of workmanship. Folk art was mass-produced as regards design; loving care entered, but into the actual making of it—the care and conscientiousness and pride of skill and material quality of the person who made things of use for himself (usually herself) and his close ones. And if the design did change, it was thanks to the most modest of impulses towards self-assertion.

Art News, September 1953

31. Symposium: Is the French
Avant-Garde Overrated?

French prestige does account in large part for the success, much greater than the domestic article's, of the latest importations of French abstract painting—and not only of abstract painting. But it doesn't explain it altogether. [1]

There is a crucial difference between the French and the American versions of so-called abstract expressionism despite their seeming convergence of aims. In Paris they finish and unify the abstract picture in a way that makes it more agreeable to standard taste (to which taste I object, not because it is standard—after all, the best taste agrees in the long run— but because it is usually at least a generation behind the best of the art contemporaneous with it).

For all the adventurousness of their "images," the latest generation in Paris still go in for "paint quality" in the accepted sense. They "enrich" the surface with films of oil or varnish, or with buttery paint. Also, they tend to tailor the

1. The editors of *Art Digest* asked Ralston Crawford, Robert Motherwell, Jack Tworkov, and Greenberg to present their opinions about "advanced Parisian art and about the phenomenal critical and financial success which it has enjoyed in this country." [Editor's note]

design so that it hits the eye with a certain patness; or else the unity of the picture is made to depend on a semblance of the old kind of illusion of depth obtained through glazing or tempered color. The result is softer, suaver, and more conventionally imposing than would seem to accord with the "idea" or inherent tendency of the new kind of abstract painting. If "abstract expressionism" embodies a vision all its own, that vision is tamed in Paris—not, as the French themselves may think, disciplined.

The American version is characterized, in failure as well as in success, by a fresher, opener, more immediate surface. Whether it is enamel reflecting light, or thinned paint soaked into unsized and unprimed canvas, the surface *breathes*. There is no insulating finish, nor is pictorial space created "pictorially," by deep, veiled color, but rather by blunt corporeal contrasts and less specifiable optical illusion. Nor is the picture "packaged," wrapped up to seal it in as an easel painting. The canvas is treated less as a given receptacle than as an open field whose unity must be permitted to emerge without being forced or imposed in prescribed terms. All this, of course, makes the American article harder to take. Standard taste is offended by what looks like an undue looseness and, as usual, mistakes a new spontaneity and directness for disorder or, at best, solipsistic decoration.

Do I mean that the new American abstract painting is superior on the whole to the French? I do. Every fresh and productive impulse in painting since Manet, and perhaps before, has repudiated received notions of finish and unity, and manhandled into art what until then seemed too intractable, too raw and accidental, to be brought within the scope of aesthetic purpose. This extension of the possibilities of the medium is an integral factor of the exaltation to be gotten from art, in the past as now. I miss this factor in too much of the latest Parisian painting; the latter does not challenge my sensibility enough. The best pictures of Gorky, Gottlieb, Hofmann, Kline, de Kooning, Motherwell, Newman, Pollock, Rothko (nor are these our only painters), offer a plenitude of presence that those of Fautrier, the Dubuffet of 1945–48, Hartung, Tal Coat (the four I like most among the Paris painters under 55 whose works I've seen) seldom match. And when

I say "plenitude of presence" I don't mean a newfangled thrill, but something I find, *mutatis mutandis*, in successful art of the past.

Our new abstract painting seems to have anticipated the Paris version by two or three years, but I doubt whether there has been, or is yet, any real acceptance of American influence on the part of the French (and I don't much care). The development of post-cubist art had brought American and French painting to the same point at about the same time, but we had the advantage of having established Klee and Miró as influences before Paris did, and of having continued (thanks to Hans Hofmann and Milton Avery) to learn from Matisse when he was being disregarded by the younger painters in France.

And André Masson's presence on this side of the Atlantic during the war was of inestimable benefit to us. Unfulfilled though he is, and tragically so, he is still the most seminal of all the painters, not excepting Miró, in the generation after Picasso's. He, more than anyone else, anticipated the new abstract painting, and I don't believe he has gotten enough credit for that.

Art Digest, 15 September 1953; A&C (slightly revised).

32. Two of the Moderns: Review of
Chagall by Jacques Lassaigne and
Soutine by Raymond Cogniat

The reputations of Matisse, Picasso, and the other contemporary masters rest ultimately on a comparatively small number of masterpieces sorted out from a much greater number of unsuccessful or trivial works. Titian, Velasquez, and Rubens, too, produced many unsuccessful pictures, but these ordinarily led *toward* their successful ones; the curious, the problematical thing about the great moderns is that their bad pictures, once the artist has reached maturity, usually lead *away* from their good pictures. Why this should be so, I do not know, but it contributes to the impression of an anarchy of tendencies and directions made by modern art as a whole—an impression that

is fundamentally false because in its best products modern art does go pretty much in the same direction.

The late Chaim Soutine offers an exception and a paradox in that his good and bad pictures lead towards each other and require each other without this making his work any the less problematical. A further paradox is offered in that the capacity of Soutine's painting to involve, intrigue, and affect other artists is out of all proportion to its degree of realization. His ratio of hits to misses is low, and even when he did hit a picture off, more often than not it teeters on the edge of a miss. It is this very teetering, however, that makes Soutine's painting so interesting to fellow artists—because it tells so vividly of the self-torture of modern painting, its inherent difficulties and frustrations, but also of the possibilities of triumph just within its reach.

Chagall got what he wanted in painting far more often than Soutine did. If the latter is the type of the tormented, dissatisfied artist, Chagall seems by contrast the type of the serene one. But this serenity is still more apparent than real, for Chagall has his doubts in plenty, only does not work them out so conspicuously in his art. He did his best oils between 1910 and 1920, and these are enough to install him in the history of art as a painter of at least the second rank. Since then his work has been softened and sweetened by the practice of that cuisine of viscous oil which seems to incorporate for him the essence of French tradition—a tradition he adores as only one originally an outsider could. However, in a few recent "pictures" (shown in New York this past winter) that were done on flat square tiles mortared together to form a support like a canvas, with the pigment fired in and the surface either glazed or unglazed, his color has recovered some of the raw immediacy that was one of the notable strengths of his early work. If his tile paintings continue to maintain this level, we shall have to assign him a larger place in the pantheon of modern art.

In any case, as an etcher and lithographer, as distinct from painter, Chagall belongs altogether in the first rank, unrivaled except by Picasso in this century; and his book illustrations, together with that master's, make a last glorious burst in what seems to be an expiring art. His blacks, whites, and grays are

here the subtler and profounder expression of a gift for color that too often contents itself in oil with tried and true effects obtained from standard recipes.

But I find Soutine not only more interesting than Chagall, for all his deficiency in achievement, but more sympathetic. Far away from him is that cloying, folkish cuteness which the latter cultivates in his role of lovable, fantastical Jewish genius from Vitebsk. Soutine had no truck with such self-indulgent exhibitionism. He was, if I may put it that way, too Jewish—or at least too much a Litvak—to put his East European Jewishness on show as something exotic and picturesque. Yet, if such a thing as Jewishness can be made palpable in art, I find more of it in Soutine's than in Chagall's. Soutine is more naive and direct and absorbed, less self-conscious and more involved with his feelings than with the effect in view. He looked away from himself, and the trees, fields, flowers, animals, houses, and people he painted from are not a set of iconographic themes on which to ring variations, as his subjects are for Chagall, but so much existence to be grasped through paint.

Coming to Paris from a *shtetl* in that same Lithuanian White Russia which Chagall came from, Soutine got his first good look at the museum art of the West in the Louvre when he was already past adolescence. He never got over it. Chagall was affected in the same way by the Louvre, but he remained less hypnotized; he deliberately went to school with Cubism and Matisse, whereas Soutine, for all he absorbed from modernism, never really gave it his assent. Aspiring above all to the depth, volume, and illustrative power that Rembrandt and Courbet got by shading, he was yet unwilling to sacrifice the expressive force of pure color as he had seen it in van Gogh; nor could he put out of his mind the way Cézanne built a picture by massing planes of prismatic tone. But these divergent methods and aims could be reconciled only if one or the other of them were drastically subordinated. Soutine's stubborn, arrogant refusal to cede an inch anywhere is as much responsible for the frenzied, turbulent look of his pictures as the high pitch of feeling at which they were painted.

This effort to do the impossible, the absoluteness of it, and the terms of it, are what fascinate so many painters today.

This, aside from his extraordinary capacity for color, pure and impure. And at the moment regard for his painting grows among non-painters too. But it should be mentioned that a lot of collectors buy him, and have bought him, mainly because he was a Jew and they themselves are Jewish (the nationalism that many Jews express in collecting art, all the more ardent for being unconscious—most of them would shrink from anything positive in the way of *that* kind of nationalism—is a curious feature of the modern art scene). This does not, however, take anything away from Soutine; he will remain, I believe, one of the very most important of the artists of our century, however incomplete.

The Soutine portfolio at hand, with an introduction and very brief notes on the individual pictures—both full of turgid commonplaces—contains ten color plates of good quality made from fairly representative originals. The only fault I have to find with their choice is that nothing is included from the last years of the artist's life, when he won through to a kind of calm that made possible a firmer control and unity of means, the result of which was some *complete* masterpieces. Also, some of the plates seem to have been trimmed a little, to judge from the way the end of Soutine's signature is cut off—but then that may have been his own doing.

The selection of the pictures reproduced in the Chagall portfolio makes more or less the same assessment of his career as I do (which is pretty standard): seven date from between 1910 and 1913. The three others, from the 1940's, are particularly well chosen, being among the few superior works Chagall turned out in that decade. And the introduction offers at least some facts about his life, while the notes on the pictures are more honest and perceptive than those in the Soutine portfolio—which may not be saying much.

Commentary, October 1953

1954

33. Some Advantages of Provincialism

The correct thing for those who care about correctness is to deprecate American art. One way is to talk about immaturity; another is to refer to the "materialism" of the country in general. Still another, and more unusual, way is to make specific judgments and draw distinctions between past and present. The last, I believe, can be valid, but ought not to be exaggerated. The past of American art, or at least of American painting, is not a calendar of triumphs, but it is not a mere record of frustrations either.

The Metropolitan Museum's grand exhibition of 200 years of American art since 1754, in celebration of the bicentennial of the founding of Columbia University, includes watercolors, drawings, prints, miniatures, decorative art, photographs and sculpture, but is devoted preponderantly to oil paintings. With a relative few exceptions, the works shown are from the museum's own collection. While the show does not make the best possible case for American painting, least of all in its present phase, it affords a representative enough survey of its past. I list the omissions that spring to mind, but in the belief that the museum regrets them as much as I do: Catlin, Quidor, Wyant, of the remoter past; of the more recent past, Twachtman, Murphy, Ranger, Preston Dickinson, Bluemner, Maurer, Arnold Friedman, Glenn Coleman, MacDonald-Wright, Morgan Russell, Stella and Walkowitz. Moreover, Whistler, Chase, Kensett, Heade, Allston, Blakelock, Whittredge and Hartley are not represented in adequate examples; Copley and Stuart could have been made to shine more brightly, and at least one of Marin's oils should have been included.

On the other hand, there are a number of compensating surprises for which a non-specialist cannot be too grateful. John Trumbull's twin portraits of John and Hannah Murray

raise faithful likenesses to an intensity of art all the more convincing because the means are so reserved. To this writer, Charles Loring Elliott, Chester Harding and Samuel Lovett Waldo—all three of whom died in the 1860s—had meant genteel middle-class versions of British portrait tradition, which indeed they are, but they are also much more, as some of their pictures at the Metropolitan now testify. Waldo's *Old Pat, The Independent Beggar* is a feat of sympathy as well as of liquid, ruddy color, and his portrait of his wife is superb in its own way; obviously, neither was a commissioned picture. Harding's *Mrs. Thomas Brewster Coolidge* and *Patroon Van Rensselaer* are more formal, but dignity does not interfere with honesty or freedom. Elliott does not reach quite as high a level in the *Caleb Casper* and *Preston H. Hodges*, but both pictures stand out for their directness and their sureness of handling. A fifth surprise (or rather a fourth, since Trumbull was not altogether a surprise) was Thomas Wilmer Dewing (1851–1938), whose interior with figure, called *The Letter*, is very 1900 in its intimacy, but more than distinguished by its delicate, lambent color.

Serious American painting through most of the 19th century would seem to have consisted largely of bust portraits and unpeopled landscapes. There is a sameness of theme in the first long halls at the Metropolitan, and perhaps of treatment, too—as we might expect from a body of art that was provincial in relation to the current capitals of art: the main trait of any provincial art being precisely a lack of variety and of strongly marked individuals. But there are still other reasons for the sameness. Genre was a favorite subject of the century, but it is scantly represented before 1900—as if, aside from Homer and Eakins, it came to serious fruition only with Sloan and the others of The Eight, who learned about it from Manet and Goya, not from the Dutch 17th-century and Düsseldorf. Mount is shown in a lone landscape—actually, one of the very best things in the exhibition—but he also specialized in genre pieces, not one of which is present. Apparently, the predominant kind of genre turned out in this country, being aimed at popular taste, was deemed insufficient in quality by the rather genteel taste responsible for the bulk of the Metropolitan's collections. With a few exceptions, that taste may have been

right. Not that it did not commit serious errors in other directions, only it was not altogether misguided, as we begin to feel, in refusing to anticipate our present esteem—as distinct from liking—for naive or popular illustrative art. A Harding or Waldo is worth a half-dozen John George Browns, refreshing though the latter may be.

Does nothing in 19th-century American painting transcend provincialism? Almost nothing. We have only to compare Homer and Eakins (in my opinion, the very best of it) with Manet and the Impressionists. The two Americans are unique, but want breadth, lack development, fail of sustained originality. Homer anticipates, but he does not originate, save in watercolor—and what he started there is less important than what he anticipated, without originating, in his early oils. But having granted its provinciality to the detractors of American art, we are better able to refuse them some other judgments. Stanislaus Lepine was as good a painter as France could show in the latter half of the 19th century, short of the famous masters, but his best landscapes will not stand comparison with an early Homer like *The Veteran*, a wonderful bright brown picture (borrowed from Mrs. Adelaide Milton De Groot) which I saw for the first time in this show.

It would seem almost as if pictures like this came to the young Homer before he had had time to ponder the seriousness of his calling. Almost every other ambitious American painter, whatever his native gift, has had to make a very conscious and strenuous effort in order to possess his craft. American art was always being outstripped by developments elsewhere, and acquired skills constantly threatened with obsolescence, and therefore with quaintness. At the same time the question of style, which was also one of culture, was mixed up with the question of proficiency by people unsure of their culture. Many an American artist mistook the means for the end in this situation, and surrendered his character to an international technique, to "culture"—and we have had some very obsessed and cultured technicians: arty artists like Whistler, mundane ones like Sargent, energetically effete ones like Sully (I mention these three because they are worth mentioning).

There were others who refused to dismiss the claims of original temperament and character, but found these difficult

to realize because no style within their ken was organic to them; yet they lacked the confidence, the culture, to dare to try to shape true styles of their own, always doubting their proficiency and being troubled by questions of technique. Within such limits, painters like Homer, Eakins, Inness, Ryder, Robert Newman and lesser ones before and after, strove nonetheless for a maximum of personal truth. They were afraid to take liberties with style—or, again, culture—and their truth remained a comparatively modest, even prosaic, one, but it was still the truth; a tradition of artistic probity developed in this country which latter-day American artists, whether or not they are trying, as their elders did not, for the world's championship, can still consult profitably.

The large room devoted to contemporary abstract art at the Metropolitan comes more abruptly than it should because intervening links like Walkowitz, Stella, Arnold Friedman and Maurer are missing. But even had they not been, the transition would still be abrupt enough. Pollock, Gottlieb, Motherwell, Stuart Davis seem to have grafted themselves upon a European trunk as decidedly as West and Copley did almost 200 years before. However, they have not had to settle abroad in order to do so. And whereas West and Copley became altogether part of the British school, these latter-day Americans constitute an American school that by now finds most of its nourishment at home. This makes a big difference—the biggest difference yet, but not one that should blind us to what American art did before. We have not been a country without art in the past, and as provincial as our art may have been, it gave us more than a few things whose like cannot be found elsewhere.

Art Digest, 1 January 1954

34. Master Léger

Léger was overlooked for a while. The conscious preoccupations of the younger painters in New York during the '40s lay in a different quarter; and so few of his 1910–13 pictures were

known. He was over here during most of the war, and what he showed us then was not impressive. Nor—but let this be said to his credit—did he try to impress us with his personality. Now we have begun to know better. His large retrospective at the Museum of Modern Art (where it came from the Chicago Art Institute, which organized it) makes it quite clear that, besides being a major fountainhead of contemporary style, Léger belongs with Matisse, Picasso, and Mondrian among the very greatest painters of the century.

The sequence of promise, fulfillment, and decline his exhibition revealed was much like that in the previous Matisse, Picasso, and Braque retrospectives, and its dates site the chronological contour lines of School of Paris painting over the last forty or fifty years. For Matisse fulfillment came between 1910 and 1920; for Braque, between 1910 and 1914; for both Picasso and Léger, between 1910 and 1925. None of the four was ever, before or after these dates, as consistent in quality, and very seldom as high.

Michel Seuphor refers to 1912 as "perhaps the most beautiful date in the whole history of painting in France." That year Cubism reached fullest flower, and Léger was one of the three artists mainly responsible, even though he did not paint with "cubes." Nineteen thirteen was another beautiful year, perhaps more so for him if not for Picasso and Braque. In 1914 he had, like Braque, to go to war, and the few paintings he finished while in the army are rather weak. But he recovered his level as soon as he had the chance to work regularly again, and the pictures he did from 1917 until at least 1922 are just as original and perhaps even more seminal. Yet they do not quite come up to the pure, the utter finality, the poised strength of his 1911–13 work—just as Picasso's art between 1914 and 1925, while manifesting its own kind of perfection, rarely attains the transcendent perfection it knew before. The same is doubly, triply true in Braque's case, though he did experience a partial—very partial—recovery between 1928 and 1931 or 1932.

The four years from the middle of 1910 to the middle of 1914 were the special ones, then. But just what made them so exceptionally favorable to painting? A trio of geniuses, born within a year of one another, were in their early thirties—but

Matisse, who was approaching his peak during the same period, was then in his forties. More of the answer may be given by something that extends far beyond the individual circumstances of the artists involved. In France, and elsewhere, the generation of the avant-garde that came of age after 1900 was the first to accept the modern, industrializing world with any enthusiasm. Even poets—thus Apollinaire—saw, at least for a moment, aesthetic possibilities in a streamlined future, a vaulting modernity; and a mood of secular optimism replaced the secular pessimism of the Symbolist generation. This mood was not confined to the avant-garde; here, for once, the latter had been anticipated by the philistines; but the avant-garde was drawing the aesthetic conclusions at which the philistines balked. Nor was painting—and sculpture—the only department of culture to benefit by this. Yeats, Joyce, Eliot, Proust, Mann, Valéry, Rilke, George, Hofmannsthal, Kafka, Stravinsky, Schoenberg, Freud, Dewey, Wittgenstein, Husserl, Einstein all developed or matured in the years of that same mood, which underpinned even those who rejected it. But professional tradition in painting, having long been distinctively secular (what great painter since El Greco was fundamentally a religious man?), now received new, and perhaps, special confirmation from its public, and felt itself to be more in the truth than ever before.

Whatever the reason, it came about that one of the greatest of all moments in painting arrived on the crest of a mood of "materialistic" optimism. And of all the optimists, materialists, and yea-sayers, none was, or has remained, more wholeheartedly one than Fernand Léger. He has told us about, and we see, his enthusiasm for machine forms. And we also seem to see in his art all the qualities conventionally associated with "materialism"; weight, excessive looseness or else excessive rigidity of form, crassness, simplicity, cheerfulness, complacency, even a certain obtuseness. But what a mistake it would be not to see how much else there is in this art, which has succeeded better, I daresay, than any other in making the rawness of matter wholly relevant to human feeling.

However, Cubism was more than a response to a certain historical moment and its mood. It was also the outcome of anterior events within painting, and an understanding of these

opens the way to the understanding of Cubism as an event itself.

In Renaissance pictorial tradition the represented object always stood, in Aristotelian distinction from everything not itself, in front of or behind something else. Cézanne was one of the first to worry consciously about how to pass from the contours of an object to what lay behind or next to it without violating either the integrity of the picture surface as a flat continuum, or the represented three-dimensionality of the object itself, which Impressionism had inadvertently threatened. The Cubists inherited the problem, and solved it, but—as Marx would say—only by destroying it: willingly or unwillingly, they sacrificed the integrity of the object almost entirely to that of the surface. This—which had, however, nothing intrinsic to do with aesthetic value—is why Cubism constituted a turning point in the history of painting.

Picasso and Braque began as Cubists by modeling the object in little facet planes, borrowed from Cézanne, in order to define its volume more vividly. But the threatened outcome of this was to leave the object standing away from its background like a piece of illustrated sculpture; so, eliminating broad color contrasts and confining themselves almost entirely to shades of brown, gray, and black, they began to model the background, too, in facet planes, as Cézanne in his last years had modeled cloudless skies. These facet planes became increasingly frontal—that is, parallel to the plane of the canvas—and soon, to make the transition from object to background even less abrupt, and expedite the transition from plane to plane within the object itself, the facets were almost all left open; whence the truncated rectangles and triangles and the semi-circles which remained the characteristic vocabulary of Picasso and Braque's Cubism until 1913. Amid all this, contours and silhouetting lines were lost (especially when the object was spread apart so as to show its surface from more than one point of view): the space inside the object now faulted through into surrounding space, and the latter could be conceived of as, in return, penetrating the object. All space became one, neither "positive" nor "negative," in so far as occupied space was no longer clearly differentiated from unoccupied. And the object

was not so much *formed*, as exhibited by precipitation in groups or clusters of facet planes out of an indeterminate background of similar planes, which latter could also be seen as vibrating echoes of the object. Either way, the Cubists ended up by doing with form what the Impressionists, when they precipitated their objects out of a mist of paint flecks, had only begun to do with color—they erased the old distinction between object-in-front-of-background and background-behind-and-around-object, erased it at least as something felt rather than merely read.

Picasso and Braque started Cubism: Léger joined it. He, too, was influenced by Cézanne after 1906, but he had used him at first for ends closer to those of Futurism, analyzing the object to show how it could move rather than how it managed to present a closed surface to eye or finger. But by 1912 the main thing for him, as for Picasso and Braque, became to assert the difference between pictorial and three-dimensional space. Though Léger's vocabulary remained different and its units larger in scale, his grammar became a similar one of straight lines and faired curves. The curves predominated with him, but the sketchy black lines that traced them left his forms just as open in effect; and the way he modeled his roundnesses—with primary blues, reds, or greens swatched around highlighted axes of crusty white pigment laid on so dry and summarily that the canvas showed through here and there—caused these roundnesses to be felt simultaneously as both curved and flattened planes. The different directions in which the cylindrical or conical forms slanted, the interspersed cubes and rectangles, the equivalence of the different colors none of which advanced or receded more than any other, the sense of volumes compressed in ambiguous space and always presenting their broadest surfaces—all this likewise erased the distinction between object and background, object and ambiance. The objects, or their parts, seemed to well into visibility out of a background of similar, interchangeable elements; or it was as if the surface were repeating itself in endless depth. The first and decisive effect was of a welter of overlapping planes. To sort these into cones, cylinders, and cubes was easy enough, but to assemble them into recognizable objects required almost as deliberate an effort on the part of the specta-

tor as to read Picasso's and Braque's "analytical" Cubism. And need I say that the deliberate effort contributes least in the experience of art?

The logic of Léger's analysis is nevertheless simpler than Picasso's or Braque's. He dissects broadly, articulating objects into their anatomical units of volume, which remain larger, and more obvious in their references, than the little planes into which the other two artists chip the surfaces of volumes. Perhaps this simplicity is what induced him, in 1913, to abandon recognizable objects altogether and paint several definitely abstract pictures with planes defining cylinders and cones that signify nothing else, and flat rectangles that define not even volume. (These works, of which there is no example in the Chicago-Museum of Modern Art show, all have the same title, *Contrast of Forms*.) Only a short while previously, Picasso and Braque had invented the collage, which, for them, turned out to be a way of saving the recognizable object from dissolution in abstract art. The object may have become for a moment even less recognizable than before, but a searching eye could still decipher it. It was Léger alone of the three master Cubists who drove analytical Cubism to its conclusion. Not that he arrived at the flat picture, as Mondrian, drawing the very ultimate consequences of Cubism, was to do, or that he even approached the flatness of Picasso's and Braque's collages: the priority analytical Cubism gave the picture plane was never absolute, and Léger always held on to some sort of illusion of depth. But he did accept, as Picasso and Braque did not, the full implication of the method of analytical Cubism: namely, that once objects are broken up into more or less interchangeable units they themselves are no longer necessary as entities—no longer necessary to the decisive effect—and the artist is free to work with the units alone, since these alone retain aesthetic pertinence. As it happened, the units into which Cubism resolved the object were planar units, but they could conceivably have been the chromatic units of the Impressionists and Neo-Impressionists.

However, Léger's evolution toward abstract art should also be seen in terms more personal to himself: his predilection for weight and decorative balance, and a *horror vacui* greater even than Picasso's, led him, again in 1913, to begin packing the

picture toward margins formerly left vague, and he found himself mustering his planar units toward a density and compactness for which there were not enough hints in nature. What nature could not supply, the planar units did by multiplying themselves in complete independence of the laws under which surfaces and their planes materialize in non-pictorial reality. Léger did not create abstract art for more than a brief period; later on, after the war, he would do a few more abstract pictures, but only intermittently, not as settled practice. In the final reckoning he was no more willing than Picasso or Braque to abandon nature altogether. The reason for this reluctance on the part of all three, and of Matisse too, is one of the most interesting of topics in contemporary art criticism, but not one to be broached here. Suffice it to say that the personal rejection of abstract art by the artists who did the most to clear the way for it calls for no value judgments.

The realization, original with Cézanne, that the eye, by following the direction of surfaces closely, could resolve all visual substance into a tight continuum of frontal planes had given the painter a new incentive in the exploration of both nature and his medium—and a rule, at the same time, to guarantee the aesthetic coherence of what was discovered. Picasso, Braque, and Léger, it could be said, were the only ones intrepid enough to carry the exploration to its end, and able by genius to apply the rule fully and yet in terms of their own temperaments. (This is to subordinate, but not to dismiss, the work of the other Cubists, who were all their followers to some extent.) Thus these three could for three or four years execute a well-nigh unbroken series of works that were flawless in unity and abundant in matter, works achieving that optimum which consists in a fusion of elegance and power that abates neither. Then the matter, for them, was exhausted, and the rule lapsed. Henceforth neither they nor any other artist could expand taste by these means, and to cling to them any longer would mean to depend on taste instead of creating it.

By 1912 or 1913 "synthesis," as I have indicated, began to replace "analysis" in Picasso's and Braque's collages. At those points where the picture was nailed to its physical surface by pieces of pasted newspaper or *trompe-l'oeil* textures, the facet planes fused into larger shapes, and gradually the object or its

part re-emerged in flat, distorted profile, to be locked into the equally flat profile of background, or "negative," space. The result was a tight picture-object in which the illusion of depth was given by overlapping and up-and-down placing but never by shading (which had played an important part in analytical Cubism) or anything else. Bright color came back, but it was almost absolutely flat color. Now the priority of the picture plane was asserted in a different and more radical way: the object was not disintegrated by the pressure of shallow space, but rolled flat in flat space—or at least space that was felt, if not read, as flat. Here Picasso found a new rule of coherence almost, if not quite, as efficacious as the previous one, and it took him ten years to exhaust its application.

Léger entered upon his own variety of synthetic Cubism as soon as he got out of the army, in 1917. In the large *City*, finished in 1919, foreground and background, object and ambiance, are alike cut up into vertical strips and discs and squares that are recombined on the surface as well as in shallow depth in a grandiose montage. He had not had to practice collage in order to learn from it. He still shades, in dark and light now, not in primary colors, but it is more for decorative and architectural effect than to produce the illusion of volume as such, and the contrast of the shaded forms with large and small areas of flat color achieves the effect of a façade, but a façade that transcends architecture by its complexity and intensity. The rhythm counts above all now, and will continue to as the artist veers away from a course parallel to Picasso's and takes hints from the Matisse of the large canvases of 1916 with their discontinuities of imagined space and abrupt but cadenced juxtapositions of broad vertical bands of color. Such concerns remain, and will remain, largely alien to Picasso, whose unrivaled capacity as a composer-designer is tied to a certain traditionalism which makes him reject large, insistent, emphatically decorative rhythms in his easel paintings.

Léger's last complete masterpiece, as far as this writer knows, is the huge *Three Women* (also called *Le grand déjeuner*) of 1921, in the Museum of Modern Art's permanent collection, a picture that improves steadily with the passage of time. Later on, Léger will be able to secure unity only by elimination and drastic simplification, but here he achieves it by adding,

varying, and complicating elements simple in themselves. First, staccato stripings, checkerings, dottings, curvings, anglings—then a massive calm, the calm that always supervenes in great painting. The great tubular, nude forms, so limpid in color, so evenly turgid, yet with their relief so firmly locked in place between busy foreground and even busier background, and their contours so expertly adjusted to still the clamor around them—these own the taut canvas as no projection of a more earnestly meant illusion could.

For Léger, as for Picasso, the impetus of Cubism gave out during the last half of the '20s. Nothing after that—and I say *nothing* advisedly—equals the breadth or finality of the pictures done between 1910 and 1925. We still get the general flavor of a great artist, but not—measured by the standards he himself instanced—great art. The firm, heavy, simplifying hand now reveals its liabilities as well as assets; what it addresses crumbles under the pressure, and machined contours and rawly decorative color schemes freeze it into but a mechanical coherence. Color, which is Léger's secret weapon, never goes quite dead—or never, at any rate, as dead as for Picasso and Braque in these later years—but that is not enough. The color may be justly felt in some of the heraldic clusters of objects and fragments, suspended in mid-air, of which Léger produced so monotonously many in the '30s and '40s, but these hang almost as limp as the others, limp past redemption—unless translated into tapestry, as one was, to its benefit, in 1950. Color, among other things, has a pleasing, old-fashioned, lithographic, popular-print sort of picturesqueness in the *Leisure* of 1949, but the composition wobbles and flutters underneath, and the result is no more than an uncertainly nice picture. And the large, bright *Builders* of 1950 is not even nice.

Despite some appearances to the contrary, Léger remains a very accomplished painter; moreover, he is still able to execute things whose virtues are more than those of plausibility. I have in mind certain small still lifes done within the past twenty years, but of which there is no example in the present show. On the other hand, there are the showpieces, which are in the show. The large *Three Musicians* of 1944 is solid and compact,

but lacks tension and intensity, as does also the large *Adam and Eve* of 1939, whose undulating chiaroscuro, for all its presence, over-unifies the picture and renders it too bland. Yet, as is obvious, only a master—a master who has, or had, greatness in him—could have turned out either of these two paintings. I should have liked to see the final, largest version of the *Bicyclist* series of 1944–45 in the exhibition; it does much the same thing as *Leisure* but, as I remember it, much better. Certainly, that series did not deserve to be represented by *The Great Julie*, also in the Museum of Modern Art's permanent collection, with its forced, arty color, a middlesized picture that is still far too large for its content. Perhaps the evidence in general could have been better chosen to make a case for the post-1925 Léger, but even so, I do not think it could have altered the conclusion much.

The decline that overtook Léger after 1925, as it did so many other estimable members of the School of Paris, was made all the more marked in his, as in Picasso's, case by the refusal to sit with past triumphs and repeat himself. Léger having created taste and still seeking to create it, but in vain, taste now revenges itself on him all the more, as it also does on Picasso—and as it seems to have done on other great artists at one time or another in their careers. This, however, is not all there is to it.

And far be it for anyone to write *finis* to a great artist's career before he dies. Matisse surprised us by painting a picture in 1948 that can stand up to anything he did in the past—the *Red Interior*. And Léger is not yet as old as Matisse was then.

Partisan Review, January–February 1954; A&C (substantially changed); *Modern Art and Modernism: A Critical Anthology*, ed. Francis Frascina and Charles Harrison, 1982.

35. Foreword to a Group Exhibition
 at the Kootz Gallery

These artists vary in direction and age, but have in common talent and seriousness—and the fact that none has yet had a

solo exhibition of painting in New York.[1] Nor, curiously, is any one of them a native of New York, city or state. Three still live elsewhere: Paul Feeley, from California, teaches painting at Bennington College; Morris Louis, from Baltimore, teaches it at Howard University in Washington, D.C.; and Kenneth Noland, from North Carolina, does the same at Catholic University, also in Washington. Saul Leiter, Philip Pearlstein, and Theophil Repke are from Pittsburgh; Herman Cherry comes from California; Paul Georges, from Oregon; Cornelia Langer, from North Dakota; Anthony Louvis, from New Jersey; and Sue Mitchell, from Tennessee, where she still lives part of the year. These eleven painters do not by any means represent all the unexhibited 'emerging talent' around, but simply some of the most interesting of that which has come within my view.

Emerging Talent, New York, Kootz Gallery, January 1954

36. Review of *The Art and Architecture of India* by Benjamin Rowland, *Painting in Britain* by E. K. Waterhouse, *Art and Architecture in France* by Anthony Blunt, and *Architecture in Britain* by John Summerson

This is one of the most ambitious projects yet launched in the field of art history, as well as the first of its kind in English. The Pelican History will cover the art of all mankind in forty-eight separate volumes. Each, to judge from the first four, will be a handsome, sturdy book containing from 150,000 to 180,000 words of text and notes, a bibliography, an index and in some cases appendices and a glossary, together with about three hundred half-tone illustrations, plus maps, drawings, and plans where needed. Nikolaus Pevsner, Slade Professor of Fine Art at Cambridge, is editor of the whole, and "most of the contributors . . . are British and American scholars . . . others are experts from France, Germany, Austria, Holland

1. Greenberg selected the painters in the exhibition, in addition to writing the foreword. [Editor's note]

and Sweden." As it appears, a single author will be responsible for each book.

Some no doubt will find fault with the way the subject-matter for three of the four (very auspicious) volumes at hand has been apportioned. The authors themselves do not pretend that the chronological divisions within which they work are necessarily organic. Granted that the books have to be kept handy and uniform in size, how else can this be done but by cutting art history up into periods, schematic or no? And can this ever be done to everybody's satisfaction? The publishers have many titles still to come, and it remains to be seen how they will further cope with the problem—and also whether the decorative and applied arts will get their due.

In their measured way the publishers promise a good deal: "It is one of the terms of reference of the authors selected to write the various volumes that they shall not regard themselves as mere encyclopedists presenting established facts, but provoke the reader to think for himself about many of the issues which are still open." One is not exactly clear as to what issues are meant. To judge from the first four volumes, they are not those of dating, provenance, or attribution. Nor yet are they those of evaluation or interpretation, although the authors do evaluate and interpret.

Perhaps what is meant is everything the authors refuse to generalize about, but the reluctance to generalize is precisely the largest fault this writer finds in all four of these otherwise superb books. And their objectivity is not sufficient compensation for this, because generalization need not have militated against objectivity.

As might be expected, the three English authors write with urbanity and a characteristic flavor of enlightened common sense, whereas the one American, Dr. Rowland, who is Professor of Fine Arts at Harvard, is a little cantankerous. Each volume is admirably organized, and reads fluently—at what cost in terms of elimination and simplification, only the specialist can tell; I myself tend to think it has not been exorbitant. Much speaks for the guiding hand of a very competent editor or set of editors. However, the copy-editing is far from faultless: the same word is spelled as both shakti and s'sakti in the book on Indian art; Cornelius Johnson in Mr. Waterhouse's

Painting in Britain changes to *Cornelis* in the plate captions and the same facts are sometimes, in that book, given in two different places. There are also inconsistencies in the titles of works of art and none of the volumes is entirely free from misprints.

Excluding the Moslem art of India from his consideration as belonging more properly to the sphere of Islamic art in general, Mr. Rowland tells the story of Hindu, Buddhist, and Jain sculpture, painting and architecture (as the case may be) in India, Afghanistan, Turkestan, Kashmir, Nepal, Tibet, Ceylon, Cambodia, Siam, Burma, and Java. Sketching in the historical frame as he goes along, after a chapter on the religions of India, he traces styles and influences, and describes many works of art and architecture, almost always with penetration and felicity.

The field surveyed is a vast one, both simplified and complicated by a paucity of facts, dates, and names of artists, but Mr. Rowland extracts order from it without seeming to do it violence and without ever losing sight of the aesthetic point. His account would show that Indian art and architecture owe almost their entire original repertory of forms to Greece, Rome, and Iran—a large fact that the layman, at least, would like to see faced up to explicitly. But the author appears to acknowledge it only grudgingly, even as he piles up the evidence for it—which has the effect, not of provoking the reader to think for himself, but of making him feel he has misunderstood something. This is a typical effect of the refusal to generalize.

E. K. Waterhouse, who is director of the Barber Institute of Fine Arts at the University of Birmingham, has produced what is probably the best history of British painting over the period in question that has yet appeared. It takes him a hundred pages and two centuries of his subject to warm up to it, but from Hogarth on he sparkles, however discreetly, and the reader at the end regrets not being able to hear him further on Constable and Turner. He may deliver himself of some very loosely strung sentences, but he is not afraid to be witty, and there is no question about the keenness of his eye.

Yet here, too, one misses a few general opinions. Why did English painting, by contrast with English architecture, get started so late and why did it achieve so little with reli-

gious, mythological, or even historical themes? Mr. Water-
house touches very little on the political and social background
of his subject, on the assumption that it is sufficiently familiar
to the English-speaking reader. Yet he might still, as Mr.
Summerson does in a similar case, have shown something of
the changing relations between English (and Scottish) art and
its public, a factor of obvious importance. If an issue is to be
left open for the reader, it must at least be approached.

The matter shaped in *Art and Architecture In France* by An-
thony Blunt (who is director of the Courtauld Institute in Lon-
don) is denser than that in the three others, which is perhaps
why he permits himself fewer sallies of temperament. French
art and architecture in the sixteenth century are not the stimu-
lating subject they might seem superficially and it takes Mr.
Blunt, like Mr. Waterhouse, almost half his book to warm to
his assignment. Moreover, he has to handle sculpture and ar-
chitecture as well as painting.

It is with painting that he deals best, especially in the sub-
chapters on Poussin and Claude, which are filled with fresh
observation as well as sound understanding. Surprisingly, he
spells out the political and social background in Marxist char-
acters, and these, though sometimes a little too elementary,
do succeed in provoking the reader to thought. We discover
that not the court but the intellectuals of the middle class
provided the highest French art (and literature) of the seven-
teenth century with its essential public. Mr. Blunt could have
done more than he has, however, with this. And perhaps he
could also have done a little better on the sixteenth century,
but otherwise I have only praise for his book.

The most polished and incisive volume is Mr. Summerson's
on British architecture. But it may be in the nature of his
subject that nothing challenges him enough to require him to
rise to it. There are fewer of those flights of critical interpre-
tation that in the other books lift one above the pressure of
factuality from time to time. On the other hand, the quality
of Mr. Summerson's prose serves to ease that pressure in a
steadier way and to make the reader feel at home in a field
otherwise inhospitable to any but the professional and the con-
noisseur. If we are not stirred, we are informed and ori-
ented—which is a lot.

And to be informed, oriented, and occasionally stimulated

as we are by all four of these books is quite a lot. They may not do everything their publishers hope; they do set a new level in general art history, and if I criticize them in one large respect it is because that level makes such criticism relevant. Forty-eight volumes that come up to the same standard—this is almost too much to imagine.

The New York Times Book Review, 17 January 1954

37. The Very Old Masters

Early man, covering the walls and ceilings of his caves with paintings and rock-engraved drawings of animals, seems today far less remote in his earliness than we might expect. His art brings him startlingly close to us. As increasing throngs visit his caves in what are now France and Spain, as books on his culture keep coming off the presses, as archaeologists and paleontologists attempt to penetrate further the mysteries of the origins and social meaning of his art, all find that these drawings and paintings are not, most of them, what we should call "primitive." In the tact and skill of their realism, they are not too unlike some of the most sophisticated products of civilized art.

Yet they were made by savages who knew neither agriculture nor the use of metals and lived mostly by hunting. The last human traces in the famous cave at Lascaux have been put back some fifteen thousand years, and some authorities hold that the tradition of which the paintings there form a part goes back another ten to twenty thousand years. The leading hypothesis is that early man's art was meant chiefly as sympathetic magic; many of the primitive peoples of our own age believe that to make an image or picture of a being gives one power of life and death over it, or will have the effect of insuring the increase of the species to which it belongs.

In other words, the art of Upper Paleolithic man was part of his economy, a means of maintaining the supply of game on which he depended for food, clothing and some of his implements. This hypothesis would help explain his concern with

realism in his art—on the assumption that the more lifelike an image, the more potent its magic—but it does not make the realism he achieved any the less amazing.

Like the Impressionist painters of France in their first phase, the prehistoric artists of Altamira, Lascaux, and Font de Gaume concentrated on the salient features of their subjects as the eye, not the mind, knew them, and strove for the accuracy of the largest forms before that of the details. And, as with Degas and even more with Cézanne, their contour lines serve to delimit planes rather than carve out shapes or suggest surfaces curving away from the eye. This the critic marvels at, aware of how much truer to the facts of vision the first procedure is—and how much more sophisticated.

Color, running mostly to earth browns, reds, and yellows, was laid on in flat washes, with contrasts of clear tint being depended on for modeling in preference to dark and light shading (though the cave painters had some command of that too). Again the critic marvels, aware of how revolutionary Cézanne is thought to be because he insisted on "modeling in clear color." But the prehistoric painter would, for the sake of three-dimensional effect, also exploit the unevenness of the surface on which he worked, making the trunk or head of an animal coincide with a swell or boss of the rock.

Early man's art does not seem to have been meant for any observer's enjoyment, lodged as it was in the darkest recesses of caves. Nor does the artist himself seem to have had much notion of a *picture*—that is, of a closed-off illusion of space. His conscious aim, apparently, was to get a single image down, regardless of anything that lay outside its own contours. Two or more figures will be grouped occasionally in an anecdotal or even decorative way, but there will be no attempt to delimit the space around them. (Though a few drawings of plants have been found, there is never a real suggestion of landscape, and seldom of a ground line.)

The evidence would show that the prehistoric painter did not try consciously to make any such thing as a "beautiful" image, but only to get a realistic one down on rock. Yet, as we see, he stopped short of a realism too literal and complete to be satisfactory as mural art, and aimed at something more vivid than mere precision, more instantaneous and lifelike

than any painstaking cataloguing of visual facts. And he cap-
tured the characteristic movements, the intense mass and the
springiness of living muscle, fat, and hide as well as any artist
has since.

The New York Times Magazine, 16 May 1954

38. Foreword to a Exhibition of Adolph Gottlieb

Adolph Gottlieb is among the half-dozen artists responsible
for the appearance since the early 1940's of the first body of
American painting that can vie with, if not surpass, the best
contemporary work in Europe. He is perhaps the most solidly
accomplished painter of the group, the surest, if not the flashi-
est, hand. His successful pictures will remain immune to the
fluctuations of taste and, as I believe, have a place in the trea-
sury of American art safe from depreciation.[1]

The modesty and patience with which he faces up to each
problem in his path, and the independence and honesty with
which he solves it, make the lessons of his development viable
as are those in the development of few other contemporaries.
Gottlieb's influence, or rather his solutions, have had an effect
the future will perceive better than we. See, for example, how
he can set a seemingly unwieldy silhouette into place without
muffling the contrast of dark and light or pulling contours
back into illusionist depth. Many of us, painters and spectators
alike, have learned from him without realizing it, or at least
without realizing the difficulties he has so unobtrusively mas-
tered. Picasso, of all people, was struck by Gottlieb's pictures
when he saw them in reproduction, said so, and incorporated
suggestions from them in his big *Kitchen* painting of 1950.

I mention this by way of illustration, not as a testimonial.
The real importance of Gottlieb's art does not derive from the
influence it exerts. The subtleties and yet force of its sim-

1. Greenberg selected the paintings for the exhibition. There were
twenty works in all, dating from 1942 to 1952. [Editor's note]

plicity, the conclusiveness with which it succeeds when it does—these make it major.

A Retrospective Show of the Paintings of Adolph Gottlieb, Bennington College, Vermont, and the Lawrence Museum, Williams College, Massachusetts, April–May, 1954

39. The Sculpture of Jacques Lipchitz

Though earlier and more securely placed as a contemporary master, Jacques Lipchitz has not yet enjoyed a boom as concentrated as those which, since the war, have swelled and somewhat inflated the reputations of Henry Moore and Alberto Giacometti. Nor has he usually received praise as unreserved as that which he now gets from Henry R. Hope in the catalogue for the large retrospective exhibition of his art that is traveling this fall and winter to Minneapolis and Cleveland from a summer showing at the Museum of Modern Art. Yet this show makes very clear the reasons why that praise should be qualified.

Lipchitz is a very great sculptor. Moore hardly deserves to be mentioned in the same breath, and the later, if not earlier, Giacometti comes off badly in any serious comparison. But still—the exhibition states the ambience of greatness, while offering relatively few great individual works; relatively little of the greatness gets precipitated as the unity and completeness of single works. A hundred-odd items, including drawings, etchings, and paintings, were shown at the Museum of Modern Art; and almost everything, from the earliest sculpture—under Bourdelle's influence, or that of Russian-style Art Nouveau—to the impossibly bathetic *Virgins* done in connection with a recent commission for a baptismal font for a French church, spoke of an enormous capacity. And by *capacity* I mean much more than promise—were it only that, Lipchitz would be but one among thousands of artists who have failed to develop gifts genuinely theirs. I mean *potentiality*: the possession of developed gifts as manifested in actual works. Yet these gifts are so seldom realized conclusively that the disproportion be-

tween potentiality and realization is too large to be taken as part of the "usual waste" attending ambitious effort in art.

Like Chagall and the late Soutine, Lipchitz came to Paris and joined the avant-garde in the halcyon years just before 1914. But Paris also meant for him, as it did for the other two artists from Jewish East Europe, a first real look at the museum art of the West, and none of the three ever got over it. Soutine, coming to Paris last, tried from the beginning to reconcile modern with pre-Impressionist painting, but Lipchitz had to wait until the 1920's before the spell of Cubism wore off enough to let him dare think of a similar reconciliation in sculpture.

The mood of the 20's in Paris favored such changes of course generally, and at that time Picasso, Matisse, Léger, and Derain likewise retreated towards tradition. But they had been born into tradition and could take it more or less for granted, whereas the three Jewish artists seemed to feel they had to prove their title to it by an express effort.

Not only has Lipchitz aspired to continue—as Mr. Hope reports him as saying—"the great stream of European sculpture from Michelangelo and Bernini to Rodin," but he has tried to cast his artistic personality in that "titanic" mold which the past century conceived for culture heroes like Michelangelo, Beethoven, and Rembrandt. More precisely, he has since 1930 sought a contemporary version of the grand, epic style. His conception of it remains somewhat old-fashioned, however, and the attempt itself to achieve it is often made too mechanically, by dint of the exaggeration and distortion of received forms. It is further evidence of Lipchitz's real greatness that his art has stood up as well as it has under such pedantic ambition.

The Cubist sculptures and bas-reliefs of Lipchitz's first period of maturity, from 1914 to 1925, show but few of the faults of his recent work. They seldom fail of unity, even if it is at the price of a kind of constriction due to adherence to a narrow repertory of forms literally translated from the painted Cubism of Picasso and Gris. Particularly successful are the bronze *Bather* and wooden *Dancer* of the year 1915, both pointing towards a new, non-monolithic kind of sculpture that Lipchitz was not to explore further for another ten years; and

in a slightly less adventurous direction, the *Standing Personage* and *Standing Half-Length Figure* in stone of 1916, and the *Man with Mandolin* of 1917, also in stone. Lipchitz's most consistently original and powerful sculpture came, however, between 1925 and 1930, when having abandoned the literal vocabulary of Cubism but still subscribing to its aims and understanding these more profoundly, he was able, paradoxically, to make its "syntax" more intrinsically sculptural by making it more pictorial. Instead of transposing the angled planes of Cubist painting into solid polygonal volumes, he now began to feel them in terms exclusively of surface and line.

The best pieces of this period are small quasi-abstract bronzes, none more than 20 inches high, whose thin, perforated planes and calligraphic straps and ropes of metal spell out the new draughtsman's language of modernist sculpture even more effectively, perhaps, than do Picasso's earlier Cubist constructions. Several of these bronzes stand forth among the most rightly felt, completely realized, and original works of our day. Yet they offer very cogent evidence, at the same time, of that arrogant badness of taste or judgment which was to dog Lipchitz from then on. For they cry out for monumental enlargement, and the proof of it is the huge, splendid *Figure* of 1926–30, which is the only large sculpture done in a manner like theirs, and happens to be Lipchitz's supreme masterpiece. Despite their calligraphic "transparency," these bronzes are modeled with a certain heaviness that does not quite accord with their scale; their power and intricacy seem cramped, even a little clumsy, and sometimes they begin to look uncomfortably like *objets d'art*. Such superb pieces as *Chimène* and *Melancholy* (both of 1930) are therefore perhaps best appreciated in photographs, as these give the eye a chance to imagine them as much larger than they are. (Since 1930 Lipchitz has occasionally turned out further "transparent" bronzes; and these, though not quite as inspired as the earlier ones, remain generally superior to his monumental sculpture over the same years.)

Except for the *Figure* finished in 1930, the large works Lipchitz executed between 1925 and that date were done in massive forms that have little affinity with those of the small bronzes. It was as if he reasoned that monumental statuary

called for unambiguously monumental forms. Yet his own *Figure* was there to tell him how much more convincingly he, for one, could achieve monumental effects with unmonumental means, and how much righter this seeming disparity between means and end was for *him* than the kind of literal equality he otherwise observed. As it is, the large sculptures of 1925–30, aside from the *Figure*, are uniformly inferior to the small ones, and in pieces like the *Joie de Vivre* of 1927, the *Mother and Child* of 1929–30, and the *Return of the Prodigal Son* of 1931 (all in bronze), there appear for the first time those bloated volumes, coarse contours, and arbitrary surface textures that have marred most of the successes and confirmed almost all the failures of Lipchitz's large-scale sculpture ever since.

Cubism had sent Lipchitz towards construction—linear, open sculpture. Now he let his great native talent for modeling take him in other directions, towards the mirage of the grand style. Great modeler though he was and is, Lipchitz now began to model excessively, self-indulgently.

As Soutine tried to combine the dark and light design of the old masters with the saturated, ungraded color of the Post-Impressionists, so Lipchitz has tried in his larger works since 1927 to marry the compact monolith of traditional sculpture, and its chiaroscuro, to the open, linear forms of Cubist and post-Cubist construction. Neither artist would have attempted his synthesis of past and present had he possessed that elementary sophistication which has made other artists, greater as well as lesser ones, automatically recognize that certain things cannot be achieved without sacrificing others. This lack of sophistication explains much of Lipchitz's bad judgment—his over-consciously grandiose aims, his bombast, his inability at times to get out of the way of his own talent (a diagnosis indicated by the general superiority of his "sketches" in plaster or terra cotta to their overworked, muscle-bound final versions).

How well, on the other hand, he could still do what he addressed himself to straightforwardly is shown by the example of two small bronzes, *Flight* and *Arrival*, executed in 1940 and 1941 respectively. Intended to express the feelings of a Jewish refugee from Hitler, they are largely Rodin in approach, even as to the nervous fingering of their surfaces, yet

by their intense clarity and unforced, compact strength, and by the infinite rightness of their silhouetting, they transcend every note of influence, so that we feel them in the end as altogether original. And the same, more or less, can be said of the equally Rodinesque *Bull and Condor* of 1932 and the *Rape of Europa III* of 1938; while in the great *Jacob Wrestling with the Angel* (1932), as in the *Embrace* (1934), Rodin is accepted merely as a premise from which to draw a sinuous bulkiness that is radically and triumphantly different from the flickering forms of the older master. Actually, influences as influences make themselves more obtrusive in Lipchitz's more deliberately self-assertive works. Some of Picasso's conceptions and even mannerisms can be recognized in the swollen sausage forms and telescoped anatomy of the *Benediction I* of 1942, and in the bulbous topknots and horsetails of the subject's hair in both *Hagar* (1948) and the *Mother and Child* (1949)—though these two are among the most successful of his recent larger sculptures.

Every artist depends on influences, and those who do so least are not always the better ones. It is not the extent of Lipchitz's dependence on influences, but their range that betrays the difficulties of his art over the last twenty-five years. He has looked for stylistic inspiration, in turn and simultaneously, to Michelangelo, Bernini, and 19th-century neo-Baroque, to African wood-carving, to Pergamum and Chaldea, to Rodin, and to Picasso. For an artist with a firm sense of his own aims it would not be impossible to fuse influences even more diverse, but Lipchitz seems to have been deprived of such a sense since parting from Cubism. His recent course has been haphazard, with no one direction leading into the next; and he has been unable to develop a style, a principle of inner consistency and control. This does not mean that everything he has done since 1930 has failed—far from it: there are the works already mentioned, and there is a masterpiece like the *Song of Songs* of the 1940's—but it has meant the inability to refine, clarify, and purify his conceptions in going from one work to the next, and the frequent inability to feel or know where he is going within the given work.

One wonders how an artist so uncertain of his felt aims can make such a great impression of strength, in failure as well as

success. The impression is not false, though one would suspect it to be the advertising of something not really there—all the more because the strength so often verges on brutality. What the strength—the insistence on demonstrating it—does conceal, I believe, is Lipchitz's failure to orient himself independently in Western and modern art. He has the superlative, and inalienable, power to knead clay into massive, simple, and energetic form; unlike Picasso, he has never lost his *touch*. But he has lacked, since Cubism, a sure instinct for the combination and elaboration of forms—and a sense, above all, of what art can and cannot do within the limitations given it by his own temperament and the time in which he lives.

Commentary, September 1954; A&C (substantially changed).

40. Abstract and Representational

It is widely assumed that in the fine arts the representational as such is superior to the non-representational as such: that, all other things being equal (which they never are), a work of painting or sculpture that exhibits a recognizable image is always to be preferred to one that does not.[1] Our present abstract art is considered therefore a symptom of the cultural—and even moral—decay of our time. Every third essay on contemporary painting and sculpture looks forward, in one way or another, to a "return to nature," which is assumed to be the same thing as a return to health and normality. Even some of the apologists of abstract art, when they defend it by saying that an age of disintegration must produce an art of disintegration if it is to express itself faithfully, implicitly concede that the abstract as such is inferior. Other apologists, those who claim—rightly and wrongly—that abstract art is never as non-representational as we think, appear often to make the

1. This essay was originally delivered as the Ryerson lecture, School of Fine Arts, Yale University, 12 May 1954. [Editor's note]

same concession. (See, for example, Leo Steinberg's "The Eye is a Part of the Mind," in *Partisan Review*, March–April 1953.)

The embattled defenders of abstract art reverse the argument by claiming for the non-representational that absolute virtue and inherent superiority which the majority see in the representational. Perhaps because they are so few and the opposition so many, they tend to be fanatical; but this doesn't make them any wronger than the other side—or any righter. Both sides are wrong for the same reason.

What counts first and last in art is whether it is good or bad. Everything else is secondary. No one has yet been able to show that the representational as such either adds or takes away anything from the aesthetic value of a picture or statue. That a work is or is not representational no more determines its value as art than the presence or absence of a libretto does in the case of a musical score. No single element or aspect of a work of art autonomously determine its value as a whole. How much any part is worth aesthetically is decided solely by its relation to every other part or aspect of the given work. This holds as true in painting and sculpture for the element of representation, absent or present, as for that of color or physical substance.

It is granted that a recognizable image will add anecdotal, historical, psychological, or topographical meaning. But to fuse this into aesthetic meaning is something else; that a painting gives us things to recognize and identify in addition to a complex of colors and shapes to feel does not mean invariably that it gives us more as art. More and less in art do not depend on how many different categories of significance we apprehend, but on how intensely and largely we feel the *art*—and what that consists in we are never able to define with real precision. That the *Divine Comedy* has an allegorical and analogical meaning as well as a literal one does not make it necessarily a more effective work of literature than the *Iliad*, in which we fail to discern more than a literal meaning. Similarly, the explicit comment on an historical event offered by Picasso's *Guernica* does not make it necessarily a better work than an utterly "non-objective" painting by Mondrian that says nothing explicitly about anything. We can never tell, before the fact, whether representational meaning—or any other

given factor—will increase and intensify aesthetic meaning, or whether it will weaken and diminish it. Until it is actually experienced, a work of art remains a law unto itself.

That those who condemn abstract art generally do so in advance of experience is shown by the completeness with which they condemn. To hold that one kind of art is invariably superior or inferior to another kind is to judge before experiencing. The whole history of art is there to demonstrate the futility of rules of preference laid down beforehand—the impossibility of anticipating the outcome of aesthetic experience. The critic doubting whether abstract art could ever transcend decoration—as Daniel Kahnweiler does—is on ground as unsure as the Hellenistic connoisseur would have been who doubted whether the mosaic medium could ever be capable of more than merely decorative derivations of encaustic panel painting. Or as Joshua Reynolds was in rejecting the likelihood of the pure landscape's ever occasioning works as noble as those of Raphael. As long as art, and the judging of it, have not been reduced to a science anything and everything remain possible in it.

It has never been more essential than today to keep in mind the precariousness of all assumptions about what art can and cannot do. If the practice of ambitious painting and sculpture continues in our time it is by flouting almost every inherited notion of what is and is not art. If certain works by Picasso as well as Mondrian are worthy of being considered *pictures*, and certain works by Brancusi and Gonzalez as well as Pevsner, *sculpture*, then it is despite all preconceptions and assumptions, and only because actual experience has told us so. And I don't think we have more reason to doubt, by and large, what it tells us than what it told his contemporaries about Titian.

II

At this point, however, I feel free to turn around and say things perilously like those which I have just finished denying any one the right to say. But I will say what I say only about the abstract art I already know, not about abstract art in principle. I will base myself on experience.

Free-standing pictorial art, as distinct from decoration, has been immemorially identified with the representational, and

so has sculpture. Now it can be properly asked whether, in view of what both arts have achieved in the past, they do not risk a certain impoverishment in renouncing image and object. I ask this carefully, and only in view of the record, not because I feel that such renunciation *must* be impoverishing. The non-representational cannot be shown to be necessarily weaker than the representational, but isn't it too little provided for by the inherited, habitual, almost automatic expectations with which we approach a thing society agrees to call a picture or a statue? May not an abstract painting, even when it is very good, still leave us somewhat dissatisfied in a way that an equally good representational painting wouldn't? At this moment in the history of art I would answer yes.

Yet my experience—which includes Velasquez and Corot as well as Mondrian and Pollock—tells me nonetheless that the best art of our day tends, increasingly, to be abstract. And most attempts to reverse this tendency seem to result in second-hand, second-rate painting or (as far as the latest generation of sculptors is concerned) *pastiche*, pseudo-archaic sculpture. In fact, it seems as though, today, the image and object can be put back into art only by *pastiche* or parody—as though anything the artist attempts in the way of such a restoration results inevitably in the second-hand. Not that most of contemporary abstract painting and sculpture is first-rate—far from it, most of it being just as bad as representational art and, more often than not, worse. But this still does not prevent the very best of it from being the most genuinely ambitious and very best of recent art.

If the abstract, then, tends to impoverish art as regards the kind of satisfaction we have traditionally looked to it for, it is apparently a necessary impoverishment—necessary to the excellences of contemporary art. Without it, it would seem, painting and sculpture fail to realize the values that our time is capable of creating in their sphere.

Why this sacrifice—if sacrifice it is—has been enjoined upon the best art of our day, I cannot try to say here. I think that the reasons are discernible, but it would require a book to deal with them. At this juncture I am more interested in stating and questioning the sense itself of deprivation and sacrifice.

Now it may be that the source of the dissatisfaction, large or small, which we feel with the very best of the abstract art we know, when we compare it with the best of the past, lies not in the absence as such of the representational, but in the rather simple fact that our time is unable to match the past no matter how it paints and sculpts, with or without the image and object. It may be that art in general is in decline (for reasons to be found both inside and outside itself). If so, the dogmatic opponents of abstract art would be right then in viewing the abstract as a symptom of decadence. But even so, they would be right on empirical, not principled, grounds— not because the abstract is invariably a sign of decline, but just because it happens to be at this moment in the evolution of art—and thus they would be right only for this moment.

On the other hand, it may be that, having only immediate experience to go by, we cannot yet see sufficiently around the art of our day to recognize that the abandonment of the representational has little to do, strictly, with the dissatisfaction we feel with contemporary abstract art. This dissatisfaction may be due mainly to our tardiness in getting used to a new language of painting.

III

From Giotto to Courbet, the painter's first task had been to hollow out an illusion of three-dimensional space. This illusion was conceived of more or less as a stage animated by visual incident, and the surface of the picture as the window through which one looked at the stage. But Manet began to pull the backdrop of this stage forward, and those who came after him—the Impressionists, the Neo- and Post-Impressionists, the Fauves, the Cubists, etc., etc.—kept on pulling it forward, until today it has come smack up against the window, or surface, blocking it up and hiding the stage. All the painter has left to work with now is, so to speak, a more or less opaque window pane. And no matter how richly he leads and inscribes this pane, even if he traces the outlines of recognizable objects on it, we are left disconsolate because this does not compensate for the loss, to our traditionally, historically determined eyes, of the old play of incident in an illusion of depth. What saddens our eyes is not so much the absence or mutilation of the

image, but the deprivation it has suffered of those spatial rights it used to enjoy back when the painter was obliged to create an illusion of the same kind of space as that in which our bodies move. It is this illusion and its space that we may miss even more than the things, as such, that filled it.

The picture has now become an object of literally the same spatial order as our bodies, and no longer the vehicle of an imagined equivalent of that order. It has lost its "inside" and become almost all "outside," all plane surface. The spectator can no longer escape into it from the space in which he himself stands; on the contrary, the abstract or quasi-abstract picture returns him to that space in all its brute literalness, and if it deceives his eyes at all, it is by optical rather than pictorial means, by relations of color, shape, and line largely divorced from descriptive connotations, and by "situations" in which foreground and background, up and down, are interchangeable. Not only does the abstract picture seem to offer a narrower, more physical, and less imaginative kind of experience than the representational picture, but the language itself of painting appears, as it were, to do without nouns and transitive verbs, so that often we cannot distinguish centers of interest within the abstract picture's field and have to take the whole of it as one single, continuous center of interest, which in turn compels us to feel and judge it in terms of its over-all unity to the exclusion of everything else. The representational picture does not, seemingly, force us to squeeze our reaction within such a narrow compass—otherwise how could we like the Flemish primitives as much as we do?

It is the language, then, the space, of abstract painting that causes most of the dissatisfaction we feel with it—not the absence *per se* of recognizable images. And if, as I believe, abstract sculpture meets less resistance than abstract painting does, it is because it has not had to change its language as radically. Whether abstract or representational, that language remains three-dimensional and literal. The construction, with its transparent, linear forms and its denial of mass and weight, may jar eyes accustomed to the monolith, but it does not require them to be re-focused in the way that the abstract painting does.

But in painting, shall we always regret the other kind, the

transfigured kind of space the old masters created for us? Perhaps not. It is possible that the connoisseurs of some future age may—all other things being equal—prefer the more literal space of abstract painting to the fictive kind. They may indeed find the old masters wanting in physical presence, in corporeality, preferring instead the physical emphasis of the more or less flat, more or less opaque plane surface that is declared as such. There have been such reversals of taste before (only in this case, I hope, it will be an expansion rather than a reversal, and leave the old masters even safer in their eminence). These hypothetical connoisseurs may be more sensitive than we to the condensed, very concrete and literal play of color and shape, they may even find this richer in "human interest" than representational painting. And who knows but that they may not point to our age as one that produced a great school of art (especially in this country), yet was unable to supply it with an adequate audience. Just as we tend to think that the contemporaries of, say, Velasquez were not as adequate to him in the way of appreciation as we ourselves are.

Moreover, these connoisseurs of the future may interpret representational as well as abstract painting in terms quite different from ours. They may see the creation of an illusion of depth and volume as valuable primarily because it enabled the painter to organize such infinite subtleties of dark and light, of translucence and transparence, into instantaneous unity—into a decorative unity whose intricacies could not have been controlled without the guiding notion of real three-dimensional objects familiar through practical experience. They may say that it was worth imitating nature because nature offered a wealth of colors and shapes that the painter, alone with his art, could never have invented. They will continue—I hope once again—to praise the old masters, but they may make explicit in their praise qualities we ourselves are still unable to discriminate consciously. And, finally, they may find much more common ground between the old masters and contemporary abstract art than most of us are able to.

This last I hope for almost more than anything else. For I do not feel that abstract painting, despite all the changes it has made in the language of painting, is so different from traditional, representational painting as to constitute a real his-

torical break with it. I myself don't need a different set of eyes for Mondrian than for Piero della Francesca. True, in going from one to the other I have to re-focus my eyes, but this is not such a difficult operation and it does not require such a shift of sensibility as, say, the one I have to make in going from European to Far Eastern painting. I find, down at bottom, that Mondrian and Piero and Rembrandt have more in common between them than any one of them has with a master of the old Chinese school. No matter what direction abstract art goes in, we shall always be able to trace it back without break to a point of departure within traditional Western art. This, I believe, non-Westerners see better than we do.

It is true that abstract painting, as it evolves (especially in this country), increasingly violates the traditional notion of the general conditions a flat surface must meet in order to claim attention as a picture. Abstract painting may, indeed, be heading towards a new format or category of pictorial art that will have no more intimate a connection with easel painting than the altar piece of the early Renaissance had with the Byzantine mosaic mural or Gothic stained window. But just as the altar piece did, after all, evolve out of the mural, the window, and manuscript illumination, so abstract painting has evolved out of the illustrative, representational painting of Rennaisance tradition, and the filiation will remain visible to those who look hard enough.

And it may be that when these things are better understood, and when the new format is realized and made stable— it may be that abstract painting will be no longer subjected then to the misguided, irrelevant, and resentful kind of discussion it undergoes now.

Art Digest, 1 November 1954; A&C (substantially changed); *Theories of Modern Art: A Source Book by Artists and Critics*, ed. Herschel B. Chipp, 1968; *Arts Magazine*, April 1974.

1955

41. Autobiographical Statement

I was born in the Bronx, in New York City, the oldest of three sons. My father and my mother had come, in their separate ways, from the Lithuanian Jewish cultural enclave in northeastern Poland, and I spoke Yiddish as soon as I did English. When I was five we moved to Norfolk, Va., but moved back to New York—Brooklyn this time—when I was eleven, and we have more or less stayed there since. My father had by that time made enough money to change over from storekeeper (clothing) to manufacturer (metal goods). However, I can't remember there ever having been any worrying about money in our family, or any one in it lacking for anything. Which is not to say that we were rich.

I attended public school in Norfolk and Brooklyn, took the last year of high school at the Marquand School, and went to Syracuse University for an A.B. (1930). For two and a half years after college I sat home in what looked like idleness, but did during that time learn German and Italian in addition to French and Latin. The following two years I worked in St. Louis, Cleveland, San Francisco, and Los Angeles in an abortive, left-handed venture of my father's into the wholesale dry-goods business; but I discovered that my appetite for business did not amount to the same thing as an inclination. During the next year I supported myself by translating. In 1934 I married and had a son, Daniel, a year later—and another year later I was divorced. At the beginning of 1936 I went to work for the federal government, first in the New York office of the Civil Service Commission, then in the Veterans Administration, and finally (in 1937) in the Appraiser's Division of the Customs Service in the Port of New York. Until then I had been making desultory efforts to write but now I began in

earnest, in my office-time leisure—of which I had plenty—
and fairly soon I began to get printed.

As a child I had been a precocious draughtsman, and I had
drawn and sketched obsessively until college; but gradually I
became much more interested in literature than in art (which
I still find it hard to read *about*), and so when I began to write
it was mainly on literature. *Partisan Review* was the first place
to publish my criticism, in 1939, and in 1940 I became one
of its editors. Late in 1942 I resigned from both the magazine
and the Customs Service, and most of 1943 I spent in the
Army Air Force. After a spell of free-lancing and translating I
took a job, in August 1944, as managing editor of the *Contemporary Jewish Record*, a bimonthly put out by the American
Jewish Committee; when the *Record* was replaced by *Commentary* I stayed on as an associate editor of the latter, which I
still am.

In the meantime my interest in art had reawakened and
become a good deal more self-conscious than before; that is, I
no longer took my opinions in the matter of painting and
sculpture as much for granted, and began to feel *responsible* for
them. By the end of 1941 I was writing an occasional piece on
art for the *Nation*, for which I had already been doing book
reviews, and in 1944 I became its regular art critic. At the
same time I wrote art criticism now and then for other periodicals, and enough book reviews—not all of them on art
books—to give me a belly-full of reviewing in general. So in
1949 I gave up the *Nation* column, though I continued for
another two years writing more or less regularly for *Partisan
Review*, which, being a bimonthly, gave me more breathing
space between deadlines. But in 1951 I gave that up too, and
have been trying ever since then to work on things, inside and
outside art, that have less to do with the current scene. The
only book I have to my credit so far is a short one, *Joan Miró*.
I am now preparing an even shorter book on Matisse.[1]

No one has written about me at any length, though some
of my failings were discussed in the reviews of my Miró

1. This statement, though not published until 1955, was written in
1953, the year Greenberg published *Matisse* (New York: H. N. Abrams).
[Editor's note]

book—and I do get referred to, rather unfavorably on the whole, in an occasional article or book. But I was pleased when Alfred Barr, in his book on Matisse, mentioned me as a painter as well as critic; and I have been painting more and more seriously in the last ten years or so. Art criticism, I would say, is about the most ungrateful form of "elevated" writing I know of. It may also be one of the most challenging—if only because so few people have done it well enough to be remembered—but I'm not sure the challenge is worth it.

Twentieth Century Authors (first supplement), New York: The H. W. Wilson Company, 1955

42. Color in Madrid and from Amsterdam: Review of *Art Treasures of the Prado Museum* by Harry B. Wehle, and *Rembrandt* by Ludwig Münz

The Prado in Madrid owes something of its unique character as a picture gallery to its "imbalance." Its directorship continues to try to rectify this, but the preponderance in quality and quantity of its Spanish, Venetian and Flemish collections could be overcome only by buying out the Uffizi and the Ryksmuseum. Until then we shall go on enjoying and prizing the Prado for what it is in all its imbalance, which so well communicates the pure and un-antiquarian appetite for painting of those responsible for most of the pictures in it. As Harry B. Wehle, former Curator of Paintings at the Metropolitan, writes in the book under review, the Hapsburgs and the Bourbons of Spain, "these apparently unlovely and uninspired individuals . . . surprisingly enough, scored an unbeaten record as collectors. . . . These kings and queens ruling Spain from the end of the fifteenth century into the nineteenth showed a marked inclination to buy paintings by their own contemporaries, but their tastes were not fenced in by national boundaries. Thus, in periods when they found Spanish art not to their taste, they bought elsewhere. . . . " Remarkable, too, is the continuity of their taste: the partiality

they showed for "painterly" painting wherever they could see it in the two centuries and more from Titian to Goya. (They missed Rembrandt and Vermeer.)

This partiality was neither exclusive nor complete—the Prado is unbalanced but it is not one-sided. Charles V, Emperor of Spain and Austria, may have founded Spanish royalty's predilection for the painterly painting of Venice by his patronage of Titian, but with the help of his relatives he also brought some superb Flemish primitives to Spain. Philip II likewise favored Titian, but he collected Bosch greedily, acquired several Patinirs—and all but totally rejected El Greco. It was Philip IV, however, who more than any one else was responsible for the dominant character of the royal collections that, a century and a half after his death, were grouped together in the Royal Museum in Madrid, which later came to be called the Prado. This Philip had Velasquez for his court painter and Rubens for a personal friend; he acquired pictures by the hundreds (among them those two magnificent Titians, *The Bacchanal* and *The Worship of Venus*). Titian, Velasquez and Rubens still set the tone in the Prado, and it is one with which the hundred odd Goyas there well accord. (Goya, too, was a court painter.)

If the Prado can be called the "citadel of painterly tradition," it can also be called, by no greater hyperbole, the "cradle of modern painting." Its late Goyas are in more than one way the first "modern" pictures; and it was at the Prado, in 1865, that Manet got that first long look at some of these and at Velasquez and Ribera, which confirmed him in his new course. The wonder is that he got to Madrid when he did. Spain had become a relatively isolated country in the seventeenth century and remained so up into the twentieth. It was at no time part of the Grand Tour. Delacroix, with all his passion for Rubens, never went there. Nor did any of the leading Impressionists go, or Cézanne—he who considered the Spanish masters to be, with the Venetians, "*les plus grands.*" In our own time the civil war and Franco plunged Spain back into isolation, and she is only now beginning to re-emerge into the tourist's ken. But the fact of the Prado has become too bright to be put out of mind as easily as before, nor will

Velasquez have to be rediscovered by our century as he was by the nineteenth. And we all know now about the late, black Goyas, which are only to be seen in the Prado.

The pictures reproduced in *Art Treasures of the Prado Museum* have been judiciously chosen to afford a representative notion of the museum's contents as a whole as well as to present the outstanding items among them. Mr. Wehle's historical introduction and the notes on the pictures are done with urbanity and conciseness, and with a minimum of that breathy prose which mars so much art writing on occasions like these. But the colorplates are very uneven in quality, often being keyed too high and light. The Rubenses, for example, look as if they had been freshly cleaned, but as of this past July they were dimmed by dirt, old varnish and passages of color that had gone dead; I cannot believe that so many of them have been restored in the short time since. In other pictures, notably some of those by Velasquez, the same over-brilliant lighting has obscured the dark and light structure—with the edifying result that one notices just how important such structure is in Velasquez's art. Moreover, several of the black-and-white plates could have been more carefully printed.

The etchings and drawings reproduced in the *Rembrandt* have the benefit of clean impressions, and there are not so many misses in its colorplates. Even so, one again detects a tendency to key the color in too high a register and induce thereby a brilliance which is just as spurious as that obtained in some of the Skira books by saturated inking. And now and then, as in the Prado book, a red gets out of hand, or appears when there is nothing in the original to indicate its presence at all. The same publishers attained higher standards of reproduction in their earlier large volumes.

The pictures in the *Rembrandt* are well chosen, but it is not so well served as the *Prado* as to text. With the effects of translation discounted, Dr. Münz's prose is still wordy, redundant, anticlimactic, bumbling. There is a lot of trouble getting anything definite said about Rembrandt's art, beyond the repeated assurance that it is very human. Only a few remarks, a few flashes of discrimination break through to remind one that Dr. Münz is, after all, an eminent authority on his subject.

In justice to him it must be said that Rembrandt is a most

difficult artist to write about. He is so profoundly literary, and such a pure painter at the same time. Yet when we focus on his craft and style we are not nearly so sure we are on the right track as when we approach Rubens the same way, or Piero, or Velasquez, or even Titian, not to mention later artists. We feel too soon that the connecting of "form" and "content" cannot be delayed, that the abstraction of one from the other is in any case too violent. And yet in Rembrandt's case we find it peculiarly difficult to discuss the two in close conjunction with each other; it is as if "form" and "content" did not lead into one another in the same way as they do in the art of other masters. Does this point to some of Rembrandt's weaknesses? Perhaps it does, and perhaps the best way to approach him would be to begin with these. It would not be the first time that attention to the negative turned out to be the best way of eliciting the positive.

Art News, January 1955

43. Review of *The Art and Architecture of the Ancient Orient* by Henri Frankfort, *Painting in Britain: The Middle Ages* by Margaret Rickert, and *The Art and Architecture of Russia* by George Heard Hamilton

The three new volumes in the Pelican History of Art series maintain the high level set by the first four. Again one senses a strong editorial hand—how else explain such uniformity of success, such unfailing perspicuity of exposition and development, such even attention to the details? This is to take nothing away from the authors themselves: they have already proven themselves elsewhere. The editorial feat is that of guiding diverse capacities toward one strictly conceived goal, that of providing histories of the various episodes of world art which can be read with pleasure by the informed layman and at the same time serve as dependable reference works.

The material treated in two of the books at hand is more refractory than usual. The nature as a whole of the art of the ancient Middle East has to be envisaged by a strenuous effort

of both the imagination and scholarship, for its remains, if not exactly scant, are fragmentary and scattered. The traditions of Russian art and architecture were radically dislocated in the Westernizing eighteenth century, and it takes a subtle eye and an understanding of things Russian to establish what continuity remained. British painting, on the other hand, presents a self-evident unity; the author's task here is less one of organization than of introduction: manuscript illumination, pictorial embroidery, and even stained glass are not forms of art that readily involve and hold the layman's eye today.

The Art and Architecture of the Ancient Orient may be a somewhat misleading title: the Fertile Crescent, eastern Asia Minor, and Persia alone are covered; ancient Egypt is left for a separate volume, and no mention is made of the Far East. The book suffers, moreover, for lack of a chronological table and maps (which the other two contain). Its distinguished author (who was director of the Warburg Institute in London) died before he could see the book through the press, but the editor should have foreseen the trouble many readers would have in orienting themselves in the unfamiliar time and place of the subject. Nevertheless, Henri Frankfort's text succeeds in making its material intelligible as a unity and vivid as art. Sumeria, in the third millennium B.C., founded the abiding character of ancient Mesopotamian and much of Levantine art and architecture, but without, on the extant evidence, reaching an artistic climax. That was left to the narrative bas-reliefs of the Assyrian royal palaces, and these perforce receive the greatest attention from Frankfort.

Despite their brutal subject-matter, the Assyrian reliefs are great art, but one suspects that more abundant evidence from remoter antiquity might show them to be surpassed by the sculpture in the round of the Akkadian-Sumerian empire 1,500 years earlier; several portrait heads from that time have the clarity and power of a realism that is without its like in the rest of the known art of the old Middle East. (It tends to be overlooked that ancient art's supreme triumphs, in the Middle East and Egypt as well as in Greece, were won through a plain and monumental kind of naturalism.)

Margaret Rickert's book (she was until her recent retirement Associate Professor at the University of Chicago) has a slightly

apologetic note. This is owing to her insistence on reminding us that the English, in medieval times at least, were capable of a pictorial art independent and native enough to reject, or transform with thorough originality, influences from abroad. The illustrations suffice, I believe, to make her case. Certainly they bear out her definition of the English bent as one for linear emphasis, thin color, and lambently decorative design. She gives most of her attention to book illumination, tracing its bright course from the seventh century to the end of the fifteenth, when the native tradition was finally smothered under importations from Renaissance Flanders. Now and then Dr. Rickert gets over-immersed in details, but the reader can recover his bearings in the summaries so wisely provided at the end of each chapter, and in the closing chapter itself, which offers a synoptic view of the whole field.

If sculpture plays the main role in Frankfort's book (little of ancient Middle Eastern painting having survived and our knowledge of its architecture, in elevation at least, being dependent on hypothetical reconstructions) and book illumination the main one in Dr. Rickert's, architecture plays the main role in the volume by George Heard Hamilton. Text and illustrations combine to show that Russian architecture deserves to rank with any in the world. This is true not only of the superb cathedrals of medieval times and the grandiose neoclassic edifices of the eighteenth and early nineteenth centuries, but also, and almost in the first place, of the highly original, autochthonous wooden construction, ecclesiastical and otherwise, carried on in Russia until Napoleonic days.

The wooden architecture of all northern Europe ought to be better known, but I doubt whether anything else in it is as good as the Russian examples illustrated in photographs and drawings in Dr. Hamilton's book. On the other hand, the famous icon art of medieval Russia does not come through in black and white as well as does British manuscript illustration. It needs its color more. However, Dr. Hamilton's words provoke our further curiosity, and most of his judgments and discriminations carry conviction.

Like British illumination, Russian icon-painting flourished in a country relatively barren of sculpture. It died out, after a life prolonged beyond the Middle Ages, when confronted with

more "lifelike" forms of pictorial art from outside—forms that had been nourished to their greater naturalism by intimate contact with sculpture.

Dr. Hamilton carries his account no further than 1914, when Russian painting and sculpture, in the hands of Kandinsky, Chagall, the Suprematists, and the Constructivists, were beginning to share in the leadership of "advancing" European art. Perhaps the story of Russian modernism transcends national limits, as Picasso's or Soutine's does; perhaps the Pelican History does not intend to deal with artists still alive; or perhaps it is impossible to ascertain satisfactorily what has happened inside Russian art since 1917, and Dr. Hamilton prefers to avoid ending with a whimper. In view of what we learn from him about Russia's artistic birthright, and what we know about Soviet art, a whimper seems to be called for.

The New York Times Book Review, 30 January 1955

44. The Jewishness of Franz Kafka: Some Sources of His Particular Vision

Much of the strangeness in Kafka's writing can well be attributed to his neuroses, and beyond them to a personality that remains unique when all the neuroses have been "explained" away.[1] But beyond both personality and neuroses there lie more general antecedents and causes. There was the literary tradition of the language, German, in which he wrote. There was the city of Prague, in which he was born and lived most of his life. There was the Jewry of that city, and its past, and the larger past of all Central and East European Jewry. Kafka carried with him a kind of "racial" memory of that past.

1. Greenberg contributed several translations to Schocken's English language editions of Kafka (see the Bibliography at the back of this volume). He had written previously on Kafka in 1946, and would write subsequently on him in 1958. The correspondence with F. R. Leavis arising from the present essay (see the following item) is one of Greenberg's lengthiest public exchanges. [Editor's note]

Though he was an emancipated Jew, he was still its product and after-effect.

And though Western culture was the only culture he commanded, he seems not to have felt altogether at home in it. On the other hand, his insights into certain large if subtle truths of the Jewish past and its culture were founded on relatively little direct knowledge of either. Such anomalies echo through Kafka's writing and may account for things in it that must otherwise seem arbitrary and opaque.

Time moves differently for Kafka than for any other storyteller who has used a modern European language. The tension is that of existence in time, certainly, but it is tension towards beginnings and towards the presence of the present rather than towards outcomes or eventualities. Yet, though Kafka's protagonist lives in fear of these, somehow everything has already been settled, the crucial decisions have already been made. If doom and resolution approach without ever quite arriving, it is because they are already and always have been present. Actual life only recapitulates a point made somewhere else.

At the same time, the ultimate and the immediate, the exceptional and the everyday, the crucial and the incidental, intersect everywhere and at every moment. Hence everything that happens exerts equal pressure and requires, in the telling, equal emphasis. But it is not, on the face of it, exaltation which thus levels everything upward. The vision that produces the words of Kafka's fiction tries to fix most literally, most anxiously, everything that happens to be the case. (Fortunately, most of physical reality is not the "case"; otherwise it is unlikely that Kafka would ever have gotten beyond the description of his face in the mirror.) The prosaic may be heightened, but it is not deprived of the quality of being prosaic. What exaltation, or rather eloquence, there is in Kafka is ironical and comes at the point where the facts of the case invite a summing up that must, inevitably, be inadequate to them.

Kafka seems to write with the aim of resolving the portents given him by his sensibility. He intends to be transparent, to deflate every mystery. The result is successful art precisely because he fails. Fictive reality remains throughout what it

started out as in his sensibility: a tissue of figures, likenesses, parables. Yet without the sustained effort he makes to thread the tissue and rationalize it away—that is, if he were simply satisfied with his own "poetry," Kafka would be no more than a fantasist, a kind of Jean Paul Richter: a writer of originality, no doubt, but one who would not move us deeply.

Kafka's protagonist cannot orient himself by the objective coordinates of chronology or geography or by those, either, of history, culture, social life, religion, science, or any department or discipline whatsoever of knowledge or practical activity. He is faced with immediate data of a nakedness, of an opaque brutality in their nakedness, such as can be found elsewhere only in fairy tales and the Arabian Nights. And, as in these, the data are all touchy, subject to a magic that inheres in the texture of reality and is the agent of nothing but itself.

Kafka's typical hero is resigned to the settled, routinized life he is leading when the story opens. (*The Castle* is the only important exception in this respect, yet even here the settled life is what the hero strives to achieve or return to.) The action begins with the disruption of routine, whether imagined or actual, and proceeds as the hero tries to assimilate the disruption itself to routine. To this end, he constructs hypotheses that will permit him to regard the changed situation as normal, and to continue to act rationally. But these hypotheses are always refuted, as often by his own criticism as by the acts of others. For his own criticism embodies the anonymous, inscrutable yet somehow coherent trend of reality itself. And as the narrative unfolds, inside as well as outside his mind, he begins to see that it is not merely his settled way of life that is endangered by reality's trend, but his very existence or *his* very reality—which can be interpreted, too, as his rationality or sanity in so far as the attack upon himself is delivered by those agents of reality which are imbedded in his own personality.

Processes of logical thought constitute much of the "action" in Kafka's fiction, and the story is often that of the inefficacy of thought, and nothing more. No one has ever made thought so vivid as an object rather than subject. And no one has succeeded so well in capturing its processes for the ends of imaginative literature.

As it happens, there is a precedent for this kind of vision, but one that lies outside Western tradition. The treadmill of routine, permanence, and pattern, with scrupulous thought as its constituent and enabling principle, to which Kafka's heroes look for their safety bears many resemblances to what is envisaged in that all-important department of post-Biblical Judaism called *Halachah*. Halachah is the rational derivation—and derivation upon derivation—and application of Jewish religious law on the basis of the precepts found in the Pentateuch. Law, or Torah, extended and elaborated by means of Halachah, inside and outside the Talmud, sanctifies as much as possible of human existence by fixing it in routines whose observance pleases God. Life is consecrated by being subjected to repetition.

The assumption, as I see it, upon which Halachah proceeds as it legislates and routinizes is that history stopped with the extinction of an independent Jewish state in Palestine and will not start up again until the Messiah comes to restore it. Meanwhile Jewish existence is to be kept in hand, kept sacred and safe and Jewish, by being rendered humdrum, thoroughly prosaic, and historically immobile within the "fence"—the "Chinese wall"—of the Law. Such history as persists is Gentile history, profane, meaningless in its novelty, at best an indifferent matter to the Jew, at worst a threat to his physical person and his routine.

Though Gentile history has finally brought Kafka emancipation, it still remains Gentile, therefore essentially dangerous to the Jew, emancipated or not. For the sake of safety alone—no longer of safety as an increment of salvation—he must still seek his refuge in a version of Halachic order and immobility. However, being irreligious now, he cannot build his "fence" against history on the original divine ordinances, but only out of the most general and self-evident features of the traditionally Jewish way of life: middle-class orderliness, routine, prudence, sedentary stability, application to daily tasks—and chronic anxiety about the future that leaves little room for sentiment about the past.

The price Kafka pays for the safety he may feel—if not actually find—in this secular, unwritten, and unspoken neo-Halachic system is claustrophobia. Whereas the old Halachah knows of the history that created the precedents from which it derives its authority, Kafka knows only that there was some

history in the past, but not what history. Religious Halachah, while denying the Jewish hunger for history its immediate satisfaction, promises it future satisfaction with the Messiah. Kafka's neo-Halachah contains no such promise; yet he, the emancipated Jew, feels the inveterate Jewish yearning for history with a consciousness and an impatience that no Orthodox Jew could permit himself; and feels it all the more because it is he himself, not divine providence, who must deny himself history as long as he continues to fear it.

One can see why Kafka became a Zionist. It is the classical Zionist position in its abiding, secular distrust of the non-Jewish world and non-Jewish history that he states. Marx and other emancipated Jews tried to hurry the Messiah by looking for him in Gentile history and foreseeing the imminent conversion of the Gentiles—not exactly to Judaism, but to a kind of humanity to which Jews could assimilate themselves. Kafka, the Jew of Prague, could not be so disloyal to what his immediate experience told him. His sense of the world around him was the sense of a trap, and as a Jew he was right, as the Jews of Europe had reason to know twenty years after his death, and as those in Prague ten years later still had reason to know.

His historical clairvoyance adds nothing intrinsic to the merits of Kafka's art; it could, conceivably, still be there were his art much less than it is. Only we are better able to understand and enjoy that art when we grasp the part that history, and Kafka's feeling about the Jewish relation to history, play in it. It is history's menace to the Jew that is figured—among other, less definable things—in the scratched "entries" of "barbaric mountain-dwellers" on the stones trimmed for the new temple; in the nomad barbarians who devour living animals under the windows of a passive, hidden emperor; in the unknown enemies of the animal hero of "The Burrow"; in the cats (presumably) that prey on Josephine's mice nation. Once we are aware of what history means to Kafka, the "Hunter Gracchus" fragments, "Dr. Bucephalus," "The Tower of Babel," and other short pieces that seemed the purest of poetry in prose turn out to be less "pure," without losing anything of their power thereby. It is not essential to the effect of Kafka's writing that the reader be any more mystified by his matter than the author himself is.

Nor is it as paradoxical as it might seem that Kafka figures forth history in the persons of barbarians. As a Jew, he feels post-Exilic history to be remote and capricious, hostile to intelligible ends. It belongs somehow to external nature and the restlessness of external nature, and so do nomad barbarians as, presumably, the human metaphors of capriciousness. In other places servants, janitors, coachmen, messengers, innkeepers, and anonymous Gentiles in general represent external nature and its ceaseless historical movement. Such figures are less symbolic than the barbarians because they are less transposed from Kafka's immediate experience; they *are* as well as represent, being the plebeian, lower-class, "folkish" Gentiles whom the Jew actually fears more than he does the seemingly more powerful "authorities."

That Kafka's hero is frustrated and doomed by the "authorities," whereas he is only harassed by the lower classes, does not change this. At least the "authorities" observe the forms and doom him only piecemeal; the *plebs*, left unrestrained in their malevolence, would obliterate Jews as they would animals. Kafka was clairvoyant here, too, if we judge from the case of Nazi Germany, where for the first time the *plebs* became the "authorities" in spirit.

Needless to say, the "Jewish meaning" of Kafka's work does not exhaust its content. Nor is that meaning as consistent as I, for the purposes of exposition, have made it appear. (Least of all is it consistent with respect to the Gentile *plebs*, towards whom Kafka had the typically ambivalent feelings of an enlightened, emancipated Jew, and in whom he could at times, as in *The Castle*, see potential allies as well as present enemies.) It would be wrong in any case to pin Kafka down to specific allegorical meanings. There is allegory in his fiction—the most successful allegory in a century and more of literature—but what makes it succeed when it does is that it transcends all final interpretation by virtue of its form.

Yet Kafka's form is Jewish, too. While he is not alone among great modern writers in finding it difficult to charge his matter with dramatic—as distinct from "nervous"—tension and draw it to dramatic resolution (think of Joyce, Eliot, Pound, Mann), Kafka makes it more difficult for himself by proceeding, as Halachah does in evolving and deciding law,

with a patient, if selective, circumstantiality that belongs more to description and logical exposition than to narrative. By dint of being manipulated, the details manage to move the story, but at what is often an intolerably slow pace. Kafka's scrupulousness, governed by so anxious a vision, risks appearing mannered at times, and the manner risks boring us.

This is why, in my opinion, his shorter efforts are generally more successful than his novels or extended short stories like "The Metamorphosis." Where description and exposition provide most of it, the action must be short. Beyond a certain point the peculiarly stealthy, gradual movement in time and perception that Kafka is able to achieve tends to bore the reader—whose patience is further taxed by the insufficient promise of a resolution. For resolutions and denouements would tear apart the fabric of Kafka's universe, in which conclusive acts and events cannot but be anti-climactic, too particular and local in meaning and time to resolve the entire weight of suspense, doubt, and ignorance. States of being are what are conclusive here, and these for Kafka can have no beginnings or endings, only middles. What is more, these exclude moral issues, and hence no moral choices are made in Kafka's fiction. To the extent that this fiction succeeds, it refutes the assumption of many of the most serious critics of our day—F. R. Leavis is notably one of them—that the value of a work of literary art depends ultimately on the depth to which it explores moral difficulties.

A world all "middle" is claustrophobic. Nor is this the only source of claustrophobia. Alien forces invade Kafka's system of safety, but they do not let air into it. Rather, it turns out that they have been in it from the first, built into it, and that the system is not one of safety, but of doom. Doom has been there all the time, as orderly, implicit, and immobile as safety was supposed to be. Kafka's neo-Halachah is a mockery of the old one: it is wide open inside a closed and stifling world. In conveying this Kafka says, essentially, everything he has to say. The premises of his vision and sensibility necessitate certain conclusions so absolutely that it requires relatively little "business" to act or worry them out. I think that Kafka had some realization of how tautological his imagination was on the plane of fiction—enough to feel disappointed by his attempts to cre-

ate fiction that would feel like fiction. This may be the reason, or part of the reason, why he asked Max Brod to burn his writings after he was dead.

More than anything else, Kafka wanted to accept himself as a writer, not as a seer, prophet, or visionary—as a writer of fiction, not of oracles, and a writer of fiction in prose, not a kind of hybrid poet. Under other circumstances he might indeed have been a poet in form as well as substance, but, as it was, too much spurious culture, too many alien associations were connected with verse—in German or any other European tongue—for Kafka's requirements. Poetry in meter would have been too high-falutin, too Gentile, would have involved a mortal falsification.

And might not fiction, too, and literature in general be falsification? One feels that what Kafka wanted to convey transcended literature, and that somewhere, inside him, in spite of himself, art had inevitably to seem shallow, or at least too incomplete to be profound, when compared with reality. (This, too, was in the Jewish tradition.) In so far as he radically tests the limits of art or literature, Kafka is one of the most "modern" of writers. But to say this is not to bestow undiluted praise. If the forms and conventions of fiction are not completely adequate to Kafka's vision, his own work suffers for it. Its shortcomings are due, more than anything else, to his effort to compel writing, language, literature, to do things they could not. This, too, makes him a "modern" writer.

Commentary, April 1955; A&C (substantially changed).

45. How Good is Kafka? A Critical Exchange
 with F. R. Leavis

To the Editor of *Commentary*:

In his interesting essay on "The Jewishness of Franz Kafka" for April Mr. Clement Greenberg, having observed that "no

moral choices are made in Kafka's fiction," writes: "To the extent that this fiction succeeds, it refutes the assumption of many of the most serious critics of our day—F. R. Leavis is notably one of them—that the value of a work of literary art depends ultimately on the depth to which it explores moral difficulties." I shouldn't myself put in this way any assumption I bring to criticism, but I do, of course, think that the response to which a great work of literary art challenges us entails a valuation of a most radical kind—a valuation of attitudes to life made at the prompting of a new profound sense of the possibilities of living. I assume, for instance, that a contemporary work that strikes us as important and vital art will do so for reasons suggested by D. H. Lawrence when he defines the criteria of "interest" with which he approaches new fiction: "Supposing a bomb were put under the whole scheme of things, what would we be after? What feelings do we want to carry through to the next epoch? What feelings will carry us through? What is the underlying impulse that will provide the motive power for a new state of things, when this democratic - industrial - lovey - dovey - darling - take - me - to-mamma state of things is bust?"

The conclusion to which Mr. Greenberg's considerations bring one is, surely, that Kafka is not a great creative writer at all. One can arrive at that conclusion while recognizing that Kafka certainly had something in the nature of genius. It is manifested in the pertinacious originality with which he achieves a literary expression for his neurosis. But "to the extent that this fiction succeeds" it succeeds as the expression of neurosis: We walk the neurotic treadmill, we suffer the claustrophobia, and we share the life-frustration in so far as we respond to Kafka's art. The two chief novels on which, along with a number of tales (which are all essentially the same, the neurosis remaining the same), Kafka's reputation rests are both unfinished, and Mr. Greenberg seems to concede that they were unfinishable. He makes a further significant concession when he says that, owing to Kafka's "scrupulousness governed by so anxious a vision," his "manner risks boring us," and this is why "his shorter efforts are generally more successful than his novels or extended short stories" (and he remarks how "tautological [Kafka's] imagination was on the plane of fiction").

The conclusion should surely be, not that "what Kafka wanted to convey transcended literature," but rather that he didn't succeed by creative art in transcending his neurosis: he remained its prisoner. Mr. Greenberg points out that the way in which Kafka gave his imprisonment literary expression has, by reason of its adaptation of a traditional theologico-legalist "logic," a special interest for those familiar with Jewish culture and tradition, and Mr. Greenberg's approach in general is explicit in his title. Can I without offense suggest that he should reflect on the widespread tendency among Catholics to attribute to (say) François Mauriac and Graham Greene an existence as distinguished creative writers that they certainly (it seems to me) haven't? As myself neither a Jew nor a Catholic I find in Kafka a genuine originality and an interest that I don't find in Mauriac and Greene. But I think all the same that, partly at any rate because of the approach represented by his title (and in spite of the explicitness of this), Mr. Greenberg tends to slip into some confusion about the nature of the interest, and so to overvalue the originality and the achievement.

<div style="text-align: right">

F. R. Leavis
Downing College
Cambridge, England

</div>

Clement Greenberg replies:

I was aware that I might have been giving Dr. Leavis's point of view a little too swiftly, but I am still not sure that the point of view I attributed to him is very different from the one he states, which indeed seems to me a less tenable one. I would agree that successful art heightens our sense of the possibilities of life, but I would say that it works on that sense as a sense alone, without indicating superior or inferior possibilities as such. Lawrence's assumption, followed to its logical consequence, would make good taste in art a sign of wisdom and of the capacity for wise action, which it manifestly is not. There is not the space here to go into this whole perennially confused question, but I am surprised that Dr. Leavis is not aware of how conclusively, and how often, the fallacies in this position have been demonstrated.

Dr. Leavis writes that my considerations and "concessions" would indicate that Kafka is "not a great creative writer at all." I think he deduces too much from what I say. I could "concede" more than I have, and the experience of Kafka's text would still leave him a "great creative writer"; all I can do here is ask Dr. Leavis to re-read that text (preferably in the original, for Kafka is a great master of language) without consulting his critical principles. I have the impression that he does not really consult them in Lawrence's case and therefore finds, rightly, that Lawrence is a great writer despite his unevenness and his obsessions. In his own way Kafka, too, transcends his fragmentariness and his "imprisonment," and perhaps does so even more triumphantly by virtue of his humor, which anticipates most of the criticisms of his view of life that Dr. Leavis or I can make.

Dr. Leavis seems to judge Kafka in part on his reputation and where it rests. As so often with writers close to us in time, we sense Kafka's genuine greatness in his very manner and mannerisms before we grasp it in the completeness of any individual work. With time, I think, we shall get a better view, and perceive that Kafka is perhaps even greater than we think, and more rounded and fulfilled, in a tale like "Josephine," or a "sketch" like "The Investigations of a Dog," or a prose poem like the second "Hunter Gracchus" fragment, than in his novels.

I suppose that Dr. Leavis brings in Kafka's special Jewish interest for *me* because he cannot account otherwise for the high opinion I retain of him in spite of the reservations I expressed. Well, I could cogently qualify my admiration for Shakespeare, or for any other great writer, and have infinite room left for praise while seeming to damn beyond redemption. It is distressing that Dr. Leavis should have to imply that Jewish egocentricity is what permits my esteem for Kafka's writing to survive everything I object to in it.

What I cannot see at all is why the resemblances I find between the method of Kafka's imagination and Halachic logic should have any more *special*—that is, exclusive—an interest for "those familiar with Jewish culture and tradition" than Shakespeare's echoes of Montaigne have for experts in 16th-century French literature, or the cosmological scheme of the *Divine Comedy* has for Catholic medievalists. I hoped I was

explaining the cause of an effect in Kafka's writings that those unacquainted with Jewish tradition feel as much as I do—who am not, in my ignorance of Hebrew and many other things, *that* familiar with Jewish tradition anyhow. The explanation of the cause was not intended to enhance one's opinion of the effect, nor was the Jewishness of Kafka's art expected to recommend it in any way that it could not recommend itself at first hand to any reader, Gentile or Jew.

I, too, happen to find Graham Greene an overrated writer, but since so many of the people who admire him are not Catholics and are even unsympathetic to Catholicism, I have to conclude that his vogue is the product of bad taste rather than of a special, weighted, extra-literary interest. (I haven't read Mauriac.) I wish that Dr. Leavis, in disagreeing with me about Kafka, had attributed my position to a similar error of taste and argued on that basis.

To the Editor of *Commentary*:

I cannot see that Mr. Greenberg has the right to feel aggrieved because in replying to his challenge (and if he hadn't brought in my name—and in that apparently considered and calculated way—I should have written no comment on his essay), I accepted the answer so obviously proposed by the essay itself for the question it faced me with: Why is Mr. Greenberg's valuation of Kafka's work so defiantly at odds with his account of it? To charge him with bad taste—*that* would indeed have been gratuitously discourteous; it would have been nothing to the point, and it didn't occur to me: one would hardly at any time, I imagine, find it to the point to talk about "bad taste" in discussing an over-estimate of Kafka.

That Kafka had a striking originality and something in the nature of genius I explicitly recognized. That the originality comes out in a remarkable and idiosyncratic prose I could hardly fail to be aware. For, in spite of Mr. Greenberg's hint at my lack of first-hand acquaintance, I was familiar with Kafka before he could be said to have, in England, a reputation. I don't claim to be a critic of German literature, but, perceiving the interest of Kafka, I took the trouble to obtain him in German, and I remember (perhaps I may record by way

of making my point) discussing the characteristics of the prose with Professor René Wellek—then much nearer to Prague, and to the *Kreis* about which he can talk so enlighteningly—twenty years ago.

Mr. Greenberg's admonition to me to read Kafka "without consulting my critical principles" conveys an unfounded imputation. What I bring to Kafka is what I bring to Lawrence, and what, it seems to me, anyone interested in literature must bring to any writer: the question, "How am I to take this, and what is the nature of the interest it offers?" In the case of Kafka one cannot give an intelligent answer to the second part of the question without dealing very largely in limiting judgments. How essentially this is so Mr. Greenberg's essay illustrates. It was *his* account of Kafka that I summarized in my reply to the challenge, and he hasn't told us what it is in Kafka that, missed by me in my impercipience, justifies the high estimate of him as a creative power. He merely asserts that, "in his own way," Kafka "transcends his fragmentariness and his 'imprisonment' "; except for an unenlightening reference to "humor," he doesn't tell us how.

What Mr. Greenberg means by Lawrence's "obsessions" I don't know, but I certainly cannot grant that there is any disability in Lawrence to set against Kafka's neurosis. As for "unevennesses," what voluminous author is not uneven? But instead of fragmentariness, monotony and tautology (Mr. Greenberg's words for Kafka) I find in Lawrence an immense body of perfect and incomparably varied work in the short story and tale, and a massive and profoundly original creative achievement in the novel that makes him one of the greatest of all writers. I have given the grounds for my valuation in a detailed analysis of the work—analysis that essentially *is* an exemplification of the approach to literature that leads me to disagree with Mr. Greenberg about Kafka.

Mr. Greenberg says: "I am surprised that Dr. Leavis is not aware of how conclusively, and how often, the fallacies in his position have been demonstrated." That again is only a form of mere assertion—and the form suggests that Mr. Greenberg doesn't know how the conclusive demonstration would be done, and doesn't at bottom believe that it *could* be. How

could he, being himself interested in literature and committed to criticism (in spite of his odd intimation that *he* is content to rest in a vaguely heightened "sense"—"sense" of the possibilities of life that is produced in him by literature)? His offer to prove my position untenable seems to me curiously naive: "Lawrence's assumption [about the relation of life to art], followed to its logical consequence, would make good taste in art a sign of wisdom and of the capacity for wise action." One may readily grant that good taste in art (Mr. Greenberg chooses his phrase cannily) is not necessarily a sign of securely attained wisdom and a consequent capacity for wise action; but it remains true that intelligence about (say) Kafka and Lawrence is intelligence about life. When, in determining how we take this, that and the other work of literature, we settle into our essential determinations and discriminations of sympathetic response, the perceptions, readjustments and implicit decisions entailed have—if the experience strikes us as new and significant—direct bearings on our future personal living. And this remains true, even if habit is potent and change difficult, and "bearings on" do not become at once "consequences for." Taking a tip from Mr. Greenberg, I might say that his denial of this assumption I have outlined, followed to its logical consequence, would lead to a doctrine of aestheticism and Pure Art Value. But this way of putting things might be taken to suggest that such a doctrine could of itself be consistently and logically held. That, however, I don't believe; the muddle and confusion that theoretical adhesion to it must portend mean, I think, that no one seriously interested in literature has ever readily held it.

<div style="text-align: right">

F. R. Leavis
Downing College
Cambridge, England

</div>

Clement Greenberg replies:

I brought Dr. Leavis's name in because I felt it was the one that had to be mentioned if I had room for only one name. As

much as I may disagree with him theoretically and practically, I happen to think Dr. Leavis the greatest, and truest, living literary critic (especially now that T. S. Eliot is in decline). I am glad that he has given me this opportunity to say so.

Also, he has me dead to rights. I do hold with art for art's sake: that is, nothing else can do for us what art does. If I agreed with Dr. Leavis, I would have to conclude that art was a practical substitute for life and experience.

In his *Critique of Aesthetic Judgment* Kant demonstrated that one cannot prove an aesthetic judgment in discourse. Let Dr. Leavis see whether he can, in practice or theory, refute Kant's arguments. For what he is claiming in effect is that one can so adequately exhibit in *words* one's grounds for an aesthetic judgment that agreement with it is compelled by the rules of evidence and logic. Kant holds that one can appeal only to the other person's *taste* as exercised through experience of the work of art under discussion.

As for one's "essential determinations and discriminations of sympathetic response": these are excluded in many works that Dr. Leavis would, I feel sure, agree are masterpieces of literature. *Oedipus Rex* and *King Lear* are among them. Morality is built into the mind, and works of art have to respect the limitations that morality imposes on fancied action; otherwise the reader's or observer's interest cannot be held, whether in high- or lowbrow literature. But this does not mean that we have to learn from literature in order to enjoy it properly or that those who do not learn from it are in no position to judge it. Art, in my view, explains to us what we already feel, but it does not do so discursively or rationally; rather, it acts out an explanation in the sense of working on our feelings at a remove sufficient to protect us from the consequences of the decisions made by our feelings in response to the work of art. Thus it relieves us of the pressure of feeling. I agree with Aristotle that art is catharsis, but the catharsis leaves us no wiser than before.

Commentary, June and August 1955

46. "American-Type" Painting

The latest abstract painting offends many people, among whom are more than a few who accept the abstract in art in principle. New painting (sculpture is a different question) still provokes scandal when little that is new in literature or even music appears to do so any longer. This may be explained by the very slowness of painting's evolution as a modernist art. Though it started on its "modernization" earlier perhaps than the other arts, it has turned out to have a greater number of *expendable* conventions imbedded in it, or these at least have proven harder to isolate and detach. As long as such conventions survive and can be isolated they continue to be attacked, in all the arts that intend to survive in modern society. This process has come to a stop in literature because literature has fewer conventions to expend before it begins to deny its own essence, which lies in the communication of conceptual meanings. The expendable conventions in music, on the other hand, would seem to have been isolated much sooner, which is why the process of modernization has slowed own, if not stopped, there. (I simplify drastically. And it is understood, I hope, that tradition is not dismantled by the avant-garde for sheer revolutionary effect, but in order to maintain the level and vitality of art under the steadily changing circumstances of the last hundred years—and that the dismantling has its own continuity and tradition.)

That is, the avant-garde survives in painting because painting has not yet reached the point of modernization where its discarding of inherited convention must stop lest it cease to be viable as art. Nowhere do these conventions seem to go on being attacked as they are today in this country, and the commotion about a certain kind of American abstract art is a sign of that. It is practiced by a group of painters who came to notice in New York about a dozen years ago, and have since become known as the "abstract expressionists," or less widely, as "action" painters. (I think Robert Coates of the *New Yorker* coined the first term, which is not altogether accurate. Harold Rosenberg, in *Art News*, concocted the second, but restricted it by implication to but three or four of the artists the public knows under the first term. In London, the kind of art in

question is sometimes called "American-type painting.")[1] Abstract expressionism is the first phenomenon in American art to draw a standing protest, and the first to be deplored seriously, and frequently, abroad. But it is also the first on its scale to win the serious attention, then the respect, and finally the emulation of a considerable section of the Parisian avant-garde, which admires in abstract expressionism precisely what causes it to be deplored elsewhere. Paris, whatever else it may have lost, is still quick to sense the genuinely "advanced"—though most of the abstract expressionists did not set out to be "advanced"; they set out to paint good pictures, and they "advance" in pursuit of qualities analogous to those they admire in the art of the past.

Their paintings startle because, to the uninitiated eye, they appear to rely so much on accident, whim, and haphazard effects. An ungoverned spontaneity seems to be at play, intent only on registering immediate impulse, and the result seems to be nothing more than a welter of blurs, blotches, and scrawls—"oleaginous" and "amorphous," as one British critic described it. All this is seeming. There is good and bad in abstract expressionism, and once one can tell the difference he discovers that the good owes its realization to a severer discipline than can be found elsewhere in contemporary painting; only it makes factors explicit that previous disciplines left implicit, and leaves implicit many that they did not.

To produce important art it is necessary as a rule to digest the major art of the preceding period, or periods. This is as true today as ever. One great advantage the American abstract expressionists enjoyed in the beginning was that they had already digested Klee and Miró—this, ten years before either master became a serious influence in Paris. Another was that the example of Matisse was kept alive in New York by Hans Hofmann and Milton Avery at a time when young painters abroad tended to overlook him. Picasso, Léger, and Mondrian

1. In the revised version of the essay, published in *Art and Culture*, this parenthesis was enlarged into a lengthy footnote in which Greenberg stated that he got the term "American-type" painting from Patrick Heron. Greenberg rejected all other labels for such painting. The attack on Rosenberg's concept of "Action Painting" was his first in public. [Editor's note]

were much in the foreground then, especially Picasso, but they did not block either the way or the view. Of particular importance was the fact that a large number of Kandinsky's early abstract paintings could be seen in New York in what is now the Solomon Guggenheim Museum. As a result of all this, a generation of American artists could start their careers fully abreast of their times and with an artistic culture that was not provincial. Perhaps it was the first time that this happened.

But I doubt whether it would have been possible without the opportunities for unconstrained work that the WPA Art Project gave most of them in the late '30s. Nor do I think any one of them could have gotten off the ground as well as he did without the small but relatively sophisticated audience for adventurous art provided by the students of Hans Hofmann. What turned out to be another advantage was this country's distance from the war and, as immediately important as anything else, the presence in it during the war years of European artists like Mondrian, Masson, Léger, Chagall, Ernst, and Lipchitz, along with a number of European critics, dealers, and collectors. Their proximity and attention gave the young abstract-expressionist painters self-confidence and a sense of being in the center of art. And in New York they could measure themselves against Europe with more benefit to themselves than they ever could have done as expatriates in Paris.

The justification for the term, "abstract expressionist," lies in the fact that most of the painters covered by it took their lead from German, Russian, or Jewish expressionism in breaking away from late Cubist abstract art. But they all started from French painting, got their fundamental sense of style from it, and still maintain some sort of continuity with it. Not least of all, they got from it their most vivid notion of an ambitious, major art, and of the general direction in which it had to go in their time.

Picasso was very much on their minds, especially the Picasso of the early and middle '30s, and the first problem they had to face, if they were going to say what they had to say, was how to loosen up the rather strictly demarcated illusion of shallow depth he had been working within, in his more ambitious pictures, since he closed his "synthetic" Cubist period. With this went that canon of drawing in faired, more or less

simple lines and curves that Cubism imposed and which had dominated almost all abstract art since 1920. They had to free themselves from this too. Such problems were not attacked by program (there has been very little that is programmatic about abstract expressionism) but rather run up against simultaneously by a number of young painters most of whom had their first shows at Peggy Guggenheim's gallery in 1943 to 1944. The Picasso of the '30s—whom they followed in reproductions in the *Cahiers d'Art* even more than in flesh-and-blood paintings—challenged and incited as well as taught them. Not fully abstract itself, his art in that period suggested to them new possibilities of expression for abstract and quasi-abstract painting as nothing else did, not even Klee's enormously inventive and fertile but equally unrealized 1930–1940 phase. I say equally unrealized, because Picasso caught so few of the hares he started in the '30s—which may have served, however, to make his effect on certain younger artists even more stimulating.

To break away from an overpowering precedent, the young artist usually looks for an alternative one. The late Arshile Gorky submitted himself to Miró in order to break free of Picasso, and in the process did a number of pictures we now see have independent virtues, although at the time—the late '30s—they seemed too derivative. But the 1910–1918 Kandinsky was even more of a liberator and during the first war years stimulated Gorky to a greater originality. A short while later André Breton's personal encouragement began to inspire him with a confidence he had hitherto lacked, but again he submitted his art to an influence, this time that of Matta y Echaurren, a Chilean painter much younger than himself. Matta was, and perhaps still is, an inventive draughtsman, and in some ways a daring painter, but an inveterately flashy and superficial one. It took Gorky's more solid craft, profounder culture as a painter, and more selfless devotion to art to make many of Matta's ideas look substantial. In the last four or five years of his life he so transmuted these ideas, and discovered so much more in himself in the way of feeling to add to them, that their derivation became conspicuously beside the point. Gorky found his own way to ease the pressure of Picassoid space, and learned to float flat shapes on a melting, indeter-

minate ground with a difficult stability quite unlike anything in Miró. Yet he remained a late Cubist to the end, a votary of French taste, an orthodox easel painter, a virtuoso of line, and a tinter, not a colorist. He is, I think, one of the greatest artists we have had in this country. His art was largely unappreciated in his lifetime, but a few years after his tragic death in 1948, at the age of forty-four, it was invoked and imitated by younger painters in New York who wanted to save elegance and traditional draughtsmanship for abstract painting. However, Gorky finished rather than began something, and finished it so well that anybody who follows him is condemned to academicism.

Willem de Kooning was a mature artist long before his first show in 1948. His culture is similar to Gorky's (to whom he was close) and he, too, is a draughtsman before anything else, perhaps an even more gifted one than Gorky and certainly more inventive. Ambition is as much a problem for him as it was for his dead friend, but in the inverse sense, for he has both the advantages and the liabilities—which may be greater— of an aspiration larger and more sophisticated, up to a certain point, than that of any other living artist I know of except Picasso. On the face of it, de Kooning proposes a synthesis of modernism and tradition, and a larger control over the means of abstract painting that would render it capable of statements in a grand style equivalent to that of the past. The disembodied contours of Michelangelo's and Rubens's nude figure compositions haunt his abstract pictures, yet the dragged off-white, grays, and blacks by which they are inserted in a shallow illusion of depth—which de Kooning, no more than any other painter of the time, can deepen without risk of second-hand effect—bring the Picasso of the early '30s persistently to mind. But there are even more essential resemblances, though they have little to do with imitation on de Kooning's part. He, too, hankers after *terribilità*, prompted by a similar kind of culture and by a similar nostalgia for tradition. No more than Picasso can he tear himself away from the human figure, and from the modeling of it for which his gifts for line and shading so richly equip him. And it would seem that there was even more Luciferian pride behind de Kooning's ambition: were he to realize it, all other ambitious painting

would have to stop for a while because he would have set its forward as well as backward limits for a generation to come.

If de Kooning's art has found a readier acceptance than most other forms of abstract expressionism, it is because his need to include the past as well as forestall the future reassures most of us. And in any case, he remains a late Cubist. And then there is his powerful, sinuous Ingresque line. When he left outright abstraction several years ago to attack the female form with a fury greater than Picasso's in the late '30s and the '40s, the results baffled and shocked collectors, yet the methods by which these savage dissections were carried out were patently Cubist. De Kooning is, in fact, the only painter I am aware of at this moment who continues Cubism without repeating it. In certain of his latest *Women*, which are smaller than the preceding ones, the brilliance of the success achieved demonstrates what resources that tradition has left when used by an artist of genius. But de Kooning has still to spread the full measure of that genius on canvas.

Hans Hofmann is the most remarkable phenomenon in the abstract expressionist "school" (it is not really a school) and one of its few members who can already be referred to as a "master." Known as a teacher here and abroad, he did not begin showing until 1944, when he was in his early sixties, and only shortly after his painting had become definitely abstract. Since then he has developed as one of a group whose next oldest member is at least twenty years younger. It was only natural that he should have been the maturest from the start. But his prematureness rather than matureness has obscured the fact that by 1947 he stated and won successful pictures from ideas whose later and more single-minded exploitation by others was to constitute their main claim to originality. When I myself not so long ago complained in print that Hofmann was failing to realize his true potentialities, it was because I had not caught up with him. Renewed acquaintance with some of his earlier work and his own increasing frequency and sureness of success have enlightened me as to that.

Hofmann's pictures in many instances strain to pass beyond the easel convention even as they cling to it, doing many things which that convention resists. By tradition, conven-

tion, and habit we expect pictorial structure to be presented in contrasts of dark and light, or *value*. Hofmann, who started from Matisse, the Fauves, and Kandinsky as much as from Picasso, will juxtapose high, shrill colors whose uniform warmth and brightness do not so much obscure value contrasts as render them dissonant. Or when they are made more obvious, it will be by jarring color contrasts that are equally dissonant. It is much the same with his design and drawing: a sudden razor-edged line will upset all our notions of the permissible, or else thick gobs of paint, without support of edge or shape, will cry out against pictorial sense. When Hofmann fails it is either by forcing such things, or by striving for too obvious and pat a unity, as if to reassure the spectator. Like Klee, he works in a variety of manners without seeming to consolidate his art in any one of them. He is willing, moreover, to accept his bad pictures in order to get in position for the good ones, which speaks for his self-confidence. Many people are put off by the difficulty of his art—especially museum directors and curators—without realizing it is the difficulty of it that puts them off, not what they think is its bad taste. The difficult in art usually announces itself with less sprightliness. Looked at longer, however, the sprightliness gives way to calm and to a noble and impassive intensity. Hofmann's art is very much easel painting in the end, with the concentration and the relative abundance of incident and relation that belong classically to that genre.

Adolph Gottlieb and Robert Motherwell have likewise gotten less appreciation than they deserve. Not at all alike in their painting, I couple them for the moment because they both stay closer to late Cubism, without belonging to it, than the painters yet to be discussed. Though one might think that all the abstract expressionists start off from inspired impulse, Motherwell stands out among them by reason of his dependence on it, and by his lack of real facility. Although he paints in terms of the simplified, quasi-geometric design sponsored by Picasso and Matisse and prefers, though not always, clear, simple color contrasts within a rather restricted gamut, he is less of a late Cubist than de Kooning. Motherwell has a promising kind of chaos in him but, again, it is not the kind popularly ascribed

to abstract expressionism. His early collages, in a kind of explosive Cubism analogous to de Kooning's, have with time acquired a profound and original unity, and between 1947 and 1951 or so he painted several fairly large pictures that I think are among the masterpieces of abstract expressionism: some of these, in broad vertical stripes, with ocher played off against flat blacks and whites, bear witness to how well decoration can transcend itself in the easel painting of our day. But Motherwell has at the same time painted some of the feeblest pictures done by a leading abstract expressionist, and an accumulation of these over the last three or four years has obscured his real worth.

Gottlieb is likewise a very uneven artist, but a much more solid and accomplished one than is generally supposed. He seems to me to be capable of a greater range of controlled effects than any other abstract expressionist, and it is only owing to some lack of nerve or necessary presumptuousness that he has not made this plainer to the public, which accuses him of staying too close to the grid plans of Klee or Torrès-Garcia, the Uruguayan painter. Over the years Gottlieb has, in his sober, pedestrian way, become one of the surest craftsmen in contemporary painting, one who can place a flat, uneven silhouette, that most difficult of all things to adjust to the rectangle, with a rightness beyond the capacity of ostensibly stronger painters. Some of his best work, like the "landscapes" and "seascapes" he showed in 1953, tends to be too difficult for eyes trained on late Cubism. On the other hand, his 1954 pictures, the first in which he let himself be tempted to a display of virtuosity and which stayed within late Cubism, were liked better by the public than anything he had shown before. The zigzags of Gottlieb's course in recent years, which saw him become a colorist and a painterly painter (if anything, too much of one) between his departures from and returns to Cubism, have made his development a very interesting one to watch. Right now he seems one of the least tired of all the abstract expressionists.

Jackson Pollock was at first almost as much a late Cubist and a hard and fast easel-painter as any of the abstract expressionists I have mentioned. He compounded hints from Picasso's calligraphy in the early '30s with suggestions from

Hofmann, Masson, and Mexican painting, especially Siquei-
ros, and began with a kind of picture in murky, sulphurous
colors that startled people less by the novelty of its means than
by the force and originality of the feeling behind it. Within a
notion of shallow space generalized from the practice of Miró
and Masson as well as of Picasso, and with some guidance from
the early Kandinsky, he devised a language of baroque shapes
and calligraphy that twisted this space to its own measure and
vehemence. Pollock remained close to Cubism until at least
1946, and the early greatness of his art can be taken as a ful-
fillment of things that Picasso had not brought beyond a state
of promise in his 1932–1940 period. Though he cannot build
with color, Pollock has an instinct for bold oppositions of dark
and light, and the capacity to bind the canvas rectangle and
assert its ambiguous flatness and quite unambiguous shape as
a single and whole image concentrating into one the several
images distributed over it. Going further in this direction, he
went beyond late Cubism in the end.

Mark Tobey is credited, especially in Paris, with being the
first painter to arrive at "all-over" design, covering the picture
surface with an even, largely undifferentiated system of uni-
form motifs that cause the result to look as though it could be
continued indefinitely beyond the frame like a wallpaper pat-
tern. Tobey had shown the first examples of his "white writ-
ing" in New York in 1944, but Pollock had not seen any of
these, even in reproduction, when in the summer of 1946 he
did a series of "all-over" paintings executed with dabs of but-
tery paint. Several of these were masterpieces of clarity. A
short while later he began working with skeins of enamel paint
and blotches that he opened up and laced, interlaced, and un-
laced with a breadth and power remote from anything sug-
gested by Tobey's rather limited cabinet art. One of the
unconscious motives for Pollock's "all-over" departure was the
desire to achieve a more immediate, denser, and more decora-
tive impact than his late Cubist manner had permitted. At the
same time, however, he wanted to control the oscillation be-
tween an emphatic physical surface and the suggestion of
depth beneath it as lucidly and tensely and evenly as Picasso
and Braque had controlled a somewhat similar movement with
the open facets and pointillist flecks of color of their 1909–

225

1913 Cubist pictures. ("Analytical" Cubism is always somewhere in the back of Pollock's mind.) Having achieved this kind of control, he found himself straddled between the easel picture and something else hard to define, and in the last two or three years he has pulled back.

Tobey's "all-over" pictures never aroused the protest that Pollock's did. Along with Barnett Newman's paintings, they are still considered the *reductio ad absurdum* of abstract expressionism and modern art in general. Though Pollock is a famous name now, his art has not been fundamentally accepted where one would expect it to be. Few of his fellow artists can yet tell the difference between his good and his bad work—or at least not in New York. His most recent show, in 1954, was the first to contain pictures that were forced, pumped, dressed up, but it got more acceptance than any of his previous exhibitions had—for one thing, because it made clear what an accomplished craftsman he had become, and how pleasingly he could use color now that he was not sure of what he wanted to say with it. (Even so, there were still two or three remarkable paintings present.) His 1951 exhibition, on the other hand, which included four or five huge canvases of monumental perfection and remains the peak of his achievement so far, was the one received most coldly of all.

Many of the abstract expressionists have at times drained the color from their pictures and worked in black, white, and gray alone. Gorky was the first of them to do so, in paintings like *The Diary of a Seducer* of 1945—which happens to be, in my opinion, his masterpiece. But it was left to Franz Kline, whose first show was in 1951, to work with black and white exclusively in a succession of canvases with blank white grounds bearing a single large calligraphic image in black. That these pictures were big was no cause for surprise: the abstract expressionists were being compelled to do huge canvases by the fact that they had increasingly renounced an illusion of depth within which they could develop pictorial incident without crowding; the flattening surfaces of their canvases compelled them to move along the picture plane laterally and seek in its sheer physical size the space necessary for the telling of their kind of pictorial story.

However, Kline's unmistakable allusions to Chinese and Japanese calligraphy encouraged the cant, already started by Tobey's example, about a general Oriental influence on American abstract painting. Yet none of the leading abstract expressionists except Kline has shown more than a cursory interest in Oriental art, and it is easy to demonstrate that the roots of their art lie almost entirely within Western tradition. The fact that Far Eastern calligraphy is stripped and abstract—because it involves writing—does not suffice to make the resemblances to it in abstract expressionism more than a case of convergence. It is as though this country's possession of a Pacific coast offered a handy received idea with which to account for the otherwise inexplicable fact that it is now producing a body of art that some people regard as original.

The abstract-expressionist emphasis on black and white has to do in any event with something more crucial to Western than Oriental pictorial art. It represents one of those exaggerations or apotheoses which betray a fear for their objects. Value contrast, the opposition and modulation of dark and light, has been the basis of Western pictorial art, its chief means, much more important than perspective, to a convincing illusion of depth and volume; and it has also been its chief agent of structure and unity. This is why the old masters almost always laid in their darks and lights—their shading—first. The eye automatically orients itself by the value contrasts in dealing with an object that is presented to it as a picture, and in the absence of such contrasts it tends to feel almost, if not quite as much, at loss as in the absence of a recognizable image. Impressionism's muffling of dark and light contrasts in response to the effect of the glare of the sky caused it to be criticized for that lack of "form" and "structure" which Cézanne tried to supply with his substitute contrasts of warm and cool color (these remained nonetheless contrasts of dark and light, as we can see from monochrome photographs of his paintings). Black and white is the extreme statement of value contrast, and to harp on it as many of the abstract expressionists do—and not only abstract expressionists—seems to me to be an effort to preserve by extreme measures a technical resource whose capacity to yield convincing form and unity is nearing exhaustion.

The American abstract expressionists have been given good

cause for this feeling by a development in their own midst. It is, I think, the most radical of all developments in the painting of the last two decades, and has no counterpart in Paris (unless in the late work of Masson and Tal Coat), as so many other things in American abstract expressionism have had since 1944. This development involves a more consistent and radical suppression of value contrasts than seen so far in abstract art. We can realize now, from this point of view, how conservative Cubism was in its resumption of Cézanne's effort to save the convention of dark and light. By their parody of the way the old masters shaded, the Cubists may have discredited value contrast as a means to an illusion of depth and volume, but they rescued it from the Impressionists, Gauguin, van Gogh, and the Fauves as a means to structure and form. Mondrian, a Cubist at heart, remained as dependent on contrasts of dark and light as any academic painter until his very last paintings, *Broadway Boogie Woogie* and *Victory Boogie Woogie*—which happen to be failures. Until quite recently the convention was taken for granted in even the most doctrinaire abstract art, and the later Kandinsky, though he helped ruin his pictures by his insensitivity to the effects of value contrast, never questioned it in principle. Malevich's prophetic venture in "white on white" was looked on as an experimental quirk (it was very much an *experiment* and, like almost all experiments in art, it failed aesthetically). The late Monet, whose suppression of values had been the most consistently radical to be seen in painting until a short while ago, was pointed to as a warning, and the *fin-de-siècle* muffling of contrasts in much of Bonnard's and Vuillard's art caused it to be deprecated by the avant-garde for many years. The same factor even had a part in the underrating of Pissarro.

Recently, however, some of the late Monets began to assume a unity and power they had never had before. This expansion of sensibility has coincided with the emergence of Clyfford Still as one of the most important and original painters of our time—perhaps the most original of all painters under fifty-five, if not the best. As the Cubists resumed Cézanne, Still has resumed Monet—and Pissarro. His paintings were the first abstract pictures I ever saw that contained almost no allusion to Cubism. (Kandinsky's relations with it from first

to last became very apparent by contrast.) Still's first show, at Peggy Guggenheim's in 1944, was made up predominantly of pictures in the vein of an abstract symbolism with certain "primitive" and Surrealist overtones that were in the air at that time, and of which Gottlieb's "pictographs" represented one version. I was put off by slack, willful silhouettes that seemed to disregard every consideration of plane or frame. Still's second show, in 1948, was in a different manner, that of his maturity, but I was still put off, and even outraged, by what I took to be a profound lack of sensitivity and discipline. The few large vertically divided areas that made up this typical picture seemed arbitrary in shape and edge, and the color too hot and dry, stifled by the lack of value contrasts. It was only two years ago, when I first saw a 1948 painting of Still's in isolation, that I got a first intimation of pleasure from his art; subsequently, as I was able to see still others in isolation, that intimation grew more definite. (Until one became familiar with them his pictures fought each other when side by side.) I was impressed as never before by how estranging and upsetting genuine originality in art can be, and how the greater its pressure on taste, the more stubbornly taste will resist adjusting to it.

Turner was actually the first painter to break with the European tradition of value painting. In the atmospheric pictures of his last phase he bunched value intervals together at the lighter end of the color scale for effects more picturesque than anything else. For the sake of these, the public soon forgave him his dissolution of form—besides, clouds and steam, mist, water, and light were not expected to have definite shape or form as long as they retained depth, which they did in Turner's pictures; what we today take for a daring abstractness on Turner's part was accepted then as another feat of naturalism. That Monet's close-valued painting won a similar acceptance strikes me as not being accidental. Of course, iridescent colors appeal to popular taste, which is often willing to take them in exchange for verisimilitude, but those of Monet's pictures in which he muddied—and flattened—form with dark color, as in some of his "Lily Pads," were almost as popular. Can it be suggested that the public's appetite for close-valued painting as manifested in both Turner's and Monet's cases, and in that

of late Impressionism in general, meant the emergence of a new kind of taste which, though running counter to the high traditions of our art and possessed by people with little grasp of these, yet expressed a genuine underground change in European sensibility? If so, it would clear up the paradox that lies in the fact that an art like the late Monet's, which in its time pleased banal taste and still makes most of the avant-garde shudder, should suddenly stand forth as more advanced in some respects than Cubism.

I don't know how much conscious attention Still has paid to Monet or Impressionism, but his independent and uncompromising art likewise has an affiliation with popular taste, though not by any means enough to make it acceptable to it. Still's is the first really Whitmanesque kind of painting we have had, not only because it makes large, loose gestures, or because it breaks the hold of value contrast as Whitman's verse line broke the equally traditional hold of meter; but just as much because, as Whitman's poetry assimilated, with varying success, large quantities of stale journalistic and oratorical prose, so Still's painting is infused with that stale, prosaic kind of painting to which Barnett Newman has given the name of "buckeye." Though little attention has been paid to it in print, "buckeye" is probably the most widely practiced and homogeneous kind of painting seen in the Western world today. I seem to detect its beginnings in Old Crome's oils and the Barbizon School, but it has spread only since the popularization of Impressionism. "Buckeye" painting is not "primitive," nor is it the same thing as "Sunday painting." Its practitioners can draw with a certain amount of academic correctness, but their command of shading, and of dark and light values in general, is not sufficient to control their color—either because they are simply inept in this department, or because they are naively intent on a more vivid naturalism of color than the studio-born principles of value contrast will allow. "Buckeye" painters, as far as I am aware, do landscapes exclusively and work more or less directly from nature. By piling dry paint—though not exactly in impasto—they try to capture the brilliance of daylight, and the process of painting becomes a race between hot shadows and hot lights whose invariable outcome is a livid, dry, sour picture with a warm,

brittle surface that intensifies the acid fire of the generally pre-dominating reds, browns, greens and yellows. "Buckeye" land-scapes can be seen in Greenwich Village restaurants (Eddie's Aurora on West Fourth Street used to collect them), Sixth Ave-nue picture stores (there is one near Eighth Street) and in the Washington Square outdoor shows. I understand that they are produced abundantly in Europe too. Though I can see why it is easy to stumble into "buckeye" effects, I cannot understand fully why they should be so universal and so uniform, or the kind of painting culture behind them.

Still, at any rate, is the first to have put "buckeye" effects into serious art. These are visible in the frayed dead-leaf edges that wander down the margins or across the middle of so many of his canvases, in the uniformly dark heat of his color, and in a dry, crusty paint surface (like any "buckeye" painter, Still seems to have no faith in diluted or thin pigments). Such things can spoil his pictures, or make them weird in an unre-freshing way, but when he is able to succeed with, or in spite of them, it represents but the conquest by high art of one more area of experience, and its liberation from *Kitsch*.

Still's art has a special importance at this time because it shows abstract painting a way out of its own academicism. An indirect sign of this importance is the fact that he is almost the only abstract expressionist to "make" a school; by this I mean that a few of the many artists he has stimulated or influ-enced have not been condemned by that to imitate him, but have been able to establish strong and independent styles of their own.

Barnett Newman, who is one of these artists, has replaced Pollock as the *enfant terrible* of abstract expressionism. He rules vertical bands of dimly contrasting color or value on warm flat backgrounds—and that's all. But he is not in the least related to Mondrian or anyone else in the geometrical abstract school. Though Still led the way in opening the picture down the middle and in bringing large, uninterrupted areas of uniform color into subtle and yet spectacular opposition, Newman studied late Impressionism for himself, and has drawn its con-sequences more radically. The powers of color he employs to make a picture are conceived with an ultimate strictness: color

is to function as hue and nothing else, and contrasts are to be sought with the least possible help of differences in value, saturation, or warmth.

The easel picture will hardly survive such an approach, and Newman's huge, calmly and evenly burning canvases amount to the most direct attack upon it so far. And it is all the more effective an attack because the art behind it is deep and honest, and carries a feeling for color without its like in recent painting. Mark Rothko's art is a little less aggressive in this respect. He, too, was stimulated by Still's example. The three or four massive, horizontal strata of flat color that compose his typical picture allow the spectator to think of landscape—which may be why his decorative simplicity seems to meet less resistance. Within a range predominantly warm like Newman's and Still's, he too is a brilliant, original colorist; like Newman, he soaks his pigment into the canvas, getting a dyer's effect, and does not apply it as a discrete covering layer in Still's manner. Of the three painters—all of whom started, incidentally, as "symbolists"—Rothko is the only one who seems to relate to any part of French art since Impressionism, and his ability to insinuate contrasts of value and warmth into oppositions of pure color makes me think of Matisse, who held on to value contrasts in something of the same way. This, too, may account for the public's readier acceptance of his art, but takes nothing away from it. Rothko's big vertical pictures, with their incandescent color and their bold and simple sensuousness—or rather their *firm* sensuousness—are among the largest gems of abstract expressionism.

A concomitant of the fact that Still, Newman, and Rothko suppress value contrasts and favor warm hues is the more emphatic flatness of their paintings. Because it is not broken by sharp differences of value or by more than a few incidents of drawing or design, color breathes from the canvas with an enveloping effect, which is intensified by the largeness itself of the picture. The spectator tends to react to this more in terms of décor or environment than in those usually associated with a picture hung upon a wall. The crucial issue raised by the work of these three artists is where the pictorial stops and decoration begins. In effect, their art asserts decorative elements and ideas in a pictorial context. (Whether this has any-

thing to do with the artiness that afflicts all three of them at times, I don't know. But artiness is the great liability of the Still school.)

Rothko and especially Newman are more exposed than Still to the charge of being decorators by their preference for rectilinear drawing. This sets them apart from Still in another way, too. By liberating abstract painting from value contrasts, Still also liberated it, as Pollock had not, from the quasi-geometrical, faired drawing which Cubism had found to be the surest way to prevent the edges of forms from breaking through a picture surface that had been tautened, and therefore made exceedingly sensitive, by the shrinking of the illusion of depth underneath it. As Cézanne was the first to discover, the safest way to proceed in the face of this liability was to echo the rectangular shape of the surface itself with vertical and horizontal lines and with curves whose chords were definitely vertical or horizontal. After the Cubists, and Klee, Mondrian, Miró , and others had exploited this insight it became a cliché, however, and led to the kind of late Cubist academicism that used to fill the exhibitions of the American Abstract Artists group, and which can still be seen in much of recent French abstract painting. Still's service was to show us how the contours of a shape could be made less conspicuous, and therefore less dangerous to the "integrity" of the flat surface, by narrowing the value contrast its color made with that of the shapes or areas adjacent to it. Not only does this keep colors from "jumping," as the old masters well knew, but it gives the artist greater liberty in drawing—liberty almost to the point of insensitivity, as in Still's own case. The early Kandinsky was the one abstract painter before Still to have some glimpse of this, but it was only a glimpse. Pollock has had more of a glimpse, independently of Still or Kandinsky, but has not set his course by it. In some of the huge "sprinkled" pictures he did in 1950 and showed in 1951, value contrasts are pulverized as it were, spread over the canvas like dusty vapor (the result was two of the best pictures he ever painted). But the next year, as if in violent repentance, he did a set of paintings in black line alone on unprimed canvas.

It is his insights that help explain why a relatively unpopular painter like Still has so many followers today, both in New

York and California (where he has taught); and why William Scott, the English painter, could say that Still's was the only completely and originally American art he had yet seen. This was not necessarily a compliment—Pollock, who may be less "American," and Hofmann, who is German-born, both have a wider range of power than Still—but Scott meant it as one.

The abstract expressionists started out in the '40s with a diffidence they could not help feeling as American artists. They were very much aware of the provincial fate around them. This country had had good painters in the past, but none with enough sustained originality or power to enter the mainstream of Western art. The aims of the abstract expressionists were diverse within a certain range, and they did not feel, and still do not feel, that they constitute a school or movement with enough unity to be covered by a single term— like "abstract expressionist," for instance. But aside from their culture as painters and the fact that their art was all more or less abstract, what they had in common from the first was an ambition—or rather the will to it—to break out of provinciality. I think most of them have done so by now, whether in success or failure. If they should all miss—which I do not think at all likely, since some of them have already conclusively arrived!—it will be at least with more resonance than that with which such eminent predecessors of theirs as Maurer, Hartley, Dove, and Demuth did not miss. And by comparison with such of their present competitors for the attention of the American art public as Shahn, Graves, Bloom, Stuart Davis (a good painter), Levine, Wyeth, etc., etc., their success as well as their resonance and "centrality" is assured.

If I say that such a galaxy of powerfully talented and original painters as the abstract expressionists form has not been seen since the days of Cubism, I shall be accused of chauvinist exaggeration, not to mention a lack of a sense of proportion. But can I suggest it? I do not make allowances for American art that I do not make for any other kind. At the Biennale in Venice this year, I saw how de Kooning's exhibition put to shame, not only that of his neighbor in the American pavilion, Ben Shahn, but that of every other painter present in his generation or under. The general impression still is that an art of

high distinction has as much chance of coming out of America as a great wine. Literature—yes: we now know that we have produced some great writing because the English and French have told us so. They have even exaggerated, at least about Whitman and Poe. What I hope for is a just appreciation abroad, not an exaggeration, of the merits of "American-type" painting. Only then, I suspect, will American collectors begin to take it seriously. In the meantime they will go on buying the pallid French equivalent of it they find in the art of Rio-pelle, De Stael, Soulages, and their like. The imported article is handsomer, no doubt, but the handsomeness is too obvious to have staying power. . . .

"Advanced" art—which is the same thing as ambitious art today—persists in so far as it tests society's capacity for high art. This it does by testing the limits of the inherited forms and genres, and of the medium itself, and it is what the Impressionists, the Post-Impressionists, the Fauves, the Cubists, and Mondrian did in their time. If the testing seems more radical in the case of the new American abstract painting, it is because it comes at a later stage. The limits of the easel picture are in greater danger of being destroyed because several generations of great artists have already worked to expand them. But if they are destroyed this will not necessarily mean the extinction of pictorial art as such. Painting may be on its way toward a new kind of genre, but perhaps not an unprecedented one—since we are now able to look at, and enjoy, Persian carpets as pictures—and what we now consider to be merely decorative may become capable of holding our eyes and moving us much as the easel picture does.

Meanwhile there is no such thing as an aberration in art: there is just the good and the bad, the realized and the unrealized. Often there is but the distance of a hair's breadth between the two—at first glance. And sometimes there seems—at first glance—to be no more distance than that between a great work of art and one which is not art at all. This is one of the points made by modern art.

Partisan Review, Spring 1955; *Forum* (Vienna), October 1955 (abridged and titled "*Abstraktes Amerika*"); A&C (substantially changed); *Partisan Review Anthology*, ed. William Phillips and

Philip Rahv, 1962; *Macula* 2, 1977 (titled *"Peinture à l'américaine"*); *Modern Art and Modernism: A Critical Anthology*, ed. Francis Frascina and Charles Harrison, 1982; *Abstract Expressionism: Creators and Critics*, ed. Clifford Ross, 1990.

47. A Critical Exchange with Fairfield Porter
 on "'American-Type' Painting"

To the Editor of *Partisan Review*:

I would like to comment on Clement Greenberg's article on "American-type" painting in the Spring (1955) number of PR. I agree that there is such a thing and that there are more good abstract painters in America than in Europe. But Greenberg does not describe "American-type" painting. He evaluates it too easily in a favorable light. He is very ready to tell painters what they may or may not do, without enough understanding of what they have done or are doing. Sometimes he says "we" when "I" would be more accurate. He speaks of "the easel convention" without being clear what he means. He says, "By tradition, convention and habit we expect pictorial structure to be presented in contrasts of dark and light or *value.*" This idea of value is widespread among, for instance, public-school art teachers.

Contrast of light and dark would be better called *chiaroscuro*. It is no accident that there is the word, "value," which is synonymous with "worth." It is difficult to talk about it without the painting (and not a reproduction) before you. Adrian Stokes in *Colour and Form* tries to but fails, because he does not sufficiently realize that it is a matter of the art of painting, not of nature. But in reported conversations of painters, and in conversations I have had, I know that there exists here a true and I think very important concept that has not been written down, except inadequately by people, not painters, who talked with painters and may not have understood. What Greenberg calls in the case of Monet that suppression of value, is really an emphasis on value, through dissociating it from *chiaroscuro*. For instance, one color can vary in "value"

236

but not in hue or *chiaroscuro* or intensity. Needless to say, it requires art to do this, and the effect may be of the greatest importance in the result. An area has as it were, different amounts of substance, or weight, or opacity, or some such thing, and this variation may be the important thing in the balance of the composition, and in this variation the form of the picture occurs. Fra Angelico was a painter who was particularly sensitive about this aspect of "value." Velasquez and Vermeer used it; but it is most frequently seen in French painting, from the fourteenth century *Pietà* of the school of Avignon, through Chardin, Corot, Courbet, Manet, Matisse, Vuillard, to Bonnard, who uses it unrealistically, that is abstractly, as can be seen in his painting that often hangs in the Guggenheim Museum, and that (though it has a recognizable subject matter) is because of this, perhaps the most abstract *painting* (as distinct from art object) in this museum devoted to "abstract" paintings. The earliest examples of complete abstraction of this kind of value from *chiaroscuro*, after the Impressionists, that I have seen, occur in paintings by de Kooning and some by Reinhardt, where a red and green, or a red and red, or a yellow-green and purple, having the same (Greenbergian) value, as well as the same value in the sense of worth (unless it is the same color), make your eyes rock. Otherwise modern painting from Cubism to William Scott and Clyfford Still depends on *chiaroscuro*. Nothing much more has been done except to leave out a recognizable subject, a negative acknowledgment of the first importance of the subject.

Greenberg writes of the great influence of Kandinsky and German Expressionism on American painting. But Americans copied the faults of these models as well as whatever positive qualities they may have. For instance, Kandinsky, not understanding value, made paintings full of dead areas—usually the darks, which in both his early realistic paintings and in his abstract landscapes do not connect with the rest of the surface. These faults can be seen in both avant-garde painting and in the sort of realist painting that derives from Expressionism and is shown in the Associated American Artists' Galleries. The German Expressionists misunderstood Impressionism because they did not understand value, and this provincial school bequeathed its provincialism to Americans. Cézanne did not, as

Greenberg says, try to bring back *chiaroscuro*—on the contrary, he understood very well the form implicit to the originality of Impressionism. The Cubists, in so far as they based themselves on a remark of Cézanne, put literary content into their as yet incomplete understanding of him. (To speak of a literary content in painting is not to disparage its painterliness.)

Greenberg says the term "buckeye" comes from Barnett Newman. I doubt this—I remember hearing the term applied to bad painting thirty years ago in Chicago, and frequently since.

Greenberg says that Still, Newman and Rothko started as "symbolists," which means they started by wondering what to paint instead of how to paint—their first concern was with the artist's social role, and their painting has a literary origin. The way to get away from literature (if this is desired) is not by being negatively literary.

Greenberg says Rothko's opposition of pure color makes him think of Matisse. But Matisse shows far greater sensitivity to an abstract use of color by attention to "value" (not as Greenberg uses the word) than Rothko has shown.

"American-type" painting has in some examples, this originality: it starts from painting as a way of manipulating pigment with a brush; that is, it starts very radically from the implied proposition that a painting is the result of moving pigment over a surface. It starts from nature—the nature of work done with paint. You start from this: if you are an artist, you make art from this. It starts from the contradiction of a rule of the critic Wilenski, who showed that in comparing a Raphael detail with a detail from Sargent, that in even the smallest part of Raphael there was a "plastic" (whatever that means) form, whereas in Sargent there was just paint, which demonstrated the inferiority of Sargent. American-type painting starts from the inferiority of Sargent, with the notion that a painting is after all, this: just paint, and not illusion. It does not express ideas as often as European painting, and in this sense it is "purer."

Greenberg seems to think that the artist today must give up the figure: the figure has been done and nothing new remains. It was also done by the Greeks, but the success of the ancients was imitated, not shunned, during the Renaissance. American painters have not been supreme in figure painting;

perhaps from shyness they have felt more at ease in landscape. There is now figure painting being done by Americans, but Greenberg doubts its validity, telling them in effect to stick to their old provincialism; and this misunderstanding of value is also provincial. American abstraction is a development from American timidity, and it is original; for instance a difference between American abstraction and European abstraction is that in the American form "there is nothing to look at," no center; as of the still-life on the table, the face in the middle, or the house on the hillside, which probably derives from one of the differences of American landscape, even American city landscape, from European landscape. However as a war is not won by brilliant retreats, so creativeness is not advanced by imposed limitations.

<div align="right">Fairfield Porter
Southampton, N.Y.</div>

Clement Greenberg replies:

One employs words as fixed by usage. "Values" is a literal translation of the French *valeurs*, which means, among many other things, the gradations of light and dark pigment by which surfaces are modelled or shaded into the illusion of volume, mass, and even depth. *Chiaroscuro*, from the Italian, tends more to mean light and dark in the sense of degrees of illumination rather than of color. The distinction is by no means hard and fast, but *chiaroscuro* is associated more frequently with the massing of lights and darks and not their gradations as such. Values, however, can be present without *chiaroscuro*, but not vice versa. Values are more or less discernible in all pictorial art in all places and times once such art becomes more than purely linear. *Chiaroscuro* is supposed to have been introduced by Leonardo, but some authorities, defining the term with what I think to be excessive narrowness, make it Correggio's innovation.

Mr. Porter is being captious when he tries to pin "value" down to its meaning as "worth." What difference does it make? He knows what I mean. Everything in a work of art has worth; the question is how much.

239

Through most of his second paragraph I can't follow Mr. Porter. If he means what I hope, for his own sake not mine, I think he does when he writes that Monet emphasized "value" by dissociating it from *chiaroscuro*, then he is just juggling words and wants to have them his own way simply for the sake of having them his own way.

I wonder how Mr. Porter discovered what was in Newman's, Rothko's, and Still's minds when they were "symbolists." Doesn't he speak himself of "the first importance of the subject?"

I can't remember saying or implying anywhere that the "artist today must give up the figure" because it has already been "done" (here again Mr. Porter worries too much about what instead of how to paint). In my piece I indicated what I thought was the best painting being turned out in this country, and perhaps the world, at the present time. I was registering my experience, not laying down rules or issuing directives. There are no "musts" in art, at least not for the critic.

Mr. Porter has equally little warrant for saying that I doubt the "validity" of the figure painting now being done by Americans. I happen to find de Kooning's *Women* pictures inferior by and large to his previous work, but that's an *ad hoc* judgment that has nothing to do with anybody else's figure paintings, not even Mr. Porter's. (He should have named some names.)

Partisan Review, Fall 1955

48. Introduction to an Exhibition of Hans Hofmann

Over the past fifteen years a body of painting has emerged in this country that deserves to be called major.[1] Hans Hofmann's art and teaching have been one of its main fountainheads of style. The value of his art is, however, independent of its func-

1. Greenberg selected the paintings for the exhibition. There were twenty-two works in all, dating from 1938 to 1955, half a dozen of which were marked for sale. A number of ideas expressed by Greenberg in this catalogue introduction were reworked for the 1959 essay, "Hans Hofmann: Grand Old Rebel" (see Vol. 4, 15). [Editor's note]

tion as an influence. If art critics and art bureaucrats in general have tended to overlook this, it is because their taste cannot solve Hofmann's difficult originality.

Then there is the multiplicity of directions he paints in. It would be easier to cope with his originality were it easier to follow connectedly the qualities that embody it. The checkered variety of work at his exhibitions deprives the spectator of a cumulative impression. Moreover, the artist who does not stick consistently to one manner, over even a short span of time, lays himself open to the charge of intellectuality, of being too much concerned with problems for their own technical sake. Klee, who is held up as the epitome of the inspired artist, did not stick to a single manner either at any time during his maturity, and, too, was a teacher who liked to formulate his thoughts on art. Nonetheless he was not accused of being too intellectual. The charge is no more warranted in Hofmann's case.

Another element of difficult originality in his painting lies in what might be called its dissonant color contrasts. Colors are still opposed in terms of dark and light, but not in those of warmth and coolness; rather, they are usually kept warm throughout. Because blue and green, for example, are inherently cool colors, a discord is created when they are used in warm shades as a foil to inherently warm colors like red and orange; instead of giving the eye the cool relief it expects from them, they tax it further by sustaining the warmth—much the way unresolved chords tax the ear. This goes against a rule of painting so implicit that we become aware of it as a rule only when it is violated. The Fauves, fifty years ago, were the first to break it with any consistency; Hofmann does so more radically, and this is why his color often seems to scream. With time, however, one's eyes become attuned.

As important as color is in Hofmann's art, his pictures, like all other pictures, stand or fall just as much by their design. Here again we meet with a kind of dissonance. His swift, rather machined line leads the eye to expect something different from the rugged, monumental composition it will often point up. Equally surprising is the crisp design he can achieve working with coils of paint squeezed on the canvas or panel directly from the tube. In either case, however, the seeming

discord between means and end is resolved in a final harmony that, as with all profoundly new art, we perceive only when we have broken with old habits of sensibility.

Hofmann, born in 1880, was brought up in Munich, and music and mechanical science were the first interests of his adolescence. But at eighteen he began to paint and immediately entered art school, attending several different ones until he was twenty-three. The teacher from whom he learned most was Willi Schwarz, one of the better German Impressionists of that time, and it was through Schwarz that Hofmann came to the notice of Philip Freudenberg, a Berlin department-store owner and art collector. In 1904 Freudenberg's patronage enabled him to go to Paris, where he stayed for ten years.

In Paris, Hofmann went through the Fauve and the Cubist movements as a close and friendly witness, if not participant. Although Matisse's color was the major revelation for him, Cubism made an equally profound impression and, as he himself puts it, he had to "sweat out" Cubism over the next quarter-century, until he was able to turn it against itself in the interests of his own temperament. Few people have absorbed Cubism as thoroughly as Hofmann has, and even fewer are as well able to convey its gist to others. A good deal of the credit is his for the fact that the American "abstract expressionists" could from the first take Cubism for granted as a necessary discipline on the way to a grand-style abstract art.

The outbreak of the 1914 war found Hofmann home on vacation in Germany, and cut him off from France. It also cut off his stipend from Freudenberg. Kept out of the army by the after-effects of a lung ailment, he opened an art school in Munich in 1915 in order to support himself. The school was a success from the first. In time Hofmann became a great teacher, though the fruits of his teaching have until now been realized more in a general influence on taste and practice than in the actual artistic achievements of his former students. More than a few of the latter now hold important posts in art schools, universities, and other educational institutions here and in Europe.

Hofmann's school continued to be a success after the war, attracting many students from outside Germany. And in 1930

he accepted an invitation from the University of California in Berkeley to teach at its summer session. He came again from Germany—this time for good—for the summer session of 1931, and during that same summer he also taught at the Chouinard Art Institute in Los Angeles. The winter of 1931–32 saw him teaching at the Art Students League in New York, and the summers of 1933 and 1934 at the Thurn School in Gloucester. Meanwhile, in the fall of 1932, he had re-opened his own art school, in New York. In 1934 he started his summer school in Provincetown, since which time he has spent five months of every year there.

Hofmann's first one-man show in New York was held at Peggy Guggenheim's Art of This Century gallery in March, 1944, and was one of the occasions that marked the public beginnings of "abstract expressionism." At that time Hofmann was just sixty-four, and he has shown in New York every year since—but not as a "grand old man," rather as an artist with his reputation to make or break along with painters thirty or forty years younger. Some of the latter have shown signs of fatigue lately, but Hofmann continues to gain in sureness and power, and his successful pictures have, in fact, become more frequent than ever over the last two or three years.

But why did he begin his effective development so late? Part of the reason lies in his experience of Paris before 1914. The leading Fauves and Cubists were more or less Hofmann's own age, but what they were doing at that time confronted him, the outsider from Germany, as *faits accomplis* that seemed to admit his participation only as a follower. This role his ingrained diffidence as well as equally ingrained pride and independence would not consent to. At the same time, Freudenberg's financial support eased him of the pressure to get himself known in order to sell—which, Hofmann himself says, made him a little *too* unambitious in those days. Then, later on, his school absorbed the best part of his energies; he was, and still is, a painfully conscientious teacher. Only in this country did teaching begin to interfere less with the practice of his own art.

Hofmann had, as it were, to wait for the movements of his youth and middle age—Fauvism, Cubism, Constructivism, Surrealism, Neo-Plasticism, and so on—to leave the scene be-

243

fore he could enter it. He had also to overcome his self-doubt. But this does not mean he produced nothing of value in the years before he began showing. The few paintings of his I have seen that were executed before 1930—not to mention the drawings—are convincing and alive. Hofmann himself says that his final evolution began back in 1919, with drawings in a Cubist vein to which he continued to devote his free time ascetically and obsessively over the next fifteen years, abstaining almost entirely from oil. A turning point in this period came in 1927 with a series of landscape drawings. Another was his arrival in this country, where, he says, he had the first chance since 1914 to "get back to himself." A short while later he began to work in oil again, painting landscapes and large still-lifes and interiors harking back in color to Fauvism and Matisse, and relying in design on a simplified, personal Cubism. These pictures also contained some allusions to Kandinsky's early quasi-abstract style, but an originality that overshadows almost every trace of derivation in them is manifested in their billowing, loosely-brushed paint, which declares depth and volume exactly, yet at no sacrifice in intensity of color.

As time went on, the landscapes and the other subjects were rendered more and more abstractly, but it was only a year or so before Hofmann's first New York show that his painting took on an outspokenly abstract appearance. (Curiously enough, many of his students became abstract artists long before he did.) And even today he relies occasionally on a model in nature to start a picture. For that matter, he has never, for himself, acknowledged any clearcut dividing line between abstraction and representation.

Among the things Hofmann had realized by the time he began to show, was the synthesis of Matisse's color with Cubist design which French painting right after the last war made one of its chief aims. He succeeded, however, where the French failed—and he had already done so long before the war. And the result for him was not an eclectic, composite art, but was an organic fusion evincing qualities that were new and not foreseeable in either Matisse or Cubism. Subsequently, when his painting became altogether abstract in appearance, this synthesis became but one among many elements of his style, or styles.

It is probably too early to begin deciding which of Hofmann's several manners has been the most fruitful. Nevertheless, one aspect of his art can already be spoken of as a triumph and contribution which time will not take away or even diminish.

Klee was the first, consciously, to broach painting as matter of addressing oneself to the responsive rather than inert or passive object constituted by a plane surface. He conceived of painting more as the prodding, pushing, marking and scoring of a surface than as the inscribing, tracing or covering of it. Hofmann found his own way to the same approach. In practice even more than in precept, he reveals the picture surface as something alive and needing only to be touched to show its life—as something that quivers to the touch, and throbs and breathes in answer to paint. This is no hyperbole. Without the help of such a metaphor, it is impossible to understand the *active* effect of Hofmann's paintings, their liveliness of surface, the way they animate the air around them. Something of this attitude to the raw material of one's art has, with Hofmann's help, spread through American "abstract-expressionist" painting in general and accounts for the open, pulsating paint surfaces that most consistently distinguish it from its French and German counterparts.

Some will say that this is really a symptom of American rawness and lack of sophistication. But most of the genuinely original painting of the last century and a half has struck standard good taste, on first sight, as being too raw in *facture*; time alone has done the smoothing and refining. Hofmann's art is a microcosm of the process, for as his thickly painted pictures dry out, and their colors come closer together in key, they become smoother, firmer in their unity, more traditional in their resonance, and their force becomes more compatible with elegance. It is perhaps too soon for the standard good taste of our time to see this, but it will surely do so when Hofmann's pictures have dried figuratively as well as literally.

A Retrospective Exhibition of the Paintings of Hans Hofmann,
Bennington College, Vermont, Spring 1955

49. Lautrec's Art: Review of *Henri de Toulouse-Lautrec: Drawings and Sketches in Colour* by Hanspeter Landolt and *H. de Toulouse-Lautrec: One Hundred Ten Unpublished Drawings* by Arthur W. and M. Roland O. Heintzelman

The boom in Toulouse-Lautrec's reputation has had the effect, customary in such a case, of promoting a too uncritical acceptance of his work. For me he is seldom an easel painter of the very first rank. He made mistakes on canvas analogous to those of Gauguin, another post and "anti" Impressionist, illustrating a derived conception of art rather than one achieved through the processes themselves of oil, canvas and immediate experience. Color and line in Lautrec's easel paintings tend to be a little too firmed, too faired and squared, too placed.

Much of that which hinders Lautrec on canvas turns into an advantage for him as a draughtsman with brush, pen or pencil on paper, cardboard, board or stone. His sketches and drawings give a truer measure of his powers than do his easel pictures, or even his poster work, because they are lighter, swifter, more spontaneous and, above all, more felt. This is why the Hanspeter Landolt volume proves to be one of the most valuable of all items in book form on Lautrec, its illustrations being composed entirely of unfinished or preliminary sketches in color.

Certainly the sketch and the drawing spare Lautrec the obligation to reveal his weakness in identifying color with mass as well as with surface, his inability often to let pigment breathe without at the same time extinguishing three-dimensional form. This kind of form—as abstract painting and Persian and Far Eastern art make clear—is not indispensable to pictures. It becomes that only when certain assumptions are accepted, and Lautrec in his canvases did accept the necessity that the space within the frame coincide completely with the illusion of three-dimensional space in and through which the artist rendered the things and beings whose appearance before his eyes was made possible by such space.

The assumption of this necessity is implicit in the whole tradition of Western painting, from Giotto to Matisse, but it has not governed drawing and sketching. There the artist has

246

been permitted to be incomplete in all times and places. This freedom from the obligation to deliver a thoroughly coherent illusion, to finish and complete, is what afforded Lautrec's genius its best opportunities. We recognize this in the beautiful plates of the Landolt book.

Lautrec had already begun to realize these opportunities when he was still an adolescent, as the Arthur W. and M. R. O. Heintzelman book attests. It contains 110 hitherto unpublished drawings made by the artist before he was 16 and gathered together in an album now in the possession of the Boston Public Library. The co-authors of the introduction—father and son—write: "It is remarkable that one so young did not elaborate in either line or value as most students are apt to do." Many of these boyhood drawings of horses—and, to an extent, of dogs, too—are indeed almost miraculous for their swift and terse accuracy in capturing the motion as well as the look of an animal. There is no question here of sporting art: the hand and eye of the artist react with spirit, not only with interest and fidelity.

The short texts of both these books are superior to the usual run of art writing.

The New York Times Book Review, 31 July 1955

50. Review of *Piero della Francesca* and *The Arch of Constantine*, both by Bernard Berenson

Bernard Berenson is one of America's most signal contributions to European culture. Without him neither scholarship nor criticism would possess the art of the Italian Renaissance as firmly as both now do. Many questions of attribution would still be unsolved, the merits of several important masters might still remain obscure, and those of others unduly inflated. Clarity, to the extent that it is not imposed by oversimplification, is a sovereign good, and Mr. Berenson has brought greater clarity to a larger and essential part of the surviving past.

Born a Jew in Lithuania (in 1865) and coming to the United States at the age of ten, then returning to Europe in

his early twenties and seldom thereafter revisiting his adopted country, Mr. Berenson continues to be surprisingly American, as those who visit him in Italy, where he has lived for more than fifty years, can testify. His emphasis on culture and cultivation, and inability to take either for granted, are very American, and so is his need—of which he himself seems largely unaware—to render connoisseurship and criticism matters of positive and particular fact. This empiricism is responsible for much in the contribution he has made to both fields.

Mr. Berenson's celebrity as an expert in the attribution of pictures and drawings may be still greater than his reputation as a critic, but I feel that the future will value him more in the latter capacity, and see that his scholarship really served appreciation before it did "archaeology." Fifty years ago and more, in his books on the regional schools of Italian Renaissance painting, he laid out a critical panorama that has withstood where it did not anticipate the revisions of judgment occasioned since by the effect of modern art on taste. Enthusiasms and revulsions have come and gone, but hardly any of Mr. Berenson's original judgments have been overruled. But perhaps this early rightness has been a liability to his subsequent development as a critic. He has not always been true to his own gifts or his immediate experience.

His frequent animadversions on modern art rest on too narrow and too indirect an acquaintance with contemporary works of painting and sculpture. Nor do his ambitions as a theorist, made more public in the books and monographs he has published since the war (a surprising number in view of his age and the fact that he was not a prolific writer in the past), seem in accord with his real inclinations. In his *Sketch for a Self-Portrait* (1949) he tells us that he has always regretted having been "seduced" by the concrete and factual from his appointed calling as a philosopher of art: something like a system, a philosophy of art, would be a more permanent achievement to leave behind. Now, while time remains, he must draw the conclusions from his vast experience of art and shape them into a coherent intellectual structure. But Mr. Berenson's aptitude, as far as I can see, is more for intuitive induction than for conscious reasoning; it is precisely because he has always been more of an "eye" and a sensibility than an intellect that he has

been able to make himself that "instrument of precision in the appreciation of works of art" which he indubitably is. Philosophical appreciation is a different matter.

When Mr. Berenson intimates that the very highest qualities of art are defined for all time in canons derived from Greek art and from its tradition as continued in postmedieval European art, he is being dogmatic, not philosophical. Whatever we conclude about the greatness of art in the past, we shall not be able to lay down limiting or enabling rules for the achievement of greatness in the present or future until aesthetics has become as exactly scientific as physics. To approach art philosophically means, moreover, to abstract from one's experience of it. Kant had bad taste and relatively meager experience of art, yet his capacity for abstraction enabled him, despite many *gaffes*, to establish in his *Critique of Aesthetic Judgment* what is the most satisfactory basis for aesthetics we yet have. Kant asked how art in general worked. Mr. Berenson asks, more specifically, how the visual arts work and what makes the difference between good and bad in them; but the answers require almost as much abstraction. *His* answers, however, diminish rather than abstract from his experience, and his experience again and again escapes from his theories, as we see from the appreciative and penetrating comments he lets himself make on works of art that violate them.

The two little books at hand show, as did Mr. Berenson's larger and more ambitious *Aesthetics and History in the Visual Arts* (1948), how much the working critic he remains amid his efforts to formulate theory, and how often the latter serves him merely as an *ad hoc* means of praising specific works of art. In the *Piero della Francesca*, he asks whether "it is not precisely Piero's ineloquence, his unemotional, unfeeling figures," and our own satiety with "exasperated passions" and with the "over-expressive" art of our own day, that account for that artist's growing popularity. Yet Piero's "ineloquence" is characteristic of all the very greatest art: "After sixty years of living on terms of intimacy with every kind of work of art, from every clime and every period, I am tempted to conclude that in the long run the most satisfactory creations are those which, like Piero's and Cézanne's, remain ineloquent, mute, with no urgent communication to make, and no thought of rousing us with look

and gesture. If they express anything it is character, essence, rather than momentary feeling or purpose. They manifest particularity rather than activity. It is enough that they exist in themselves." A rapid review of the history of art, from Egypt and Mesopotamia to van Gogh, confirms Mr. Berenson in this impression. "Expressionism," which he makes synonymous with the overexpressive, produced "masterpieces of their kind not only in the sumptuously illustrated manuscripts of the Ottonian and Hohenstaufen periods, but in the sculptures of Bamberg, Naumburg, and Meissen. As illustration, they can be poignant and even impressive. But the moment their message reaches us, we think little or not at all of the messenger, in this case the miniature, the statue, the relief, the painting, little of art intrinsically, art for its tonic life-enhancing properties."

Though we may not be convinced by every example offered in demonstration—I myself reject the verdict on the Bamberg and Naumburg sculptures—the general point of this short essay seems to be well taken. Yet when van Gogh's self-portraits are praised because they remain "as inexpressive . . . as Piero della Francesca himself" we see that Mr. Berenson is stretching the point to suit himself. The nonillustrative elements in the Naumburg sculptures are found wanting, but are not the corresponding elements in van Gogh's self-portraits too "eloquent" not to be equally wanting in this respect? Mr. Berenson has not taken the trouble to render his generalization viable beyond his own empirical practice as a critic. To do that he would have had to deal with some knotty questions involving the distinction between the illustrative and the "decorative" or nonillustrative. For himself as a working critic he was right not to, and right to feel free to contradict himself—but he lays himself open to misunderstanding.

The Arch of Constantine is both longer and more interesting than the Piero essay. Here Mr. Berenson addresses the ripened precision of his taste to the heterogeneous friezes, bas-reliefs, medallions, and roundels which busy the surface of the arch that was erected to greet Constantine I on his return to Rome to preside over the decennial festival of the Roman Empire in A.D. 315. Learning too is brought to bear, with a marvelously easy and lively pertinence. In his introduction Mr. Berenson

tells us that this monograph is intended as the first chapter of a "voluminous work on Decline and Recovery in the Figure Arts," a study of the "successive changes that took place in the art phenomena" of Eurasia in the twelve hundred years between Constantine and Charles V.

At the outset the "sinister fact" is noted that much of the sculpture on the Arch of Constantine was looted from earlier structures put up for Trajan, Hadrian, and Marcus Aurelius. Whether this was due to hurry or to "a feeling that nothing could be done there and then as worthy of the occasion . . . it was a confession of inferiority to the past, whether economic or artistic. . . . " And in the squat figures and insensitive modeling of the reliefs done expressly for the Arch, Mr. Berenson finds signs of a *sudden* decline of artistic skill; Roman sculpture executed a short time before or even contemporaneously is not nearly so clumsy. Rejecting the notion that we are confronted with the first emergence of a proto-Byzantine or proto-Romanesque style, he ascribes the "newness" of these reliefs to simple ineptitude and hazards the explanation that "in the troubled state of the world, and of Rome in particular, the stonecutters who were real sculptors (and Greeks almost to a man) ran away for relative safety to Gaul, to Spain, or back to the Aegean world, leaving behind them the humble native artisans who had little to lose and nowhere to go . . . nothing could have been further from the conceit of these humble stonecutters than that they were precursors . . . of an entirely new way of feeling, visualizing and representing the world outside themselves." They were mere copyists, and bungling ones, as is proven by those of the works of art they copied from that are still extant.

Such originality as these artisans were capable of is to be found in the frontality, repeated verticals, and the geometrical rigidity and symmetrically centered design of the two friezes that show, respectively, Constantine distributing largess and making a speech. Mr. Berenson suggests that these innovations were politically rather than artistically motivated, their aim being to enhance Constantine's dominating role. If Oriental influence played any part, it must have come from as far away as the Greco-Buddhist friezes, with their serried figures, on the gates of Indian temples like that at Sanchi, done around

a hundred years earlier! He hypothesizes that other spectacular examples of sudden decline, like the porphyry group portraits of the Tetrarchs in Venice and in the Vatican Library, which were made shortly before Constantine's reign, reflect influences from Palmyra in the Syrian Desert, and that provincial and anticlassical distortions of Greco-Roman tradition like these entered the mainstream of Roman art with the connivance of Diocletian and his successors, whose taste in art went hand in hand with their despotic and antihumanist tendencies as rulers.

This, presumably, is Mr. Berenson's main explanation for the general decline of Roman art—in his "Epilogue" he makes exotic influences and tastes similarly responsible for what he maintains is the present catastrophic decline of Western art. Actually, he says in his introduction, he is not interested in his present study in "technical questions of why things happened or with metaphysical or ethical explanations." His chief object is to trace the phenomena as such of decline, and to describe and define them—he implies—in the autonomous terms of art.

It is not of course as simple as that, and Mr. Berenson enters ethical judgments in deciding the aesthetic worth of a remarkable fourth-century stone bust of Licinius and that of an even more remarkable first-century bronze head of Augustus, both of which were found in Egypt. The first "pushes one down into a deep-lying, long-buried layer of emerging mankind barely beginning its pilgrimage toward the even now still distant goal of humanization"; the second "takes on a terrifyingly sinister expression . . . that may have been thought indispensable in a ruler of fellahin, that is to say, of bipeds who are never participants of government but its victims." Mr. Berenson is not necessarily wrong in these judgments, but the large, staring eyes that mark both portraits, and which become so conspicuous in representations of the human face from Constantine's time on, cannot be taken simply as evidence of a failure of feeling and skill: it is just as easy to carve or paint eyes small as large. Obviously—and I am surprised Mr. Berenson does not accept it—the large eyes mean a new attitude to the human person, and the "will" to show it in art through a new style. That style may be as sorry as Mr. Berenson holds it to be, but it is a new one nonetheless. Here, as elsewhere, he lets a standard of naturalism on the Hellenic model decide

too much, as if all representations of the human form were to be judged by their distance from it, and had no qualitative independence in relation to other aims.

However, one does not have to agree with the author at every or even most points to have one's appetite whetted for further installments of his study of decline and recovery. I find my understanding and awareness, not only of single works of art, but of a whole age of art sharpened by his words. Where I disagree I always find something *worth* disagreeing about; Mr. Berenson is never trivial or obtuse. And he invites one to take issue with him by the very ingenuousness with which he reveals the operations of his taste. This is the trait of the great critic, and Mr. Berenson is one of the greatest of them all. But he is a working critic, not a philosopher of art.

Perspectives USA, November 1955

51. Polemic Against Modern Art: Review of *The Demon of Progress in the Arts* by Wyndham Lewis

T. S. Eliot has called Wyndham Lewis the "greatest prose stylist of my generation—perhaps the only one to have invented a new style." I happen to find this exaggerated, but even were it not, Mr. Lewis would still be paying too high a price for the distinction. The metallic bounce of his style, its conversational rapidity and tartness, seem to be made possible most often by the evasion of any challenge to sustained thought or scrutiny. It is the failure to sustain or develop, whether on the plane of reason or that of imagination, that characterizes most of the Wyndham Lewis I have read, and it may explain why so many people can read him only in snatches.

Mr. Lewis is not the first categorically to denounce modernism or "extremism"—in this case, more narrowly, abstractness—in painting and sculpture. And he is not the first, nor will he be the last, from whose rough hands it emerges unscathed. This is small failure for a small book. Invariably, the enterprise of anti-modernism, whether in book, article or newspaper column, has been a frustrated one, for Berenson as much as for Robsjohn-Gibbings or Howard Devree—doomed

to frustration because the denunciation is *a priori* and categorical, which honest art criticism can never be, since good as well as bad art remains possible *anywhere*, and the critic has to wait upon possibility.

To be *categorically* against any current style in art means, in effect, condemning works of art one has not yet seen or which have not yet been produced, which means in turn questioning the motives of their producers, which means in further turn directing one's attention to causes solely instead of effects—though, as we all know, the effect, the result, alone matters in art. I can but deplore the waste of energy that has gone into the whole business of anti-modernism and keeps going into it.

Nineteen out of twenty abstract paintings or pieces of sculpture are bad. Perhaps the ratio of success to failure was the same in Renaissance naturalism, but we shall never know, since inferior works of art, even in ages we consider to have had execrable taste, have a greater tendency to disappear than superior works do. But even if the ratio of failure to success is now higher than ever in the past, the fact remains that some, if only a few, works of abstract art are better than others. And the denouncer of "extremism" is, in all conscience, under the obligation to be able to tell the difference before sounding off in public. The refusal to attempt to do so is enough of itself to render denunciations like Lewis's suspect. Lewis does not satisfy us on this score when, in the beginning of his book, he hails Moore, Sutherland, Bacon, Colquhoun, Minton, Craxton, Passmore, Trevelyan, Richards and Ayrton as forming "actually the finest group of painters and sculptors which England has ever known." On the contrary.

In places, Lewis does even worse than the run-of-the-mill anti-modernists. Sir Herbert Read, supposedly the all-out advocate of "extremism" (which he is not—though it would not matter one way or another if he were), is an incompetent art critic; Lewis, to judge from his *Listener* pieces, has at times, when addressing himself to the art of a past more than recent, been a superb one (as, for instance, on the superiority of Michelangelo's painting to his sculpture). But his keenness as a critic of traditional art enters not at all into this polemic. All one can say is that where Sir Herbert would be furtively, surreptitiously incoherent, Lewis is unabashedly so—which, again, is

not enough praise. And then there is the misinformation in which he, like Sir Herbert abounds: as, for example, that Cubism was a "borrowing . . . from science."

As with all such books, one could go on. All the old strawmen are on hand: the undiscoverable people—undiscoverable, at least, since 1900—who hold that art gets better as it "advances," in time and otherwise. In spite of his title, Lewis never attacks the "demon of progress" frontally; whom could he quote as believing Picasso and Pollock to be better than Titian, Rubens and Rembrandt? Actually, none of the antimodernists except Berenson seems to choose the frontal attack. Lewis's denunciation of abstract or "extremist" art is largely in terms of its social context, audience, and the qualifications and public roles of its literary champions—just as so many antimodernists in this country find nothing more to the point, when attacking abstract art's disrespect for "human values," than to quote Art News prose.

Suffice it to say that Lewis attributes the proliferation of abstract art to the fact that it offers a handy concealment to artists who lack talent and/or training; to the further fact that painting and sculpture cost less to bring before the public than music, drama, dance or literature; and to the historical, cultural and sociological fact that "mass-life today is the worst kind of thing for an appreciation of the arts, or of any cultural product. . . . The absurd things which are happening in the visual arts at present are what must happen when an art becomes almost totally disconnected from society, when it no longer has any direct function in life, and can only exist as the plaything of the intellect."

What truth there is in the last is badly, misleadingly and even dishonestly stated (Lewis would be hard put to define the role of the "intellect" in either the making or the appreciation of any art), but I am surprised most by the fact that he bothers to repeat, as if it were a fresh and startling truth to be proclaimed with self-satisfied asperity, what has been said a thousand times before, and not always with such a banal absence of qualification.

The New Leader, 12 December 1955

52. Foreword to the Tenth Anniversary Exhibition of the Betty Parsons Gallery

Whether or not the public acknowledges it, the status of American art vis-à-vis that of the rest of the world has radically changed in the last ten years. No longer in tutelage to Europe, it now radiates influence and no longer merely receives it. This is a triumph, and I do not see why we should not celebrate it without too many qualms about chauvinism.

One of the notable scenes of that triumph has been, and continues to be, the Betty Parsons Gallery. Mrs. Parsons showed artists like Pollock, Hofmann, Still, Newman, Rothko, Ferber, Lipton at a time when they could bring her little prestige and even less money. Since then many of these painters and sculptors have gone elsewhere, but a large measure of the prestige, if not of the profits, that is now theirs redounds upon her, as the present exhibition, commemorating the tenth year of her gallery, should establish incontestably.[1]

Mrs. Parsons has never lacked for courage. It is not a virtue signally associated with art dealers (or, for that matter, with art critics or museum directors either), but then she is not, at least for me, primarily a dealer. I have seldom been able to bring her gallery into focus as part of the commercial apparatus of art (I am not sneering at that apparatus); rather, I think of it as belonging more to the studio and production side of art. In a sense like that in which a painter is referred to as a painter's painter or a poet as a poet's poet, Mrs. Parsons' is an artist's—and critic's—gallery: a place where art goes on and is not just shown and sold. Long may it flourish.

Ten Years, Betty Parsons Gallery, New York, December 1955—January 1956

1. The exhibition included the work of twenty-five artists, all of whom were associated with the gallery at one time or another. [Editor's note]

1956

53. Impress of Impressionism: Review of *Impressionism* by Jean Leymarie

Cézanne's posthumous success has occasioned much damage to the prestige of Impressionism, perhaps the greatest it ever will suffer. Though itself founded on Impressionism, his art has seemed to many to imply the refutation of Impressionism, not just its correction. And his famous remark, that he wanted to make of it something as solid as the art of the Old Masters, has been taken as explicit evidence of that. To me, the remark means that he thought Impressionism worth "saving," preserving, not refuting. And I think he was over-solicitous. At any rate, with the beginning of Cézanne's apotheosis forty years ago, it became avant-garde cant to find Impressionism wanting in "form" or structure. This preposterous judgment can still be heard today from people who should know better.

But even without Cézanne, there would have been a reaction against Impressionism, if only because some of its innovations were premature. The Cubists, sensing how profoundly traditional it had remained under certain aspects, felt that it was to be rejected for this reason in part. In other part, they missed in Impressionism certain qualities associated with tradition—"architectural structure," notably—that they wanted to revive and preserve. They, and the Fauves too, failed largely to appreciate the strength and viability of what had been put in place of these qualities. For the masterpieces of Impressionism (those pictures, say, of the 1870s that were to be seen in the first-floor galleries of the Jeu de Paume in Paris) exhibit their own unique and characteristic perfection of structure or "form," and would not be the masterpieces they indubitably are did they not do so.

The best Impressionist pictures—which include many of the late Monets and late Pissarros—represent the culmination

and purest statement of a tradition and a vision of oil painting born among the Venetians and prolonged in a variety of directions over the next two hundred and fifty years: a vision of the plenitude of a picture surface whose every square inch had equivalent impact—an art of maximum saturation if not of maximum richness. Painterly painting yearned towards this as something never fully realizable but powerful and necessary as an ideal and an orientation, until the Impressionists, borne up by the ambition to match nature's luminosity rather than its "appearance," set themselves to spelling the vision out literally and completely. One of their enabling assumptions was that the "motif" sliced out of nature by a single glance, and transferred to a 20-by-25-inch rectangle, did not have to be rearranged in terms of a geometrical and sculptural orderliness of volumes and hollows in order to manifest pictorial coherence; color almost alone would suffice, and the shapes emanating from and diffused by color. It was no longer necessary to rely exclusively on an underlying armature of dark and light contrasts. Thus the Venetian vision was realized in its *attainable* purity, and by artists whose skill and sensitivity of eye and hand surely qualify them as among the very greatest practitioners of their craft.

The purity would have been impossible had it not encompassed pictorial structure, the dividing up of the picture surface by contrasts; otherwise it would not have been art, and the Impressionists would not have been painters. Only it was not structure conceived under the sculptural categories of mass and volume, but structure summoned from color, from the delivered color that surfaces wear but do not sustain, color that rests lightly and changes as the pressure of light changes. Such "form" can be, in principle, as convincing as that obtained sculpturally through the contrasting of values (as the latest abstract painting demonstrates to us anew.) Those without an eye for this kind of chromatic form miss one of the intrinsic pleasures to be gotten from the contemplation of pictures in color.

The two volumes at hand give the more or less standard facts and views on Impressionism. M. Leymarie, who is Curator of the Grenoble Museum, takes his account as far as Bonnard, but does not relate the movement quite adequately

to what went before and came after it. No deep penetrations of critical insight are made, no wider or longer perspectives offered; perhaps Skira does not want that in its texts. What we do get are many descriptive passages that have a certain originality as well as a felicity which makes itself felt through the veil of a translation clumsy at times. Colorplates are supplied in profusion, and though they are small, as the page size dictates, they come up for the most part to the standards to which this publisher has accustomed us.

Art News, May 1956

54. Methods of the Master: Review of *Leonardo's Treatise on Painting*, annotated by A. Philip McMahon

We can say for our age of criticism and sickly thought that it at least has less illusions than the past about what is definitely knowable about art. Leonardo's observations on painting are sown with contradictions, ambiguities and rephrasings not only because they were set down, unedited, at different times over a span of several decades, but because he, along with his age, sought for definiteness in many matters not susceptible of it.

The intention in his *Treatise on Painting* is to develop pictorial art into a science by exact and exhaustive observation of its presumptive subject-matter—nature—and by equally exact and exhaustive formulation of the means by which that subject-matter could best be rendered or communicated. Rendered or communicated to what end? That the purpose of the art of painting is to convey knowledge, even of an exalted kind, is not so easy to assume. Leonardo discovered many regularities in visual experience but very little, to judge from what we have left of his own words, about the nature of art as such. And it is as if he himself, turning over and rewording his ideas, sensed this negative possibility. He managed to say significant things about his art, and therefore about the tradi-

tion to which it added, but almost nothing that holds for art outside that tradition.

The readiness to let experience again and again undo thought belongs to Leonardo's greatness. But a tentativeness so praiseworthy in the scientist was a great weakness in the worker: Leonardo finished too few pictures, and the books he planned never got beyond the note-jotting stage. He had three books in mind, on painting, anatomy and mechanics, and he collected a wealth of observations for them. The difficulty in the selecting and ordering of these—which he seems never to have attempted anyway—may have been more than a matter of temperament, however.

Science inheres in method much more than in facts, and Leonardo was not enough ahead of his age, apparently, to perceive this. Otherwise it is possible he would have had more than unconscious second thoughts about "raising" painting to the status of a science. Art inheres, so obviously, in particular results, which once achieved legitimize any kind of method; and it is equally obvious that, in art, method of itself guarantees nothing. Yet it was for a sure method of art that Leonardo sought.

Exaggerated notions of what could be generalized about art led in the past to a greater discrepancy than now between what artists said and what they actually did. It is true that a good deal in what Leonardo writes might prepare someone who did not know his actual work for the inspired systematization and expansion of dark-and-light effects that form his great viable contribution to the art of painting. But from other observations in the *Treatise on Painting* it might be deduced that his ideal of pictorial art was the *tableau vivant*, or even the colored photograph. Almost nothing would lead one to expect the intense, and sometimes cloying, affective atmosphere in which he bathes his figure compositions, and for which the *sfumato*, that luminous yet heavy shading which is the most conspicuous feature of Leonardo's mature style, is not, in its nature as a technical device, entirely responsible. There is less discrepancy between Cézanne's art and what he says about art.

In Leonardo's discussion of reflected colors and reflected lights, of the color of atmosphere, and of the alteration of color by atmosphere, we are amazed to see how much he knew that

the Impressionists, three hundred and fifty years later, had to discover. But one is equally amazed at how little, relatively, of all that he noted about color is incorporated in his actual painting—just as, in view of the amount and kind of attention he gives to landscape, one is surprised at how relatively little landscape there is in it, notwithstanding one's awareness of the iconological biases of his age.

Part of the explanation lies, patently, in Leonardo's conception of the illusion of relief as the most important of all the immediate effects to be achieved through painting: "The primary purpose of the painter is to make a plain surface display a body in relief, detached from that plane, and he who in that art most surpasses others deserves most praise, and this concern, which is the crown of the science of painting, comes about from the use of shadows and lights, or, if you wish, brightness and darkness. Therefore whoever avoids shadows avoids what is the glory of art for noble minds, but gains glory with the ignorant public, who want nothing in painting but beauty of color, altogether forgetting the beauty and marvel of depicting a relief on what in reality is a plane surface." This was much the way the Cubists in their time felt about the popularity of Impressionism. And they were not landscape painters either.

The primacy of relief is reiterated in many other places in the *Treatise*, and lightness and darkness (or values), as its chief means, are given much more attention in general than color. Wherever relief, or a sculptural illusion of the third dimension, is insisted upon—as it was by Leonardo and by the whole Renaissance and post-Renaissance tradition of painting, more or less, up until Impressionism—many of the effects proper to color cannot prevail. This may not have been as much the case with the Venetians, Rubens, Velasquez and Rembrandt, as it was with Leonardo, Michelangelo and the other Florentines but it remained largely the case with them too.

Volume I of the book at hand offers the first English translation of the Codex Urbinas Latinus 1270 (the Vatican cataloguing number), with facsimile of the original in Volume II. The text of the Codex Urbinas, with its illustrations, was transcribed from Leonardo's original manuscripts, many of which have since been lost, and the work of copying, which

entailed compilation and organization as well, was done, presumably, under the supervision of Leonardo's literary heir, the Milanese nobleman, Francesco Melzi (1473–1570). The Codex was intended as the basis for an edition of the *Treatise on Painting*, such as Leonardo himself had planned, but of whose contemplated organization he had given only the broadest indications.

The Codex is the archetype of all versions of the *Treatise on Painting*, written or printed, that were available before Guglielmo Manzi rediscovered the manuscript in 1817 and had it printed for the first time. None of the numerous versions of the *Treatise* in circulation before 1817 is as complete.

The late A. Philip McMahon's translation, though a word-for-word one that does little re-editing of the original, reads lucidly and smoothly; the obscurities, repetitions and errors are (as is pointed out) the fault of the copyists or of Leonardo himself. Mr. McMahon's appended Concordance of the Codex with the extant manuscripts from Leonardo's own hand will prove interesting to scholars and students. But it would be hard to say what value aside from its historical and documentary one the *Treatise* has.

I doubt whether the edification, not to mention pleasure, to be gotten from it cannot be more readily found elsewhere. Such is the fate of writing on art that does not itself achieve art—or achieves it only intermittently. Leonardo, was a master of Italian prose, but his breath seems never to have held out for more than a paragraph or at most a page. Perhaps we should be grateful enough for such fragments, but I, for one, would be even more grateful to an editor able to lift these out and put them together in some order that held the reader's curiosity throughout.

The New York Times Book Review, 26 August 1956

55. Review of *Four Steps Toward Modern Art* by Lionello Venturi

Lionello Venturi is one of the relatively few authoritative art critics of our time, and the combination of taste and scholar-

ship he brings to bear makes him edifying even when he repeats himself. Much of what he says in this present little book he has said before, and sometimes better, yet I find myself stimulated anew. I do not always agree with Professor Venturi, and I often wish he would pursue his insights further than he does, and work out his observations more connectedly and in greater detail, but I would still rather read him than almost any other writer on art now alive.

The book at hand, composed of four lectures given last year at Columbia, reflects Venturi's characteristic, if seldom explicitly stated, assumption that every manifestation in art must be approached as part of a historical continuum extending through the present. Each work of art is, of course, an entity whose purpose is contained in itself, and needs neither history nor society to justify it; but to account for it—to the small extent that a work of art of any importance can be accounted for—we have to keep before us its relations with other works. It is possible that Professor Venturi overemphasizes the continuity of our Western art, but if so, it is a welcome corrective to the opposite and far more prevalent tendency to treat modern art as an utter historical novelty.

Everything of significance in the art of the past, if we confine that past to our own Western tradition, can be seen as leading toward the modern in one way or another. Why start then with Giorgione, the appearance of whose art is less modern than that of Piero della Francesca's, which is in turn less modern than that of many a Byzantine mosaic and fresco? And why make Caravaggio the next step? His final manner is even less modern in appearance than Giorgione's art. But Professor Venturi's point has little to do with *appearance*, notwithstanding the fact that it is by that alone that works of art have virtuality as art.

A Byzantine mural, no matter how much its appearance may remind us of high Impressionism, does not "feel" as modern as Giorgione because it conveys a certain kind of anecdotal meaning in a certain way. It is Giorgione's attitude that brings him closer to ourselves. Giorgione is the first artist in our tradition, says Venturi, to conceive art on the "musical level" and as "no longer directed toward stress upon knowledge"—which it was in the hands of the Florentines—but following

the "senses and imagination." "Venetian painting opened the horizons of a new realism, broader than that of the Renaissance because no longer limited to man. Man was no longer abstract from, but immersed in, reality, and nature became humanized, not because it was subdued but because it was adored by man."

There is less that we already know, or has already been said by others, in Professor Venturi's lecture on Caravaggio. It is the latter's abstractness, the seeds of which came from Mannerism, as well as his psychological expressiveness, that is held to lead toward the modern. Because Caravaggio's "abstract forms had such an intensity of feeling, such an evidence of truth, they were considered reality itself." "Besides volumes, geometric lines, and effects of light and shade, Caravaggio brought into art a new longing for truth which gave a dramatic aspect to his life as well as to his art."

The lecture on Manet is the best in the book. Professor Venturi says; " . . . suppose that the painter be subjective in the sense that he only organizes the impressions received from reality and thereby creates impressions coherent in themselves without modification through checking them either against reality or against ideal beauty. What would be the result? The expression of a way of seeing, of a pure vision, of a plastic-chromatic whole, or form for form's sake . . . this is the breaking point, forced by Manet, which resulted in the birth of modern art." With Cézanne the "autonomy of art in the face of nature became more complete than that of the impressionists, became a new world, a world of imagination which was developing along a line parallel to that of nature, meeting it only in the infinite." This is true, but too simple to be left at that, which is where Professor Venturi does leave it more or less. The compulsion Cézanne felt, to a greater degree than did Manet, to "check against nature" made the autonomy of his art a more difficult and also a more ambiguous one. One feels Venturi's somewhat chronic short-windedness here, his reluctance to explain himself in depth when contradictions have to be wrestled with. And then there is his conception of modern art itself.

According to Professor Venturi, the "fundamental exigency" of Cubism, which took its departure from Cézanne, was "to

interpret reality by abstract geometrical forms. . . . " Abstract geometrical forms may have played a great part in the development of Cubism, but they are by no means one of its essential features; rather they are a mere by-product of Picasso's and Braque's original effort to model three-dimensional form more firmly by simplifying the shapes of objects and of their constituent planes. The forms remain simplified throughout, but in synthetic Cubism they are no longer "geometrical."

One might find other things to argue with in this little book, especially in the chapter on Cézanne, but the principal thing is the level Professor Venturi asserts and maintains, and for that one cannot be grateful enough. There is surprisingly little art writing in our time that is informed by genuine philosophical and historical sophistication coupled with truly "professional" taste.

Arts Magazine, September 1956

56. American Stereotypes: Review of *Cousins and Strangers: Comments on America by Commonwealth Fund Fellows from Britain, 1946–1952,* edited by S. Gorley Putt

Every year the Commonwealth Fund, administered by the British but set up by a rich American, sends to this country, for study in their respective fields, twenty university graduates and five civil servants from Great Britain, along with five civil servants from the Dominions, two more from the Colonies, and up to three "editorial journalists." They submit informal reports, and the present book is made up of excerpts from seventy-odd of these, arranged under headings that go from the very broad to the rather specific (e.g. "Medicine," "Road Traffic"). A pretty accurate and sympathetic if sketchy view of many aspects of our life is afforded, but hardly anything gets described or explained in a really fresh way. This is not solely because the contributors write for non-Americans. The fact is that the American character, and the American scene, lend themselves to stereotyping, and most of the stereotypes seem

to be true. Moreover, it is we Americans who are usually the first to recognize their truth.

Perhaps this can be explained by the unique nature of the tradition of American self-criticism no less than by the nature itself of the American people and of America. In most other countries earnest self-criticism has been aimed at a single class, the middle class. The English criticize their Philistines, but not the English as such; the French their bourgeoisie, not the French as such; and it has been a good deal the same with the Italians and the Germans (though there are many exceptions in the latter case). It is quite different with us. The whole of America is seen as middle class in character, if not in social actuality, and so when we criticize our middle class or classes— and critical Americans share the animus of critical people the world over against the middle class—we criticize Americans as such. What is partial self-criticism for others becomes total for us, and hence we have tended to be more aware of our national self than others are of theirs.

Another reason is the fact itself of our being so predominantly middle class. It would seem that where the middle class can have its way it inclines toward openness and outwardness, if only to promote that mutual understanding which is so beneficial to efficiency and trade. There is also our frontier tradition, which is really the "tradition," as much operative in the city as elsewhere, of uprooted people who must turn strangers into friends as quickly as possible. Whatever other factors are accountable, we do in this country behave as though intent on Hegel's millennium, when the public and the private shall be as one, and the outside of a man declare everything about his inside. We sound, in Mr. Putt's book as in others, like an imaginary country about which Gullivers can find out almost everything. And we sound all the more so because of the ostensible sameness that goes with our openness, the uniformity which smothers those inconsistencies and contradictions that would break us out of the realm of the imaginary into that of the unthinkably real.

The openness and sameness that make us so easy to stereotype are themselves stereotypes. They are stereotypes (and not the only ones) that we live out, which go deeper than ideas or words, and form actual part of ourselves. They determine the

266

American personality, which is a standardized one, as we ourselves and all the world know. Without a standardized personality, we doubtless would not manifest that "unity and diversity" which is frequently remarked upon in *Cousins and Strangers*; without it, we probably would not get along with one another as well as we do, given our ethnic, racial, and regional heterogeneity. But to grant this does not make the standardized personality any the less a burden, or enable us to refute the devastating criticism implicit in even such a friendly book as *Cousins and Strangers*.

The English and the French—especially their cultivated classes—have a standardized manner, but it is a *manner*, not a personality, and leaves plenty of room for individuality and temperament. A standardized personality does not. And whereas the English or the French manner can make many a person appear more interesting than he really is, the American personality most often has the opposite effect. One commits oneself to a personality and believes in it; a manner can be put on and off, and private inclinations can be indulged and personal goals pursued behind it. A personality, ostensibly declaring the whole of oneself, leaves too little of the self over for self-cultivation or self-development. Not that many Englishmen and Frenchmen do not exhaust their selves in their manners as Americans exhaust their selves in their personalities: only the former are not expected to do so, and the latter are. And various informal sanctions are imposed to make sure that this expectation is met.

The observation in *Cousins and Strangers* that struck me most was A. Jane Pinsent's (who was a Fellow in microbiology): "It is uncommon to find children listening to the conversations of their elders, or taking much notice of advice, and it is natural, therefore, that they miss many opportunities for learning by any means but direct experience. Moreover, having thus little contact with older people who have formed standards of their own, the process of formulation of private aims and ambitions is often greatly delayed. The standards of the group are readily adopted, success being measured entirely in terms of admiration elicited from the group. . . . " We used to think that this applied only to the children of immigrants, but Miss Pinsent makes no such qualifications.

What has been said above is not new; it is in the orthodox tradition of American self-criticism. But we are beginning to see, I think, how little this piling of true stereotypes and clichés on one another avails to rid us of what the stereotypes and clichés point to and are. This may be part of the reason for the greater political emphasis American self-criticism has acquired in recent years. At least things happen in politics, or seem to do so more definitely. But not only has this renewed emphasis on politics diverted attention from the real sources of our discomfort with ourselves; it has served to create stereotypes that, this time, are false.

The alarmed comments on the McCarthy episode in *Cousins and Strangers* are typical, and they could just as well have been made by most enlightened Americans at that time (before 1953). The latter find it as hard as any foreigner does to understand how the side of light usually manages to win out in an area where the means and the conditions seem so overwhelmingly on the side of darkness. If this is indeed hard to understand, it is because politics is the sphere in which the standardized American personality plays falsest with the reality of Americans themselves, and where what we seem to be doing corresponds least with what we actually do—which is to say that politics is one of the aspects of American life least amenable to accurate stereotyping, and where even what true stereotypes there are are largely misleading or irrelevant. Which is also to say that our politics, with everything that is wrong about it, stands least in need of the attention of our specifically American tradition of self-criticism. It has worked—for whatever extra-political reasons—better than the politics of most other countries, and cannot be complained about in terms like those in which we complain about the American personality or the quality of our life.

Right now, nonetheless, many enlightened Americans continue to insist on doing so. McCarthy and McCarthyism were already on their way out when the anti-shibboleth of "conformism" was raised, meaning that the demand that Bolshevism be universally regarded as a scandal, and not as "another point of view," was acting to stifle independence, individuality, and dissidence in almost every department of American life. Manifestly, politics does not affect that much of it, and anti-

Communist "conformism" weighs mostly on people actually drawn to Communist politics. Why then is such an issue made of anti-Communism, one that goes far beyond the necessity of defending civil liberties?

A most important, if unconscious, motive is, I feel, the need to project upon an outer agent the responsibility for an inner, voluntary conformism, from which American liberals suffer in their way as much as Nixon Republicans in theirs. (Illuminating in this context is how much the contributors to Mr. Putt's book tend—albeit inadvertently—to lump intellectual and enlightened Americans together with the rest of the populace, character-wise.) The difference is that liberals are made more uncomfortable by the inner conformism even if they may not be more aware of its real nature. And sensing in politics a freedom from stereotyped actuality as is hardly to be found elsewhere in American life, they think that there they will be able to act most effectively against their discomfort. But this is asking of politics what it cannot give. The conformism we genuinely suffer from is not a matter of politics and cannot be overcome by political means. The perverse result of such a misconception is the attempt, precisely, to subject our politics too to stereotypes.

And since American politics has not generated enough of its own stereotypes (which have nothing to do with campaign oratory), these have to be imported from abroad—from the politics of the Continent, which is truly stereotyped. The Continental left and, even more, the Continental right are imposed upon American politics by mental violence, and politics in general becomes a theater for moral attitudinizing in which "correctness" and righteousness count for more than actual consequences. Fortunately, this system of rhetoric has remained confined to liberal and "neo-conservative" journalism, influencing no one's real political behavior—not even that of the journalists themselves. Unfortunately, foreigners tend to think it (for understandable reasons) representative, and to take it more seriously. To that extent American politics is traduced in the world outside by Americans themselves; and to the extent that Americans cut their attitudes and expressions of feeling to its measure—as so many of the supposedly most enlightened of us are tending to do—to that extent they tra-

duce politics at home. If Graeme C. Moodie—a Fellow in political science, no less, and one of the few contributors to *Cousins and Strangers* who happens to be a professional writer— can write in 1950 that the United States was to "an appreciable degree along the road to a relatively polite and civilized form of totalitarianism," his own weaknesses as a political observer are not entirely to blame; he was, I am sure, told the same thing by many Americans.

Commentary, October 1956

57. Roundness Isn't All: Review of *The Art of Sculpture* by Herbert Read

This reviewer is not the only one puzzled by Sir Herbert Read's prestige as a critic and a philosopher of art. The book at hand contains the Mellon lectures he delivered in 1954 at the National Gallery in Washington, and though perhaps one of the better things to come from his pen, it adds to the enigma. Sir Herbert has already betrayed his discomfort with painting; now he betrays it with sculpture, the only important difference being that he seems to believe in the sculptor Henry Moore as he believes in no painter living or dead.

The titles of the six lectures give a good indication of the nature of the book's content: "The Monument and the Amulet," "The Image of Man," "The Discovery of Space," "The Realization of Mass," "The Illusion of Movement," and "The Impact of Light." Sir Herbert's aim "is to give, with appropriate illustrations, an aesthetic of the art of sculpture."

This involves a brief exposition of the historical development of the art in which he contends that "Both architecture and sculpture may be conceived as evolving from an original unity"—the monument. Another independent origin of sculpture, however, was the amulet; and the "specific art of sculpture, an art with its distinct aesthetics, comes into existence somewhere between these two extremes—as a method of creating an object with the independence of the amulet and the effect of the monument." Sir Herbert admits that he re-

constructs the origins of art imaginatively rather than scientifically, and his speculations provoke thought, even if the available evidence hardly bears them out.

But the formulation of his "aesthetic" of sculpture proves dangerously simple. "An art owes its particularity to the emphasis or preference given to any one organ of sensation . . . sculpture is to be distinguished from painting as the plastic art that gives preference to tactile sensations as against visual sensations, and it is precisely when this preference is clearly stated that sculpture attains its highest and its unique aesthetic values. This particularity does not mean, of course, that we can discount our visual reactions to sculpture; nor does it mean that we refuse any aesthetic value to sculpture that is visually conceived."

He continues: "The specifically plastic sensibility is, I believe, more complex than the specifically visual sensibility. It involves three factors: a sensation of the tactile qualities of surfaces; a sensation of volume as denoted by plane surfaces; and a synthetic realization of the mass and ponderability of the object." The "art of sculpture in its complete aesthetic integrity [independent of architecture and even of architectural siting] had to grow from sculpture in miniature," from *Kleinplastik*, "small objects that can actually be handled." The decadence of sculpture is usually marked, as it was in Europe between Michelangelo and Rodin, by infatuation with pictorial effects and alienation from tactility.

All this is nicely said (the poise, the just and quietly authoritative tone of Sir Herbert's prose may help account for his reputation). But the conclusion that sculpture, when it attains its "highest values," states clearly its "preference" for "tactile sensations" is deduced from a definition of the medium rather than from actual experience of works of sculpture.

The analogous conclusion for pictorial art would be that painting, when it attains its highest values, states clearly its preference for full color as against monochrome, since the art of painting owes its particularity to its emphasis on visual sensations, and full color is what speaks most emphatically to the eye. The analogy is exact, color being as neutral a means in the one case as plasticity in the other. This should suffice to demonstrate the fallaciousness of Sir Herbert's "aesthetic" of

sculpture, with its implication that bas-relief and incised relief are necessarily inferior in aesthetic value to sculpture in the round.

Sir Herbert advances ideas that are more than fallacious when he discusses the actual part that the sense of touch plays in the appreciation of sculpture. It is true that amulets or small objects were made in the Far East, designed to be handled as much as to be looked at, and that many works of sculpture fairly ask to be touched. But to say flatly, as Sir Herbert does, that "Sculpture is an art of palpation—an art that gives satisfaction in the touching and handling of objects" is downright absurd.

I doubt whether he realizes what he is saying. Of all the works of sculpture that have moved us, there are very, very few that have not provided their decisive satisfaction through the eyes. I have heard of no one who let his pleasure in a piece of sculpture wait upon his handling it, and of very few who have succeeded in actually touching most of the pieces they admire.

To what extent, in any case, can a work of sculpture be apprehended as a coherent artistic whole by palpation? And to what extent has any sculptor, except one who made tiny figurines, worked with the criteria of touch rather than those of sight predominantly in mind? Sculpture does invoke the sense of touch—as well as our sense of space in general—but it does so primarily through the sense of sight and the tactile associations of which that sense is capable.

Sir Herbert does not inquire into these (they play a part in the experience of pictorial art, too), and he calls Adolf von Hildebrand's assertion that the "sculptor strives to accommodate his three-dimensional forms to the visual ease of a two-dimensional surface" a heresy. But Hildebrand was at least aware of the crucial problem offered by sculpture's dependence upon the association of virtual tactility with actual visibility, and tried to deal with it. Sir Herbert contents himself with lamenting the fact that museums won't let people touch the things shown in them.

It is true enough that the arts have over the last century shown a consistent tendency to withdraw into their respective mediums and "purify" themselves, by renouncing illusion, among other things. Just as painting ever more insistently

declares its flatness, sculpture has declared its roundness and the nature of the materials of which it is made.

This, apparently, is what leads Sir Herbert to write that the sculptor "now has a much clearer conception of the scope and methods of his art and is free to develop that art with a purity and power that can only make more evident whatever greatness or nobility he may possess." But sculpture, having attained a maximum of roundness and compactness with Brancusi and Arp, some forty years ago underwent a mutation without parallel in any other contemporary art and issued from Picasso's hands in a new mode that had its origin in the Cubist collage and bas-relief.

This new constructivist and quasi-constructivist sculpture, with its linear and transparent forms and its striving for weightlessness, runs counter to everything in Sir Herbert's canon. Instead of broadening that canon and acknowledging its at best limited and provisional validity, or else condemning the new sculpture out of hand, his response is to call it a new *art* and suggest that "technically it would be classified in any museum not as sculpture but as wrought ironwork"! Such are the expedients of dogmatism.

Not everything Sir Herbert has to say about sculpture is as unthought out as his "aesthetic." He does convey information and offer some fresh if marginal perceptions; he does provide the benefit of his wide reading in the philosophy and the history of art. And *The Art of Sculpture*, for all its *gaffes* and fallacies, is definitely worth reading.

The New York Times Book Review, 25 November 1956

58. Picasso As Revolutionary: Review of *Picasso* by Frank Elgar and Robert Maillard

This is one of the better among the many books on Picasso that have appeared recently. But most of these have been bad books, and this is not altogether a good one.

On the credit side are its numerous illustrations, both in color and in black and white, which are of a decent fidelity

273

and reproduce many things not familiar to Americans. The chronological list provided of 261 of the artist's "principal works," each illustrated with a small half-tone cut, is invaluable, and so is a catalogue of all works owned by European museums as well as a list of the books for which Picasso has expressly made engraved illustrations. And the text has the benefit of the easy English into which Francis Scarfe has put its French original.

The text page itself is laid out in novel fashion: The main text, by Frank Elgar, a young French critic, is given in single-columned roman on the upper half, with Robert Maillard's shorter biographical account running below in two-columned italics like a continuous footnote. That the page, despite this layout, achieves a certain neatness (and that the book, crowded with plates and half-page illustrations, has a nice compactness in general) speaks for the taste and skill of its German makers (Praeger).

Mr. Maillard's is much the more interesting contribution, not only because he presents facts—some of them fresh—in an interesting way, but also because his own critical observations are a little more incisive than Mr. Elgar's, whose fundamentally uncritical approach he nevertheless shares. Mr. Elgar's "critical study" is indeed the only thing really wrong with the book, but it also forms the main part of it.

Picasso was a very great artist between 1906 and 1926, and the achievement of those years will, I am sure, bulk as large in time to come as any Old Master's. But he has been a very uneven artist since then, and in the last 20 years not even a good one on the whole. For Mr. Elgar, however, as for most people who write appreciatively on Picasso, he can do nothing wrong. Instead of criticism and analysis, we get rhapsodic description. Not everything the master creates is of equal value, to be sure, but nothing ever really fails for him, or fails enough to detract from the enormous figure he cuts. It is as if the heart of Picasso's achievement were to confound and astound us, to become the myth of himself, and the quality of the individual works of art he has produced were of peripheral importance.

Like most of those who treat him as a prodigy rather than as a mortal man, Mr. Elgar makes a lot of the Picasso who keeps reversing his tracks, who is a "prodigious creator yet at

heart a fierce negator," the artist who "sent his blasphemies echoing down our century," the "revolutionary who pushes his inquiries in every direction, with no use for prejudices, opening doors on every hand and shutting them with a bang after him." Yet, it is quite easy for those who take the trouble to look to see how firmly Picasso is tied to tradition, which he continues in the same direction as Cézanne, who continued it in the same direction as Manet, who continued it in the same direction as Goya. The exaggeration of certain traditional elements of the discipline of painting that Picasso undertook in Cubism was revolutionary in scale and in aspect but not in intent—certainly he did not intend abstract art, which he has never accepted for himself. Nor, for that matter, does an honest artist intend anything but good works of art, to which innovation and "revolution" are solely means.

It has been many years, in any case, since Picasso has been revolutionary in any real or relevant sense. Given that his formal language, which remains essentially Cubist in his ambitious projects, received its last creative touches by 1937 at the latest, the shock value of his art has derived since then mostly from its illustrative effect. The shock comes from what is done to the human or animal anatomy—to the idea of it as a norm—and not from what is done with or to the language itself of painting, where Picasso's frequently deliberate bad taste and ruptures of stylistic unity have the effect of rearrangements of the familiar rather than of re-creations of it. The impression left is not of an artist engaged in permanent revolution, but of one who continues to go through the motions of a revolution already won and over with. If this were better understood, the truly prodigious quality of Picasso's best work would also be better understood.

The New Leader, 10 December 1956

59. David Smith

Ten years ago there were bright hopes for sculpture. Renewed in vitality since Rodin and having found a fresh point of de-

parture in modernist painting, it seemed about to enter into a great new inheritance. The new, quasi-pictorial modes born of the Cubist collage and bas-relief had, in liberating sculpture from the monolith, given it access to a vast new field of subject matter. Indeed, in the thirties and forties the range of style and subject open to modernist sculpture seemed to be expanding in the same measure as that at which the range open to ambitious painting seemed to be narrowing, and it looked then as though sculpture might shortly become the dominant vehicle of figurative art. Certainly, there was enough sculptural talent on hand to make this appear a possibility.

These hopes have faded. Painting continues to hold the field, by virtue of its greater breadth of statement as well as by its greater energy. And sculpture has become a place where, as hopes have turned into illusions, inflated reputations and inflated renaissances flourish. There are Moore, Marini, and the postwar Giacometti, and there is the "awakening" of British sculpture at the hands of Butler, Chadwick, Turnbull, et al. Yet it is significant that the monolithic statues of such older artists as Marcks and Wotruba still carry greater conviction than the more "advanced" linear, thin-planed, and more or less geometrical art of these British followers of Gonzalez. And it is also significant that modernist American sculpture should have succumbed so epidemically to "biomorphism," and that then, after the fanciful and decorative improvisation of plant, bone, muscle, and other organic forms, there should have come a spinning of wires, twisting of cords, and general fashioning of cages and boxes—so that the most conspicuous result of the diffusion of the use of the welding torch among American sculptors has been a superior kind of garden statuary and a new, oversized kind of *objet d'art*.

Modernist sculpture's common affliction, here and abroad, is artiness, whether the archaic artiness of Moore, Marini, and Giacometti, the Cubist artiness of the younger British sculptors, or the expressionist-*cum*-surrealist artiness of the Americans. Artiness is usually the symptom of a fear for the identity of one's art, and the result of, among other things, a self-imposed restriction of subject matter. Sculpture must continue to look like sculpture—like art. Here Constructivism has been the terrorizing agent, with its machinery and machine-made

look. The exceptions—and there are some notable ones—to the general disappointment that has been modernist sculpture over the past decade mark themselves off precisely by their relative freedom from this terror. And the most notable of such exceptions is in my opinion David Smith, whom I do not hesitate to call the best sculptor of his generation.

Smith was among the first in this country to practice the art of aerial drawing in metal and to use the welding torch and materials like steel and the modern alloys in sculpture. And he was perhaps the very first to devise a kind of sculptural collage, essentially without precedent in either Picasso or Gonzalez, that involved found and contrived machine parts. But the means in art never guarantee the ends, and it is for the individual and underivable qualities of Smith's art that we praise it, not for its technical innovations.

That Smith shows everything he finishes, and that he has had a high frequency, at least in the past, of failure to success, has caused many misconceptions about his art. That he works, moreover, in such a diversity of manners (as well as tending to violate presumable unity of style within single pieces) does not make it easy to form a clear idea of his achievement as a whole. Add to this the fact of an almost aggressive originality, and we can understand why the art public and its mentors, while not exactly refusing their admiration, have not yet accepted his work in a way that would bring prizes, commissions, and the purchases of important pieces by museums and other public or semi-public agencies. At the same time, I have the impression that if a poll were taken among non-academic American sculptors, Smith would come out as the rival most highly regarded by the majority of them. And according to what I hear, the avant-garde in Paris finds him lately to be the most interesting of all American sculptors, Calder not excepted.

Smith is one of those artists who can afford mistakes and even need them, just as artists need and can afford bad taste and an incapacity for self-criticism. It is most often by way of errors, false starts, overrun objectives, and much groping and fumbling in general that great and original art arrives. The inability or unwillingness to criticize himself may permit Smith to lapse into illustrative cuteness or decorative whimsicality, or to descend suddenly to a petty effect, but it also

enables him to accept the surprises of his own personality, wherein lies his originality. Which is to say that he has been triumphantly loyal to his own temperament and his own experience in defiance of whatever precedents or rules of taste might have stood in the way.

To state Smith's shortcomings is but to reinforce his praise. His most chronic fault has been a compulsion to develop and elaborate a work beyond the point to which the momentum of inspiration has carried it. This can be accounted for in part by the extent to which he, too, is afraid that the result might not look enough like art; but it is more largely explained by the nature itself of Smith's talent. Characteristic strengths entail characteristic weaknesses. The very copiousness of his gift, the scale and generosity of his powers of conception and execution, are what more than anything else impel him to overwork a piece of sculpture, to act unconsideredly on every impulse, and explore every idea to its limits. Yet when the piece is brought off, its triumph is enhanced by the sense we get of a checked flow whose further, unactualized abundance and power reverberate through that which is actualized. And we would not get this sense were Smith not a headlong, reckless artist ready to chance anything he felt out of confidence in his ability to redeem in another piece whatever went wrong in the given one.

In recent years he has become more consistent, and the successful pieces come more steadily. It used to be that a period of expansion and trial and error during which new ideas were explored, with much attendant failure, would be followed by a much shorter one of consolidation in which there was a higher proportion of success to failure. Now Smith seems to be able to proceed more rapidly and directly from conception to realization. It is as if his sensibility had become more refined. The change is, however, in ourselves, too, who through longer acquaintance have become convinced of the premises of his art, so that it now seems to us to adjust itself better to antecedent art. Much that looked at first like *gaucherie* now reveals itself as a new definition of sculptural elegance, economy, and strength, combined in ways that are equally new. It was once plausible to characterize Smith's art as baroque, but it has become equally plausible today to call it classical. In this respect, its course has, from the viewpoint of criticism, repeated that of the *oeuvres* of many other modern masters.

The quick success with the art world that Butler, Chadwick, and the others of the British "sculpture renaissance" have known is owed in largest part to the fact that these artists started out as "classical." But to this same fact is owed their fundamental thinness and insipidity. For "classical" means in this instance a canon of forms and good taste taken abjectly from Gonzalez, Picasso, Matisse, and Miró, and a sculpture that pleases because it never offends (at least not eyes that have learned to like Cubist painting). How different Smith's case has been. He has done things in a manner ostensibly not too unlike Butler's and Chadwick's. But a short look suffices to reveal the truly enormous difference. The elegance of the figure pieces in Smith's recent *Tank Totem* series has a tenseness, and tension, not to be found in the anemic elegance of the works of these British sculptors; nor is there anything at all in their work to match the sustained yet varied fusion of felicity and ruggedness which distinguishes the dozen-odd pieces of Smith's *Agricola* series. In the one case we have the fruits of a struggle for a complete and personal insight into a new realm of style; in the other, an art that affords only glimpses into this realm, and these through other men's eyes. Smith had to help create and expand the taste that enjoys him; the taste which enjoys Butler and Chadwick was given ready-made.

A complex simplicity, an economic abundance, starkness made delicate, and physical fragility that supports the attributes of monumentality: these are the abstract elements comprehended in the canon of Smith's art. But naming them is of little use. What is desirable is that his works be more widely and publicly distributed, here and abroad, so that they can present their claims in person. And perhaps to be hoped for most of all is that he receive the kind of commission that will permit him to display that capacity for largescale, heroic, and monumental sculpture which is his more than any other artist's now alive. For want of such commissions, Smith's self-fulfillment is still less than complete.

Art in America, Winter 1956–1957; A&C (slightly revised); *Art in America*, August 1963.

Bibliography

Works by Greenberg

UNCOLLECTED WRITINGS, 1939–1949

"An Interview with Ignacio Silone," *Partisan Review* 6 (Fall 1939): 22–30.

With Dwight Macdonald. "10 Propositions on the War." *Partisan Review* 8 (July–August 1941): 271–78.

With Dwight Macdonald. "Reply" (to Philip Rahv, "10 Propositions and 8 Errors," in the same issue). *Partisan Review* 8 (November–December 1941): 506–508.

"Walter Quirt." *The Nation* (7 March 1942): 294.

"L'art américain au XXe siècle." *Les Temps Modernes* 2 (August–September 1946): 340–52.

BOOKS

Joan Miró. New York: Quadrangle Press, 1948.

Matisse. New York: H. N. Abrams, 1953.

Art and Culture: Critical Essays. Boston: Beacon Press, 1961.

Hans Hofmann. Paris: Georges Fall, 1961.

The Collected Essays and Criticism: Perceptions and Judgments, 1939–1944. Vol. 1. Edited by John O'Brian. Chicago: University of Chicago Press, 1986.

The Collected Essays and Criticism: Arrogant Purpose, 1945–1949. Vol. 2. Edited by John O'Brian. Chicago: University of Chicago Press, 1986.

TRANSLATIONS FROM THE GERMAN

The Brown Network: The Activities of the Nazis in Foreign Countries. Introduced by William Francis Hare. New York: Knight Publications, 1936.

With Emma Ashton and Jay Dratler. Manfred Schneider, *Goya: A Portrait of the Artist as a Man.* New York: Knight Publications, 1936.

Franz Kafka. "Josephine, The Songstress: Or, the Mice Nation." *Partisan Review* 9 (May–June 1942): 213–28.

With Willa and Edwin Muir. Franz Kafka, *Parables*. New York: Schocken Books, 1947.

With Willa and Edwin Muir. Franz Kafka, *The Great Wall of China: Stories and Reflections*. New York: Schocken Books, 1948.

Paul Celan. *"Fugue."* *Commentary* 19 (March 1955): 242.

Works on Greenberg

Most of the literature on Greenberg dates from the appearance of *Art and Culture* in 1961. Before then Greenberg's criticism was not subjected to any sustained analysis, at least not in print, although it was referred to with increasing frequency in articles and books. The fullest attention it received was in several reviews that followed the publication of *Joan Miró* in 1948, in George L. K. Morris's article of the same year, and in Alfred H. Barr, Jr.'s book on Matisse in 1951.

Art and Culture thus marked a shift in the kind of critical attention paid to Greenberg's work. The book seems to have clarified the extent to which his writings were informed by a developed theory of modern art and the extent to which he understood the practice of art criticism to be marked by peculiar limits and constraints that reflected the peculiar limits and constraints of its subject. In short, it clarified what he meant by modernism. Since 1961 most of the extensive discourse on Greenberg's critical practice has dealt with the implications of his modernist stance. The following list of selected secondary sources reflects this interest.

Alloway, Lawrence. *Topics in American Art Since 1945*. New York: W. W. Norton, 1975.

Auping, Michael. *Abstraction-Geometry-Painting: Selected Geometric Abstract Painting in America Since 1945*. New York: Harry N. Abrams, 1989.

Barr, Alfred H., Jr. *Matisse: His Art and His Public*. New York: Museum of Modern Art, 1951.

Bois, Yve-Alain. "Dossier Pollock: Clement Greenberg; les textes sur Pollock." *Macula* 2 (1977): 36–39.

Brook, D. "Art Criticism: Authority and Argument." *Studio International* 180 (September 1970): 66–69.

Burgin, Victor. *The End of Art Theory: Criticism and Postmodernity*. Atlantic Highlands, N.J.: Humanities Press International, 1986.

Calas, Nicolas. "The Enterprise of Criticism." *Arts Magazine* 42 (September–October 1967): 9.

Carrier, David. "Greenberg, Fried, and Philosophy: American-Type

Formalism." In *Aesthetics: A Critical Anthology*. Edited by George Dickie and R. J. Sclafini. New York: St. Martin's Press, 1977.

———. *Artwriting*. Amherst: University of Massachusetts Press, 1987.

Cavaliere, Barbara, and Robert C. Hobbs. "Against a Newer Laocoon." *Arts Magazine* 51 (April 1977): 110–17.

Clark, T. J. "Greenberg's Theory of Art." *Critical Inquiry* 9 (September 1982): 139–56.

———. "Arguments About Modernism: A Reply to Michael Fried." In *The Politics of Interpretation*. Edited by W. J. T. Mitchell. Chicago: University of Chicago Press, 1982–1983.

Collins, Bradford R. "Clement Greenberg and the Search for Abstract Expressionism's Successor." *Arts Magazine* 61 (March 1987): 36–43.

Crow, Thomas. "Modernism and Mass Culture in the Visual Arts." In *Modernism and Modernity*. Edited by Benjamin H. D. Buchloh, Serge Guilbaut, and David Solkin. Halifax, N.S.: Press of the Nova Scotia College of Art and Design, 1983.

Crowther, Paul. "Greenberg's Kant and the Problem of Modernist Painting." *British Journal of Aesthetics* 25 (no. 4, 1985): 317–25.

Curtin, Deane W. "Varieties of Aesthetic Formalism." *Journal of Aesthetics and Art Criticism* 40 (Spring 1982): 315–26.

De Duve, Thierry. "The Monochrome and the Blank Canvas." In *Reconstructing Modernism*. Edited by Serge Guilbaut. Cambridge, Mass.: MIT Press, 1990.

———. "Clement Lessing." *Essai daté* 1. Paris: Editions de la Différence, 1987.

Dorfman, Geoffrey, and David Dorfman. "Reaffirming Painting: A Critique of Structuralist Criticism." *Artforum* 16 (October 1977): 59–65.

Fisher, Philip. "The Future's Past." *New Literary History* 6 (Spring 1975): 588–606.

Foster, Stephen C. *The Critics of Abstract Expressionism*. Ann Arbor, Mich.: UMI Research Press, 1980.

Frascina, Francis, ed. *Pollock and After: The Critical Debate*. New York: Harper & Row, 1985.

Fried, Michael. Introduction to *Three American Painters: Kenneth Noland, Jules Olitski, Frank Stella*. Exhibition catalogue. Cambridge, Mass.: Fogg Art Museum, 1965.

———. "Art and Objecthood." *Artforum* 5 (June 1967): 12–23.

———. "How Modernism Works: A Response to T. J. Clark." *Critical Inquiry* 9 (September 1982): 217–34.

Gagnon, François-Marc. "The Work and Its Grip: Essay on Clement

Greenberg's First Critical Approach to Pollock." In *Jackson Pollock: Questions*. Montreal: Musée d'art contemporain, 1979.

Goldwater, Robert. "The Painting of Miró." Review of *Joan Miró*, by Greenberg. *The Nation* 168 (26 February 1949): 250–51.

Guilbaut, Serge. "The New Adventures of the Avant-Garde in America." *October* 15 (Winter 1980): 61–78.

————. *How New York Stole the Idea of Modern Art: Abstract Expressionism, Freedom and the Cold War*. Chicago: University of Chicago Press, 1983.

Guilbaut, Serge, ed. *Reconstructing Modernism: Art in New York, Paris and Montreal 1945–1964*. Cambridge, Mass.: MIT Press, 1990.

Halasz, Piri. "Art Criticism (and Art History) in New York: The 1940s vs. the 1980s; Part Three: Clement Greenberg." *Arts Magazine* 57 (April 1983): 80–89.

Harrison, Charles. *Essays on Art and Language*. Oxford: Basil Blackwell, 1991.

Harrison, Charles, and Fred Orton. Introduction to *Modernism, Criticism, Realism: Alternative Contexts for Art*. New York: Harper & Row, 1984.

Heron, Patrick. "A Kind of Cultural Imperialism?" *Studio International* 175 (February 1968): 62–64.

Hess, Thomas B. "Catalan Grotesque." Review of *Joan Miró*, by Greenberg. *Art News* 47 (February 1949): 9.

Higgens, Andrew. "Clement Greenberg and the Idea of the Avant-Garde." *Studio International* 182 (October 1971): 144–47.

Hoesterey, Von Ingeborg. "Die Moderne am Ende? Zu den ästhetischen Positionen von Jürgen Habermas and Clement Greenberg." *Zeitschrift fur Ästhetik und allgemeine Kunstwissenschaft* 29 (1984): 19–32.

Howard, David. "From Emma Lake to Los Angeles: Modernism on the Margins." In *The Flat Side of the Landscape*. Edited by John O'Brian. Saskatoon: Mendel Art Gallery, 1989.

Kees, Weldon. "Miró and Modern Art." Review of *Joan Miró*, by Greenberg, *Partisan Review* 16 (March 1949): 295–97.

Kelly, Mary. "Re-viewing Modernist Criticism." *Screen* 22 (Autumn 1981): 41–62.

Kozloff, Max. "A Letter to the Editor." *Art International* 7 (June 1963): 89–92.

————. "The Critical Reception of Abstract-Expressionism." *Arts Magazine* 40 (December 1965): 27–33.

Kramer, Hilton. "A Critic on the Side of History: Notes on Clement Greenberg." Review of *Art and Culture*, by Greenberg. *Arts Magazine* 37 (October 1962): 60–63.

Krauss, Rosalind. "The Im-Pulse to See." In *Vision and Visuality*. Edited by Hal Foster. Seattle: Bay Press, 1988.

Kroll, Jack. "Some Greenberg Circles." Review of *Art and Culture* and *Hans Hofmann*, by Greenberg. *Art News* 61 (March 1962): 35, 48–49.

Krupnick, Mark. "Art and Politics Once More." *Bennington Review* (Winter 1981): 23–26.

Kuspit, Donald B. *Clement Greenberg: Art Critic*. Madison, Wis.: University of Wisconsin Press, 1979.

————. "The Unhappy Consciousness of Modernism." *Artforum* 19 (January 1981): 53–57.

Leja, Michael. "The Formation of the Avant-Garde in New York." In *Abstract Expressionism: The Critical Developments*. Buffalo: Albright-Knox Gallery, 1988.

Mahsun, Carol Anne. *Pop Art and the Critics*. Ann Arbor, Mich.: UMI Research Press, 1987.

Mitchell, W. J. T. "*Ut Pictura Theoria*: Abstracting Painting and the Repression of Language." *Critical Inquiry* 15 (Winter 1989): 348–71.

Morris, George L. K. "On Critics and Greenberg: A Communication." *Partisan Review* 15 (June 1948): 681–85.

Natapoff, Flora. "The Abuse of Clemency: Clement Greenberg's Reductive Aesthetic." *Modern Occasions* 1 (Fall 1970): 113–17.

O'Brian, John, ed. *The Flat Side of the Landscape: The Emma Lake Artists' Workshops*. Saskatoon: Mendel Art Gallery, 1989.

————. "Greenberg's Matisse and the Problem of Avant-Garde Hedonism." In *Reconstructing Modernism*. Edited by Serge Guilbaut. Cambridge, Mass.: MIT Press, 1990.

Orton, Fred. "Action, Revolution and Painting." *Oxford Art Journal* 14, no. 2 (1991): 3–17.

Orton, Fred, and Griselda Pollock. "*Avant-Gardes* and Partisans Reviewed." *Art History* 4 (September 1981): 305–27.

Platt, Susan Noyes. "Clement Greenberg in the 1930s: A New Perspective on His Criticism." *Art Criticism* 5 (Spring 1989): 47–64.

Ratcliff, Carter. "Art Criticism: Other Eyes, Other Minds; Clement Greenberg." *Art International* 18 (December 1974): 53–57.

Reise, Barbara M. "Greenberg and The Group: A Retrospective View." *Studio International* 175 (May–June 1968): 254–57, 314–16.

Sandler, Irving. *The Triumph of American Painting: A History of Abstract Expressionism*. New York: Praeger, 1970.

Shapiro, David and Cecile Shapiro. "Abstract Expressionism: The Politics of Apolitical Painting." *Prospects* 3 (1977): 175–214.

Stadler, Ingrid. "The Idea of Art and of Its Criticism: A Rational Reconstruction of a Kantian Doctrine." In *Essays in Kant's Aesthetics*. Edited by Ted Cohen and Paul Guyer. Chicago: University of Chicago Press, 1982.

Steinberg, Leo. *Other Criteria: Confrontations with Twentieth-Century Art*. New York: Oxford University Press, 1972.

Storr, Robert. "No Joy in Mudville: Greenberg's Modernism Then and Now." In *Modern Art and Popular Culture: Readings in High & Low*. Edited by Kirk Varnedoe and Adam Gopnik. New York: Museum of Modern Art, 1990.

Wald, Alan M. *The New York Intellectuals: The Rise and Decline of the Anti-Stalinist Left from the 1930s to the 1980s*. Chapel Hill: University of North Carolina Press, 1987.

Wallis, Brian, ed. *Art After Modernism: Rethinking Representation*. New York: New Museum of Contemporary Art, 1984.

Chronology, 1950–1969

Clement Greenberg continued as associate editor of *Commentary*, a position he had held since the periodical began to publish in 1945. His home address remained 90 Bank Street, New York.

April 25–May 15. With Meyer Schapiro, organized *Talent 1950* for the Kootz Gallery, New York. The exhibition featured "work by unknown or little known young artists of promise," including Elaine de Kooning, Robert De Niro, Friedel Dzubas, Robert Goodnough, Grace Hartigan, Franz Kline, Alfred Leslie, and Larry Rivers. It was the first exhibition Greenberg agreed to organize. During the 1950s and 1960s he would organize eight more exhibitions and contribute to twice that number of catalogues.

July 6–August 30. Taught in the summer session at Black Mountain College, North Carolina. His courses were "The Development of Modernist Painting and Sculpture from Their Origins to the Present Time" and a seminar on art criticism organized around Kant's *Critique of Aesthetic Judgment*. Leo Amino, Theodoros Stamos, and Paul Goodman were among the summer faculty, Kenneth Noland among the students.

December 5–30. A painting by Greenberg was included in *Fifteen Unknowns*, an exhibition at the Kootz Gallery chosen by gallery artists. Adolph Gottlieb selected *Lake Eden* by Greenberg, as well as work by Helen Frankenthaler and William Machado. During 1950, Greenberg began a relationship with Frankenthaler, who had graduated from Bennington College in 1949. The relationship lasted some years.

December 9. Published in *The Nation* for the last time: "T. S. Eliot: The Criticism, The Poetry."

December 14. Attended the first official meeting of the American Committee for Cultural Freedom, held at the New York University Faculty Club, at which Sidney Hook was elected chairman.

1951

February 7. Wrote to Freda Kirchwey, editor of *The Nation*, protesting the political point of view expressed in J. Alvarez del Vayo's weekly column. Greenberg charged that it paralleled "Soviet propa-

ganda." When Kirchwey refused to publish the letter, Greenberg sent it to *The New Leader* for publication. *The Nation* initiated a libel suit against both Greenberg and *The New Leader* that was eventually settled out of court. The protest and the suit generated a good deal of press coverage.

Began to lessen his association with *Partisan Review*. During the year the magazine lost the patronage of a major sponsor and scaled back its operations.

1952

October 1. Nominated to the executive committee of the American Committee for Cultural Freedom.

November 17–30. Organized *A Retrospective Show of the Paintings of Jackson Pollock* at Bennington College, Vermont, at the invitation of Paul Feeley, which afterwards travelled to the Lawrence Museum, Williams College, Massachusetts. Greenberg wrote in the accompanying pamphlet: "[The exhibition] does much to clarify what has been happening in American art since the war, and shows why the most adventurous painters of the latest generation in Paris have begun to look to this country with apprehensive rivalry."

During the 1950s, Greenberg would organize three more exhibitions—of the work of Adolph Gottlieb (1954), Hans Hofmann (1955), and Barnett Newman (1958)—at Bennington College. He would also be invited to present two series of "seminars" at the college, the first in 1962 and the second in 1971.

1953

January 11–February 7. Wrote the foreword to the *Second Annual Exhibition of Painting and Sculpture*, and had one of his own paintings included in this cooperative venture involving close to one hundred artists at the Stable Gallery, New York.

April 4. Arranged for Morris Louis and Kenneth Noland to visit Helen Frankenthaler's studio in New York, where they saw *Mountains and Sea* (1952); when they returned to Washington, D.C., they began painting together in a style informed by her work.

April 8. Resigned from the executive committee of the American Committee for Cultural Freedom.

Summer. Wrote the text for *Matisse* (New York: H. N. Abrams, 1953) at Nag's Head, North Carolina.

1954

January 11–30. Selected eleven artists for inclusion in *Emerging Talent*, an exhibition at the Kootz Gallery, New York; Morris Louis,

288

Kenneth Noland, and Philip Pearlstein were among those included by Greenberg.

April 23–May 5. Organized *A Retrospective Show of the Paintings of Adolph Gottlieb* at Bennington College, Vermont; the exhibition travelled to the Lawrence Museum, Williams College, Massachusetts.

May 12. Delivered the Ryerson lecture, "Abstract and Representational," at the School of Fine Arts, Yale University; the lecture was published by *Art Digest* in November.

Summer. Travelled to Europe for the first time since 1939; visited England, France, Italy, and Switzerland.

1955

Spring. Publication of "'American Type' Painting," one of Greenberg's most anthologized essays; the essay was the last Greenberg would publish in *Partisan Review*. Also organized *A Retrospective Exhibition of the Paintings of Hans Hofmann* at Bennington College, Vermont.

June–August. Engaged in a critical exchange with F. R. Leavis over Greenberg's essay "The Jewishness of Franz Kafka" (*Commentary*, April).

December 19. Contributed the foreword to *Ten Years*, an anniversary exhibition at the Betty Parsons Gallery, New York.

1956

May 4. Married Janice (Jenny) Elaine Van Horne; the marriage was Greenberg's second.

1957

April. Fired from *Commentary*, where he had been associate editor since 1945, by the periodical's publication committee.

June. Travelled to Toronto, Ontario, at the request of William Ronald. Greenberg's visit was sponsored by members of the Painters Eleven, a group of Toronto artists. Spent half a day with nine of the eleven artists, looking at work and offering comments; Jack Bush was among the artists Greenberg visited.

November–December. Contributed the introduction to *An Exhibition of Paintings of Adolph Gottlieb*, Jewish Museum, New York.

1957–1961

In the period from 1957 to 1961 Greenberg worked on three books. Two were published, one was abandoned. *Art and Culture* (Boston: Beacon Press), a collection of critical essays, and *Hans Hofmann* (Paris: Georges Fall) were published in 1961. The abandoned project was a critical biography of Jackson Pollock.

Also during these years, Greenberg began to write for larger and more varied audiences. He accepted commissions from *Art News Annual* (1957), *Saturday Evening Post* (1959), *The New York Times Magazine* (1961), and *Country Beautiful* (1961); and his much discussed essay, "Modernist Painting," was originally delivered as a Voice of America broadcast (1960).

1958

February. Contributed the foreword to *An Exhibition in Tribute to Sidney Janis* at the Hetzel Union Gallery, Pennsylvania State University.

May 4–28. Organized *Barnett Newman: First Retrospective Exhibition* for Bennington College, Vermont.

Fall. Conducted the Christian Gauss Seminar in Criticism at Princeton University. Michael Fried, then an undergraduate student at Princeton, was among those present.

1958–1960

From December 1958 until February 1960, Greenberg was an adviser to French and Co., Inc., New York, at a salary of $100 per week. In October, 1958, French and Co. had opened a gallery devoted to contemporary art. Greenberg did not see clients but did advise the gallery about which artists to exhibit. Among the artists shown during his tenure were Friedel Dzubas, Barnett Newman, Adolph Gottlieb, Morris Louis, Kenneth Noland, and Jules Olitski. In 1959, French and Co. sent Greenberg overseas to search out promising European artists.

1962

August 13–24. Invited to lead the Emma Lake Artists' Workshop, Saskatchewan, by Kenneth Lochhead, Director of the School of Art, Regina College. Twenty-four artists attended, including Lochhead, Roy Kiyooka, Dorothy Knowles, Arthur McKay, Guido Molinari, Robert Murray, and William Perehudoff.

Following the workshop, Greenberg visited studios and galleries in Saskatchewan, Alberta, and Manitoba to gather material for an article on prairie painting and sculpture commissioned by *Canadian Art* (March–April 1963).

September–October. Conducted a weekly "seminar" on art at Bennington College, Vermont.

Fall. Became an adviser to Morris Louis's estate following the artist's death, and continued in that capacity until 1971.

1963

January 11–February 15. Organized the exhibition *Three New American Painters: Louis, Noland, Olitski* for the Norman MacKenzie Art Gallery, Regina, Saskatchewan.

February–March. Considered accepting a fall teaching appointment at the University of Saskatchewan, Regina; rejected the invitation in March.

April 16. Birth of Sarah Dora Greenberg, his second child and only daughter.

1964

April 23–June 7. Organized the exhibition *Post Painterly Abstraction* for the Los Angeles County Museum of Art. The exhibition included work by thirty-one American and Canadian artists, and travelled to Minneapolis (Walker Art Center) and Toronto (Art Gallery of Toronto).

Fall. Invited to Buenos Aires to be juror of an international exhibition. Visited Uruguay, Brazil, Peru, Columbia, and Barbados on the return journey to the United States.

1965

Spring. Travelled in the Middle East and Europe, visiting Israel, Greece, and Italy.

Late May. Named an executor of David Smith's estate, following the artist's death in an automobile accident.

October. Invited to Liverpool, England, to act as jury chairman of the John Moores Biennial of Painting.

October–December. Invited to Regina to select work for the *Diamond Jubilee Exhibition of Saskatchewan Art*.

1966–1967

June 18–October 16, 1966. Contributed the introduction to Jules Olitski's exhibition of painting at the XXXIII Venice Biennale.

October–November 1966. Undertook a lecture tour of Japan under the auspices of the American State Department; the tour was timed to coincide with an exhibition of American painting organized and financed by the International Council of the Museum of Modern Art, New York.

Winter 1967. Repeated the lecture tour in India, under the same auspices and for the same reasons.

October 1967. Published "Complaints of an Art Critic" in *Artforum*, eliciting responses from Robert Goldwater and Max Kozloff.

December 1967. Invited to Ireland to review *Rosc*, a juried exhibition held in Dublin.

1968

January. Publication in *Studio International* of an interview conducted by Edward Lucie-Smith, the first of many subsequent interviews.

May 17. Delivered the inaugural John Power Lecture in Contemporary Art, University of Sydney, Australia. The lecture, "Avant-

Garde Attitudes: New Art in the Sixties," was published the following year.

Following the visit to Australia, travelled to New Zealand at the invitation of that country's Arts Council.

1969

April. Interviewed by Lily Leino for the United States Information Service. A press circular described the purpose of the interview, which was one of a series, as "designed to present the views of prominent Americans on issues and situations of current significance."

Greenberg concluded the interview with a cautionary remark. "Art shouldn't be over-rated," he said. "The quality of art in a society does not necessarily—or maybe seldom—reflect the degree of well-being enjoyed by most of its members. And well-being comes first. The weal and woe of human beings come first. I deplore the tendency to over-value art."

<div align="right">John O'Brian</div>

Index

Motherwell, Robert, 156, 164, 223–24
Mrs. Thomas Brewster Coolidge (Harding), 162
Münz, Ludwig: *Rembrandt*, 198–99
Murray, Hannah, 161
Murray, John, 161
Museum of Modern Art, 72, 99–100, 165, 171, 173, 181

Nation, The (magazine), xvi, 60, 62, 71; del Vayo controversy, xxvi–xxvii, 78–82
Neo-Impressionism, 169, 190
Neo-Plasticism, 243
Neo-Romanticism, 82
Neue Sachlichkeit, 82
Neumann, J. B., 18, 21
New Leader, The (magazine), xxvi, 78, 79n, 255, 275
Newman, Barnett, xviii, 156, 226, 238, 240, 256; and abstract expressionism, 230–33; exhibition of, 103–4
Newman, Robert, 164
Newsweek (magazine), xxvii
New Yorker, The (magazine), xxv, 217
New York Times, The, xvii, xxviii, 59, 65, 137, 178, 180, 202, 247, 262, 273
"Ninth Street" show (exhibition),120
Noland, Kenneth, xxxii, 174
"Note on Richard Crashaw, A" (Eliot), 67
Notes Towards the Definition of Culture (Eliot), 122–31, 133, 151–52
"Novelty" art, xxxii
Nymph and Shepherd (Titian), 31

Oedipus Rex (Sophocles), 216
O'Hara, John, 137
Old Pat, the Independent Beggar (Waldo), 162
Olitski, Jules, xxxii
Ortega y Gasset, José, 142

Pach, Walter: *Pierre-Auguste Renoir*, 63–65
Painting: abstract expressionism, xvii, xxxi–xxxii, 155–57, 217–35, 242–43, 245; abstract and representational, 186–93; action painting, 217; "buckeye" painting, 230–31, 238; Chinese, 42–44; color-field painting, xxxii, 103; French, 155–57, 165, 244; modern, 113–18; Paleolithic, 178–80; and sculpture, 107–13; Venetian, 29–34, 264
Painting in Britain (Waterhouse), 174–78
Painting in Britain: The Middle Ages (Rickert), 199–202
Palmavecchio: *Bath of Diana*, 32
Paris: and abstract expressionism, 218, 228; abstract painting in, 155–57; and Cézanne, 116; Chagall and Soutine in, 159; Hofmann in, 242–43; Lipchitz in, 182; and Renoir, 22; School of, 4–5, 9, 16, 165, 173
Parsons (Betty) Gallery, 103, 105, 256
Partisan Review (magazine), xvi, xxv–xxvi, xxx–xxxi, 35, 39n, 91, 106, 123, 173, 187, 195, 235, 240
Passmore, Victor, 254
Patroon Van Rensselaer (Harding), 162
Pearlstein, Philip, 174
Penguin books, 134
Pevsner, Antoine, 188
Pevsner, Nikolaus, 174
Phidias, 110
Philadelphia Museum, 100
Philip II, 197
Phillips, William, xxviii
Picasso, Pablo, xxiii–xxiv, xxxi, 97, 102, 121, 140, 157, 182, 188, 202, 255, 279; and abstract expressionism, 218–25; American artists compared to, 61–62; and Cézanne, 83, 90, 117; Chagall compared to, 158; and Courbet, 92; and Cubism, 167–70, 265, 275; and Gorky, 38; *Guernica*, 187; Klee compared to, 9–11; and Léger, 165–66, 171–73; and Lipchitz, 185–86; Matisse compared to, 100; and Maurer, 17; *Picasso*, 273–75; sculpture of, 107, 110–11

301